The Hudson

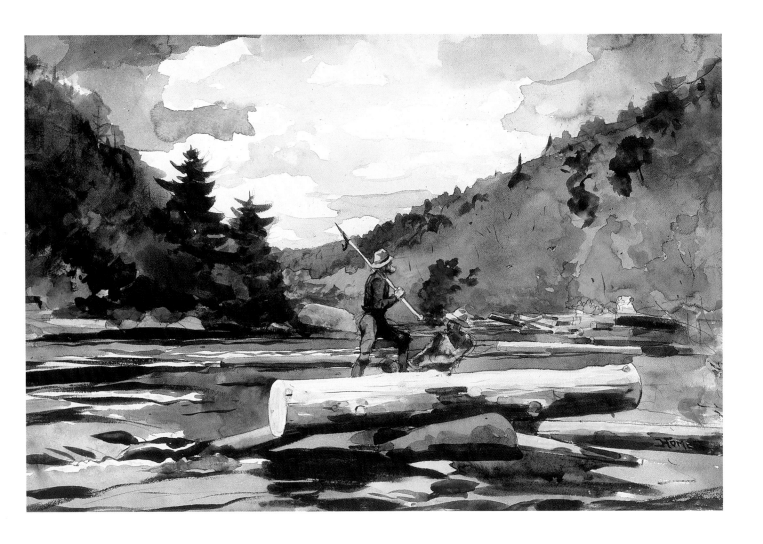

Winslow Homer, "Hudson River, Logging." Watercolor and graphite on paper, 14 x 20 5/8 inches, 1892.
In the collection of the Corcoran Gallery of Art, Washington, D.C., Museum purchase (03.4).

Frances F. Dunwell

the Hudson

AMERICA'S RIVER

COLUMBIA

UNIVERSITY

PRESS

NEW YORK

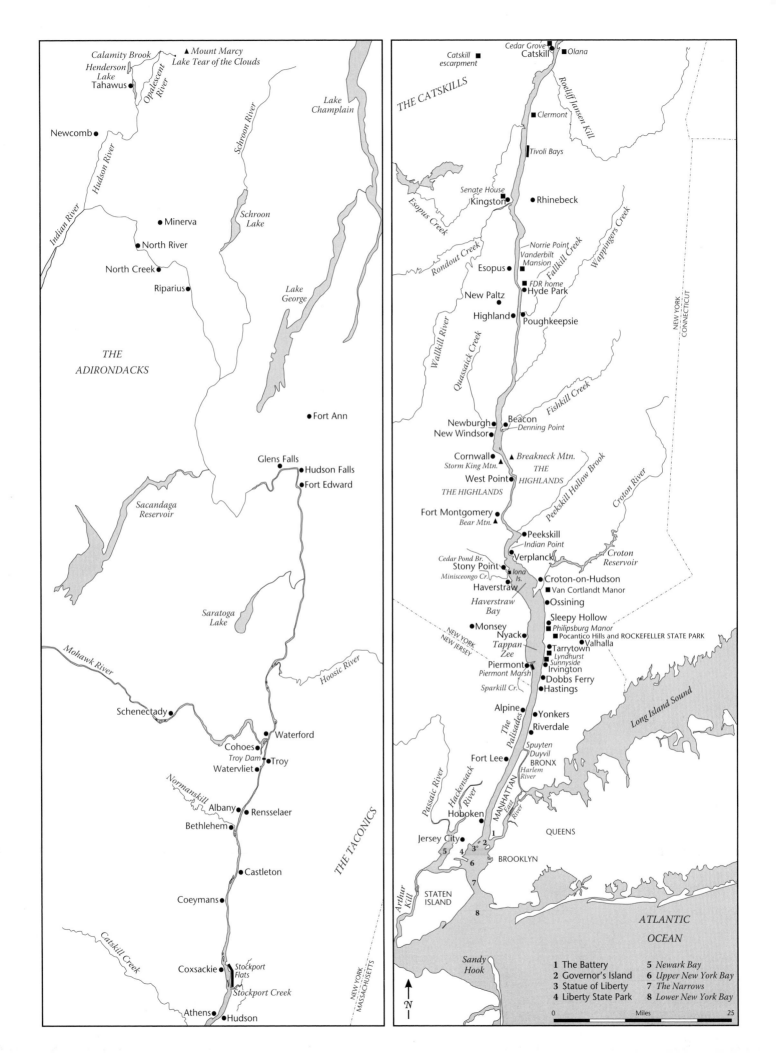

To my family and friends, and in particular to Franny Reese,
without whom, in so many ways, this book could not have been written;
to Wes, Davis, and Lia for their love; and to the Hudson, river of mystery,
for its continual inspiration

CONTENTS

FOREWORD

W HEN I WAS a child my father took me and eight or nine of my brothers and sisters white-water rafting near North Forks in the Adirondacks; the water was so clean it tempted me to drink it, but the guides said it was better not to. I thought about that often in the ensuing years, and in 1984, I had the opportunity to do something about it. That year I began working as an attorney for the Hudson River Fishermen's Association in Garrison. We worked out of a small farmhouse below Osborn's castle in the river stretch between Bear Mountain and Storm King. It was then also that I fell in love with the Hudson Highlands rising in fairy-tale splendor from the river's banks. The grand homes of the nineteenth-century railroad robber barons seem to nestle in every gully between these sugarloaf peaks. The fishermen operate a patrol boat, the *Riverkeeper*, which plies the river searching for polluters.

The Hudson is home to one of the most vigilant, sophisticated, and aggressive environmental communities to protect any resource in the world. Since the early 1960s an uncompromising collection of environmental associations—the Natural Resources Defense Council, the Hudson River Fishermen's Association, Clearwater, and Scenic Hudson, to name a few—have fought to maintain the river's biological and aesthetic integrity.

Today there is a citizen group at every bend and on both banks ready to do battle with any potential polluter or developer. Many of these battles have ended in victory. Hudson River environmentalists have succeeded in stopping the construction of two major Hudson River highways, two nuclear power plants, and the proposed pumped storage facility on Storm King Mountain. We have forced one utility to create a $17 million endowment for the river and to spend another $20 million to research and build special equipment to avoid fish kills at its power plants. The Hudson River Fishermen's Association has brought many polluters to justice. Their willingness to hire lawyers to fight has contributed substantially to our country's environmental case law. Successful cases against Exxon for its secret water thefts, the Westway project, General Electric for its PCB discharge, Anaconda Wire and Copper for its toxic discharges, and Con Ed for fish kills at its Indian Point Power Plant have created a black letter jurisprudence that forms the foundation of American

environmental law. The Hudson River Storm King case is the first case in many environmental law textbooks. That decision gave American environmentalists the standing to sue polluters who injured their aesthetic values. Prior to Storm King, environmentalists could bring actions only where they could prove direct economic damage.

The fight to preserve the river's viewshed and its astounding biological productivity continues. Once the butt of *Tonight Show* quips, the Hudson surprisingly is, gallon per gallon, among the planet's most productive water bodies. The Hudson is the last estuary on the East Coast of North America and perhaps in the entire North Atlantic drainage that still retains strong spawning stocks of all its historical fish species. I have seen the evidence of this productivity first hand.

Although the Hudson itself is too turbid for good visibility, I've often gone scuba diving in its tributaries. My favorite is the Croton River, where I've snorkeled or scuba dived from the rail yard at its mouth upstream to Quaker Rock below the first dam. The pool there is about 12 feet deep during high water in the spring. If I go to the bottom and hug a big rock to stabilize myself in the current, I can sit and watch the pool fill up with fish. Thousands and thousands of alewives or "sawbellies" come up the Croton on their spawning run from the Atlantic in the early spring. You can see great striped bass that swim up to feed on the herring schools or to spawn. Just above the rail yard the Croton River bottom is carpeted with barnacles. Blue crabs are common during some seasons and you see glass shrimp and other marine invertebrates and crustaceans almost anytime during the spring or summer. Atlantic eels 5 feet long hide between the rocks and in crevices, having migrated from their spawning grounds in the North Atlantic. They feed in the Hudson River for a couple of years and then run back to the Sargasso Sea to spawn. Ravenous schools of snapper bluefish, which I used to catch on Cape Cod as a boy, snatch mayflies in their vicious little teeth, competing with the Croton's abundant trout populations—rainbow, brown, and brook. The freshwater species—largemouth bass, smallmouth bass, white perch, yellow perch, bluegills, beautiful pumpkinseed sunfish that are as colorful as any of the tropical fish that adorn pet store fish tanks—congregate in large numbers in the aerated waters beneath the spillway.

Because of its hydrological connection to the Gulf Stream, tropical fish are common in the estuary. In the Croton, one sees odd creatures like sea horses and a fish called a moongazer, which emits an electric shock when you touch it. Jack Crevalle and Atlantic needlefish, whose home waters are in Florida and the Caribbean, are abundant in the Hudson. Giant carp, weighing 30 to 50 pounds and having the appearance of giant mustachioed goldfish, darken the bottom as they swim overhead in pairs or trios. We also have proper goldfish in the Hudson, though they are less abundant than in former times. They grow extraordinarily large—up to 4 pounds—and at least one man, Everett Nack of Claverack, New York, supplemented his income by capturing them for collectors.

The underwater observer is struck by the Hudson's diversity and by its abundance; the impression is of being thrown into a stocked pet store aquarium. Hudson fisherman Tom Lake wrote me that he had caught a permit in the Hudson, the river's 200th confirmed species. Years ago, I was out with a commercial fisherman under the Tappan Zee Bridge pulling up 10,000 pounds of fish on every lift. The nets were filled with each tide every 6 hours, day and night, week after week, month after month, all springtime. The State Department of Environmental Conservation asked

the commercial fishermen to drive their boats slowly in the shallows because at high speeds they were hitting so many fish. In spring the fishermen pulled their nets early because the bountiful striped bass fouled their nets, making it unprofitable to fish for shad. Striped bass from the Hudson cannot be sold, because they are contaminated with PCBs.

Because of its relative diversity, health, and abundance, the Hudson is the Noah's Ark of the East Coast and perhaps of the entire North Atlantic. As the great estuaries of the North Atlantic—the Chesapeake, the St. Lawrence, the Sea of Isov, the Rhine, Long Island Sound, Narragansett Bay, and the Carolina estuaries—decline, the Hudson grows in importance. It is the gene pool—the last safe harbor for species that face extinction elsewhere.

The Hudson's defenders have won many battles to save the river, but ironically, our success on the Hudson has increased the river's allure to developers and industry. The most challenging fights are yet to come. The big challenge to the Hudson's viability today comes not from a single giant project but the death of a thousand cuts, the decline of the river as condominiums occupy every available piece of shoreline.

Sometimes in a court, or across a negotiating table from a polluter or developer, I am asked of the Hudson or perhaps of one of its denizens, "How much is it worth?" In one context we have the tools to measure the value of, say, the Hudson River striped bass. We can estimate their numbers and multiply by twice the cost of a striped bass filet at the fish market. Or we can derive that value through the dollars paid the state for fishing licenses or the total revenues of local bait shops and marinas. But there are other costs we cannot measure—the cultural and spiritual costs of losing a species. We have a right, even an obligation, to make economic choices for our children—but there are other choices we have no right to make and there are costs we have no right to impose. I brought the question to Thomas Berry, a Catholic priest who lives on the Hudson and contemplates our environment: "Why do we need to spend all these resources saving, for example, the snail darter?" The snail darter is a small fish whose presence in a Tennessee river delayed a million-dollar dam project. Unlike the Hudson River striped bass, this fish is insignificant economically. From an ecological standpoint it is nearly insignificant; a dozen other members of the darter family could easily fill its ecological niche. He replied that if we lose a single species, we lose part of our ability to sense the divine, to know who God is. That is an old theological theme. St. Paul said we know the invisible God by looking at visible nature. St. Thomas Aquinas said that by looking at a single flower we can begin to think about God, but that in order to comprehend something of the divine majesty we must look at the entire fabric of nature with all its intricacies, its vast interwoven complexity.

Today, as we pull the threads from that fabric and as the patchwork tatters, we lose part of our ability to "sense the divine." This is a cost we cannot measure. The Hudson is a critical piece of that fabric. Under tremendous development and industrial pressure, the river has continued to thrive, partly as the result of its own miraculous resilience, and partly because of the devotion and sacrifice its beauty has inspired in the populations that live along its banks.

Fran Dunwell has given us wonderful stories about America's river highlighting the symbolic power that the Hudson has acquired over its people and over our nation. She shows us how we as Americans have responded to our environment in a

place where divine presence has long been sensed. She reveals the Hudson's beauty and exposes the contradictions of its history with insights born of personal experience. This book helps us understand how one river holds the key to our past and our future. The Hudson River has changed the way our nation views its land and resources and given us the tools to protect our natural, spiritual, and cultural heritage through the development of an ethic that has spawned an environmental jurisprudence now protecting our resources from sea to sea. We owe Fran our gratitude for capturing all this in her beautifully written book.

Robert F. Kennedy Jr.
Mt. Kisco, New York

PROLOGUE

River of Imagining, People of Passion and Dreams

HERE IS A certain magic about the Hudson River, something that captures the imagination and creates a sense of possibility. The river has personality, energy, and resplendent beauty, a kind of magnetism that attracts visionary people and inspires them to do extraordinary things. That is its nature and disposition. The Hudson nurtures those who are attuned to its voice.

The river's mystique and power combine with unique natural features to make it a force for transformation and a wellspring of new ideas for thoughtful people. No other river can match its role in changing the course of America's continually evolving future. None evokes such passion, fantasies, and dreams. It is a mythic river of monuments and monumental heroes. Its currents run deep in our national character.

I have come to know these aspects of the Hudson through the good fortune of a career that began in 1975, focused on conserving its natural resources and historic heritage. For more than thirty years, I have been blessed to work with many extraordinary individuals who have played a key role in the river's story and to learn about others who came before—innovators in fields as diverse as the arts, engineering, and public policy. The Hudson has something most rivers do not: a following, a diverse and growing cadre of people who will fight for it and argue about it. They come from all walks of life. They are fishermen, auto mechanics, factory workers, socialites, journalists, stockbrokers, lawyers, developers, mayors, mothers, congressmen, janitors, governors, and presidents. Some are practical people, some are radical, and others are dreamers. All are agents of change, carrying on a centuries-old tradition of men and women who listen to the river and imagine new things, contributing to our nation's heritage and our sense of who we are.

My personal experience of the river began in childhood, but it took a long time for love to develop. Like so many people who live along the Hudson, I did not know the river well, at first. Indeed, when I was growing up, in the 1950s and '60s, the river was at its worst—a stinking sewer that was hard to appreciate. Though my parents often took the family to the Fish Net, a favorite restaurant in Poughkeepsie, where we strolled along the water's edge, my most vivid memory of the Hudson is the day I had to get a shot before going out on a boat with a friend—in case I fell in.

I was barely aware of another side to the river: Its landscape lingered in the background, affecting my feelings and my mood. I took for granted the pastoral vistas and rich Victorian architecture of my childhood haunts. Yet they seeped into my thinking and shaped my perspective, giving me a lasting sense of beauty and connection to nature.

The expansive quality of the valley was hard to reconcile with the filth and smell of the river, until I attended an event that shifted my thinking. In the early 1970s, the Clearwater group began having festivals at the same Poughkeepsie waterfront, which was then being ripped apart by urban renewal. Like many river cities of this era, Poughkeepsie turned its back on the polluted Hudson, tearing down the Fish Net restaurant along with whole neighborhoods around it and letting a run-down park to go to ruin. The Clearwater volunteers painted a compelling picture of the problems of the river and their newsletter described the need for action. I came away with a sense of possibility and hope. Like many others, I felt inspired to do something.

In 1975, a series of lucky breaks launched a varied career that made it possible for me to participate in the Hudson's recovery as a waterway pulsing with life, where eagles nest—after a hundred-year lapse—and millions of fish bump their noses at the base of waterfalls in springtime, when they ascend the river to spawn. My work has focused on protecting scenic vistas and historic sites, conserving fish and wildlife habitats, cleaning up pollution, and helping to promote the Hudson's designation as an American Heritage River and its valley as a National Heritage Area. My efforts, and those of my colleagues, contributed to a major reinvention of the river, something I now understand as a recurring theme that links both past and present for those who have made the Hudson their focus. The river has made a great comeback and is celebrated by its cities and citizens, though, of course, new challenges continually arise.

My spiritual connection with the Hudson grew as well, as I came to appreciate its mysteries. For those who have never fished the Hudson, the scenery alone makes a lasting impression, but seeing the abundance that lies below the surface brings the river to life. Recently, I had the opportunity to feel the swollen belly of an eight-foot-long sturgeon, while biologists collected measurements before releasing her to resume an ancient journey. Such experiences intensify our feeling of connection.

My deepening passion for the river inspired me to learn more, and writing this book has been part of that journey of discovery. It has helped me understand the river in new ways and to put daily events into a historical context. I have especially come to appreciate the way the river affects the ideas and imaginations of diverse individuals. In any given week, it is not hard to find news accounts of people who have big plans for the river, for some part of its waterfront, for new art forms that celebrate it, or for new research to unlock its secrets. Some of them will succeed, others will fail, but all are touched by the Hudson's particular magic. A few of them will become transformative leaders, people whose ideas are so powerful that they change the direction of our country. That is the river's unique contribution to our national heritage.

In every era, it is the people of the Hudson River who have provided a new definition of what it means to be American. The legendary rags-to-riches entrepreneur, the brash New Yorker, the rugged outdoorsman, the artist who sees beauty in wildness—all trace their roots to the unique river environment.

The unusual confluence of nature and people on this river enabled New York's rise to greatness; it gave us both Gotham and the Empire State. Because of the Hudson, Manhattan Island developed as a nexus of money, power, intellect, and the arts as well as a melting pot and a global crossroads. The river has streamed into political movements, environmental movements, and the movement of people. It has floated in the consciousness of innovative leaders. The Hudson is a fluid force for change whose effects have rippled outward in widening circles to the nation and the world.

Dutch traders stamped a commercial imprint on the island at the river's mouth, and established a welcoming tradition for aspiring people of all faiths and all nations. Revolutionary War leaders studied the river terrain to gain key strategic military advantages that gave us our democracy. The Hudson's beauty inspired America's first artists and writers. Civil War industrialists used its natural resources to produce winning technology that helped reunite a fractured nation. Engineers developed pioneering bridges, aqueducts, canals, and tunnels to meet changing human needs and desires. The entrepreneurial spirit fostered by the river environment created leading companies like General Electric and the New York Central Railroad, as well as new models for conservation.

The Hudson not only stirs ambition but also seeps down into the soul, inspiring other kinds of imagining. People may sprinkle it with fairy dust, or they might project their inner dreams and fears onto its misty surface. It is a haunted river of pirates and ghost ships. It ebbs and flows with memories from ages gone by. In the rolling thunder of the Catskill Mountains, Henry Hudson's crew can be heard playing ninepins. Among the Highlands—so reminiscent of the Rhine—the Valkyries once rode their winged steeds to Valhalla. The river reflects our most fantastic notions.

The Hudson's creative power begins with its unique natural blessings: breathtaking scenery that makes people's spirits come alive, and useful resources. Its nourishing estuary supports an abundant ecosystem, where new life springs forth in predictable cycles of birth and rebirth. "Famine they fear not," wrote one colonial settler about the Native Americans who lived from its bounty centuries ago.[1] On the Hudson, tidewater breaches the Appalachian Mountain range and extends far inland. Connecting waterways radiate to the north, south, east, and west, placing the river at the heart of an ideal transportation system for boats of every description. The river's deep, salty harbor doesn't freeze. The geology of its valley, shaped by glaciers, lava, and earthquakes, creates cascading waterfalls as well as the raw materials for commerce and industry: tall forests, veins of iron, and deposits of limestone and clay.

The advantages of the river's geography draw entrepreneurs and innovators to its shores, where the magnificence of the Hudson reinforces a belief in the power of their dreams. They come with great aspirations and mythic ideas, sensing the river's enormous potential and seeing it as a theater, with themselves as heroic actors on its stage.

Something else happens too, something unique and wonderful. For those who are open to it, the river becomes more than a platform from which to speak their lines. It emerges as a player, dancing with the cast as they improvise their acts, bewitching them, so the drama unfolds in new ways. A transformation takes place, and people are swept forward with the river's flow.

Inspired by engagement with the Hudson, imagination takes many forms. People write about the river in a different way, paint it in a new light, harness its natural

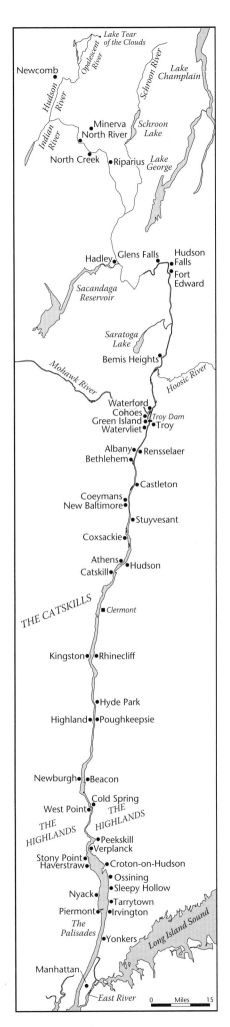

resources to new economic advantage, or challenge these uses and revise national policies. Their actions have larger meaning: a poem expresses a relationship to the divine, a canal is a pathway to empire. The imaginings of river visionaries alter the course of America's future. New movements are born, new precedents are set. The impossible becomes possible. "It can't be done," is a steady drumbeat on the Hudson, one that precedes the march of new kinds of progress in response to challenges the river poses.

Individual people are the key to the Hudson's story, because before dreams can become real, they must be given voice and energy. Passionate men and women have shaped the river and its shoreline as if it were an ever-changing sculpture made by many hands. The river responds by molding character. National leaders from many fields have found their muse on the Hudson. Their stories, past and present, become intertwined. Artists, funded by industrialists, created works that inspired conservationists. Dutch sailors became characters in literature that was read by French and British tourists who were trying to understand America. Engineers remodeled the river and then designed the mechanics of its recovery. People who became fabulously wealthy through extraction and use of the river's natural resources later became the donors who spent millions to preserve its treasures.

As a result of this interaction between people and the environment, the influence of the Hudson can be felt in faraway places. It boosted the port of Chicago, shaped the architecture of Mendocino, produced the prototype for riverboats of the Mississippi, and changed the fish populations of Oregon. It turned Buffalo, Syracuse, and Utica—mere hamlets—into large cities. It shaped our national park system and the design of college campuses in many states.

The Hudson's oysters were among America's early exports to China. Iron ore, mined on its shores and cast into myriad products in riverfront factories, has been carried on camelback along the shores of the Black Sea and by llamas up the slopes

of the Andes. The river has received sugar from Brazil, pepper from Sumatra, silver from Mexico, wine from Madeira, whale oil from the deep ocean off the Canary Islands, and gold from California, as well as silk, porcelain, televisions, and toys from Asia and diamonds from Africa. It has welcomed the children of every continent, every country, every state—a gateway for immigrants seeking liberty and freedom.

❖ ❖ ❖

The Hudson is a mere 315 miles in length, but in that short distance, it compresses centuries of innovation and imaginationg into visible form. A traveler from the Hudson's marshy source, at Lake Tear of the Clouds, to its briny chop in New York Bay can witness the full sweep of American history and ideas and the relationship of people to the environment with which this heritage is so deeply intertwined.

The river begins in a remote wilderness on the shoulders of Mount Marcy. It descends—a mere brook—across granite, feldspar, and opalescent rocks through steep gorges and then meanders through lush meadows into settled rural valleys. As the Hudson gathers the waters of the Indian River, the Schroon, and the Hoosic, it cascades over high waterfalls to merge below with the broad Mohawk, itself a large river.

In its first 162 miles, the Hudson passes through old-growth forest protected through the efforts of a passionate surveyor and traverses the defunct titanium and iron mines at Tahawus, where David Henderson tried to make steel. Dropping more than 4,000 feet in elevation, it flows by dairy farms, religious retreats, and paper mills. It passes Fort Edward, a post in the French and Indian War, now home to a GE factory, and Bemis Heights, the battlefield where Benedict Arnold's stunning victory convinced the French to aid the American Revolution. The river tumbles over rapids and swells behind the dam created for DeWitt Clinton's pioneering canal system, which took New Englanders and immigrants on their great westward migration. It

(top) The Opalescent River, headwaters of the Hudson in the Adirondacks.
Lossing, The Hudson from the Wilderness to the Sea, *1866*

(bottom) Jacques Gerard Milbert, "Extremite de la Chute d'Adley's" (Hadley's Falls). From *Picturesque Itinerary of the United States*, 1826.
Courtesy of the Adirondack Museum, Blue Mountain Lake, NY

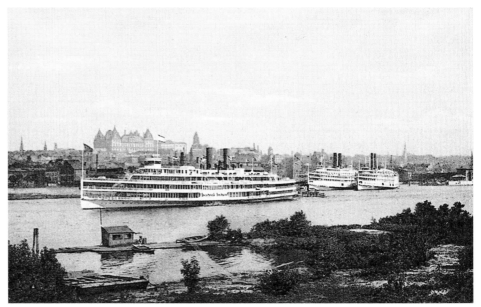

(top) General Electric factory at Hudson Falls.
Courtesy of Scenic Hudson

(bottom) "The Waterfront, Albany."
Undated postcard circa 1910, author's collection

reaches river cities—Cohoes, Waterford, Green Island, Watervliet, and Troy—where innovators like Henry Burden led the Industrial Revolution and Stephen Van Rensselaer created the first of three engineering schools the river passes.

Spilling over the federal dam that stretches between Troy and Waterford, only halfway on its journey to the ocean, the Hudson meets tidewater and becomes a long estuary, an arm of the sea, though lacking even a trace of salt at this point. Flowing to a different rhythm, less urgent now, streaming back and forth through the day, it gives up turbulent whitewater and smoothes out like a lake. The pace of human activity picks up even as the river slows down, for now every inch of the shore is connected to the ocean and to the great restless city below.

For the next 153 miles, the Hudson passes numerous villages and river cities, most of them clustered around creeks and bays. It flows by the Watervliet Arsenal, where

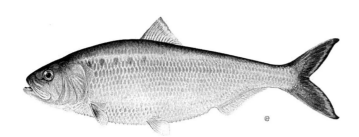

Civil War bullets and tank guns were made, and the capital, Albany, the seat of power in the Empire State. It circles sandy islands where Native Americans held their council fires and laps the shores of Bethlehem, Coeymans, New Baltimore, Athens, Coxsackie, Stuyvesant, and Rhinecliff—communities whose names reflect the mix of cultures and aspirations among people who settled here.

Now, the river wends its way through rare freshwater tide marshes and welcomes seasonal oceanic visitors: Atlantic sturgeon, American shad, blueback herring, and striped bass. It passes the city of Hudson, once a home port for whalers bound for far-off seas. Brown and green, the color of roiled silt and tiny plankton, the Hudson rolls on past the distant blue Catskills, where Washington Irving dreamed and Rip Van Winkle slept. It glides below the studios of the renowned landscape painters Thomas Cole and Frederic Church, sparkling with a million reflections of sun and clouds by day and soaking up the rose hues of the approaching dusk. As the river passes Clermont, home of the Livingstons and once a hotbed of political and technological ferment, it receives vital oxygen from pale green fronds of water celery. They dapple its surface, acres of freshwater seaweed, moving back and forth like kite tails in the wind as the river flows north and south with the tide. Nearby is the city of Kingston, a so-called "nursery for villains," rebuilt after it was burned to ashes by the vengeful British officer John Vaughan.

The river broadens below castles of America's first millionaires and beneath the country estate where President Franklin D. Roosevelt tested his ideas about conservation and human dignity. On the opposite shore, monasteries line the western

(top) American shad. Lithograph by Hugh Crisp.
New York State Museum

(bottom) Seneca Ray Stoddard, *The Old Man of the Mountains.* Undated (late nineteenth-century) albumen print.
Courtesy of the Chapman Historical Museum

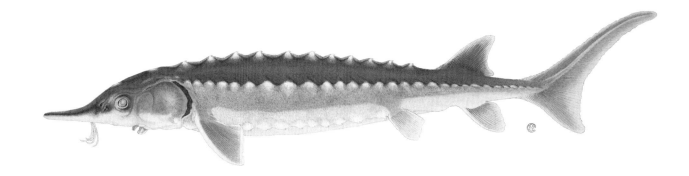

bluffs. Then, Poughkeepsie, Newburgh, and Beacon rise up—industrial cities reinventing themselves around new uses that take advantage of the river's history and beauty.

When the river reaches the Highlands gorge, it courses through a narrow, deep channel, guarded by the fortress and military academy at West Point. In the dark recesses of the river bottom, 100 feet below, ancient sturgeon graze for mussels, peering through the water with clouded eyes. Above, burly mountains rise 1,000 feet high, and Mr. Roebling's graceful Bear Mountain suspension bridge takes flight, an engineering marvel of its day. As in many spots along the Hudson's journey, but most intensely here in the Highlands, we sense a kinship with the river that is expressed in the design of houses, tollbooths, bridges, and barns—even in the ramparts of West Point itself.

Emerging from the Highlands' southern gate, the Hudson broadens to a series of bays surrounded by marinas, quarries, suburbs, cities, power plants, and historic sites, among them Stony Point, the fort stormed by Mad Anthony Wayne; Peekskill, a stop on the Underground Railroad; and Verplanck, home to a nuclear power plant, a focus of perpetual controversy.

Three and a half miles wide at Haverstraw Bay, the river is brackish and shallow, warm and rich with nutrients. Here is a nursery for tiny fish, where they gather strength for adult life in the sea. Below the surface of the river are ancient oyster beds, 6,000 years old, and on Croton Point nearby are the shells left by Native people who feasted on the river's bounty.

(top) Atlantic sturgeon. This fish commonly grows to eight feet long or more in the Hudson. Lithograph by Hugh Crisp. *New York State Museum*

(bottom) A. Van Zandt, *The Hudson North, from West Point.* Undated wash on paper, showing a peacetime view of the Highlands. *Courtesy of the Hudson River Museum, Yonkers, NY*

On shore, deep clay pits and beaches full of bricks are all that remain of the Haverstraw brickyards that supplied New Yorkers with fireproof building materials. Above Nyack, Piermont, and Alpine are the red cliffs of the Palisades, a battleground for New Jersey's progressive women's clubs.

Across the river at Tarrytown, the Headless Horseman rides at night through Sleepy Hollow country, where the Dutch and the English had their quarrels, while by day the car factory started by Louis de Chevrolet has been torn down to make way for condominiums.

As the river approaches Manhattan, it gains power and energy. It is narrower once more, but still a mile wide, with strong currents and swelling waves that rush past the glass, steel, and concrete of the towering city and Frederic Bartholdi's Statue of Liberty, with its welcoming beacon of light. More immigrants to the United States can trace their arrival to this spot than to any other port. Tugboats, container ships, ocean liners, ferries, yachts, and kayaks crowd the docks of a harbor that joins those of Hong Kong and San Francisco Bay as the best in the world. From here, thousands of soldiers shipped out for Europe in World War II, along with much of the nation's war materiel.

Skyscrapers rise, the financial district hums, and many languages are spoken in a city made great by its location on the Hudson. Around the piers, sea horses and oyster toadfish get caught in the nets of inquiring marine biologists.

At the tip of Manhattan Island, the Hudson officially ends, though its waters continue to flow another seventeen miles to the sea. The North River, as mariners still call it (using its early Dutch name), joins with the East River and the Harlem River—both actually a single tidal strait circling behind the island—and the Hackensack and Passaic rivers of New Jersey. These waters mingle in the upper bay and then course through "the Narrows" into the lower bay, past Sandy Hook and Rockaway Point into the Atlantic.

Throughout this long journey, the Hudson is hypnotic and alluring. The same river that inspires feats of daring and dreams of conquest also invites courtship,

"Grants Tomb and Palisades, New York City."
1911 postcard, author's collection

induces thoughtful reverie, and welcomes tender conversation and caring embrace. It is beguiling, flirtatious, and temperamental. Because of this, when the river beckons, people respond passionately.

For those who fall in love with the Hudson, the relationship has transformative power. Its effect may be personal, or it may change the nation. This aspect of the river is still very much alive. There is every reason to believe that the river will keep dancing with us in a creative process in which new movements will be born and new precedents set. That is the nature of the Hudson.

Frances F. Dunwell
New Paltz, New York

View of the Battery at the southern tip of Manhattan. The Hudson River is on the left, the East River—a tidal strait—is on the right. As it goes north, it becomes known as the Harlem River and rejoins the Hudson at Spuyten Duyvil.

Copyright 2007 Alex S. MacLean / Landslides

ACKNOWLEDGMENTS

THIS BOOK IS a sponsored project of the Desmond-Fish Library. Scenic Hudson played a significant role in the early development of the project, supporting both its spiritual and temporal needs.

The author, the publisher, and the sponsor would like to take this opportunity to express our special gratitude to the New York State Council on the Arts (NYSCA) and the Hudson River Foundation. Through grants to Scenic Hudson in 1981 and 1982, where the author worked at the time, NYSCA launched this project providing funding for preproduction research as well as photography by Robert Beckhard, whose lovely contemporary images of the Highlands illustrate the book.

In recognition of their early and most helpful support, and to assist them in their important ongoing programs to protect the Hudson River estuary and its shores, royalties earned from sales of this book will be donated to Scenic Hudson and the Hudson River Foundation.

We would also like to thank the organizations for providing critical financial support for this book. They are: Chris and Sharon Davis; Fordham University; The Gannett Foundation; Furthermore, a program of the J. M. Kaplan Fund; members of the Perkins Family (Anne P. Cabot, Penelope P. Wilson, and George W. Perkins Jr.); Alex Reese; Constantine and Anne Sidamon-Eristoff; T. Roland Berner Fund of the New York Community Trust; and an anonymous contributor.

The Hudson River Foundation supported the writing of *The Hudson River Highlands*, out of which this book has grown. Support also came from the Richard King Mellon Foundation through the Yale School of Forestry and Environmental Studies; the Newington-Coopsey Foundation; the Ogden Foundation; the Perkins Foundation; Franny and Willis Reese; and Nancy Stover, in memory of Robert Stover.

The author would also like to thank the following people for what can only be described as extraordinary effort and helpfulness—without which this book would not have been possible: Roger Panetta; Frances Stevens Reese; Francie Brody and her firm, Brody and Weiser; Tamara Watson and Deborah Begley; Carol Donick and the board of the Desmond Fish Library; Julia and Steve Dunwell; Wes Natzle. Gary Allen has provided enthusiastic, clear, and steady editorial guidance enhanced by a deep knowledge and

understanding of the Hudson Valley region and a gift with words. My research intern, Peter Cutul, helped fill the gaps in my understanding of early subject matter. Steve Bates read the entire manuscript and provided valuable feedback and advice.

It has been nothing short of a pleasure to work with the staff and editors at Columbia University Press. They have made difficult tasks seem easy, they have been responsive and enthusiastic, and they have been unflappable in dealing with the unique complexities of this project. Extra special thanks to: Jennifer Crewe, Afua Adusei, Leslie Kriesel, and Lisa Hamm.

Books such as this cannot be written without reference to historic collections of books, periodicals, and documents and access to works of art. The following institutions and libraries have outstanding collections that were of invaluable use: the Adirondack Museum; the Association for the Protection of the Adirondacks; Fordham University, the Franklin D. Roosevelt Library; Hudson River Sloop *Clearwater*; Marist College; the Mid-Hudson Library System; the New-York Historical Society; the New York Public Library; the New York State Library, Archives and Museum; the New York State Office of Parks, Recreation, and Historic Preservation; the New York State Department of Environmental Conservation; the Palisades Interstate Park Commission; Riverkeeper; Scenic Hudson; the Smithsonian Institution; the Sojourner Truth Library (SUNY New Paltz); USMA West Point; Yale University; and the county historical societies of the region.

Numerous people have contributed their time as readers, researchers, advisors, providers of photographs, and sources of information and linkages, or have made other personal efforts that have been particularly helpful. For this I am grateful to: Wint Aldrich, Carol Ash, Betsy Blair, Bob Boyle, Ralph Brill, P. Thomas Carroll, John Cronin, Kerry Dawson, my brother Steve Dunwell Jr., Kate Dvorkin, Rachel Eskow, Sidney Forman, Elisabeth Funk, Charles Gehring, David Gibson, Kathy Hattala, Chuck and Katherine Henderson, Clay Hiles, Tom Lake, Russ Lange, Cara Lee, Stephen Lippman, Kenneth Jackson, Col. Jim Johnson, Andy Kahnle, Charles Kutter, Simon Litten, Alex Matthiessen, Andy Mele, Dan Miller, Carl Mondello, Marc Moran, Ken Moody, John Mylod, Leo Opdycke, Anne Fred Osborn, Richard Panman, Edith Pilcher, Patty Prindle, Chip Reynolds, Fred Rich, Lindsay Roi, Pete Seeger, Steve Stanne, Dennis Suszkowski, Philip Terrie, Pamela Read, Warren Reiss, Klara Sauer, Sue Smith, Ned Sullivan, Gregg Swanzey, Veronica Vencat, Dick Wager, Beth Waterman, Bob Weinstein, and Tom Wermuth. Without the encouragement of Bill Moyers, I would never have embarked on writing this expansion of my first book, *The Hudson River Highlands*.

Finally, a curious thing happened in the writing of this book. I discovered, after the Revolutionary War chapter was completed, that a Connecticut ancestor—Stephen Dunwell—fought in the battles of Fort Montgomery and Stony Point, which I had described, before he joined the westward migration of New Englanders along the route of the Erie Canal. I also learned that a Virginia ancestor on my mother's side— Anthony Crockett—fought at the Battle of Saratoga. Writing this book has provided a way to put many other details of our family history into context, including the "air treatment" that my grandfather, another Stephen Dunwell, received for his tuberculosis, and the immigration of the French Huguenot branch of the family. So, in closing, thanks to my relatives for saving these family records, and to the two soldiers who campaigned for a new nation on the shores of the Hudson in the fall of 1777.

The Hudson

World's End, World Trade, World River

*Henry Hudson's Failed Quest, Adriaen Van der Donck's Utopian Vision,
and the Legend of the Storm Ship*

I

AT THE NORTHERN tip of Manhattan Island, where the Harlem River narrows to join the Hudson, is a spot shown on maps as Spuyten Duyvil, from the Dutch name meaning Spitting Devil or Devil's Spout. Both rivers are tidal here—the Harlem is actually a tidal strait—and this spot swirls and boils with the ebb and flow of colliding currents. The name serves as a warning of dangerous conditions.

It also serves as a jumping-off point for folklore. It was here at Spuyten Duyvil that Washington Irving's fictional character, a certain Antony Van Corlaer, drowned after foolishly swearing he would cross the Harlem River "in spite of the devil!" The devil, Irving tells us, in the shape of a huge fish—a moss bunker—dragged him beneath the waves.[1] Irving, who avidly studied the old Dutch records of the New Netherlands colony, liked to tell stories that mixed fact with fantasy. The tale of Antony Van Corlaer is a caricature of real Dutch colonists, and historically, many people drowned at Spuyten Duyvil, but the moss bunker—a menhaden—is a small,

harmless fish. Like many of Irving's stories, it was told in jest and created a new legend to explain the name of a place along the Hudson—while keeping alive the memory of the Dutch colony, which predated the thirteen British colonies, and a folk tradition that gave the Hudson more lore than any other American river.

Spuyten Duyvil is just one example of the dual nature of the Hudson River. It flows to its own beat, apart from human wishes and desires, yet it also dwells in hearts and memory. These two rivers are so braided together, it can be hard to figure out where one starts and the other ends. On the Hudson, nature mixes with human imagining to create new ideas, new meanings, and new traditions. The river is inhabited by the ghosts of people like Van Corlaer, and Irving himself. Their voices echo from the past.

Long before the Hudson was a haunted river, it was a life-giving river, supporting the needs of thousands of Native Americans who lived on its shores before the Dutch traders arrived in 1609. Native villages could be found up and down the valley. The area from the river mouth to roughly present–day Red Hook was the territory of the Lenape people, also known as the Munsee Delaware. Sapohaniken Point on Manhattan Island, where Greenwich Village now stands, was one of their many settlements noted in early colonial records. To the north, from Cruger's Island in Red Hook extending as far north on the river as Fort Edward and beyond to Lake Champlain, were the Mohican people, relatives of the Lenape, all people of the Algonkian lineage.[2] To the west, along the Mohawk River, the largest tributary of the Hudson, were the Haudenosaunee, known to themselves as the People of the Longhouse and to the French as the Iroquois, a federation of five and later six independent Indian nations who provided mutual aid. "Iroquois" is a Basque translation of an Algonkian word meaning man killer, and indicates the historic animosity between the Haudenosaunee and their Mohican neighbors.

For these diverse native people, life revolved around the river and its feeder streams. Its fish provided them with food throughout the seasons, and the surrounding forest abounded in wild game—turkeys, grouse, deer, and quail. The river valley offered a long growing season for raising the three sisters—corn, beans, and squash—and on the lower estuary, where the river is brackish, large beds of oysters crusted the bottom of the river.

For the River Indians, as the Algonkians were known, their location was particularly advantageous. In April, as the shadbush, or serviceberry, bloomed, the American shad and other ocean fish would enter the tidal river in large numbers and swim upstream to spawn, providing a reliable source of protein after the hardship of winter. The north-south route of the Hudson also put it directly in the flyway of ducks and other migratory waterfowl, which would land in river marshes and vegetated flats to rest and feed. Passenger pigeons, so plentiful that they blocked out the sun, also migrated north over the Hudson, an easy target for hungry hunters.

Villages served as home bases from which the valley's original residents would move in seasonal rounds to temporary camps, following the fish and game in spring and fall, tending gardens on the river lowlands in summer, and moving off the river to more sheltered areas as cold weather approached. Winter stores of dried meat, fish, berries, and nut meats would last until spring arrived and people moved to the river again.

Native presence on the Hudson dates back as far as 11,300 years, and the remains of settlements have been found dating to about 500 A.D., although villagers tended to

move every 10 to 12 years. At the time of contact with European colonists, Native people cultivated cornfields hundred of acres in extent on floodplains that, in many cases, are still planted in corn by farmers today. They roamed large territories, which generally conformed to the boundaries of a watershed or stream drainage basin. Water, used as a dividing line for property by many European settlers, was a uniting feature for native people of the Hudson Valley.

Like the colonial people who followed, Native Americans found the Hudson endowed with unique conditions that allowed many uses. It provided a long water highway for their canoes, enabling the exchange of goods between the Atlantic coast and the interior of the country. The river and its valley also served as a home, a warpath, a sanctuary, and a place to escape from disease. As one colonist observed in 1653, "sickness does not prevail much . . . the Indians with roots, bulbs, leaves, &c. cure dangerous wounds and old sores, of which we have seen many instances."[3]

Little is known of the sacred culture of River Indians; it was not studied by the Dutch. There is no evidence of particular sacred spots on the river, or ceremonial places, except that Schodack Island is known to be where the Mohican held their council fire, and a point above Newburgh still known as Danskammer—so-called by the Dutch because the Lenape people danced there—may have been a place where the late summer Green Corn ceremony was celebrated, as was the case with many flats along the river. However, all Native Americans viewed rivers as members of their extended family, deserving of reverence, like all bodies of water and all parts of the universe. Like the rocks, the trees, and the animals, the Hudson River was animated with a life of its own, part of the spirit world in which all of nature was seen as having a soul, called *manito*.

The Mohican people called the Hudson Muhheahkunnuk, or Mohicanituck, meaning "great waters or sea, which are constantly in motion, either flowing or ebbing," according to the Mohican tribal historian Hendrick Aupaumut.[4] The name of the original Mohican people is derived from the same term, Mohicaniuk, or People of the Ever-Flowing Waters. The river and the people were as one.[5]

The river meant something entirely different to Englishman Henry Hudson, who explored it in 1609 in the employ of the Dutch. Hudson hoped to discover a new sea route to China, and the river would be his path to fame and glory. If he succeeded, he would also fulfill the hopes of the Dutch corporation that sent him there, the East India Company, which sought to expand its economic empire to the far side of the globe, bringing the riches of Asia—silks, spices, and dyes—back to Amsterdam. The river was to be the stage on which he would play a heroic role as the man who found the shortcut to the Orient.

For Henry Hudson, the waterway he called the "Great River of the Mountaynes" turned out to be a place of dashed hopes and thwarted dreams. He would not find the elusive Northwest Passage, and within just a few weeks of his arrival he would leave it forever. Even so, he could sense the possibilities of this place, how the river might be useful in other ways. Here was a different kind of business opportunity for his sponsors:

It is as pleasant a land as one need tread upon; very abundant in all kinds of timber suitable for ship-building, and for making large casks or vats. The people had copper tobacco pipes, from which I inferred that copper might naturally exist there; and iron

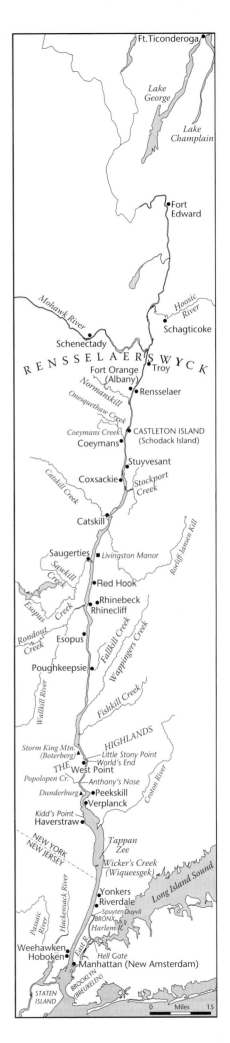

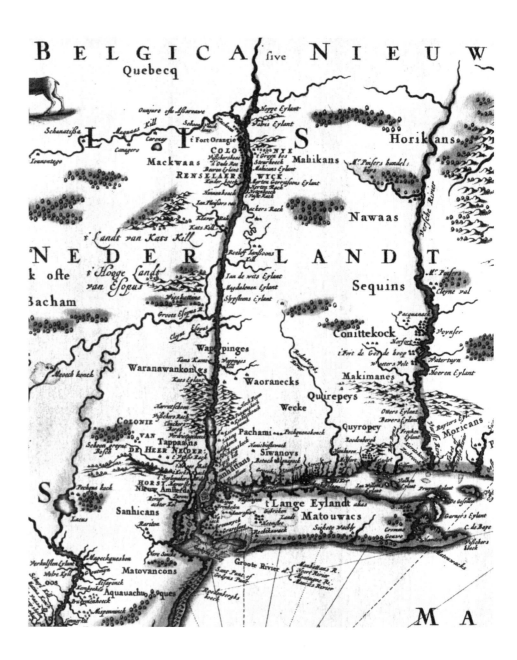

Detail of the Jansson-Visscher map of New Netherland (Nieuw Nederlandt), depicting the Hudson River (groote Rivier), circa 1651–53 and likely published between 1655 and 1677. The map shows the territory of many Native people, including Mohicans and the related Munsee-Delaware—Wappingers, Tappans, and Manhattans—along the Hudson River, and Haudenosaunee (Mohawks shown as Mackwaas) along the Mohawk River, as well as Dutch settlements such as Rensselaerswyck and Long Island (Longe Eylandt).

Courtesy of Penn Prints

likewise according to the testimony of the natives, who, however, do not understand preparing it for use. . . . The land is the finest for cultivation that I have ever set foot upon, and it also abounds in trees of every description.[6]

Hudson and the crew of his small ship, the *Half Moon,* also found Native people willing to trade with him, bringing beaver pelts, otter skins, and tobacco, all valuable products in the European economy. The river spoke to Hudson in its own language, and he listened with seventeenth-century ears. He understood that he had found a great place for international commerce, a place with colonial potential, a place to make money.

Hudson was not the first European to explore this river. However, he was the first to present its advantages for European trade, the first to imagine how its valley might be shaped to meet a market opportunity. In this, he was one of many people

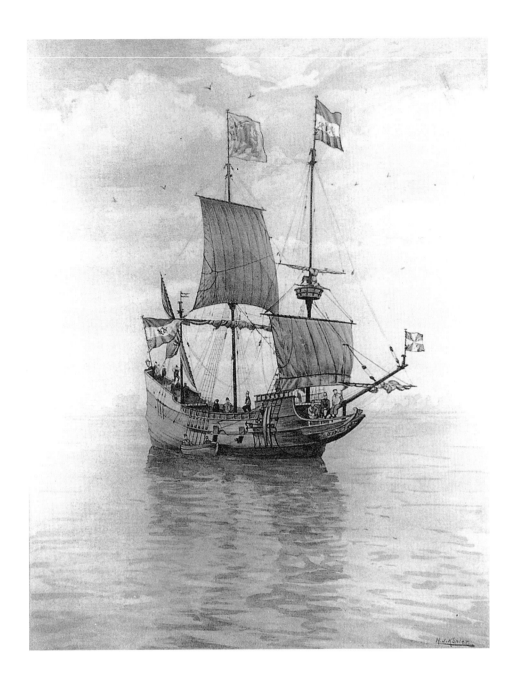

to come who would read the signs of nature—rocks, ores, trees, fishes, animals—and interpret them in a new way. In so doing, he transformed the meaning of the river and sparked the interest of a new audience: the ambitious merchants and traders of the Netherlands. Though he stayed only a few days, he would enter the river's pantheon of ghosts, becoming part of the collective memory that haunts the Hudson still. He would also set the river on a course to becoming the most important waterway in American history.

Henry Hudson made four voyages to find a passage to the Orient. With this exception, he explored for England. However, his 1609 voyage gave control of the river to the Netherlands. This twist of fate would have important consequences for the river and the nation by allowing Dutch culture to take root, which provided a context for the bounty of nature to be used and understood in ways unlike those derived from our country's English heritage. The mix of nature and culture that developed on the

The *Half Moon*, showing Henry Hudson's ship in 1609. Hudson–Fulton Celebration, 1909. *Author's collection*

Hudson after 1609 would provide a uniquely supportive environment for visionary people to make changes that reverberated into the future.

Dutch merchants read the explorer's account and dreamed of wealth and power. Reports that the natives offered beaver pelts and otter skins in trade for beads, knives, hatchets, and other "trifles" particularly caught their eye. They imagined the river in a different way, as the place to get rich and to challenge the French in Canada for control of the fur trade. They also noted descriptions of a sheltered harbor and a long, tidal water route upstream.

For the seafaring Dutch, waterways were what mattered. They staked their claim to "New Netherlands," a territory that extended from the Delaware River, which they called the "South River," to the Connecticut River (the "Fresh River"), including all the lands and waters in between. The Hudson, at the center of New Netherlands, became the backbone of their new colony. Over the next fifty-four years, they would give it many names, but North River is the one that stuck—a name still found on maps today. It would not be called the Hudson until later.

During the decades that the Dutch claimed the river as the central waterway of their colony (1609–1664), they emerged as the world's leading sea power, developing coastal trading posts in the Caribbean, South America, Japan, India, and Indonesia. The Dutch controlled trade in dozens of high-value products, including coffee, sugar, cotton, silk, indigo, copper, black pepper, and spices. Amsterdam became the world's busiest port.[7] They also fought for and won independence from Spain (1648), developing military capability that protected their commerce. Though we tend to think of England as the naval power of this era, the British did not begin to challenge Dutch supremacy on the seas until 1652, and it would take years for them to gain the upper hand.

New Netherlands was just one of many Dutch trading ports, and it was a relatively minor one in the grand scheme of things. The income from the river's fur trade paled in comparison to that of the sugar-producing islands in the Caribbean and along the coast of Brazil. However, the river gained importance as a key North Atlantic hub in a web of Dutch commerce spanning the globe. From their trading posts on the Hudson at Fort Orange (now Albany) and New Amsterdam (now Manhattan), the Dutch developed a circle of commerce that shipped out beaver pelts, timber, wheat, and tobacco in exchange for sugar and salt from the Caribbean; manufactured goods from Europe, such as pottery, clothing, and metal implements; and spices from Indonesia. Reprehensibly, Dutch profits also depended on slaves from Africa, brought to the island of Curacao. About three hundred ended up in Manhattan, but tens of thousands were sent to work the sugar cane fields of Brazil and the Caribbean.[8]

The Dutch also discovered that New Netherlands provided a perfect outpost for privateering—a form of government-approved piracy—against the Spanish fleet in the Caribbean, and this soon became the real money maker. The capture of a single boat carrying South American gold, silver, wine, tobacco, and ebony could yield millions of Dutch guilders and build the fortunes of colonial settlers and corporate investors.[9] Many prominent businessmen grew rich from this activity, which began as soon as the new Dutch West India Company was established, in 1623. Their attacks on Spanish ships also helped weaken the enemy as the Dutch fought their war for independence.

Though the Dutch held the Hudson for just over fifty years, they would reinvent the river, setting the stage for it to become a center for world trade and laying the foundations of New York City's great rise. Though Native people would be crucial economic partners at first, supplying the pelts that were the foundation of the colony's commerce

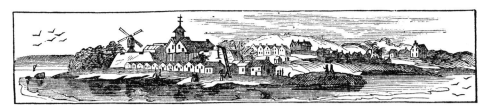

OITY OF NEW YORK IN 1664.

and teaching the early settlers how to survive and thrive, the Dutch would slowly force them out, and the river would no longer be recognizable as their domain. By 1653, their numbers had declined by 90 percent, primarily due to European diseases such as smallpox, to which they had no immunity. One settler went to great lengths to describe the original people of the Hudson Valley so that a memorial of them might be available after they had "disappeared and melted away."[10] Only the Haudenosaunee (the Iroquois), based in the Mohawk River Valley, remained strong, aided by their confederacy among six member nations and by their ability to bring furs east from the Great Lakes region after beaver populations in the Hudson Valley had been wiped out. After 1817, the economic rise of New York would also force out the Haudenosaunee, whose lands lay squarely in the path of new American visions of progress.

New Netherlands proved to be a fertile environment for world trade, because unlike the English colonies sprouting up to the north and south, it was a purely commercial venture, governed by the Dutch West India Company. New England's Puritans believed God had instructed them to form a new religious society on American soil; however, the Dutch came primarily to seek their fortune. Although merchants started trading for furs with the Native Americans in 1610, the first boatload of true settlers didn't arrive until 1624, most of them not actually Dutch but rather French-speaking Walloons from what is now Belgium. Their purpose was to serve the needs of the company in its quest for control of the North American fur trade.

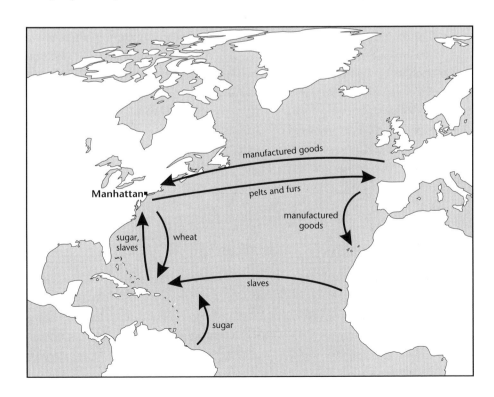

(top) Dutch New Amsterdam on Manhattan Island.
Lossing, Primary History of the United States, *1858*
(bottom) Trade routes of the colonial era.

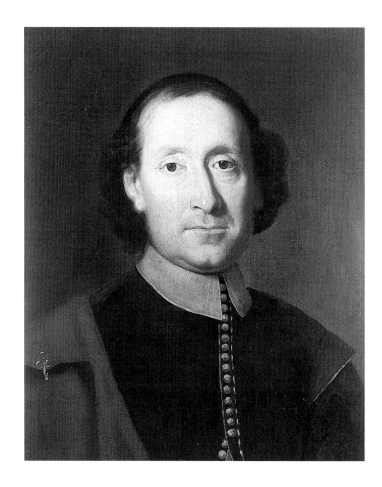

Once they got here, however, many settlers began to relate to the river in a different way from their sponsors. This was not just a place to do business in the emerging global economy. For them, New Netherlands seemed like heaven on earth. One colonist described "beautiful rivers, bubbling fountains flowing down into valleys; . . . considerable fish in the rivers; good tillage land." He concluded, "we would not wish to return to Holland, for whatever we desire in the paradise of Holland is here to be found."[11] In 1661, the colonial poet Jacob Steendam sang the praises of New Netherlands in similar terms:

This is the land, with milk and honey flowing
With healing herbs like thistles freely growing
The place with buds of Aaron's rods are blowing,
O, this is Eden![12]

Adriaen Van der Donck, who arrived on the Hudson in 1641, was equally entranced. He would become one of the river's passionate change agents, alive to its possibilities, swept up in it like a man in love. In 1653, he wrote *A Description of the New Netherlands*, which praised the virtues of the river valley with unabashed affection, as these excerpts from more than forty pages of text reveal:

[There are] brooks having many fine falls, which are suitable for every kind of milling work, . . . an abundance of pure living water. . . . Game abounds . . . deer are feeding, or gamboling or resting in the shades in full view. . . . I admit, that I am incompetent

to describe the beauties, the grand and sublime works, wherewith Providence has diversified this land . . . the oak trees are very large; from sixty to seventy feet high without knots, and from two to three fathoms thick . . . there are much better and richer metals of different kinds . . . than in New-England. . . . The country has . . . several sorts of fine clay . . . suitable for pots, dishes, tobacco-pipes, and the like wares . . . bricks and tiles can be baked of the clay . . . there is also . . . serpentine stone . . . quarry stone . . . bluestone . . . marble. . . . The pigeons . . . are astonishingly plenty . . . they resemble the clouds in the heavens, and obstruct the rays of the sun. . . . The swans. . . . appear as if they were dressed in white drapery . . . my acquaintance has killed sixteen geese at a shot. . . . All the waters of the New-Netherlands are rich with fishes. . . . Lobsters are plenty in many places. Some . . . being from five to six feet in length. . . . Oysters are very plenty. . . . I have seen many in the shell a foot long, and broad in proportion.[13]

Best of all, said Van der Donck, the river had that most precious quality desired by all sailors: "swift fostering winds, the messengers of commerce."[14] This Hudson was a bountiful river, and a blessed one—very different from the one in the minds of merchant traders overseas in the Netherlands, for whom it was just a cog in a great wheel.

The river itself was what made the difference for people living there. It offered something unique—a long, deep estuary, an artery of the ocean, and other natural assets. On the Hudson, tidewater extends more than 150 miles inland, nearly half of the river's 315-mile length. Twice a day, the Hudson flows downstream like any other river would do. However, at slack tide, the tidal portion becomes still, and during flood tide, the flow of water actually reverses, moving north.[15]

Tidal action creates a wonderfully productive natural environment. Salt water mixes with fresh as far north as the Highlands, 50 miles from the mouth of the river. In drought years, the salinity can extend even farther. North of the "salt wedge," the river is tidal but the water is fresh. As a result, there is a richer mix of fish species and wildlife than one would find either on the coast or inland, and a greater variety of nutrients. Resident fish, like perch, share the river with ocean fish that require fresh or brackish water to spawn—such as alewives, shad, herring, striped bass, and sturgeon. These migrants spend their adult lives in the sea and enter the Hudson in April, May, and June to deposit their eggs. Native people and colonial settlers har-

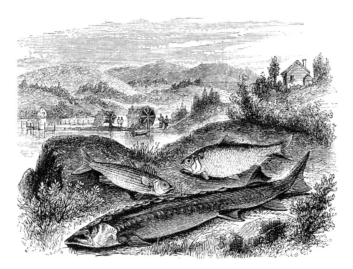

Ocean fish that come to the Hudson to spawn include the prehistoric-looking sturgeon, the striped bass, and the shad. The nets of commercial fishermen are shown in the background of this river scene.
Lossing, The Hudson from the Wilderness to the Sea, *1866*

vested them in large numbers, which helped them get through the meager months of spring, when summer crops had not yet been planted. Jasper Danckaerts, in 1680, noted that shad were so abundant he could catch them with his bare hands. He recalled seeing fishermen near Albany catch more than 500 shad, bass, and other fish in a single haul of the net. In 1749, Peter Kalm described the sight of sturgeon leaping all day long in shallow water north of Albany and reported that people fished for them by torchlight at night.[16] Fish from the Hudson were a major source of food for Native Americans and for immigrants to the valley until well into the 1940s.

The bounty of the river environment provided for human needs in myriad ways, as Van der Donck had noted. Yet, another aspect of the river that profoundly influenced its future had more to do with ideas based in Dutch culture. Most important were the Dutch commitment to free trade and the openness to people of other backgrounds that came with it, as well as an emphasis on upward mobility unusual in aristocratic Europe at the time. The Dutch also allowed religious freedom, both on moral grounds and as a business strategy, and enforced it in New Netherlands when company officials wavered. These concepts would eventually find their way into the Bill of Rights and our country's self-image.

However, in 1646, the principal effect of Dutch culture was to make the river a magnet for enterprising people. In that year, 18 languages were spoken among the 400 to 500 residents of Manhattan Island, who included settlers from England, Scotland, France, Germany, Eastern Europe, Scandinavia, and Belgium, as well as Native Americans who traded with them and Africans there by force. In addition to Calvinists of the Dutch Reformed Church, the island village called New Amsterdam attracted Catholics, Jews, Lutherans, English Puritans, and Mennonites. Quakers came soon after.[17] This collection of diverse people, America's first melting pot, had one thing in common—a desire to seek their fortunes and a society that encouraged them. Transformative individuals would emerge from this environment.

Innovation and money making became a lasting part of the personality of the valley, fostered by a bounteous river and strengthened by the position of the harbor as a hub of world trade. This upwardly mobile society laid the foundation of the river's importance as a force shaping our national character, and it created the financial powerhouse on Manhattan Island. The beginnings of a new mythology took root, one that would evolve with the changing river for centuries to come, as the rags-to-riches stories of river entrepreneurs gave tangible expression to the great American dream.

Another aspect of Dutch tradition enhanced the wealth-building nature of the river for those who knew how to take advantage of it—a pattern of land ownership and governance established in 1629 for lands outside the company trading posts. Twenty years after Henry Hudson's voyage and just a few years after the first boatload of colonists had arrived, the directors of the Dutch West India Company decided to settle more people on the Hudson to provide a source of labor for developing the agricultural potential of the colony. To limit its costs, the company gave large land grants to patrons, or "patroons," who would bring additional colonists to the New World at their own expense. Patroons were required to buy land from the Native Americans; they then leased it to the settlers, requiring the tenants to pay rent in the form of a share of their farm produce and keeping them in semifeudal servitude. In this way, Kiliaen Van Rensselaer, an Amsterdam diamond merchant and a director in the West India Company, gained an estate eight miles long on both sides of the Hudson around the trading post at Albany, then called Fort Orange, with the

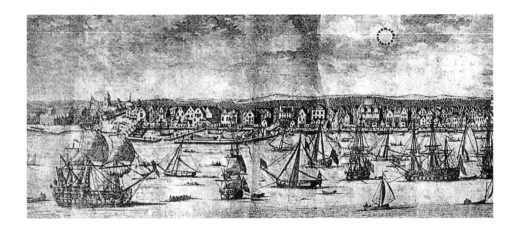

first new settlers arriving in 1630. The estate came to be called Rensselaerswyck, and extended to the east and west "as far as the situation permitted," deemed eventually to be as much as one million acres.[18]

Native people, of course, had a different idea about what it meant to possess land. It was unthinkable to "sell" such a thing as the Hudson or its valley. Land was a gift to their ancestors, given by the Great Spirit. For them, the transaction was more of a mutual aid agreement, an understanding of partnership on shared territory. They continued to occupy the land they had sold and looked to the Dutch settlers as allies in trade and in times of war.[19] It seemed like a good deal until the fences and stone walls went up, and they came to understand the permanence that the Dutch intended by their purchases. To their credit, the Dutch respected Native American ownership rights to the land. However, the purchase price they offered, generally in the form of blankets, duffel cloth, brass kettles, metal hunting tools, and liquor, provided only short-term gain to the eventual loss of territory for hunting, farming, and settlement and the loss of cultural tradition and identity that went with it.

The sale of land was the first step in the eventual removal of Native people from the main part of the river valley, a process that was nearly complete by 1736, when the remaining Mohican moved to a settlement in Stockbridge, Massachusetts set up for their use.[20] Dutch policies, which encouraged Mohawk Indians to cross Mohican lands in order to trade in pelts, were another factor in the loss of Mohican power. At the time of contact, in 1609, the Mohican people had nearly conquered their Mohawk neighbors, but the balance of power would tip in the other direction as a result of Dutch commerce and trade.

As Dutch settlement proceeded, other people with good political connections became patroons as well, acquiring large estates from Native people with the blessing of the Dutch West India Company. Adriaen Van der Donck, who had arrived in New Netherlands in 1641 to accept a post as Van Rensselaer's sheriff, later established his own estate north of Manhattan in what is now Yonkers and Riverdale. Yonkers is named for him, the Yonck Heer (young lord). The Bronx is named for another patroon, Jonas Bronck. The landscape pattern of the valley still shows signs of these large tracts of private land bought along with aristocratic titles, adding yet another dimension to the meaning of the river as a place of privilege and wealth. The patroon system also helped to conserve river scenery, a long-term benefit for all who came after.

The scenery of the Hudson has inspired rich folklore, a mix of stories that reflects the traditions of the diverse people who came to its shores, including Native

This detail of an engraving by William Burgis shows Manhattan in 1717. The city and the colony of New York are now under English control. The Dutch influence is still clearly evident in the city's architecture and culture.
Courtesy of the New York Public Library, I. N. Phelps Stokes Collection, Miriam and Ira D. Wallach Division of Art, Prints and Photographs

Americans, Africans, Germans, English, and Dutch. The legendary *Flying Dutchman* is renowned worldwide as the ghost of a ship that sank off the Cape of Good Hope in 1641; it would appear at sundown as an omen of disaster. On the Hudson, in colonial times, a similar ghostly ship would seem to materialize out of the mist below the steep cliffs of the Palisades and disappear just as quickly upriver on the Tappan Zee. The story comes to us through Washington Irving, who attributes it to the Dutch colonial poet Hendricus Selyns. Irving freely embellished the tale, as he did with so much river lore:

> A mysterious ship . . . is said to have been seen entering the river with sails bellied by winds nowhere else apparent, riding forward against a strong ebb tide. The astonished burghers signaled a command to her to stop and show her papers; but the ship sailed on. Then a gun . . . sent a ball thundering toward her. But her hull did not stop the ball, nor did the ball check her course. On she sped past the Palisades . . . until she disappeared from sight and for ever. She was never seen to pass down river and out to sea. But that is not the last of her here, as many a Tappan fisherman has attested, for she is the Storm Ship . . . that makes mysterious journeys . . . running free in the teeth of a gale, with never a concession to any weather that mortals give heed to.[21]

Though the Hudson could inspire superstition and fear, the Dutch also appreciated its beauty. Unlike the New England Puritans, who had a notoriously dim view of the wild nature surrounding them, thinking it little more than a gloomy wilderness, Dutch settlers brought a love of nature with them. "Here our attention is arrested in the beautiful landscape around us," wrote Adriaen Van der Donck, "here the painter can find rare and beautiful subjects for the employment of his pencil."[22] He described the Cohoes waterfall on the Mohawk River, near where it flows into the Hudson, as a place "well calculated to exalt the fancy of the poets."[23] In 1680, Jasper Danckaerts visited the river and found the ceaseless flow of its waterfalls "wonderful to behold." The falls spoke to him of the "power, wisdom and directions of God" and "a great manifestation of . . . [his] glory."[24]

Anonymous 1784 watercolor showing Philipse Manor Hall in Yonkers, where the Saw Mill River enters the Hudson. The manor house was the home of Frederick Philipse I, a Dutch merchant, slave trader, miller, and land speculator who prospered under British rule. His manorial estate, which stretched from Spuyten Duyvil to the Croton River, included property once owned by Patroon Adriaen Van der Donck. The Manor Hall was preserved in 1908 by the American Scenic and Historic Preservation Society and the Cochran family. It is now a New York State Historic Site.
Courtesy of Historic Hudson Valley, Tarrytown, NY

The power of the Hudson to inspire a sense of connection to the divine had affected Native people in a similar way, and it influenced at least one of the Puritans who came to Manhattan decades later, in the British colonial period. Jonathan Edwards, the man who became the leader of the Evangelical Christian movement in America, wrote about the Hudson in describing his journey to faith. "I frequently used to retire into a solitary place, on the banks of the Hudson River . . . for contemplation on divine things and secret converse with God: and had many sweet hours there," he wrote in 1723.[25]

The river inspired another form of admiration as well, due to the geographic advantages that set it apart from the other rivers on the Atlantic coast of America. The most important was the sea level passage through the Appalachian chain of mountains that stretch from Alabama to Maine. Elsewhere, this mountain range goes by the name of the Great Smokies, the Blue Ridge, and the Ramapos. They form a barrier between the coast and the fertile land beyond them. Where the Appalachians cross the Hudson, about fifty miles inland, they are called the Highlands. There, a gap allows the river to penetrate the fifteen-mile-wide mountain pass in a narrow, sinuous channel. The course of the Hudson through the Highlands is the only place where a river breaches the coastal range below sea level.

Geologists refer to the Hudson as a fjord—a valley cut by glacial ice, then flooded by the sea. The bottom of the river is below sea level all the way to Troy, and its mean gradient is only 5 feet over that entire distance. This makes the river navigable for more than 150 miles inland—the length of the estuary—and this feature set the Hudson's history on a unique course. The Hudson was the only sea level water route to the interior of the country. In an age without cars or trains, it was the best passage through the coastal range. Heavily laden boats could move upstream or down with the tides.

Furthermore, the river connected to other lakes and rivers to the north: "the Indians . . . assert that we can proceed in boats to the river of Canada, which we deem incredible," wrote Adriaen Van der Donck.[26] Settlers also knew that the Hudson's major tributary, the Mohawk, which flowed from west to east, somehow connected to a distant lake and was an important trade route for the Indians, who loaded their canoes with furs from the lake country to sell at what is now Albany.

Traders and settlers explored these water routes and discovered their unparalleled importance. In the Mohawk River Valley—the lands of the Haudenosaunee—they found that with modest portages, they could reach Lake Ontario and Lake Erie. To the north, the Hudson provided easy access, with short portages, to Lake George, Lake Champlain, the Richelieu River, and from there, the St. Lawrence River and the harbor at Montreal. Thus, it quickly became apparent that extensive north-south and east-west travel was possible, linking the Hudson with the interior of a large part of the North American continent and with the seaports of Canada.

The river became an artery of commerce for a far larger area than its immediate shores. "The country is well calculated and possesses the necessaries for a profitable trade," wrote Van der Donck. "First, it is a fine and fruitful country. Secondly, it has fine navigable rivers extending far inland, by which the productions of the country can be brought to places of traffic."[27] Even better, other people did the work for the newcomers. "The Indians, without our labor or trouble, bring to us their fur trade, worth tons of gold," wrote Van der Donck.[28] As beaver pelts became scarce along the

This 1901 map shows the locations of major Native American tribes as well as the Great Lakes, the St. Lawrence River, the Appalachian chain of mountains, and the Adirondack Mountains (north of Mohawk Indian territory). The Hudson River is very small—shown in the center of the map, just above Long Island—but its route through the mountain range is clear, as well as its water connections west along the Mohawk River and the level terrain to the Great Lakes and north to Canada via Lake Champlain.

R. G. Thwaites, 1896-1901, Jesuit Relations and Allied Documents

Hudson from overharvesting, Native people would bring in furs from ever more distant places, using the waterways connected to the river.

One other key feature made the Hudson important in the colonial era and the age of sail: the sheltered natural harbor at its mouth, seventeen miles from the open ocean. Past Manhattan Island, the Hudson officially ends as it flows into a large bay and is joined by the waters of the East River (a tidal strait) and the Hackensack. The tidewater of this upper bay streams through a narrows into a lower bay and from there to the sea. The upper bay in particular, at the mouth of the Hudson, offered outstanding port potential. As Van der Donck noted, it: "affords a safe and convenient haven from all winds, wherein a thousand ships may ride in safety inland."[29]

The Hudson River and the bays below it also connect to other coastal waterways, including the East River and Long Island Sound, which provided a protected passage for sailing vessels headed to what is now Connecticut, Rhode Island, and Massachusetts. The Raritan River, which enters the lower bay, offered early voyagers a convenient route into New Jersey, and with a short overland segment, a fast connection to

the Delaware River and Philadelphia. Finally, the harbor's position on the Atlantic seaboard made for easy access by foreign trading partners.

All of these features added up to commercial advantages summed up by Van der Donck:

> The country is so convenient to the sea, that its value is enhanced by its situation. On the northeast, within four or five days sail, lay the valuable fishing banks [of Newfoundland]. . . . Canada and New-England will bring a profitable inland trade. On the southwest we have Virginia, which affords us a profitable tobacco trade with the Floridas, the Bahamas, and the other continent and West India Islands, upon which much reliance may be made.[30]

However, increasingly, corporate management of the colony failed to support the needs of the settlers and failed to deliver the commercial potential so many of them foresaw. In 1649, Adriaen Van der Donck sailed to Amsterdam to press the Dutch government to make needed reforms in New Netherlands. He had a vision of what the colony could be if the West India Company directors weren't calling all the shots. He suggested a form of municipal self-government, based on Dutch models. He also urged more settlers to come to the colony to help it flourish. His book, *A Description of the New Netherlands*, written as a propaganda piece while he was there, made the case that New Netherlands was a treasure, a kind of utopia "wherein all people can more easily gain a competent support, than in the Netherlands, or in any other quarter of the globe," and it was being ignored. In 1653, his efforts bore fruit, and New Amsterdam was given a municipal charter. As a result, its merchants and businesspeople became its political leaders, as they had desired. Though Van der Donck himself was not allowed to return for a time, this became another aspect of Dutch culture that helped the Hudson emerge as a leading commercial river.[31] His enthusiasm also spurred new waves of immigrants to sail for New Netherlands. The river had transformed Van der Donck and he had transformed it, though things did not turn out as planned.

The Dutch period ended in 1664, when the British fleet sailed into the harbor and took Manhattan. Facing overwhelming force, Governor Peter Stuyvesant surrendered the colony without a fight. The geographic advantages described by Van der Donck were now widely understood; this was the gateway to the rest of the continent, a key port for trade—and a prize that England's King Charles wanted. In 1673, the Dutch navy captured it back, but a year later, the Dutch gave it away in treaty negotiations, deciding to concentrate on the sugar trade along the coast of Brazil. The Hudson was more important to the British, who by now had a vision of an expanding empire. They would use it to gain access to the resource-rich lands beyond the Appalachian Mountains and to dominate eastern North America. Though we tend to think of Jamestown and Plymouth as America's founding colonial settlements, they both dwindled away. New York and Albany grew steadily from their early days as Dutch colonial villages, and the Hudson and its valley formed the central axis of Britain's expanding American empire.

As the first act of business, the British split the colony in two, putting most of the river valley in the colony of New York. The harbor, once at the center of New Netherlands, became a dividing line between New York and New Jersey (a source of future conflict the British would have been wise to consider). In time, the British

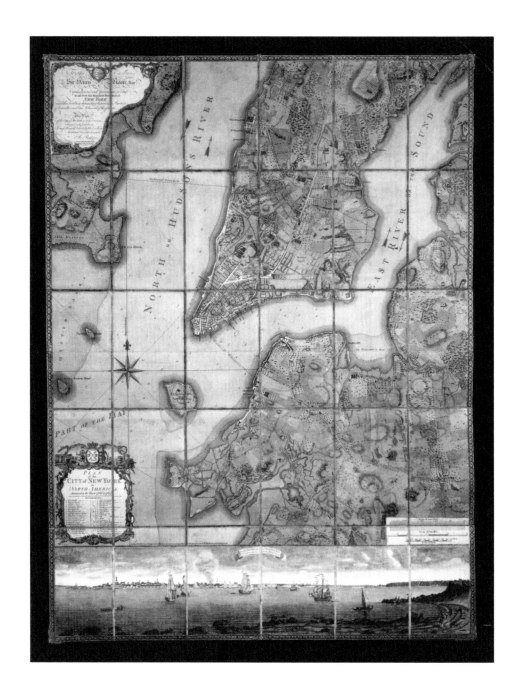

1767 map by British army officer Bernard Ratzer, drawn just over 100 years after the British takeover of New Netherlands. *Library of Congress*

would establish thirteen American colonies, with these two at the center. They also gave the North River a new name. Now it would be known as the Hudson, in honor of their countryman.

The English allowed the Dutch colonists to stay, and most of them did. The terms of surrender in 1664 also guaranteed that many of the Dutch traditions of New Netherland—so different from those of New England—would continue, including policies of free trade and freedom of religion that attracted entrepreneurs of many backgrounds. A century later, the latter idea would be written into the American Bill of Rights. The new governor, Colonel Richard Nicolls, and his successors also encouraged continuing trade with Amsterdam, even as they opened up trade with London, giving New York a unique commercial advantage over all other ports. As a result, the British continued to nourish the enterprising character of the colony and

its emphasis on world trade, and the Dutch impact on the river continued long after the end of Holland's period of colonial rule.[32]

The British also honored the land grants and privileges of the patroons, substituting the title "Lord of the Manor" and making new land grants of their own. In 1686, Robert Livingston, a Scottish clerk who arrived in America in 1673, received title to a 160,000-acre estate, Livingston Manor, spanning both sides of the river below Albany. His rise to wealth and power was enabled by his marriage to the socially connected Alida Schuyler, widow of one of the Van Rensselaers and a capable businesswoman. Their descendants would expand their landholdings through astute marriages. One would later play a leading role as an innovator in the river's future. However, the political power of the manor lords would keep the feudal system of tenant farming in place long after the Revolution, depriving many farmers of the vote.

The British also kept many Dutch place names, including Dunderberg (Thunder Hill), Tappan Zee (Tappan Bay), and Stuyvesant and Rensselaer—both family names. Other names kept their Dutch meaning, but with English spelling, including Helle Gadt, which became Hell Gate. Boterberg, which described a mountain shaped like a big lump of butter, became Butter Hill, though later it would be renamed Storm King Mountain. Several Dutch place names received new spellings—like Brooklyn, originally called Breukelen, and Popolopen Creek, which appears in old documents as Pooploop's Kill. The seventeenth-century Dutch word *kil*, meaning "stream" or "tidal creek," appears in the names of many Hudson River tributaries, such as Sawkill, Fallkill, and Fishkill. Other place names, such as Weehawken, Manhattan, Hoboken, Wicker's Creek (Wiqueesgek), Wappingers, Esopus, Poughkeepsie, Coxsackie, Schenectady, and Schagticoke, owe their origin to Native American names. Rhinebeck and Rhinecliff hark back to a time when German families came to settle the manor lands of Robert Livingston.

Another tradition kept alive by the British was piracy and privateering, which continued unabated through the end of the century, depending on the status of treaties settling international disputes. "We have a parcel of pirates in these parts which [people] call the Red Sea men, who often get great booty of Arabian gold," wrote resident Peter De la Noy in 1695.[33] Such ill-gotten riches further stimulated the economy of the colony, although official records, such as this one from Albany in 1696, show that pirates attacked local targets as well as foreign ones: "Pirates in great number infest the Hudson River at its mouth and waylay vessels on their way to Albany, speeding out from behind coves and from behind islands and again returning to the rocky shores, or ascending the mountains along the river to conceal their plunder."[34]

The reputation of the Hudson as a pirate river would become deeply imprinted with the story of Captain Kidd. In 1695, as pirates became more brazen, investors financed a mission to pursue the most notorious ones and bring them to justice. Backers included the King of England and Robert Livingston, the manor lord, as well as other politically connected individuals. In return for their investment, they would keep a share of the captured pirates' booty. On Livingston's recommendation, they enlisted Captain Kidd, a respected Manhattan sea captain who had a history of trading with pirates and knew where to find them.

Kidd set sail from New York in 1696 and headed for Madagascar, the gathering place of pirates, but he soon turned to piracy himself. Over the next year, Kidd and

his crew raided many merchant ships and eventually seized the *Quedah Merchant*, with its cargo of opium, silk, calico, and sugar, which he sailed to the Caribbean. On the island of Santo Domingo, Kidd left the *Quedah Merchant* and purchased a small sloop, which he filled with gold and jewels before setting off for his home port on the Hudson. However, Lord Bellomont, one of the investors in Kidd's mission, turned the captain in when he landed at Boston and sent him to England to stand trial. Kidd was hanged in England in 1701.

The fate of Kidd's treasure remains a mystery. It is rumored that Kidd buried some of his booty of gold and gems before he was captured and arranged to get some of it to his wife in New York. Other stories suggest that the crew of the *Quedah Merchant* sailed from the Caribbean back home to the Hudson and headed for the manor of Robert Livingston. Encountering a storm in the Hudson Highlands, they scuttled the ship at Kidd's Point, near Stony Point. It is thought to be one of many places where the treasure might be buried. Despite decades of searching, it has never been found. Kidd's story became the source for many legends and ballads, such as this one:

> My name was Captain Kidd, when I sail'd, when I sail'd,
> And so wickedly I did, God's laws I did forbid, When I sail'd, when I sail'd.
> I roam'd from sound to sound, And many a ship I found,
> And then I sunk or burn'd, When I sail'd. . . .
> Farewell to young and old, All jolly seamen bold,
> You're welcome to my gold, For I must die, I must die.[35]

In later years, guidebooks to the river would retell the story of Kidd and his scuttled ship, rekindling the memory of the pirate's exploits and with it the meaning of the Hudson as a haunted river. As one such book noted in 1907, "It was said that the ship could be seen in clear days, with her masts still standing, many fathoms below the surface."[36]

William Guy Wall, *Fort Edward.* Aquatint, circa 1820.
Courtesy of the New York Public Library

In 1695, when British investors sent Captain Kidd forth on his mission, they gave him permission to capture French ships without consequence. France was Britain's competitor in the quest for empire and its opponent in the long battle for control of North America that would eventually become a world war fought around the globe and on American soil. The Hudson River and Lake Champlain would be an axis of the conflict between these two superpowers.

The tug of war began in 1609, as colonial people began to explore new waterways and discover their importance. The alliances they developed with Native people would play a major role in the balance of power that determined the future of the continent. Just a few months before Henry Hudson sailed into the river that would be named for him, the French explorer Samuel de Champlain had worked his way south from Canada, joining a war party of Algonkian, Huron, and Montagnais men to do battle against their enemy, the Iroquois. He found what is now Lake Champlain along the way. Using firearms, Champlain and his men killed several Haudenosaunee warriors and two chiefs, creating enemies for the French, but he also came to understand the value of the lake as a long water route to the south and claimed it as French territory.

Later, the fur trade cemented the alliance of the Dutch and then the British with the Haudenosaunee tribes, with both colonists and tribal leaders favoring exclusive trade agreements designed to deprive their enemies in Canada of economic advantage in the fur trade. For 150 years, native people of the Hudson and Mohawk valleys were crucial partners for the settlers in keeping control of the colony, while northern tribes continued to come to the assistance of their French fur trading partners in Canada.

Border skirmishes became increasingly frequent toward the end of the seventeenth century, as both the French and the English sent expeditions to harass and capture each other's growing settlements between Quebec and Albany and in neighboring New England, using Lake Champlain and the Hudson as one route for movement of troops. In 1690, the French and their Native American allies swept down these waterways to attack Schenectady, on the Mohawk River not far from Albany, leaving the entire settlement in flames and killing sixty people, including women and children. In 1709, Peter Schuyler of Albany moved up the Hudson toward Lake Champlain to mount an attack on Canada but failed due to effective French resistance. In 1710, in search of a greater commitment of support from the British military, Schuyler took four native sachems to London to visit Queen Anne and request her assistance. The "Indian Kings," as they were called—three Haudenosuanee and one Mohican—pledged their military support against French Canada, a move that produced the desired effect of new British troop deployment in America.

Moves and countermoves continued for decades, escalating on the Hudson River–Lake George–Lake Champlain corridor from 1755 to 1763, with the British occupying Fort Edward, located at the Great Carrying Place, a route of portage between the Hudson and Lake Champlain. *The Last of the Mohicans*, written in 1826 by James Fenimore Cooper, romanticized the role of the Mohican "good Indians" who aided the British in their eventual conquest of the French and their Huron allies. It may be very loosely based on the history of the Stockbridge-Munsee band of Mohican, which formed two companies in support of the British during this war. They assisted the legendary Roger's Rangers.

GROUND-PLAN OF FORT EDWARD.

Lossing, The Hudson from the Wilderness to the Sea, *1866.*

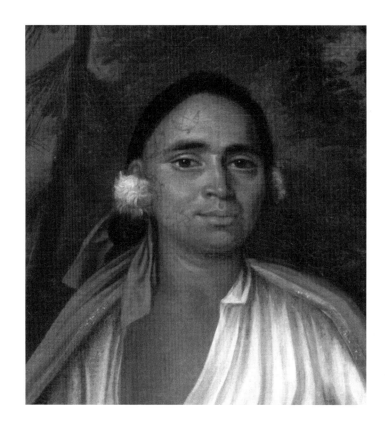

Etow oh Koam, a Mahican sachem of the Turtle Clan, from Kinderhook. Portrait by John Verelst, court painter for Queen Anne, commissioned when this chief and three others visited London in 1710 in the company of Peter Schuyler of Albany, New York, to cement an alliance against the French in Canada.

National Archives of Canada

By contrast, at the same time, through a policy of neutrality, the League of the Haudenosaunee effectively became a third imperial superpower, playing the British off against the French in order to gain strength and influence for its six member nations. Located in the strategically important Mohawk valley, between the Great Lakes and Albany, the increasingly powerful alliance was both respected and feared. Formal treaties governed relations. Colonial diplomats carefully negotiated League cooperation.

In 1763, the Treaty of Paris ended the global conflict, giving the British control of Canada and all French territories east of the Mississippi, except New Orleans. Fort Edward, now a river city on the upper Hudson, gets its name from this time in history, as do nearby Roger's Island and Fort Ticonderoga on Lake Champlain. Onondaga, in central New York, remained the seat of power for the Haudenosaunee, and the League solidified its hold on the lands between the Hudson River and the Ohio, rising to a peak of military and political power that eventually extended their reach from Maine to Tennessee.

The Hudson River north from the Adirondack Mountains above Fort Edward remained largely unexplored by any of the warring colonial powers, who used the river mainly for navigation toward Canada. The French called the uncharted Adirondack territory the Couchsagrage, or "dismal wilderness." On English maps of the period, it is largely blank.

Through military alliances, the Haudenosaunee culture became very familiar to New York soldiers and other colonial leaders. The league of six separate Indian nations that came together as a federation for mutual defense and support impressed Ben Franklin, among others. Franklin met with Haudenosaunee elders in 1754. "We

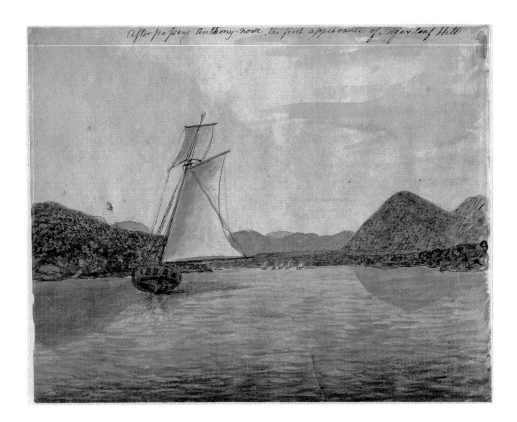

are a powerful Confederacy," advised an Onondaga leader, "and if you observe the same methods . . . you will acquire fresh Strength and Power." Franklin found their example informative, observing: "It would be a strange thing if [the] Six Nations . . . should be capable of forming . . . such a union . . . in such a manner as that it has subsisted for the ages, and appears indissoluable; and yet that a like union should be impracticable for ten or a dozen English colonies, to whom it is more necessary, and must be more advantageous."[37] This idea stayed with him and grew larger over time.

By 1775, the Hudson River and its valley had been under Dutch, then British control, and territory was still shared with Native people whose trade, politics, and decision making shaped a complex dynamic among diverse people. The north-south and east-west axis of the Hudson and the Mohawk had become a global crossroads where Europeans, Africans, Caribbean islanders, Native Americans, and other people of many nations began the struggle to learn to get along.

The river had become steeped in meaning and symbolism: as a military river, a sacred river, a pirate river, and a bountiful river. It was an inspiration to the poet and the painter; a home; a source of good health; and a hub of world trade. It was haunted by the ghosts of Henry Hudson and Captain Kidd and it had been transformed by visionary people like Adriaen Van der Donck. It would soon take on yet another meaning, influenced by the fast currents, winds, and eddies that create dangerous sailing conditions in the Highlands gorge.

World's End in the Highlands marks the deepest spot in the Hudson's course from the Adirondack Mountains to the sea, 177 feet.[38] It is the resting place of hapless sailors and round-bottomed sloops that never arrived at their ports of call.

Charles Wilson Peale, *After Passing Anthony's Nose, the First Appearance of Sugarloaf Hill.* 1801 watercolor.
Courtesy of the American Philosophical Society, Philadelphia

Four-foot ocean tides wash daily over this cold grave, the calm water surface masking the turbulence of a broad river forced through the narrow mountain channel. Whirlwinds and squalls sweep through the hills to confront sailing ships with crosswinds as they round the sinuous curve at West Point. At the "southern gate," where the Hudson emerges from the confines of Dunderberg and Anthony's Nose, the river's narrowest point, the current is so strong that sailors called this river reach the Devil's Horse Race, or simply the Race.

The dangers of navigating the Highlands gorge are well documented. In 1824, the sloop *Neptune*, laden with cargo, sank off Little Stony Point, a section of river known to the Dutch as the Wey-Gat, or Wind Gate. "Changing currents, unexpected dead air alternating with gusts" characterize this area, according to the 1974 *Illustrated Hudson River Pilot*, and "Storm King and Breakneck Mountains funnel the wind currents giving no advantage to either tack."[39]

Ben Franklin could attest to the apt name for Seylmaker's (Sailmaker's) Reach, near the southern gate. He was part of a delegation of commissioners who sailed into the Highlands on April 3, 1776 on a political mission to Canada shortly before the Declaration of Independence was written. Charles Carroll of Maryland kept a diary of their trip and describes the conditions they experienced that day:

> About five o'clock wind breezed up from the south; got under way, and ran with a pretty easy gale as far as the highlands, forty miles from New York. The river here is very contracted, and the lands on each side very lofty. When we got into this strait the wind increased, and blew in violent flaws; in doubling one of these steep craggy points we were in danger of running on the rocks; endeavored to double the cape called St. Anthony's nose, but all our efforts proved ineffectual; obliged to return some way back in the straits to seek shelter; in doing this our mainsail was split to pieces by a sudden and most violent blast of wind off the mountains. Came to anchor: blew a perfect storm all night and all day the fourth. Remained all day (the fourth) in Thunder Hill bay, about half a mile below Cape St. Anthony's nose, and a quarter of a mile from Thunder Hill. Our crew were employed all this day in repairing the mainsail.[40]

Geology created the conditions for the whirlwinds, tides, currents, and unpredictable weather that made passage through the Hudson Highlands so treacherous for sailors. However, it was human imagining that created the reputation of this stretch of river and the lore that went with it. Captains who made it safely through the Race, past World's End, and out the northern gate had put the worst of their voyage behind them. Home once more, they told their children of the spirits that haunted those hills, driving poor sailors to their destruction. Washington Irving later drew on folklore of the river, retelling it in his own satiric voice. This version of the ghost ship legend, an excerpt from "The Storm Ship," which Irving wrote in 1832, recalls the Dutch era on the Hudson.

> It is certain, nevertheless, that strange things have been seen in these highlands in storms. . . . The captains of the river craft talk of a little bulbous-bottomed Dutch goblin, in trunk-hose and sugar-loafed hat, with a speaking-trumpet in his hand, which they say keeps about the Dunderberg. *They declare that they have heard him, in stormy weather, in the midst of the turmoil, giving orders in Low Dutch for the

piping up of a fresh gust of wind, or the rattling off of another thunder-clap. That sometimes he has been seen surrounded by a crew of little imps in broad breeches and short doublets; tumbling head-over-heels in the rack and mist, and playing a thousand gambols in the air; or buzzing like a swarm of flies about Antony's Nose; and that, at such times, the hurry-scurry of the storm was always greatest. One time a sloop, in passing by the Dunderberg, was overtaken by a thunder gust, that came scouring round the mountain, and seemed to burst just over the vessel. Though tight and well ballasted, she laboured dreadfully, and the water came over the gunwale. All the crew were amazed when it was discovered that there was a little white sugar-loaf hat on the mast-head, known at once to be the hat of the Heer of the Dunderberg. Nobody, however, dared to climb to the masthead and get rid of this terrible hat. The sloop continued laboring and rocking, as if she would have rolled her mast overboard, and seemed in continual danger either of upsetting or of running on shore. In this way she drove quite through the highlands, until she had passed Pollopol's Island, where, it is said, the jurisdiction of the Dunderberg potentate ceases. No sooner had she passed this bourn, than the little hat spun up into the air like a top, whirled up all the clouds into a vortex, and hurried them back to the summit of the Dunderberg; while the sloop righted herself, and sailed on as quietly as if in a mill-pond. Nothing saved her from utter wreck but the fortunate circumstances of having a horse-shoe nailed against the mast,—a wise precaution against evil spirits, since adopted by all the Dutch captains that navigate this haunted river.

*i.e., The "Thunder Mountain," so called for its echoes.[41]

Stories like this, though fanciful, were based on the real difficulties of navigating the Highlands—and Dutch sloop captains weren't the only ones who understood the river's perils. By 1775, the Continental Congress knew them as well. As a result, World's End, Seylmaker's Reach, and the Race were to figure prominently in the American strategy to avoid British control of the Hudson River during the Revolutionary War.

The River That Unites, the River That Divides

King George and George Washington Vie for the Hudson

 N MAY 25, 1775, five weeks after the opening skirmish of the American Revolution at Lexington, the Continental Congress met in Philadelphia and adopted the following resolution:

> *Resolved*, that a post be also taken in the Highlands on each side of Hudson's River and batteries erected in such manner as will most effectively prevent any vessels passing that may be sent to harass the inhabitants on the borders of said river; and that experienced persons be immediately sent to examine said river in order to discover where it will be most advisable and proper to obstruct the navigation.[1]

From that moment on, the Hudson took on new significance in world affairs, and a new image of the region became indelibly stamped on the public consciousness. Visionary people would transform the river again, making it the decisive boundary in

A section of the log boom installed to prevent British ships from sailing up the Hudson River through the Highlands. Photographed at the Washington's Headquarters State Historic Site, Newburgh, New York.

Copyright @ 1990 by Robert Beckhard

the revolution, one that would either unite the new country or divide and defeat it. Recognizing the enormity of the river's place in the country's future, heroes and villains would act out their dramas on its stage. War stories of the Hudson would be told and retold until the river came to symbolize the fight for freedom from tyranny, influencing future chapters of its history as a birthplace of art, literature, and conservation.

The river would also work its magic on generals and soldiers. Its beauty would shine through, even in time of war. Its mysteries would throw some people a surprise. Others would use their knowledge of its topography to advantage. New leaders would emerge, people steeped in their experience of the river, who then influenced the direction of the country, and New York would take its place as one of the founding colonies of America.

In May 1775, when the Continental Congress decided to fortify the Hudson, its members anticipated the likely British attack with prophetic vision. In London, two months later, King George III posted orders to his commanders in America. The British plan of campaign was:

> To get possession of New York and Albany; to command the Hudson and East Rivers . . . to cut off all communication by water between New York and the Provinces. . . . By these means . . . divide the provincial forces as to render it easy for the British Army at Boston to defeat them, break the spirits of the Massachusetts people, depopulate their country, and compel . . . absolute subjection.[2]

King George saw the river on a map and acted on his knowledge of geography to make it the central strategic objective. Since the British controlled Canada and the Atlantic coast, they could use the river to sever the connection between the northern and southern colonies, blocking the movement of supplies and military reinforcements. The king's troops would control one of the most valuable harbors in the colonies, and they could establish a military command post midway between Virginia and the colonies to the north. He would pursue this strategy repeatedly—in 1776, 1777, 1779, and 1780.

The Continental Congress aimed to neutralize Britain's superior strength by using local knowledge of river conditions to place forts in strategic locations. The firing distance of cannon, the location of important supply lines, and the capabilities of the British fleet dictated their decision to focus initially on the Highlands, 50 miles north of Manhattan. The Hudson Highlands formed a natural fortress, providing the best choke point to stop the British fleet from moving north. With battlements on both sides of the river, British frigates would be forced to run the gantlet under a hail of cannon fire, while the narrow, twisting passage through the gorge forced the ships to tack and turn through tricky winds and currents. The ascending fleet would be an easy target from the bluffs above. The Highlands also protected critical ferry crossings that connected overland routes between New England and the Middle Atlantic colonies. A fort erected there could shield the movement of supplies and troops and protect the remaining 100 miles of navigable river up to Albany.

The New York legislators selected two delegates, Christopher Tappen and Colonel James Clinton, to go to the Highlands and prepare a report on possible fort locations. On Friday, June 2, 1775, Clinton and Tappen hired a sloop and sailed north. They selected the site known to sailors as World's End:

It is not only the narrowest part of the said river, but best situated, on account of the high hills contiguous to it . . . so that without a strong easterly wind, or the tide, no vessel can pass it; and the tide on said part of the river is generally so reverse, that a vessel is usually thrown on one side of the river or the other, by means whereof such vessel lay fair and exposed to the places your Committee have fixed on.[3]

Work began in September 1775. With trained engineers in short supply, the commissioners hired a Dutch botanist named Bernard Romans to supervise. Romans reconnoitered the terrain and began constructing a "grand bastion" on the southwest end of the island. The patriots named it Fort Constitution, in honor of the struggle for constitutional rights under British law (the American Constitution had not yet been written). Martelaer's Rock, where the fort was built, soon assumed the name Constitution Island as well. However, a few weeks later, Romans and the five New York commissioners appointed to supervise the fortification of the Highlands began to be interested in another site, four miles south, just above the river reach known as

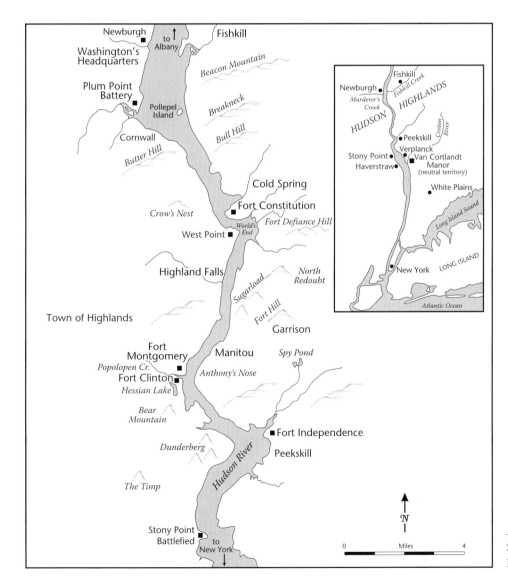

Strategic sites on the lower Hudson in the Revolutionary War era.

Lossing, Pictorial Field-Book of the Revolution, *1860*

the Horse Race. On October 16, they submitted a report to the New York Provincial Congress, noting: "at *Pooploop's Kill* [Popolopen Creek], opposite *Anthony's Nose*, it is a very important pass: the river narrow, commanded a great way up and down, full of counter currents, and subject to almost constant fall winds; nor is there any anchorage at all, except close under the works to be erected."[4] On January 5, 1776, the Continental Congress approved the recommendation to cease work on Fort Constitution and shift downriver, where they would build Forts Clinton and Montgomery (a decision they would later regret).

At the same time, colonial leaders became even more convinced of the river's importance as the decisive waterway around which the conflict would revolve, and prepared to defend it. On January 6, 1776, John Adams wrote to General Washington, urging his attention: "the North River . . . is the Nexus of the Northern and southern Colonies, as a kind of Key to the whole Continent, as it is a Passage to Canada to the Great lakes, and to all the Indian Nations. No effort to Secure it ought to be omitted."[5] Though Washington was not very familiar with the Hudson from personal experience, he understood its geographic importance. The river was already beginning to act on him. In short order, he would know its possibilities intimately and become another of its transformative figures. The next day (January 7), Washington wrote to Governor Jonathan Trumbull of Connecticut:

> As it is of the utmost importance, to prevent the Enemy from possessing themselves of the City of New York and the North River [Hudson River], which would give them Command of the Country and the Communication with Canada; I shall dispatch Major Genl Lee with orders to repair thither . . . to put the City and Fortifications on the North River, in the best posture of defence the Season and circumstances will admit of . . . as expeditiously as possible, for counteracting any designs our Enemies may have against us.[6]

In the coming months, Continental forces erected the defenses Washington spoke of—Fort Washington on Manhattan and Fort Lee across the river, atop the Palisades in New Jersey. By April, when the general came to New York from Massachusetts, he noted good progress, as he told his brother John: "We have already gone great lengths in fortifying this City and the Hudson River; a fortnight more will put us in a very respectable posture of Defence."[7] Though he had no clear idea what the British might do, his instincts told him to concentrate his troops on Manhattan, as he explained in a May 5 letter to the Continental Congress from his New York headquarters:

> The designs of the Enemy are too much behind the Curtain, for me to form any accurate opinion of their Plan . . . ; we are left to wander therefore in the field of conjecture, and as no place, all its consequences considered, seemed of more Importance in the execution of their grand Plan, than possessing themselves of Hudsons River; I thought it advisable to remove, with the Continental Army to this City, as soon as the Kings Troops evacuated Boston.[8]

By mid-June, as Washington prepared for the expected British assault, he became concerned that work on the strongholds in the Highlands was moving too slowly and urgently ordered Colonel James Clinton to take charge of the construction:

Sir: You are to report to Fort Montgomery and take upon you the Command of the Posts in the Highlands.... Use every possible Diligence in forwarding the works at Forts Montgomery and Constitution....

As these are or may become Posts of infinite Importance especially the lower one; I cannot sufficiently impress upon you the Necessity of putting them into a fit Posture of Defence, without Delay.[9]

LORD HOWE.

Lossing, Pictorial Field-Book of the Revolution, *1860*

Washington also appointed a new engineer, Thomas Machin, to plan the defenses, replacing Romans, the botanist.

Washington's order was none too soon. On July 2, 1776, as delegates worked on the Declaration of Independence in Philadelphia, General William Howe sailed through the Narrows into New York harbor and landed at Staten Island, where he set up a base of operations for his planned invasion. Soon after, his brother Admiral Richard Howe arrived. By August, they would assemble a force of 427 ships, bearing 34,000 British troops and German mercenaries under their joint command.[10] This was the largest armada ever sent abroad by the British Empire, and it was meant to crush the rebellion quickly.

The events of the revolution are familiar stories whose retelling highlights the myriad ways that the British and patriot forces vied for the Hudson as the central axis of the war. Though battles were fought in many other places, the rebellion could not succeed without keeping control of the Hudson, and both sides knew it. These stories also show how the military used the river and its surrounding terrain to tactical advantage, and how the significance of the river changed. The campaigns became mythic episodes in a heroic landscape. In time, accounts of them became as important as the battles, because they gave meaning to the events of the war.

The first British attempt to use the Hudson as a wedge took place on July 12, 1776, when two warships, the *Phoenix* and the *Rose*, were sent on a foray up the river to interrupt supply lines between Manhattan and Albany.[11] General Howe's brother, the admiral, had not yet arrived, nor had all of the ships and reinforcements, so this was just an opening salvo. To the shock and dismay of American troops, the two warships easily passed the defenses at Fort Washington on Manhattan, carried by a flood tide and a strong wind, and then anchored in the Tappan Zee, twelve miles south of the Highlands, where they stayed. A month later, the patriots launched a fireboat attack on the two vessels, successfully burning one of the tenders and sending the ships on retreat to Manhattan. The incident with the *Phoenix* and the *Rose* was more symbolic than anything, though it is remembered locally to this day. However, it forced Washington to adjust the Continental strategy.

Engineer Machin was instructed to design underwater obstacles that could block British ships more effectively. Machin was one of many engineers who would study the Hudson's topography for tactical purposes. The river posed both a challenge and an opportunity. It was his job to come up with a response. The solution was inventive— he placed sharpened logs, known as *chevaux-de-frise*, north of the Highlands in the shallow waters of Cornwall Bay between Pollepel Island (now Bannerman's Island) and Plum Point, and he stretched a heavy iron chain across the river between Anthony's Nose and Popolopen Creek, guarded by Fort Montgomery. Colonial forces also constructed Fort Independence at the mouth of Annsville Creek in Peekskill, just south of Anthony's Nose, to provide additional protection against the British fleet.

Meanwhile, British warships and reinforcements continued to arrive in New York harbor. The recent Declaration of Independence only added to their resolve to destroy the patriot forces. On August 22, General Howe prepared for the big attack, landing 15,000 troops and 40 pieces of artillery on Long Island, across the bay from his headquarters on Staten Island. Five days later, with another 5,000 troops at hand, he very nearly ended the revolution on the spot.

The Battle of Brooklyn Heights was America's first battle as an independent nation, and it had the makings of a disaster. The British stormed American positions from every direction. Fewer than 10,000 Continental soldiers and militia fought bravely all day against more than twice as many trained British and Hessian soldiers. By the evening of August 27, about 900 patriot soldiers had been captured and another 200 killed. The remaining troops were surrounded and faced imminent slaughter and defeat.

However, the British did not attack for the next two days, using the time to dig trenches that would protect their approach to the American batteries. On the evening of the 29th, as darkness fell, Washington secretly evacuated his men through enemy lines and sent them across the mile-wide East River to Manhattan Island. Every available boat for miles around was pressed into service, silently ferrying troops from Brooklyn to New York all through the night. Massachusetts mariners from Marblehead, Lynn, Salem, and Danvers rowed back and forth with muffled oars while local merchants and ship captains sailed beside them.

Miraculously, around 7 a.m. on August 30, as the dense fog lifted from the harbor, the last of about 9,500 American troops made it safely across, along with their horses, cannon, and barrels of provisions. The shocked British soldiers arrived on the Brooklyn shore moments later, but the secret plan had worked. Though the British took Brooklyn Heights, the patriots had survived to fight another day. It would be one of many strategic retreats by the Americans and one of many miscalculations by the Howe brothers. "General Howe . . . had our whole army in his power," wrote General Israel Putnam, "and yet suffered us to escape without the least interruption. . . . Had he instantly followed up his victory, the consequence to the cause of liberty must

Chevaux-de-frise, obstructions made of 60-foot logs, sharpened and tipped with iron points, that were wedged into stone caissons and sunk on the river bottom to gouge the hulls of northbound enemy vessels.
Collection of the New-York Historical Society (#212326)

have been dreadful."[12] The Battle of Brooklyn Heights, though it ended in victory for the British, proved to be one of several pivotal moments on the harbor and on the Hudson that swung the rebellion in favor of the Americans. The story of this battle came to symbolize the day the revolution could have ended but didn't.

Over the next three months, a series of skirmishes drove Washington out of lower Manhattan Island to White Plains, where, in October, the two armies battled to a draw. On the Hudson, Fort Lee in New Jersey and Fort Washington at the upper end of Manhattan remained in American hands—but not for long.

In early November, expecting another attack, Washington and his commanders assembled 5,500 men at Fort Lee and 2,800 at Fort Washington. The forts had been constructed on high ground, where cannon could fire on ships coming up the Hudson. The attack came on November 16, when British and Hessian soldiers swarmed up Fort Washington from behind. Again, they sought to crush the rebellion quickly by dealing Washington's forces a decisive defeat. Again, the Americans fought bravely—among them women like Margaret Corbin, who aimed deadly cannon fire at the attackers—but by the end of the day, the entire American garrison surrendered. They later endured horrible conditions of captivity that became part of the river lore, an example of British cruelty that justified the quest for freedom.

Control of Fort Washington allowed the British to sail to the base of Fort Lee on the Palisades of New Jersey, which they did on November 20. This time, as the British closed in with 6,000 men, commanded by Lord Charles Cornwallis, the American soldiers escaped with little time to spare, leaving most of their ammunition, cannons, and muskets behind, heading west into New Jersey and north toward Croton. Once again, Washington's army had staged a successful retreat, yet another close call in the early months of the war that would be etched in memory.

In the remaining weeks of 1776, Cornwallis chased George Washington relentlessly through New Jersey from Fort Lee to Trenton, on the Delaware River, where on Christmas morning Continental forces achieved their first victory. Now the British dug in for a longer war. Manhattan Island and the harbor became their

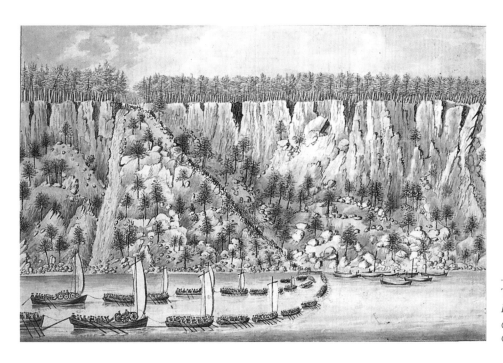

Thomas Davies, *Landing of the British Troops, Fort Lee, New Jersey*, November 20, 1776.
Courtesy of the New York Public Library, Emmett Collection

headquarters, terrain they would zealously guard. To supplement their forces, they provocatively began recruiting slaves to join them, offering freedom in return for military service. Because of this, many African Americans fought valiantly for the British in the coming years. Some 5,000 others fought for the patriots, service that won freedom for many but not for themselves; slavery continued unabated after the war. Similarly, both sides recruited Haudenosaunee warriors who did not benefit afterward.

Meanwhile, from London, the British formulated a new plan to gain control of the Hudson, a three-point offensive that they kicked off in June 1777. The goal was the same—to make the river a great divide that would separate the parts of the struggling country and compel the "absolute subjection" of the people.[13] Sir Henry Clinton, a key player, explained the British objective in *The American Rebellion*:

> The Hudson naturally presents itself as a very important object. . . . For, as long as a British army held the passes of that noble river and her cruisers swept their coasts, the colonists would have found it almost impossible to have joined or fed their respective quotas of troops. And indeed, the inhabitants of the countries on each side must in that case have experienced the greatest distresses, on account of the scarcity

The theater of war on the Hudson, 1777.

of bread corn in those to the east and of black cattle and horses in some of the others, with which they have been accustomed mutually to supply each other. A ready intercourse would also have been by this means obtained with Canada by the lakes [Lake George and Lake Champlain] from whence many obvious advantages might have been derived.[14]

As a first step, on June 13, Lieutenant General John Burgoyne set off with troops from Canada, following the Richelieu River to Lake Champlain, bound for the Hudson. A second force mustered in Canada under Lieutenant Colonel Barry St. Leger, headed to Oswego to capture Fort Stanwix (Schuyler), on the Mohawk River. Plans called for Burgoyne and St. Leger to be joined in early fall at Albany by General Howe, sailing north from Manhattan Island to lead the third prong of the attack. Howe was to destroy the rebel forts along the lower Hudson, then move upriver. However, in July, he decided the time was right to pursue George Washington, whom he expected to find in Philadelphia, and he left New York with most of his troops. It would fall to Lieutenant General Sir Henry Clinton to carry out the Hudson River strategy with the smaller garrison of troops that remained in New York.

When Burgoyne left Canada, he commanded an entourage of nearly 10,000 fighting men, with enough provisions, artillery, and ammunition to support a campaign of many months. His forces included 5 regiments of German mercenaries, about 1,000 loyalist volunteers, and 400 Native Americans assembled from a number of tribes, mainly those west of the Great Lakes, including Chippewa,

John Burgoyne.
Courtesy of Library of Congress

GENERAL SCHUYLER.

Lossing, Primary History of the United States, *1858*

KOSCIUSZKO.

Lossing, Primary History of the United States, *1858*

Ottawa, Sioux, Fox, and Winnebago, as well as a few local Haudenosaunee (Iroquois) and Algonquins. At the rear were hundreds of camp followers—wives, girlfriends (including Burgoyne's mistress), cooks, nurses, merchants, and servants—among them the Baroness von Riedesel, wife of the German general, and their young children.[15]

Within days they reached Lake Champlain, and, with surprisingly quick success, Burgoyne captured the key forts. First Crown Point fell, then Fort Ticonderoga and Mount Independence. Overwhelmed, the patriots fled without a fight. Moving off of the lake and over land to the Hudson, the British commander exchanged fire with Continental forces and took Fort Anne on Wood Creek. Then, nineteen days later, he arrived at Fort Edward to find it abandoned. It was July 29. He had left Canada on June 13, and now the Hudson River flowed by before him.

His campaign was not without major difficulty, however. During a raid to the east to find supplies and capture horses for the German dragoons, Continental soldiers killed or captured about 700 of his troops in the Battle of Bennington, on the banks of the Walloomsac River. Another battle, at Hubbardton, Vermont, had caused major casualties as well. Furthermore, Continental troops, guided by General Philip Schuyler and Polish Colonel Tadeusz Kosciuszko, had cut down trees and destroyed bridges all along the swampy overland route from Lake Champlain to the Hudson. A tangle of stumps and logs brought Burgoyne's supply wagons to a near standstill, and this march of more than 20 miles took them 23 days. The reality of the Hudson and its surrounding terrain caught Burgoyne by surprise. He underestimated it and suffered the consequences.

Adding to Burgoyne's problems, he learned on August 3 that General Howe had recently gone south to capture Philadelphia, taking large numbers of men with him. Sir Henry Clinton, in charge of the forces at New York, reported that he was left with "too small a force to make any effectual diversion in your favour," though he pledged he would "try something at any rate."[16] Stunning bad news came in September by another courier, who reported that Continental forces, aided by Oneida Indians, had defeated St. Leger on the Mohawk at Fort Stanwix. Burgoyne also learned that his supply lines back to Canada were under attack.

An experienced and confident soldier, Burgoyne was undeterred. He sent a messenger to Sir Henry Clinton stationed in New York, requesting assistance, and on September 13, left Fort Edward with his troops, supply train, artillery, and camp followers to engage American forces. British and Hessian troops crossed the Hudson on a pontoon bridge carried along for the purpose, then marched south, crossing Fish Creek, and made camp at the edge of a ravine in what is now Schuylerville. They were then six miles upstream of Bemis Heights, near Stillwater, where thousands of American troops waited.

A week later, Burgoyne attacked. On September 19, British and American soldiers battled on the fields of Freeman's Farm, home of a loyalist who had fled. The fighting seesawed all day, with heavy casualities on both sides. Burgoyne lost 700 men but held the field. However, river fortifications engineered by Kosciuszko at Bemis Heights blocked the path to Albany. Burgoyne settled in to wait for Clinton to make a move from British headquarters on Manhattan.

Weeks went by, but on October 4, Burgoyne learned that his rear guard troops were facing attacks on Ticonderoga and did not expect to hold it much longer. As a

result, his supply line was cut, and supplies were running low. He decided it was time for action. Coincidentally, the next day, Sir Henry Clinton set off to help. His first stop was the Hudson Highlands, to engage Continental forces guarding the river.

On October 5, at the Highland forts, James Clinton, now a Brigadier General in the Continental Army, and his brother George, the governor, braced for attack. Sir Henry Clinton (a distant cousin) had landed an amphibious force at Verplanck's Point on the eastern shore of the Hudson just south of the Highlands. That night, it was hard to ignore the noise and lights as British ships sailed from Verplanck to Peekskill Bay. American forces stationed two frigates, two galleys, and an armed sloop upriver from the iron chain that stretched across the river below the Popolopen forts, hoping to block the passage of British men-of-war. The Clintons sent some of their patriot troops across the river to Peekskill to aid General Israel Putnam at Fort Independence, where British ships approached. It was an act they would soon regret.

The move on Peekskill was merely a diversion. At dawn on October 6, when the river was locked in fog, Sir Henry Clinton quietly transported 2,100 men across the river to Stony Point and sent them on a 12-mile march around the back of Dunderberg Mountain through a cut called Timp Pass, to attack the forts from behind. The fighting was bitter and disastrous for the outnumbered Continentals and militia. The Highland forts had been designed for firing on ships below and were virtually defenseless from the rear, with walls not more than half raised in places. By nightfall the British and their hired Hessian soldiers had killed, wounded, or captured 350 men. Seeing that all was lost, the rest of the American garrison fled, among them James and George Clinton.

On the river below, the patriots guarding the chain realized that their own ships were now vulnerable to attack by the British from the forts above. They attempted to sail upriver; however, the same conditions that made the Highlands difficult for advancing British frigates plagued the American vessels. With adverse winds preventing their escape, the Americans set fire to three of their ships. The sight of the river lit up in flames made a lasting impression on Charles Stedman, who served the British under Sir Henry Clinton. He later wrote:

GENERAL CLINTON.

Lossing, Primary History of the United States, *1858*

Anonymous engraving, "View of the West Bank of the Hudson's River 3 miles above Still Water, upon which the Army under the command of L. General Burgoyne took post on the 20th Sept. 1777." From *Travels through the interior parts of America: In a series of letters* by Thomas Anburey, London, 1789. *Library of Congress*

CIPHER ALPHABET.

CLINTON HAS SENT A SECRET EXPEDITION UP
THE HUDSON TO INTERCEPT WASHINGTON.

FAC-SIMILE OF CIPHER WRITING.

The flames suddenly broke forth; and, as every sail was set, the vessels soon became magnificent pyramids of fire. The reflection on the steep face of the opposite mountain [Anthony's Nose], and the long train of ruddy light which shone upon the water for a prodigious distance, had a wonderful effect; whilst the ear was awfully filled with the continued echoes from the rocky shores, as the flames gradually reached the cannon. The whole was sublimely terminated by the explosions, which left all again to darkness.[17]

That was October 6, 1777. As Sir Henry Clinton's troops celebrated their victory in the Highlands, Burgoyne's forces on the upper Hudson prepared for battle on the same field where they had fought in September. At dawn on October 7, the royal troops assembled to the sound of fife and drum and marched with their bayonets onto the meadows of Freeman's Farm, a site sometimes referred to as Saratoga. Continental soldiers charged to meet them as sharpshooters took aim from the woods. Burgoyne rode among his men, encouraging them to hold their ground. When a well-aimed bullet felled his horse, he leaped onto another and kept up the battle all day. Then sharpshooters fired a fatal shot at his trusted general, Simon Fraser, and Burgoyne's men pulled back to the safety of earthworks.

As the sun dipped below the horizon, it seemed that the battle would end in a draw, until an American officer turned his horse and galloped full speed at the German-held redoubt. It was General Benedict Arnold, and he showed no fear. He knew the stakes of the battle were high. Arnold took a bullet in the leg but led the troops to victory, capturing the redoubt that held the key to the battlefield.

The patriots had won, but Burgoyne did not give up. He crossed the Hudson River to the safety of Fort Edward, where, the next day, he dined at the deserted house of General Schuyler and spent the night with his mistress. With provisions running dangerously low, the Baroness von Riedesel, wife of the German general, fed thirty officers from her own rations, while many of the enlisted men went hungry. For the next week, patriots shelled the British camp but did not attack.

Meanwhile, downriver, British ships had stayed in the Highlands, sending convoys to raid the surrounding countryside. Then, on the morning of October 15, con-

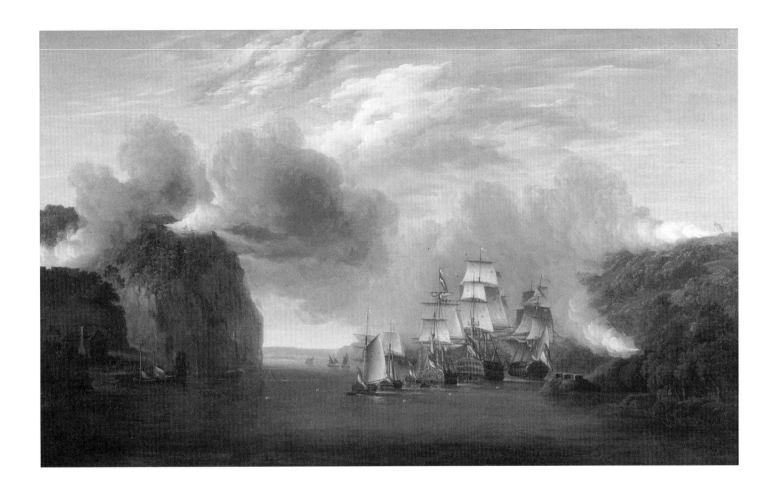

cealed in fog and aided by the tide, 20 of the king's warships slipped over the underwater *chevaux-de-frise* in Cornwall Bay and moved rapidly north under full sail, with 1,500 troops. Word quickly reached American General George Clinton, who dispatched about 1,000 Continental soldiers and militia by overland route from New Windsor to Esopus (now Kingston), the provincial capital, anticipating the next attack. New York State had adopted its Constitution there six months earlier, on April 20, 1777, making it a likely target.

The British fleet gathered for the night at Esopus Island, south of Rondout Creek, and the next morning, October 16, they attacked. It took Major General John Vaughan only three hours to destroy Kingston, a town he described as "a Nursery for almost every Villain in the Country."[18] General George Clinton, arriving in advance of most of his men, could only watch as the British burned everything. Only one building remained standing. As the *New York Packet* reported:

> In a very short time that pleasant and wealthy town was reduced to ashes. . . . Thus by the wantonness of power the third town in New York for size, elegance and wealth, is reduced to a heap of rubbish, and the once happy inhabitants (who are chiefly of Dutch descent) obliged to solicit for shelter among strangers . . . to defend themselves from the cold blasts of approaching winter.[19]

The next day, the British sailed ten miles north, and over the following several days, they destroyed the homes, barns, mills, and storehouses at the Livingston estate,

William Joy, *Forcing the Hudson River Passage.* Undated oil on canvas showing the 1777 Revolutionary War battle in the Highlands below Fort Montgomery, a battle site now protected by New York State. *Collection of the New-York Historical Society (#1951.69)*

Clermont. On October 18, Vaughan sent a dispatch to Admiral Hotham: "I shall send off this night to Gen Burgoyne."[20] He did not know that it was already too late. Burgoyne, out of food and out of options, had just surrendered.

On October 17, as Vaughan laid waste to the Livingston estate on the Hudson, 5,000 British and Hessian soldiers formally laid down their arms and marched for Boston, now prisoners of war. To the surprise of the British, Continental soldiers treated the departing prisoners with respect. Later, this would be seen as an aspect of the American character, and the story would be told as an example of it. Meanwhile, Burgoyne, who had negotiated well for himself and his officers, attended a banquet with General Gates and visited the Albany home of General Philip Schuyler, the man who had so effectively slowed his march from Lake Champlain to the Hudson. Joining Burgoyne at the Schuyler home was Baron von Riedesel, commander of the German soldiers, and his wife and children.

(top) The Senate House, Kingston, provincial capital of New York, a State Historic Site.
Library of Congress

(bottom) Clermont, home of the Livingston family. Burned by the British in October 1777 and rebuilt, it is now a State Historic Site.
Lossing, The Hudson from the Wilderness to the Sea, *1866*

GENERAL SCHUYLER AND BARONESS RIEDESEL.

With Burgoyne's defeat, another British attempt to control the Hudson was foiled. The river had been center stage for heroic acts. It had been the strategic objective. It had inspired close study by those seeking military advantage. Battles there would later become part of the collective memory, and stories of the Hudson in 1777 would be used to teach future generations their heritage as Americans.

However, Sir Henry Clinton could not hold the Hudson alone without risking the loss of Manhattan, which needed his troops for protection. The British fleet occupied the river through October, then retreated. Within a few months, the scene of war shifted to Pennsylvania, where Washington's troops endured the harsh winter

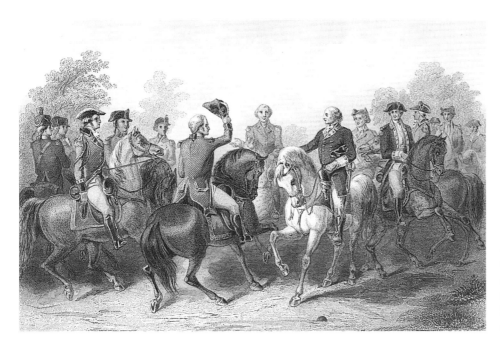

(top) Baroness Friederike von Riedesel.
Lossing, Pictorial Fieldbook of the Revolution, *1860*
(bottom) Burgoyne surrenders to General Horatio Gates.
Courtesy of the New York Public Library

at Valley Forge. However, the British did not abandon the idea of controlling the Hudson-Champlain corridor.

In the spring of the following year, 1778, Timothy Dwight, a young chaplain in the American army, visited the scenes of battle in the Highlands. The chaplain, who would later be president of Yale College, felt overwhelmed at the devastation he saw. He sought out the river, which seemed to reflect his mood yet offered spiritual refreshment:

> Yesterday afternoon, in company with Major Humphreys I went up to the summit of Sugarloaf, a mountain near Col. Robinson's house.... Everything which we beheld was majestic, solemn, wild, and melancholy.... Directly north, the Hudson, here a mile in breadth, and twice as wide higher up, is seen descending from a great distance, and making its way between the magnificent cliffs of the two great mountains, Butter Hill and Breakneck. The grandeur of this scene defies description.[21]

Burgoyne's surrender at Saratoga would loom larger in time, as the pivotal moment in the Revolutionary War. The astonishing news that Continental troops had defeated one of Britain's most famous generals reached Benjamin Franklin on December 4 in France, where he was trying to persuade Louis XVI to join the fight against their common enemy. With this evidence of patriot resolve and ability, Franklin convinced the King of France to give formal recognition to American independence and to sign a treaty pledging full military support. The momentum of the revolution was building. By 1779, Spain and the Netherlands joined with France in the alliance against the British, and the Russians formed a League of Armed Neutrality, which included Denmark and Sweden. Great Britain was now virtually alone as the war became a global one, forcing the British to draw off many of their troops from New York to defend the previously unthreatened West Indies. The significance of Burgoyne's defeat at Saratoga has caused some modern historians to consider it "the most important battle ever fought in the western hemisphere."[22]

On December 2, 1777, two days before word of Burgoyne's defeat reached France, George Washington decided to redouble his efforts to protect the critically important Hudson. He wrote to General Israel Putnam, his highest-ranking officer in New York:

> The importance of the North [Hudson] River in the present contest and the necessity of defending it, are Subjects which are so well understood, that it is unnecessary to enlarge upon them . . . it is the only passage by which the Enemy . . . can ever hope to Cooperate with an army that may come from Canada; That the possession of it is indispensably essential to preserve the Communication between the Eastern, Middle and Southern States; And further, that upon its security, in a great measure, depend our chief supplies of Flour.... I therefore request you in the most urgent terms, to turn your most serious and active attention to this very and infinitely important object. Seize the present opportunity and . . . secure the River against any future attempts of the Enemy.[23]

In 1778, with these instructions and a new engineer in charge of the plans, Colonel Tadeusz Kosciuszko, Continental forces relocated the American defenses to West Point, opposite Constitution Island. Kosciuszko's study of the river terrain on the

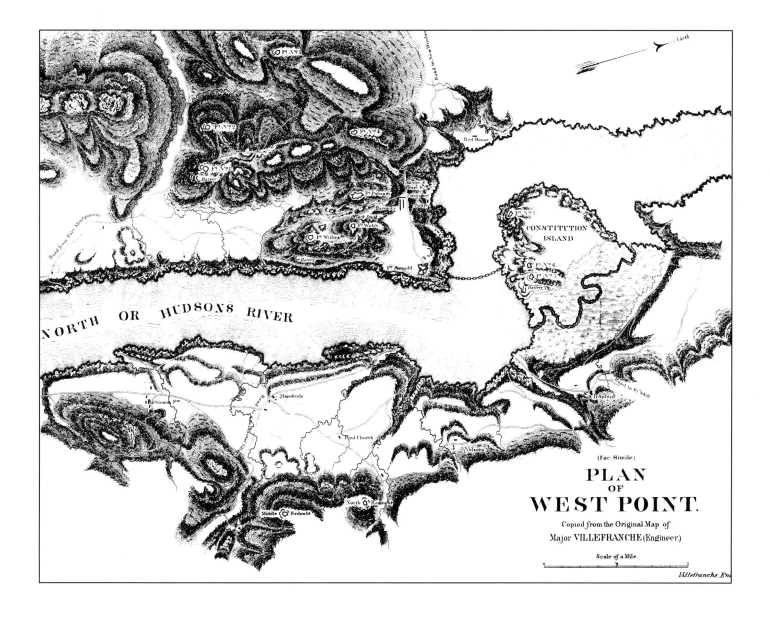

(Fac Simile)

PLAN
OF
WEST POINT.

Copied from the Original Map of
Major VILLEFRANCHE (Engineer.)

Scale of a Mile.

upper Hudson had helped the Americans defeat Burgoyne, and with this next as-signment the Polish colonel demonstrated his skill again. Where the river posed a challenge, he came up with an innovative response.

His plan for West Point called for a fortified area consisting of mutually support-ing strongholds. Much more difficult to attack than the traditional "single position" of the eighteenth century, this system was far ahead of its time. On Constitution Is-land, two low-lying batteries and three redoubts covered the river. Above all the forts and batteries, on the highest ground, was Redoubt 4, overlooking Fort Putnam. A new chain blockaded the river between West Point and Constitution Island, just upstream of World's End. Produced at the Sterling Iron Works near Harriman and joined together at nearby New Windsor, its links were 2 feet long and weighed on av-erage about 105 pounds.

West Point was so well designed that it forced the British to try a different tack: using the Hudson as a wedge between the colonies. In May 1779, Sir Henry Clinton sailed north again with 6,000 troops and captured Verplanck's Point on the east

Major Jean Louis Ambroise de Genton Villefranche, engineer, *Plan of West Point.* Facsimile engraving from the original 1780 map.
From a copy in the Special Collection Division, U.S. Military Academy Library, West Point

GENERAL WAYNE.[1]

shore and Stony Point on the west shore. These forts protected vital King's Ferry, the link on the supply line between New England and the Southern states.

Washington couldn't allow this. On July 15, he dispatched troops commanded by Brigadier General Anthony Wayne in a surprise night attack on Stony Point that many deemed to be sheer madness. A handpicked force of 1,350 men swarmed the fort. They wore white badges so they could tell themselves apart from the enemy in darkness, and they didn't fire a single shot that would give away their positions. Using only bayonets, they forced surrender, and British ships moved downriver again. Mad Anthony Wayne would go down in history as another savior of the patriot cause.

By 1780, the promise of French reinforcements under the Comte de Rochambeau led George Washington to conclude that he might have sufficient force to drive the British from New York. He approached General Benedict Arnold to command the left wing of the army for an attack on Manhattan. However, Arnold was sullen and strangely quiet. "His countenance changed and he appeared to be quite fallen," recalled Washington, "and instead of thanking me . . . never opened his mouth."[24] Arnold later told Washington that he wished to be given command of West Point instead.

Washington granted the request, but he was mystified that Arnold should turn down a key combat assignment. Arnold was one of the Americans' most trusted and courageous generals. At Quebec, Valcour Island, and Danbury, he had demonstrated superb leadership. In 1777, at Fort Stanwix on the Mohawk River against St. Leger, he was so fearless that some suggested he had been momentarily insane, or had taken opium, or had simply wanted to die. At Freeman's Farm, his daring attacks on Burgoyne's troops had delivered an American victory. The choice of a noncombat position seemed quite uncharacteristic. However, Arnold claimed his injuries were too debilitating, and Washington complied with his wishes. Arnold's request in 1780 set in motion a new British plot to capture West Point and with it control of the Hudson. The redcoats had not given up their strategy to use the river to separate the provincial forces and compel their "absolute subjection." Now they would resort to spies and treason.

No one knows what really caused Arnold to turn traitor, but it is clear that he felt his repeated heroism on the field of battle entitled him to promotions that had not

(top) *Lossing,* Pictorial Field-Book of the Revolution, *1860*

(bottom) *Lossing,* Pictorial Field-Book of the Revolution, *1860*

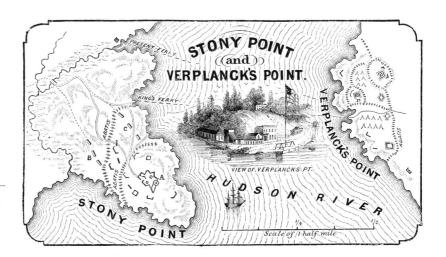

come. In 1779, in Philadelphia, Arnold contacted an aide to the British general, Sir Henry Clinton, and offered, for a price, to provide his services to the crown. In July 1780, Arnold informed the British that he would receive command of West Point and plotted to help them capture it, which would allow England to regain control of the Hudson River and squash the rebellion once and for all.

On Thursday, September 21, he set the plan in motion in a midnight meeting with Major John André of the British Army on the banks of the Hudson near Haverstraw. André had rowed over from the British ship *Vulture* to receive the plans of the fort and discuss West Point's vulnerabilities with Arnold. At dawn, as André prepared to return to his ship, he heard the sound of cannon fire on the river. American troops had shelled the *Vulture* from Teller's (Croton) Point, forcing it to move downriver. This left André stranded, forcing him to travel the risky overland route through the no man's land between the American strongholds in the Highlands and the British lines at the Croton River. With Arnold's help, André disguised himself as a civilian. With the plans to West Point in his boot, he crossed the Hudson by boat to Verplanck's Point and began the thirty-mile ride south to the British headquarters, bearing a pass signed by Arnold.

Approaching Tarrytown and safety, André was accosted by three volunteer militiamen. Mistaking them for Tories, André declared that he was British. The three Americans then searched him and pulled his boots off, discovering the maps and plans of West Point. André sought to bribe the militiamen into letting him continue, but this merely convinced them that he had something of value, and they turned André in to the American command. The plot to betray West Point had failed, though Arnold himself escaped to the safety of the *Vulture*.

News of Arnold's deceit spread like wildfire. On October 10, the *Pennsylvania Packet* printed General Greene's orders of the day for September 26:

> Treason of the blackest dye was yesterday discovered. General Arnold, who commanded at West Point, lost to every sentiment of honor, of public and private obligation, was about to deliver up that important fort into the hands of the enemy. Such an event must have given the American cause a deadly wound if not a fatal stab.[25]

The people of Philadelphia were so outraged that they carted an effigy of Arnold through the streets to be hanged and then burned. Later, George Washington was to write: "That overruling Providence which has so often, and so remarkably interposed in our favor, never manifested itself more conspicuously than in the timely discovery of his horrid design of surrendering the Post and Garrison of West Point into the hands of the enemy."[26] André was tried and hanged. Arnold was given a pension in the British army.

After this, the British attempts to capture the Hudson ended. A year later, in 1781, there would be new problems for the British, as the French General Rochambeau marched with 4,200 men from Rhode Island to the shores of the Hudson in Westchester, at Philipsburg, to join up with the Continental Army. They considered laying siege to New York but instead moved on General Cornwallis's army in Virginia when French Admiral de Grasse promised to sail to Chesapeake Bay. The main fighting in the war had been taking place in the South since 1779. In October 1781, the British, under Cornwallis, suffered a crushing defeat at Yorktown, Virginia, in what proved to be the last major battle of the revolution.

BENEDICT ARNOLD.

Lossing, Primary History of the United States, *1858*

For the next two years, while peace was being negotiated, British forces remained on Manhattan Island, and in 1782, Washington moved his headquarters to the Hasbrouck House in Newburgh, just north of the Highlands, to keep an eye on the British and maintain control of the Hudson River. His troops were stationed nearby at the cantonment in New Windsor. He remained there for the duration of the war, until 1783 when the British departed. At New Windsor, hearing that news, some of his troops suggested that he become their new king; however, Washington refused to entertain the idea, a moment that has passed into mythology as the time when America truly committed itself to a new form of government.

On November 25, 1783, Washington rode into New York City on horseback among cheering crowds, returning it to official American control. Two weeks later, on December 4, Washington addressed his officers at Fraunces Tavern in Manhattan, bidding them farewell, and then returned to Mount Vernon. The river had changed him and changed a nation.

In the following years, states on both sides of New York voted to adopt the Constitution—enough of them to ratify it—but were separated in the middle as communities up and down the Hudson River vigorously debated the pros and cons, arguing the points of states' rights versus a strong federal role. The federalists, led by New Yorkers Alexander Hamilton and John Jay, supported the Constitution.

The Hasbrouck House in Newburgh, Washington's headquarters from 1782 to 1783, now preserved as a State Historic Site.

Lossing, Life of Washington: A Biography, Personal, Military and Political, *1860*

Governor George Clinton, a states' rights man, refused to sign without a bill of rights to prevent abuse of power. A compromise allowed for the Bill of Rights to be adopted soon after, guaranteeing, among other things, freedom of religion, first practiced here in New Netherlands. In 1788, New York ratified the Constitution at the courthouse in Poughkeepsie, becoming the eleventh state, and joining the states north and south of it as one. No longer a dividing line, the Hudson once again united the states.

In 1789, Washington returned to Manhattan, the nation's first capital, to be sworn in as president. State Chancellor Robert Livingston, whose Hudson River estate had been burned by the British, administered the oath of office.

The revolution and its aftermath gave new meaning to the Hudson River, transforming it in the national consciousness. Now it was America's river and a symbol of the cause for freedom. From Fort Edward to the harbor, every feature of the landscape told a story. The Highlands, in particular, would be referred to as America's Gibraltar, and Saratoga would be known as the site of the turning point of the war. The heroes of the river campaigns—both decorated commanders and common soldiers—would become examples to define traits of the American character. Engineers showed ingenuity and innovation in using the river to advantage; generals acted with daring and passion to capture key forts and redoubts, knowing their strategic importance. The men who caught Major André could not be fooled and proved loyal to home and

Chancellor Livingston administers the oath of office to George Washington as first President of the United States on April 30, 1789, from the balcony of Federal Hall, overlooking Wall Street on Manhattan Island.

Collection of the New-York Historical Society (#54615)

country, while the soldiers at Saratoga showed restraint and respect for their adversaries. The river symbolism continued as new place names came into use along the Hudson: Fort Lee, New Jersey; Fort Montgomery, New York; Victory, New York; Beacon Mountain; Hessian Lake; Continental Village; Fort Tryon; and Horatio Street on Manhattan, named for Horatio Gates, all mark the heroic battleground for national independence. On the Hudson, America had shown its military prowess. In 1780, when the Marquis de Chastellux visited the Highlands, he characterized West Point as a "wild and warlike abode" evoking "the dominion of the God Mars."[27]

By 1800, the mere mention of the Hudson River was sufficient to recall thoughts of George Washington, American heroism, and the birth of the new republic. British traveler John Maude kept a journal of a sloop voyage up the river that year, in which he wrote:

> Turned out at 4 a.m. Sketched a view of Fort Clinton, Fort Montgomery, St. Anthony's Nose, the Bear Mountains, and surrounding scenery; highly romantic and beautiful. . . . The view from our present situation [West Point] was most sublime and magnificent. I do not recollect one that I enjoyed so much; it was historic ground and had been trodden by Washington.[28]

The Revolutionary War also marked the beginning of the river's role as a major military asset. To avoid a reprise of 1777, Americans built forts for the War of 1812, this time guarding the Narrows as well as the city and preventing British ships from gaining any access to the upper bay. The forts remain as part of the river's strategic legacy. The Civil War, the Spanish-American War, and both world wars would see a deepening military function for the Hudson. Offering a sheltered harbor and essential raw materials, the river developed as a place of manufacture for weapons and warships and a site for naval operations, military barracks, and troop deployment.

George Washington would not forget the disadvantages of an untrained militia. No sooner was he elected president than he addressed Congress on the need to establish a military school. In 1802, after his death, the lawmakers established the academy at West Point. It was a site that many would visit to reflect on the events of the war, a place filled with memorials. As the foremost leadership school in the country, it continues to be the focus of the military river.

Washington also turned his thoughts to a peacetime strategy that would keep the nation together. The way to do this, he thought, was through waterway improvements linking the eastern states with those to the west, creating economic interdependence and "binding those people to us by a chain which can never be broken."[29] In 1783, he toured New England and New York, making excursions to Lake Champlain and the Mohawk River. "Prompted by these actual observations," he wrote, "I could not help taking a more contemplative and extensive view of the vast inland navigation of these United States, and could not but be struck with the immense diffusion and importance of it; and with the goodness of that Providence which has dealt his favours to us with so profuse a hand. Would God we may have the wisdom to improve them."[30]

Washington could not have imagined the speed with which such navigational improvements would be realized and the scale at which they would be accomplished on the lands and waters he had just visited. Less than four decades later, the Hudson and its major tributary the Mohawk River would be in the vanguard of a new

transformative era in American life, creating the binding ties among people that he envisioned.

In the process, however, new state and federal policies would drive out Native people who for 200 years had shared their land with colonial Europeans and had fought decisive battles for them in this and previous wars. The Haudenosaunee (Iroquois) had been particularly important during the Revolutionary War, siding with those they thought would best protect their interests in return for promises that their territory would be preserved. Oneida warriors had played a key role in Burgoyne's defeat. Others, including many Mohawks led by Chief Joseph Brant, another visionary leader of this era, allied themselves with Britain but remained influential with Americans after the British surrender. In repeated negotiations, the Haudenosaunee bargained to preserve their way of life and the free access to the environment that supported it, but by 1800, new laws and treaties had slowly chipped away at their sovereignty, along with the power of fierce warriors to defend it.[31]

Iroquoia, the territory of the Haudenosaunee stretching from Albany to the Great Lakes, was now up for grabs. Soon, Governor George Clinton's nephew, DeWitt Clinton, would seize the opportunity to redefine it, taking advantage of its connection to the Hudson via the Mohawk River. The Hudson River would continue to grow legendary as the battleground of the republic, but through the efforts of Clinton and others inspired by visions of empire, it would also develop a new reputation that was quite different. People around the globe would come to know it as the nation's premier river of commerce, the gateway into America's interior, and the place where human mastery of nature could be proved. The Hudson would again transform the nation.

America's River of Empire

Robert Fulton's Folly, Robert Livingston's Venture Capital, and DeWitt Clinton's Ditch Spark the Rise of New York Port

3

N 1807, WHILE the steamboat *North River* was being built, Robert Fulton would wander by the East River shipyard to watch, and he would overhear the gossip of strangers who gathered to inquire about the strange new vessel. "The language was uniformly that of scorn, or sneer, or ridicule," he wrote. "The loud laugh often arose at my expense; the dry jest; the wise calculation of losses and expenditures, the dull, but endless repetition of Fulton folly."[1] Even his best friends shared the feeling as they boarded the ship for its maiden voyage to Albany on August 17, 1807. Fulton later wrote of that day:

> The moment arrived in which the word was to be given for the boat to move. My friends were in groups on the deck. There was anxiety mixed with fear among them. They were silent, sad and weary. I read in their looks nothing but disaster, and almost repented of my efforts. The signal was given and the boat moved on a short distance

Varick de Witt, *Steamboat "Clermont" on North River.* 1861 watercolor showing Fulton's invention as it may have appeared on its maiden voyage past the Palisades. The boat was actually registered as the *North River Steamboat of Clermont,* and Fulton himself called it the *North River.*

Collection of the New-York Historical Society (#38716)

and then stopped and became immovable. To the silence of the preceding moment, now succeeded murmurs of discontent, and agitations, and whispers and shrugs. I could hear distinctly repeated—"I told you it was so; it is a foolish scheme: I wish we were well out of it."

I elevated myself upon a platform and addressed the assembly. I stated that I knew not what was the matter, but if they would be quiet and indulge me for half an hour, I would either go on or abandon the voyage for that time. This short respite was conceded without objection. I went below and examined the machinery, and discovered that the cause was a slight maladjustment of some of the work. In a short time it was obviated. The boat was again put in motion. She continued to move on. All were still incredulous. None seemed willing to trust the evidence of their own senses. . . .

We left the fair city of New York; we passed through the romantic and ever-varying scenery of the Highlands; we descried the clustering houses of Albany; we reached its shores, . . . and then, even then, when all seemed achieved, I was the victim of disappointment. Imagination superseded the influence of fact. It was then doubted if it could be done again, or if done, it was doubted if it could be made of any great value.[2]

It is no wonder that Fulton had so much trouble convincing people to accept his invention. His boat was unlike anything they had ever experienced. The weather determined everything for sailboats, yet the steamboat made it practically irrelevant. This was both exciting and frightening. The vessel traveled from New York to Albany and back, a distance of 300 miles, in only 62 hours. The same round-trip passage would have taken a sloop about a week. "I overtook many sloops and schooners, beating to the windward, and parted with them as if they had been at anchor," Fulton noted.[3]

It didn't help that the steamboat looked so strange. Unlike the glorious steamers that later plied the Hudson and the Mississippi, this one was a raw machine—it looked like a "backwoods saw mill mounted on a scow and set on fire."[4] Fueled by pine logs, a cascade of sparks flew from its smokestack, a sight that was especially dramatic against the night sky. Until they got used to it, the captains of sloops and schooners waiting for a favorable wind or a change of the tide found it almost supernatural. As one person described it: "The crews of many sailing vessels shrunk beneath their decks at the terrific sight, while others prostrated themselves and besought Providence to protect them from the approach of the horrible monster which was marching on the tide and lighting its path by . . . fire."[5]

Even so, the time was ripe for steam navigation as a way to move people and goods faster in the rapidly developing country, and many people had tried to find a way to make it work. Fulton did not invent the steamboat; his 1807 triumph lay in making it both practical and profitable. John Fitch had briefly operated a steamboat on the Delaware, in 1787, but it was a commercial failure since overland transportation was nearly as fast, and it was soon forgotten. In 1802, Colonel John Stevens, in Hoboken, had designed a small steamboat powered by a screw propeller to commute between New Jersey and Manhattan, but it was only for his personal use. Through careful study, Fulton improved on earlier steamboat designs to make a practical commercial vessel that could carry passengers, powered by a paddle wheel. However, it was the choice of the Hudson River as a place to debut the steamboat that made his invention profitable.

The surrounding terrain made land transportation along the Hudson difficult. For passengers on carriages, the bumpy, lurching ride between New York and Albany, the two major ports, was extremely uncomfortable. Shifting winds and tides made sloop travel on the river itself slow. For these two reasons, people were willing to pay high prices for steam travel—enough to earn back the approximately $20,000 it cost Fulton to build the boat. In July 1808, 10 months after the steamboat began regular service from New York to Albany, his company earned a profit of about $1,000 per week. Fulton's engineering skill and business acumen not only put him in the vanguard of steamboating but also made him one of the richest men in the country. His was a rags-to-riches success story, a realization of the American dream.[6]

Yet Fulton could not have enjoyed this success without the partnership of Robert Livingston, of Clermont on the east shore of the Hudson near Germantown (Livingston was heir to one tenth of what had been the Livingston Manor a century before—the Town of Clermont at 16,000 acres). Livingston provided venture capital as well as the political connections to secure, defend, and extend a state monopoly on steamboat operations for the company they formed.

The two men had met at a dinner party in Paris, France in 1802, when both were seeking favors from Napoleon. Fulton, a poor but charming Pennsylvania tinkerer, hoped to interest the French government in his design for a submarine armed with torpedoes. He was looking for his lucky break. Livingston, a wealthy aristocrat, had been sent to France by President Jefferson to negotiate with Napoleon for the purchase of the port of New Orleans and possibly some surrounding territory. The two

Gilbert Stuart, *Chancellor Robert Livingston.* Circa 1795.

Courtesy of the NYS Office of Parks Recreation and Historic Preservation, Clermont State Historic Site

Robert Fulton, self-portrait (attributed).
Watercolor on ivory miniature,
circa 1800–1814.
Courtesy of Clermont State Historic Site

men discovered a common interest in steamboat technology. In 1798, Livingston had tried to finance an experimental boat on the Hudson in partnership with his brother-in-law (Colonel John Stevens of Hoboken), and he had secured a state monopoly for commercial operation of a steamboat on the river. The project had failed, but Livingston kept the monopoly.[7] In France, the two men struck a deal to build one together and operate it on the Hudson. They each would pay half the cost. Since Fulton had no money to speak of, Livingston would put up the initial funds for Fulton to go to England and secure a steam engine and work on a trial design.

Meanwhile, in their dealings with the French, Livingston had success while Fulton did not. In 1803, Livingston returned home with an agreement for the United States to buy the entire French holdings in North America for $15 million: the Louisiana Purchase. Fulton, having failed to spark interest in his torpedoes, moved to England, where he began work on his new project. He studied the designs of other steamboat inventors, determined the proper design for the hull, experimented with paddle wheels, and figured out how to use the power of the steam engine to turn them. He also sold his torpedo design to the British, gaining the cash he needed for his half of the partnership with Livingston. In December 1806, he returned to the United States and soon set about building the boat he had designed for the Hudson.[8]

A life of dreams and failures seems to have prepared Fulton for the success that followed. After the launch of the *North River*, steamboats became an increasingly

common sight on the Hudson. Livingston and Fulton licensed other companies to operate steamboats on New York State waters, including one connecting the seaport in New York City to Long Island Sound and another linking Manhattan to New Jersey. Fulton ferries also steamed from Manhattan to Brooklyn across the East River. A trade embargo and coastal blockade during the War of 1812 had brought the commerce of the port to a virtual standstill, with only Hudson River traffic sustaining it. However, forts and batteries built around Manhattan and at the Narrows (several of which are now preserved by the National Park Service) had successfully prevented an attack on the harbor, and after the Treaty of Ghent ended the British blockade, the North River Steamboat Company operated steamboats in all directions, making the port even more of a transportation hub. The company also enforced the monopoly vigorously, even against Livingston's brother-in-law, Colonel Stevens. He had started his own commercial steamboat service, which he was now forced to move to the Delaware River.

Fulton also understood that if a steamboat could succeed on the Hudson, it would do even better on the boundless Mississippi and its tributary rivers, now American territory thanks to Livingston's diplomacy. There, boats that could travel easily upstream would create opportunities for trade and settlement. Though Livingston had initially been interested only in the Hudson, the two partners put a steamboat on the Mississippi in 1811. By 1815, their company operated four of them there, though fierce competition soon arose.

Together they had launched a transportation revolution that made it possible to move goods and people quickly over long distances in spite of wind, current, and tide. By 1821, both men had died, but steamboats could be found on most of America's major waterways. As many as 69 of them operated on the Mississippi and Ohio rivers alone, making it easier to develop the lands acquired from France. In the decade after the first steamboat was launched on the Mississippi, about 1.1 million people settled the newly created states of that river system. The steamboat brought luxuries from Europe to remote cabins in Louisiana, Indiana, Mississippi, Illinois, and Missouri.[9]

Though the Hudson eventually had more steamboats than any other river, it was many years before they completely replaced sailboats. Steamboats carried passengers, for whom shorter travel time was worth the extra cost, but freight continued to move by sail, which was cheaper. Furthermore, it would be years before steam navigation became a viable option for oceangoing ships, in 1838. So the age of steamboats on the Hudson was also the glorious age of sloops, schooners, and brigs—all ships of sail that plied its waters and departed to points near and far.

In 1807, when the steamboat *North River* was launched, Manhattan had recently become the nation's leading port city, though not decisively. John Lambert wrote of South Street Seaport that year:

Bales of cotton, wool and merchandise; barrels of rice, flour, and salt; hogsheads of sugar, chests of tea, puncheons of rum, and pipes of wine; boxes, cases, packs and packages of all sizes. . . . The carters were driving in every direction; and the sailors and laborers upon the wharfs . . . were moving their ponderous burthens from place to place. The merchants and their clerks were busily engaged in their counting houses. . . . The Tontine coffee-house was filled with underwriters, brokers, merchants,

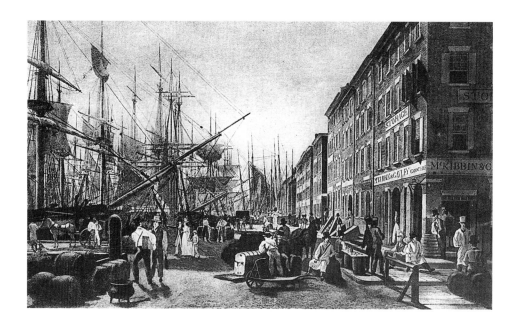

traders, and politicians; selling, purchasing, trafficking, or insuring; some reading, others eagerly inquiring the news. . . . Everything was in motion; all was life, bustle and activity.[10]

It might seem that the blessings of nature had guaranteed that New York harbor would develop as America's chief port. The Hudson, the upper bay, and the East River offered a sheltered area, as Van der Donck had earlier noted, "a safe and convenient haven from all winds, wherein a thousand ships may ride in safety inland."[11] Located on salt water, it didn't freeze. More important, it connected to waterways that opened up access to a large hinterland.

However, major success for the port had only come recently. Boston, and then Philadelphia, surpassed it until 1797, and even then, the three ports continued to jockey for position. Soon, two other ports became prominent because of their access to the commerce of America's interior. With the Louisiana Purchase in 1803, New Orleans was poised to be a major funnel for trade from the Midwest down the Mississippi River. To the north, Montreal was in a position to draw products from the Great Lakes region into Canada via the St. Lawrence River. Compared to these ports, New York harbor had the best natural conditions, but its continuing preeminence was not assured. After 1807, however, the port began its meteoric rise, carrying the fortunes of the entire city with it.

What turned the harbor's natural advantages into commercial success was the clever entrepreneurship of businessmen and the bold vision of political leaders at a critical moment in time. From 1807 to 1825, with innovations in finance, transportation, and ways of doing business, and a little bit of luck, New York drew the trade of the entire nation to its port, giving the harbor on the Hudson a jump start over others—a lead it never lost. The Hudson became America's river of empire, and New York the commercial capital of the nation.

The rise of the port began in 1807 with the successful application of steamboat technology. Even during the coastal trade embargo of the War of 1812, this kept the port busy with local trips to Albany, New Jersey, and Long Island Sound. In addition, Manhattan began a complete makeover: in 1811, the city adopted a plan to flatten its

Wm. J. Bennett, *South Street from Maiden Lane, 1828*. Painted and engraved.
Courtesy of the New York Public Library, Emmett Collection

hills, fill its marshes, and establish a grid system of city streets, all connecting to the water. The grid plan was a visionary innovation, overlaying a proposed street pattern on rural open spaces that would take decades to develop. Though it charted the destruction of much of the island's natural beauty, the plan put a premium on making the waterfront accessible, giving the port added economic advantages.

Then, in 1818, after the coastal embargo was lifted, a simple but unprecedented idea gave New York shipping a huge boost over all the competition, linking it firmly to the rest of the world.[12] That year, Jeremiah Thompson and his partners initiated regularly scheduled departures of sailboats traveling between Liverpool—which was then the outlet for the largest manufacturing district in the world—and New York. Thompson operated the New York end of a family business, importing Yorkshire woolens manufactured by his brother William and exporting Southern cotton on the return trip to England. He organized the four boats they owned into a fleet of Black Ball ocean liners that would sail on a set schedule. Perhaps Thompson got the idea from the steamboat, with its regular departures up the Hudson River. It would be twenty years before steamships crossed the ocean, and at the time, sailboats bound for Europe tended to wait for their holds to fill and good sailing conditions to arrive. Thompson changed that and revolutionized the shipping industry.

Dry goods merchants and manufacturing agents liked the predictability and speed of scheduled packet service. Soon Black Ball ships carried all the time-sensitive cargo, including the mail, and high-value freight, as well as upscale passengers willing to pay extra for comfort and speed. The service was so successful that, by 1822, more than four times as many ocean liners made the round trip to Liverpool, including ships of the competing Red Star and Blue Swallowtail lines. This solidified the role of New York as the port of choice for trade with Europe, which in turn led to the development of dockside facilities and related businesses such as mahogany yards, sail makers, and, eventually, machine works and foundries. It also boosted the financial services associated with shipping. By 1828, duties collected at the U.S. Custom House in New York provided much of the cost of operating the federal government—enough to pay everything except the national debt—and the duties charged on the valuable cargo of the ocean liners made up a large share of this amount.

Success led to more success. Ships that sailed to Asia from other U.S. ports (including Boston, the leader in the China trade) started selling their cargo at New York. Large numbers of merchants streamed to the seaport to buy and sell their goods, many arriving by fast steamboat. In addition, New York State passed laws to make conditions more favorable for trade.

While the ocean liners expanded trade routes east with Europe, the Yankee migration into New York, around 1800, brought in new trade from the north, as New England families started up satellite businesses on Manhattan. Lumber from Maine, whale oil from New Bedford, and eventually manufactured cotton from Lowell and Fall River and shoes from Lynn and Haverhill all changed hands at New York port as well as at their traditional outlet in Boston.

Most important, though, was trade with the South. After Eli Whitney invented the cotton gin in 1793, making it possible to mechanically remove the seeds from cotton bolls, cotton grew from a specialty crop to a plantation crop. Since much of the cotton from the South was shipped to New York before being sent to England,

DEWITT CLINTON.

Lossing, Primary History of the United States, *1858*

the impact on the port was enormous. In 1789, New York ships had delivered just 330 bales to Liverpool. However, 21 years later, in 1810, the number had jumped to 240,000 bales. By 1822, cotton had become America's most important export product, and it filled the holds of outgoing ships that later returned to the Hudson with manufactured goods from Britain and France.

At New York port, imports were plentiful, but ships needed export products to fill their holds, and cotton filled the gap. Interestingly, there was really no need for Southern planters to ship cotton via New York. New York merchants and New Englanders with New York connections found ways to bring cotton north. They sent family members to become dealers or traders in Southern ports. Their banks extended lines of credit that allowed the plantations to quickly expand. These financial relationships with New York turned into trade relationships for export of their crop. Even the cotton shipped directly from Southern ports to Europe was insured in New York and shipped on vessels provided by a New York ship broker, so that eventually, about forty cents of every cotton dollar went to New York in the form of taxes, commissions, interest income, and insurance, among other things.[13]

When Southern planters woke up to this fact, they were not happy. A report, prepared after an 1839 economic convention in Charleston, summed it up this way: "The South thus stands in the attitude of feeding from her own bosom a vast population of merchants, ship owners, capitalists, and others, who without the claims of her progeny, drink up the life-blood of her trade."[14] On the other hand, the South gained an important Northern ally in its bid to maintain slavery. New York was so dependent on Southern cotton that city businessmen, with a few exceptions, endorsed slavery in the South. In 1861, after Lincoln's election, Mayor Fernando Wood went so far as to suggest that the city secede from the union and form its own republic rather than risk the loss of the cotton money.

Having secured the trade of north, south, and east, there remained only the question of establishing trade with the west, and several visionary New Yorkers had an idea for one way to go about it: they would build a 363-mile-long canal through the wilderness, connecting the Hudson River to Lake Erie. While many people played key roles in promoting this plan, including Robert Livingston, Robert Fulton, Stephen van Rensselaer, and others, DeWitt Clinton was the one who brought it to pass.

Born on the eve of the evolution in 1769 in New Windsor, New York, Clinton was the son of Mary DeWitt and James Clinton. His mother could trace her ancestry to Sarah Rapalje, the daughter of colonists who made their way to the Hudson Valley from Amsterdam in 1624.[15] Clinton's father was the same James Clinton who had fought the British in the Highlands. Thus, DeWitt was steeped in the traditions of the region and was in every way a native son.

Clinton began public life at the age of twenty-one, when he apprenticed with his uncle, General George Clinton, who was then serving as the state's first governor, and rose through elected and appointed offices to become a U.S. Senator at age thirty-three. He left national politics to accept appointment as Mayor of New York City in 1803, an office he held almost continuously until 1815.

As a local, state, and national politician, DeWitt Clinton had immense talent and wide-ranging interests. He repealed colonial-era restrictions on voting rights for Roman Catholics and sought to abolish slavery. He proposed forest management policies, helped Robert Livingston extend his steamboat monopoly, and launched a

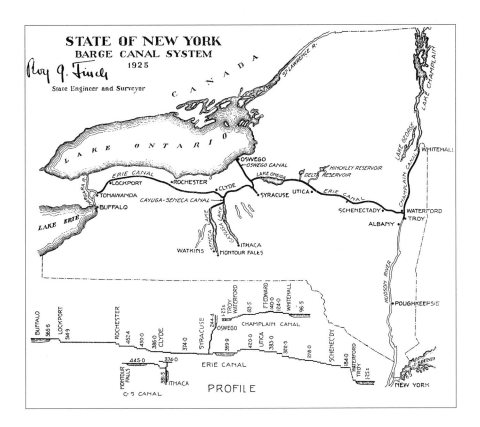

project to translate the early Dutch colonial records. He also established public schools in New York City and supported the schooling of immigrant children, blacks, women, orphans, and the deaf. Clinton invited Vermont's Emma Willard, a women's rights advocate and educator, to come to New York State and establish a female seminary—which she did, in Troy, supported by donations raised locally. An opponent of the practice of putting people in jail for unpaid debts, he gave official pardon to Amos Eaton, who had been exiled from New York after his release from debtors' prison. Eaton went on to become the leading geologist in America.[16]

In his spare time, Clinton wrote articles on science, memorized bird calls, and studied migratory fishes. At this time, nature study was flowering in America and abroad. A variety of books and artwork on natural history came on the market, including Alexander Wilson's 1810 *American Ornithology*, with beautiful drawings of birds, and Samuel Mitchill's *The Fishes of New-York*. This was followed in 1820 by the work of John James Audubon, who painted the famous watercolors of birds.

A man of his times, Clinton studied nature closely, including the Hudson. He wrote a book on the natural resources of New York State and sent a copy to Thomas Jefferson. He is credited with discovering a native species of wheat and describing a new species of minnow, the spottail shiner, which he named *Clupea hudsonia* (now renamed *Notropis hudsonius*) in honor of the Hudson, where he found it.

Clinton also helped elevate New York City from a cultural backwater of Boston and Philadelphia to a position of leadership in the arts, helping to create the Academy of Fine Arts, the New-York Historical Society, and the Literary and Philosophical Society. Like many educated men of his day, he was trained in the classics. He studied the rise and fall of ancient empires, and he saw the possibilities that a great civilization could develop on the shores of the Hudson.

The route of the Erie and Champlain canals (also known as the Western and Northern canals), later enlarged and called the state barge canal system.
New York State Archives

It has been said that DeWitt Clinton did more than any other person to shape the future of New York City. His understanding of the river and of nature, his grasp of politics and finance, his commitment to education, culture, and the arts, and his visionary thinking all converged to support the growth of the city. A man with a unique set of skills and interests, he was about to make Manhattan the dominant seaport, New York the Empire State, and the Hudson the dominant river of America.

Clinton's interest in developing a canal to the Great Lakes stemmed from his sense of the importance of commercial waterways to the prosperity of the city and the state. The Hudson River, he believed, was an asset to be developed:

> A geographical view of the country, will at once demonstrate the unexampled prosperity that will arise from our cultivating the advantages which nature has dispensed with so liberal a hand.... [Our] Hudson has decided advantages. It affords a tide navigation for vessels of eighty tons to Albany and Troy, 160 miles above New York, and this peculiarity distinguishes it from all the other bays and rivers in the United States.... The importance of the Hudson river to the old settled parts of the state, may be observed in the immense wealth which is daily borne on its waters, in the flourishing villages and cities on its banks, and in the opulence and prosperity of all the country connected with it, either remotely or immediately.... If a river or natural canal, navigable about 170 miles, has been productive of such signal benefits, what blessings might not be expected if were extended 300 miles through the most fertile country of the universe, and united with the great seas of the west!... [How] unspeakably beneficial must it appear, when we extend our contemplations to the great lakes, and the country affiliated with them?... we are fully persuaded that now is the proper time for its commencement. Delays are the refuge of weak minds, and to procrastinate on this occasion is to shew a culpable inattention to the bounties of nature; a total insensibility to the blessings of Providence, and an inexcusable neglect of the interests of society.[17]

If New Yorkers could succeed in building a canal, it would be possible to take cargo boats all the way from Manhattan to Chicago. On their return trip, they would carry the agricultural products of all the surrounding countryside through the canal to the Hudson and down to its port, making New York the "greatest commercial emporium in the world." A second canal linking the Hudson to Lake Champlain would draw the products of the north country to the port and make New York the "brightest star in the American galaxy."[18] This was not just about moving boats. It was about competing with Canada to build a new empire.

Clinton was sure that if New York did not act, Canada would, and the Great Lakes trade would go to Montreal on the St. Lawrence. Even so, many people thought he was out of his mind to suggest it. At that time, the largest canal built in America was 27 miles long, and the average canal was only 2 miles long.[19] America had no trained engineers. In Europe, canal building had a longer track record, but the longest built so far (the Languedoc canal in France) was only half the length of the proposed Erie Canal. The technology for digging canals was simple—pick, shovel, axe, and wheelbarrow—and the primary building materials were dirt and wood. Neither the steam shovel nor dynamite yet existed; nor was there a known source of hydraulic cement in the United States. Skeptics thought the promoters of the canals were "hallucinat-

ing," and they suggested one might as well try to sail a steamboat to the moon, build a bridge across the Atlantic, or dig a tunnel to China.[20]

Even so, in 1808, President Jefferson's Secretary of Treasury, Albert Gallatin, had issued a report recommending a program of road and canal building in America to tie the young nation together, and he mentioned a possible route linking the Hudson River to Lake Ontario. This prompted New York legislator Joshua Forman to meet with President Jefferson in Washington in search of federal support for a canal to Lake Erie. However, Jefferson told Forman that the idea was pure folly: "You talk of making a canal of 350 miles through the wilderness—it is little short of madness to think of it at this day." Jefferson suggested that it might be a century before such an undertaking could be contemplated, to which Forman replied that "New-York would never rest until it was accomplished."[21]

Two years later, in 1810, a state commission of prominent New Yorkers, representing all political factions, concluded that a canal system linking the Hudson to Lake Erie was feasible. The next year, two commissioners, DeWitt Clinton and Gouverneur Morris, went to Washington to lobby for support, but they were rebuffed. Then the War of 1812 intervened, and everyone's attention shifted to the battle against England until 1815, when the Treaty of Ghent restored peace. Then New York legislators made one last attempt to gain federal funding, citing military reasons for linking the Hudson River with these two inland lakes. The need to transport troops quickly from the Atlantic seaboard to the Great Lakes had been painfully evident in the recent war. However, President Madison vetoed their bill, stating that the Constitution did not give the federal government the authority to build canals.[22]

By then, Clinton was no longer in office. He had run for President of the United States against Madison, but lost political favor at home. With time on his hands, Clinton revived the idea of a canal system, proposing one to Lake Erie and another to Lake Champlain, and became its biggest promoter. Building the canals would require solving a number of problems, but Clinton had the unique knowledge and skills to make that happen. Much of his advantage stemmed from his understanding of politics, finance, and particularly science. Wherever he went, Clinton sought to learn about the geology, the soil types, and the useful plants and minerals that could contribute to the wealth of New York State. He carried a kit of simple chemicals to analyze the rocks he found, and in this way became even more convinced the practicality of building a canal from the Hudson to Lake Erie and the advantages of creating access to a rich agricultural area. Skeptics like Jefferson, he believed, did not understand the geology of the valleys through which the canal was to pass. To Clinton, if the geologic conditions were right, it was just a question of time and money. He noted "a gentle rising from the Hudson to the lake; a soil well adapted . . . no impassable hills, and no insurmountable waters. . . . If a canal can be made for fifty miles, it can be made for three hundred."[23]

Though the project was expected to cost $6 million (a shocking amount equal to about two thirds of the annual federal budget), he devised a way to pay for it that was unique at the time. New York could issue bonds, to be repaid from tolls collected from canal boats and taxes levied on those who would benefit, including the steamboat companies. No federal assistance would be required.

However, not everyone shared his confidence, and the canal project had many enemies in the state legislature, primarily the representatives of New York City and the agricultural areas along the Hudson River. New York City merchants feared the tax

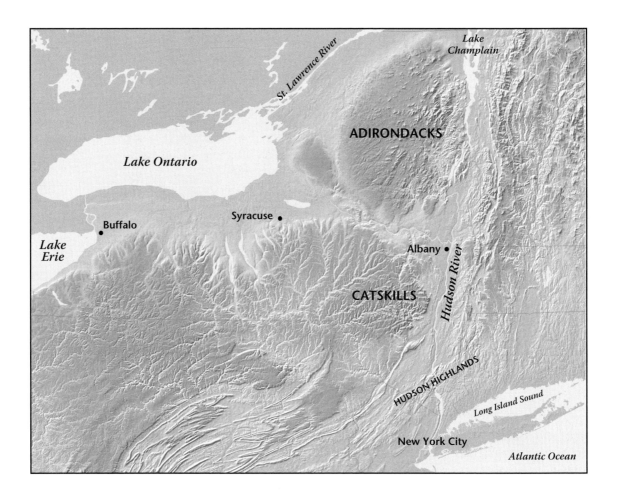

Relief map of New York State.

impact, while Hudson Valley farmers feared competition for their products from western New York, where soils were better for agriculture.

On top of that, the scale of the project troubled many people. The two canals would require engineering skills yet untried in America at that time, including construction of an 800-foot masonry aqueduct across the Genesee River at Rochester. Building locks posed challenges as well, and the Erie Canal alone required 77 of them to surmount a change in elevation of 568 feet from sea level at the Hudson to the water level of Lake Erie. The Champlain canal also required major feats of engineering. North of Waterford, 2 miles of rapids impeded north-south boat travel; to provide deep water, a substantial dam would have to be built across the Hudson River at Troy.

Political machinations surrounded the proposal. Two Albany aristocrats supported it—Stephen Van Rensselaer, the patroon of Rensselaerswyck, and Philip Schuyler, the general who helped to defeat Burgoyne at Saratoga—and so did politicians from central New York. Hudson Valley Senator Martin Van Buren (later the eighth President of the United States), leader of the political party opposing Clinton, was against the canal. Van Buren's pals (known as "bucktails" because they wore deer tails in their hat brims) did their best to kill the project and nearly succeeded, even as it was being built.

To put pressure on the legislature, in 1816 Clinton drew up a petition proposing the canal system and held meetings on it throughout the state. He secured thousands of signatures in favor of the project, and this propelled him to the governor-

ship (winning the election 43,310 to 1,479). He presided at the groundbreaking ceremony on July 4, 1817.

Construction began on both canals in sections, starting with the 96 miles between Utica and Rome, on the Erie, and the stretch from Fort Edward, on the Hudson, to Lake Champlain. As sections of "Clinton's Ditch," as the Erie Canal was called by some, were completed, they opened for boat traffic. These first sections of the two canals opened in the fall of 1819, just over two years after ground was broken.[24]

Horses or mules, driven along the canal's towpath, pulled the boats. The tolls collected far exceeded expectations and quickly helped pay for the construction of the next sections being built. The discovery of a source of limestone that could be used for hydraulic cement was one of many lucky breaks that made the project a stunning success instead of a colossal failure. The eastern section of the Erie Canal (where it joins with the Hudson) was completed next, in 1823, with masonry locks around Cohoes Falls and stone aqueduct bridges in the Mohawk Valley. So was the rest of the Champlain Canal, with its lock system. On October 26, 1825, the rest of the Erie Canal opened for business, carrying both freight and people. It had cost nearly $8 million and could carry boats of 80-ton burden. In a blockbuster ceremony of fireworks, cannon salutes, and glittering dinner parties, DeWitt Clinton rode a canal barge from Buffalo to New York City and poured a keg of Erie water into the ocean at Sandy Hook, New Jersey. To symbolize the commerce with the ports of the world that the canals would enable, speakers then followed this gesture by pouring in vials of water collected from the Nile, the Ganges, the Elbe, the Amazon, the Thames, the Seine, and many other rivers.

The success of the canals made New York, and New Yorkers, legendary. The canals gained almost mythical status in novels, essays, songs, and poems. People traveled from far and wide to see them, remarking on how the locks could make water flow uphill and how the long, high aqueduct bridges allowed boats to "fly." As tourist Caroline Gilman said, the canal "defied nature, and used it like a toy."[25] Together with the steamboat, it liberated ships from winds and tides. This seemed to be the

John William Hill, *Junction of the Erie and Northern (Champlain) Canal,* in Waterford, New York, circa 1830–1832, graphite on paper, 9½ x 13 inches. The site is now part of the Erie Canalway National Heritage Corridor.

Collection of the New-York Historical Society (#34684)

era when mankind could finally hold the forces of nature at bay. Events on the Hudson promoted a new idea: that waterways and land could be improved and made useful by human invention, and barriers could be overcome. From now on, such efforts would be seen as both duty and destiny for Americans. The legacy of the canal system would be a new attitude toward the Hudson River. It would symbolize the place where humans showed they could bend nature to their will.

Once again, the economy of New York was transformed—and with it the Hudson River and the harbor. Flour from Rochester, cloth from Utica, and salt from Syracuse could be transported quickly and cheaply to New York City and beyond, allowing the industries that produced them to grow rapidly. A ton of wheat from Buffalo could be moved to Albany in 10 days instead of 20, and at a cost of $5 instead of $100. Diverse products from Canada, Vermont, and the Adirondacks could move down the Champlain Canal. Every community along the Hudson, the canals, and the Great Lakes benefited, especially Chicago and New York City. The entire country had become accessible to the port, and the trends of financial consolidation that led to the stock exchange, the insurance industry, and international trade were set in motion, making Manhattan the Empire City of New York, the "Empire State."[26]

The communities located where the canals joined the Hudson (Waterford, Albany, Cohoes) became prosperous transfer points for cargo and people. Modest villages in central New York became cities overnight. Buffalo, Rochester, Syracuse, Rome, Utica, and Amsterdam enjoyed spectacular growth because of their new connection to the Hudson River and its international port. One British traveler, Basil Hall, wrote in his journal:

> Take Syracuse for example, which in the year 1820 consisted of one house, one mill, and one tavern: now in 1827, it holds fifteen hundred inhabitants, has two large churches, innumerable wealthy shops filled with goods, brought there by water-carriage from every corner of the globe; two large and splendid hotels . . . several busy printing presses . . . in short, it is a great and free city. Where is this to be matched . . . in ancient Italy or Greece?[27]

The canal system's greatest impact was on the Midwest, as it gave farmers a place to sell their crops and allowed them to buy imported products. Manufactured wares from England, tea and tea cups from China, coffee from Java, pepper from Sumatra, and many other foreign goods moved through the port, up the Hudson to the canals, and from there across Lake Erie to Chicago and the interior of America. The canal also assisted the migration of thousands of New Englanders, who had depleted the soil and searched for better land to farm, and of immigrants heading west.

Eventually, farmers in Nashville, Tennessee or Cincinnati, Ohio could choose to purchase goods transported up the Mississippi by steamboat or across the Great Lakes from the Erie Canal, but either way, many products arriving on the developing frontier passed through New York port first. In return, farmers gained access to trading partners in distant Europe, Asia, and Africa. Soon after the Revolutionary War, George Washington had suggested that canals could become the bond tying the midwestern states together with those of the East through shared economic interest, and could help them see the advantages of remaining united as states. The Erie Canal, with its connection to the Hudson, made that happen.

The achievement of building the canals boosted the confidence of New Yorkers and the aspirations of their countrymen. Here was living proof that America had joined the ranks of civilized nations, capable of great public works (and without slave labor). Newspapers compared the canals to the Seven Wonders of the World, proclaiming the Erie to be the eighth, as great as the Great Wall of China or the pyramids of Egypt. America was an empire in the making, like Greece or Rome. DeWitt Clinton, father of the canals, was depicted in paintings wearing a toga. Biographers described his Grecian nose.

To many, America's form of government was what made that possible. In a commemorative volume prepared for the official opening of the canal, Cadwallader D. Colden, former Mayor of New York City, boasted:

> Foreign nations . . . have told us that our government was unstable—That it was too weak to unite so large a territory—That our republic was incapable of works of great magnitude—That these could only be performed where corporal labor might be commanded and enforced, not where it must be voluntary. But we say to them, see this great link in the chain of our union—in the great bond which is to bind us together

irrefragably and for ever.—It has been devised, planned, and executed, by the free citizens of the Republican State. A work merely of pride and ostentation, it is true, could not be executed here. It would be as impossible to build the pyramids of Egypt on our soil, as it would be to float them to our shores.[28]

No doubt, the canals added momentum to the growing craze to compare the newly formed democratic country to ancient civilizations. Even before the canals were built, small hamlets along the Hudson and in the Mohawk Valley had been renamed in honor of great cities of the Old World. In 1789, just above Albany, city leaders gave a new name to the hamlet of Van der Heyden, calling it Troy, and one of its hills was given the name Mount Olympus. Farther south, the village name Athens replaced Esperanza in 1800 (it had been Loonenburg from 1685 to 1794), and a bit farther inland in the same county, Cairo replaced Canton. In central New York, communities named Greece, Rome, Carthage, Palmyra, and Ithaca sprang up. Between 1818 and 1850, white-columned Greek Revival became the popular style for civic buildings, banks, churches, and homes along the river and elsewhere, making the link between classical architecture and democracy.

The success of the Erie and Champlain canals prompted many other large canal projects elsewhere, including the privately financed Delaware and Hudson Canal (D&H), stretching 105 miles from the coal mines in Carbondale, Pennsylvania to Rondout Creek and its tidewater port in Kingston. Organized by the Wurts brothers of Philadelphia, it attracted many investors from New York City, including Philip Hone, former Mayor of New York, who served as its first president. The D&H canal opened in October 1828, and provided conveyance for the coal needed to further stimulate economic growth along the Hudson. It became New York's most profitable private canal. In 1836, another link to the Pennsylvania coal fields opened up—the Morris Canal, which extended from Phillipsburg to Jersey City, on upper New York Bay. Built with inclined planes and locks, it was another engineering marvel.

The canals leading to the Hudson also provided a training ground for engineers in an era when West Point was America's only engineering school. The men who built them developed their skills on the job. Canvass White, James Geddes, Benjamin Wright, John Jervis, John Roebling, and many others went on to become the

Rondout Creek in Kingston, where the D & H Canal meets tidewater.

Lossing, The Hudson from the Wilderness to the Sea, *1866*

leading civil engineers of nineteenth-century America, designing canals, reservoirs, aqueducts, bridges, and railroads. Some of them would build projects that radically changed the Hudson River itself.

The canal projects also proved the need to provide formal training for engineers, and in 1824 Stephen Van Rensselaer III founded the Rensselaer School on the Hudson at Troy. Van Rensselaer had served on the state's canal commission and was keenly interested in transforming the American economy through "diffusion of a very useful kind of knowledge, with its application to the business of living."[29] He selected Amos Eaton, the man who had earlier been rescued from debtor's prison by DeWitt Clinton, now an eminent geologist, to run the school. The Rensselaer School became the first college of civil engineering in any English-speaking country and was the forerunner of what is now Rensselaer Polytechnic Institute (RPI). The steamboat also stimulated the emergence of the engineering profession—the harbor became a hub of marine engineering, focused on the machinery of the fast-developing steamboat technology. In 1870, a third engineering school was established on the Hudson, in Hoboken, founded by the family of Colonel Stevens, the steamboat man.

Van Rensselaer became an important leader in the economic revolution in New York through the engineering institute he created as well as other efforts. Yet, even as he promoted a new vision for the future, he still held the title of Patroon of Rensselaerwyck, owning thousands of acres of land on both sides of the Hudson that operated on a feudal system of tenant farming. The Revolutionary War had not changed this aspect of land ownership for the aristocrats who backed the patriot cause. Van Rensselaer's death in 1839 and his heirs' attempts to collect rents owed to their father's estate triggered tenant uprisings that swept this system away. The Hudson River would change again in an industrial era both Van Renssalaer and Livingston had helped to create.

Meanwhile, in the 1820s, with the Erie, Champlain, and D&H canals all leading to the Hudson River and steamboats heading off in every direction, port activities that had once clustered around the East River expanded on the Hudson River shoreline of Manhattan, where new commercial piers were built. The riverfront, which had been rural when Fulton launched his steamboat in 1807, began to steadily develop, initially for shipping and related uses. Over the course of the nineteenth

Canal boats on the Hudson, 1908.
Postcard, author's collection

century, slaughterhouses, factories, ferries, oyster dealers, ocean liners, railroads, and industrial plants all competed for space on the now-booming Hudson River waterfront. As property values rose, residents dumped coal ash and garbage into the river to make new land, creating much of what is now the neighborhood of Greenwich Village and filling in a large marsh—the Great Kill—near Forty-second Street.[30]

The activity on the waterfront laid the groundwork for new fortunes to be made. Among those who started out very poor and became fabulously rich in this period were Cornelius Vanderbilt and John Jacob Astor. Vanderbilt, a wily sloop captain, built a steamboat empire and later a railroad monopoly, while Astor, a one-time street peddler, used his fur trade earnings to speculate on the fast-developing real estate of Manhattan. In the 1830s, encouraged by state laws and city policies, he had filled in water lots on the west shore of Lower Manhattan to make new land. He also bought rural acreage mapped on the city grid and subdivided lots, which he sold for a fortune. These rags-to-riches stories, like that of Fulton, helped create the legendary American dream and establish the Hudson River's reputation as a waterway of opportunity and wealth. Some of the descendants of Astor and Vanderbilt would later build mansions and country estates on the shores of the Hudson River.

They were not the only people who made a fortune in early nineteenth-century New York. This was also a brief time when free African Americans could be successful entrepreneurs, even as their slave brothers and sisters suffered increasing oppression. Among them, Samuel Schuyler achieved the American dream on the river. He established the Schuyler Towboat Company in Albany, using steamboats to transport canal barges down to New York City. The company grew for nearly eighty years, passing into the capable management of his sons, with offices in Troy, Albany, and New York City. With his earnings, Captain Schuyler gradually acquired several blocks of waterfront real estate in Albany and became one of its leading citizens, serving on the board of a bank.[31]

For Schuyler, Vanderbilt, and others, state and federal court decisions breaking the Livingston-Fulton steamboat monopoly created this opportunity. In 1824, the legendary Daniel Webster had argued the case against Livingston before the U.S. Supreme Court. Chief Justice Marshall established the power of Congress to regulate interstate commerce and struck down the monopoly, a landmark decision. Competition soon produced a new era on the Hudson, as dozens of new steamboats took Europeans on a tour of America's most famous river and its legendary canals.

First Stop on the American Tour

Europe Discovers Sylvanus Thayer's West Point, a Catskills Sunrise,
and a River That Defines the American Character

4

FULTON'S INVENTION BROUGHT great changes to the Hudson Valley, and not just economic ones. Steamboats ushered in an age of leisurely travel and introduced the river to the world. This was a time when international sightseeing gained popularity, and a period of intense nationalistic sentiment among Americans. For Europeans and Americans alike, the river scenery inspired a sense of pride; it came to represent the fresh face of the country, and its Revolutionary War sites became visible symbols of the nation's democratic experiment. For the curious, both at home and abroad, what better way to see America than from aboard a paddle wheeler? And how better to evoke a surge of patriotism than by floating past the Hudson's historic forts and romantic landscape? With New York the port of entry for most foreigners, the Hudson River soon shot to national and international prominence as the first stop on the American tour.

A. E. Emslie, "Up the Hudson." July 30, 1870 engraving from *Harper's Weekly.*
Courtesy of Steve Dunwell

In the 1830s and 1840s, American and European tourists published travel diaries of these visits, and people who never took the tour came to know the river as if they had visited it themselves. Books like *American Notes* (1842), by Charles Dickens; *Travels in North America* (1829), by Basil Hall; *Men and Manners in America* (1833), by Thomas Hamilton; and *The Poetry of Travelling* (1838), by Caroline Gilman presented the Hudson as *the* place to understand the character of America and its people.

Of course, the Hudson was not the only place in the country where spectacular scenery could be viewed, nor was it the only location of Revolutionary War interest. However, on the Hudson, both could be enjoyed in one place. Also, with the valley's varied geology, the vistas changed from hour to hour in an almost mystical way, adding interest and variety to the experience.

Furthermore, the Hudson also had fascinating destinations. In Hoboken, a short ferry ride across the river from Manhattan, one could visit the estate of Colonel Stevens, with its twelve miles of trails below the Palisades and its meadows dubbed the Elysian Fields. Fifty miles upriver was the military academy at West Point with its forts, monuments, and dramatic scenery. Past that was Hyde Park, the Dutchess County estate of Dr. David Hosack, with its pastoral river scenes, and the Catskills, where a "mountain house" hotel had been built to receive the rising tide of visitors who wished to view the river from above. Finally, the Hudson connected to the Erie Canal, the triumph of American engineering that many visitors wanted to see. From a steamboat, the traveler could switch to a canal boat and journey west to see another American wonder, Niagara Falls, as well as points beyond.

The age of touring on the Hudson took off after the Livingston-Fulton monopoly was broken (1824), allowing more steamboats to ply the river, and the completed Erie Canal opened to barge traffic (1825), creating a link to new destinations. Traveling by water came very much into vogue and increased even more in 1838, when steamboat service between England and New York replaced the sailboat as a mode of crossing the Atlantic. By 1850, nearly 150 steamboats traveled the Hudson, carrying as many as a million passengers annually, many of them tourists.[1]

Steamboat companies, competing for business, made lavish improvements in the design of their vessels, so that travel on one of them soon became an experience in itself. The original Hudson River steamboat was, at best, an "ungainly craft," but by 1842—when Charles Dickens took the Hudson River tour—the ships had been turned into "floating palaces." In the heyday of steamboating, some measured as long as 350 feet and could carry several thousand people on large upper decks. They were painted white, highlighted with gold, and some had two-story saloons surrounded by staterooms. Captain Frederick Marryat, a British author of popular seafaring novels, described the impression they made on him: "When I first saw one of the largest sweep round the battery, with her two decks, the upper one screened with snow-white awnings—the gay dresses of the ladies—the variety of colours—it reminded me of a floating garden."[2]

The excitement of traveling by steamboat affected Americans and Europeans alike and was matched only by the passion for sightseeing from on board. This fascination lasted for at least fifty years and lingered into the twentieth century, when the automobile replaced the steamboat as a popular way to travel. In the 1820s, French-

man Jacques Milbert was amazed at the "national enthusiasm for these magnificent scenes." His compatriot, Edouard de Montule, reported in 1821 that the conversation of his traveling companions, "like that of most Americans, had always for its subject the excellence of their country. . . . Although this national spirit, which is nurtured by the newspapers, is a near relative of conceit, it is very beneficial for a people . . . the Romans, too, had this pride; it made them and kept them for a long time the masters of the world."[3]

The early nineteenth century saw America seeking to define its own distinctive culture—and Europeans trying to understand the implications, for themselves, of the American social and political experiment. After fifty years of independence, Americans had begun to develop a sense of national identity, but it lacked shape and substance. The new nation had big ideas, but its history and traditions, when judged by European standards, could hardly compare to the cultural heritage of Europe, ancient Greece, or Rome. However, in one area, it was clear that America was incomparable: its wilderness had no counterpart in the Old World.

To be sure, there were patches of wild land in Europe, but America was an entire continent. By 1825, wilderness was becoming attractive—no longer as frightening as it had been a century earlier—and people began to look at the land in a new way. Governor DeWitt Clinton was one of the first to challenge his countrymen to take pride in America's landscape. In an 1816 speech before the National Academy of Fine Arts, he asked, "Can there be a country in the world better calculated than ours to exercise and exalt the imagination . . . ? Here nature has conducted her operations on a magnificent scale. . . . This wild, romantic . . . scenery is calculated to . . . exalt all feelings of the heart."[4] Simply put, nature was better in America—bolder, grander, untouched. Increasingly, people on both sides of the Atlantic agreed and visited the Hudson to see it firsthand by steamboat.

Among Americans, this fervor for scenery merged with a glowing pride in the recent victory of independence, an accomplishment that was equally admired abroad. A steamboat tour of the Hudson offered a way to see places that had become steeped in meaning. The forts of Manhattan, New Jersey, and the Highlands had been built on the river for strategic reasons, and now they were in full view from the deck of a steamboat, symbols of the triumph of democracy. As their boats passed by, tourists listened to tales of the capture of Fort Lee, the storming of Stony Point by Mad Anthony Wayne, the brave but hopeless defense of Forts Montgomery and Clinton, and the burning of Kingston—stories repeated and embellished to glorify the struggle for freedom.

Similarly, the landscape of the Hudson became a pleasant backdrop for a favorable portrait of America's economic system. The farms and cultivated fields of the valley showed signs of prosperity, while the manufacturing and trade in towns and villages along its shores offered proof that the country was modern and inventive. Sites associated with American government, such as courthouses, also gained a measure of fame.

The effect on the Hudson was far-reaching, as the river became the focus of a quest for national identity. Its forts assumed the importance of Grecian temples. The stories and scenes of the Revolution supplied a sense of a heroic past, while Dutch folklore pushed "history" back another century. And finally, the landscape of the Hudson provided a basis for national pride and self-confidence. Visitors from afar

VIEW FROM FORT LEE.

came to admire the Hudson River. Their letters, books, and commentaries show that its dramatic scenery and its associations with the recent revolution played a major role in defining American character and culture in the first half of the nineteenth century. At West Point, Dickens expressed a sentiment commonly held by many foreign visitors when he wrote: "Among the fair and lovely Highlands of the North River: shut in by deep green heights and ruined forts . . . hemmed in, besides, all around with memories of Washington, is the Military School of America. It could not stand on more appropriate ground, and any ground more beautiful can hardly be."[5]

For Europeans and Americans alike, the fashionable northern tour of America's most famous scenic spots typically began on the Hudson and moved from New York to other states. The journey took travelers up to Albany or Troy. From there, they could go west on the Erie Canal to Niagara Falls, with excursions along the way to Oswego and the famous waterfalls at Genesee, near Rochester. Less rugged tourists might travel north from Albany to Lake George and Saratoga, or they might head east by overland stagecoach to Boston, taking tours of Mount Holyoke and the Connecticut Valley or the White Mountains and Lake Winnepesaukee.[6] All of these destinations offered scenic wonders, but only the steamboat tour on the Hudson offered the unique combination of history and natural beauty that became so closely associated with American character, as noted by James Silk Buckingham.

Lossing, The Hudson from the Wilderness to the Sea, *1866*

A Member of the British Parliament, Buckingham was one of many Europeans who took the American tour. His book, *America, Historical, Statistical, and Descriptive* (1841), included an account of a journey from New York up the Hudson. It demonstrates the Europeans' association of American history with the river scenery. It also shows the sympathy and admiration felt, even by the British, for American independence.

On the morning of Saturday, the 23rd of June [1838] we accordingly embarked at seven o'clock, on board the steamer for Albany, and found there between four or five hundred passengers bound up the river.... Leaving the wharf at the foot of Barclay Street, we proceeded upwards on our course ... the western bank of the river begins to assume a very remarkable appearance ... cliffs extend for nearly twenty miles along the western bank of the Hudson, and are called "The Palisadoes" [Palisades] ... there were pointed out to us the sites of two remarkable forts: one of them, called Fort Lee, ... and the other called Fort Washington.... This latter fort was taken by the British in 1776, and the garrison, consisting of 2,600 troops, were captured as prisoners of war ... but these were only temporary disasters in the glorious effort by which the oppressed colonists of Britain achieved their independence....

At the termination of the Palisadoes, the river, which hitherto continues its breadth of about a mile, suddenly expands to a width varying from two to five miles, and is here called Tappan Bay.... This spot is also consecrated in American history, for, close by ... is pointed out the grave of André, whose connection with the conspiracy of the traitor Arnold is well known.... About twenty miles beyond the bay of Tappan, and forty from New York, the scenery of the river becomes changed again, and the range of hills, called the Highlands, approach close to the water, and hem in the stream on either side.... Here, too, the recollections of the revolutionary war are preserved in the names of Fort Montgomery and Fort Clinton, which were captured from General [Israel] Putnam by the British troops in 1777....

Beyond this.... The river again expands in breadth; the shores on either side are well cultivated in rising slopes, and studded with small villages ... while Newburgh ... is a rising and flourishing place of trade....

Among the whole is preserved, with great care, the "stone house" in which General Washington held his head-quarters ... a spot rendered sacred by its former occupier.[7]

As steamboating became ever more popular, a new genre of guidebooks developed to enhance the experience of travelers by recounting the history and folklore of every feature of the passing river scenery. Popular books included William Colyer's *Sketches of the North River* (1838) and Wallace Bruce's *The Hudson by Daylight* (1873). Such guides would point out the spot, by the cliffs of Weehawken, where Vice President Aaron Burr killed Alexander Hamilton—author of the *Federalist Papers*—in the famous duel. They would note the location of Kidd's Point and tell the story of the famed pirate's lost treasure.

Guidebooks also compared the Hudson Valley to the Rhine and to famous European and classical landscapes. "The Danube or Rhine, does not furnish more beautiful or picturesque views than our own beautiful Hudson," Freeman Hunt declared,

164. Steamer Robert Fulton, Passing the Palisades of the Hudson.

in his 1836 *Letters about the Hudson*.[8] Colyer, in *Sketches of the North River*, went even further in this line of thinking:

> *The Highlands*, the magnificent Matewan mountains of the Indians are now before us—they rise to the height of from twelve to fifteen hundred feet in bold and rocky precipices that would seem to defy the labor of man to surmount, and where the eagle builds her eyrie, and the hawk raises her callow brood, fearless of the strategems of the spoiler. The mighty river, pent within a narrow channel, struggles around the base of the hills, and lying deep in the shadows of the mountains, often appears like some dark lake shut out from the world. Our country offers no scenes more grand and sublime, and we may well doubt where the far-famed Rhine the cherished theme

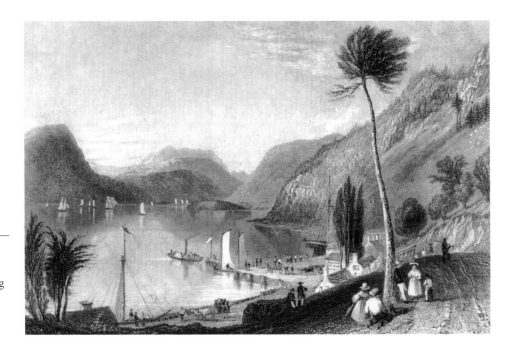

(top) The Palisades.
Postcard circa 1900, author's collection

(bottom) William Bartlett, "Peekskill Landing (Hudson River)." In N. P. Willis, *American Scenery*, 1840.
Author's collection

of every European tourist, can exceed in those attributes the one we are now voyaging upon. There is here, it is true, no classic spot to recall the days of the Caesars, "no castled crag of Drachenfels" encircled with its thousand years of romance, as on the German river, but to an American it is a land of enduring interest; every spot of this mountain pass, whereon man could gain a foothold, is interwoven with the history of a struggle that gave birth to a mighty empire, and, in coming ages, may we not suppose that it will be looked upon with some such feeling of veneration as with which we of the present now contemplate the pass of Thermopylae or the plains of Marathon?[9]

This type of comparison between America and Europe was not uncommon. Books and articles frequently contained passages proclaiming this country's superior landscape, feeding nationalist sentiment, and focusing on the Hudson as the best example. "Nature has wrought with a bolder hand in America," wrote N. P. Willis in his book *American Scenery.* "A fig for your Italian scenery!" Charles Lanman exclaimed, "this is the country where nature reigns supreme." William Cullen Bryant suggested that "the southern shore of the Hudson" was "as worthy of a pilgrimage across the Atlantic as the Alps themselves."[10]

West Point was the first stop on the American tour, and steamboat passengers approached it with hearts astir. Primed by histories and tales, travelers allowed their imaginations to roam through the mountain wilderness that rose up around them from the narrow, winding channel of the river. As they reached the southern gate to the Highlands, they scanned the peaks for signs of the supernatural creatures known to lurk there and listened for the rumbling spirits of the Dunderberg. Consulting their guidebooks as they neared Bear Mountain and the Popolopen gorge, tourists read about the fortuitous escape of General Clinton and how, after the capture of the forts, the Americans burned their frigates to prevent those too from falling into enemy hands. Passing Beverly Dock, the scene of Benedict Arnold's flight to the safe haven of the British ship *Vulture*, they read George Washington's despairing words: "Whom then, can I trust?" Every feature of the landscape took on new meaning, and many spots assumed almost mythical importance.

At West Point, passengers boarded a carriage that drove past the cadet encampment to the West Point hotel. From there, they set off for a walking tour of the academy's famous scenery and historic monuments. West Point did not assume its present imposing military appearance until the turn of the twentieth century. In the early 1800s it was much smaller in scale and parklike in its arrangement of monuments, parade grounds, officers' quarters, and barracks.

Kosciuszko's Monument was a popular destination for tourists, followed by a visit to the more secluded Kosciuszko's Garden. The Polish general who came to fight for American independence and planned the fortifications at West Point constructed this hidden terrace overlooking the Hudson. The American people cherished his memory, and nearly every nineteenth-century guidebook features the garden that was his sanctuary for meditation as wartime events swirled around him. Visitors sought this spot for a moment of contemplation.

The Cadet Chapel was another favorite scene for visitors. They searched among the tablets on the wall commemorating Washington's generals for the "blank"—a stone with rank and date of birth but no name—the tablet for Benedict Arnold, whose name was erased for his treachery. From the chapel, tourists continued to the adjacent

Robert W. Weir, *Sylvanus Thayer.* 1843 oil on canvas. Weir was professor of drawing at West Point during Thayer's term as superintendent.

Courtesy of the West Point Museum

cemetery. Located on bluffs above the plain, it offered an unparalleled opportunity to contemplate the valor of the nation's expired heroes amid awe-inspiring scenery.

World-famous views could also be seen from the Siege Battery that overlooked the northern gate to the Highlands, Storm King and Breakneck. James Silk Buckingham described them as "Two frowning Hills [that] overhung the stream on either side," a scene "of great grandeur and beauty," beyond which "the character of the landscape changes into a softer or more subdued style."[11] The evening parade and drills at sunset provided a fitting conclusion to a visitor's day.

The military academy at West Point might never have become a stop on the American tour without the efforts of Sylvanus Thayer, Superintendent of West Point from 1817 to 1833. Thayer's name has been immortalized in Thayer Hall, the Hotel Thayer, the Thayer Gate, and the Thayer monument. He is known as the father of West Point—the hard-nosed disciplinarian who instituted the rigorous program of study for which West Point became famous and the strict controls on cadet activity that, with some modification, continue to this day. Under his guidance, West Point emerged as a leading institution of civil engineering, training the men who built America's canals, railroads, and lighthouses.

Less known is Thayer's role in making West Point one of the most important social and cultural centers in the country—a gathering place for artists, writers, politicians, merchants, industrialists, and distinguished guests from abroad—and a focus of nature appreciation. Presumably, he intended only to put West Point on firm footing as a military school, but the effect of his program was to draw international attention to the landscape and Revolutionary War history of the Hudson River, and particularly the Highlands. Thayer was an astute politician and understood the connection between public opinion and appropriations from Congress. He had many ways of cultivating support, and one was to capitalize on the growing interest in the scenery and history of the Hudson.

In expanding the facilities at the academy, building a hotel was one of the most important things Thayer did. The effect on the Highlands of this simple act was profound. The area changed from mere scenery to ride through into a popular destination with a place to stay. The hotel had little to do with training for warfare but a great deal to do with developing a constituency, as it allowed day-boat passengers to spend more time at the academy and become acquainted with its many monuments, its scenery, and, incidentally, its academic program.

Developing the academy as a first-class school produced public relations benefits as well, because it attracted an elite corps of cadets and drew the affection and interest of their families. Thayer hired a distinguished faculty and revived the Board of Visitors, an independent review team established to report to the War Department on conditions at West Point. By appointing prestigious members to the board (such as New York's Governor DeWitt Clinton and Connecticut's Governor Oliver Wolcott), he assured frequent visits by powerful men. The presence of these influential people lured prominent guests as well as tourists. Authors Mark Twain, James Fenimore Cooper, and Charles Dickens; opera singer Jenny Lind; painter Frederic Church; ballerina Fanny Elssler; Emperor Dom Pedro of Brazil; and Lord Napier and the Grand Duke of Russia are among the many names recorded in the hotel's guest register. Because many of the cadets were deemed to be especially eligible bachelors, West Point also became a very popular place for upper-class tourists to bring their daughters.

Thayer succeeded in building support for his academy while also promoting the historic and scenic values of the grounds and the region. Through the diaries of visitors, the columns of journalists, and the travel accounts of authors and writers, the beauty and history of the Highlands reached a public who had never ventured there in person.

The superintendent, the officers, and the professors saw to it that guests were well entertained. In her 1842 article for readers of *Graham's Magazine*, Eliza Leslie describes the activities arranged for the pleasure of visitors. Music, dancing, sumptuous dining, and daily enjoyment of the romantic scenery of the Highlands were standard fare, punctuated by events such as concerts by distinguished singers, Thursday-night reading parties, and weekly chess games. The social season opened on July fourth and continued through August, while the cadets were in their summer encampment. The annual cadet ball was the gala event of the season, but for most of the summer, guests spent their days and evenings enjoying the scenery.

Miss Leslie wrote that the band was frequently enlisted for special moonlight serenades. A favorite performance on summer evenings was the "Nightingale," a composition played under stately elms from whose branches a flute soloist imitated the warbling of birds. She describes another occasion when the "gentlemen attached to the military academy had made arrangements for taking the ladies on a moonlight voyage through the Highlands." Seven boats ferried the professors, officers, and ladies, with soldiers at the oars. An eighth boat carried the band. "In the course of our little voyage," she writes, "several steamboats passed us: and all of them slackened their steam a while, for the purpose of remaining longer in our vicinity that the passengers might enjoy the music. One of these boats, in stopping to hear us, lay directly on the broad line of moonlight that was dancing and glittering on the water, the red glare of her lanterns strangely mingling with the golden radiance beneath. Our band was just then playing the Hunter's Chorus." The group rowed north as far as Storm King and then "the men resting on their oars, we floated down with the tide nearly as far as the Dunderberg, and never did this picturesque and romantic region look more lovely."[12]

The most prominent guests were entertained at the Superintendent's Quarters, and on Saturday evenings they rowed across the river to the weekly open house of the rich and hospitable industrialist, Gouverneur Kemble. It has been said that the Superintendent's Quarters has welcomed more distinguished visitors than any other home in the United States except the White House.

On tours of the grounds, guests enjoyed the sights and sounds of cadet training. The Irish airs and drill music of the band, the explosions of cannon, the daily maneuvers of brightly uniformed soldiers against a backdrop of white tent rows, and the sunset parades—all provided excellent atmosphere for viewing historic monuments and spectacular landscapes.

Being part of the stage set did not prevent the cadets from enjoying the Hudson Valley themselves. Their letters described rambles through the woods that offered welcome respite from the regimented life on the post. On August 21, 1829, cadet Jacob Bailey wrote in a letter to his brother, "There is scarcely a place near the Point which I have not visited, from the highest point of the Crow's Nest, to the muddiest marsh on the shores of the Hudson."[13] About a week later, he wrote, "I went up to Crow's Nest last Saturday and found a party of 10 or a dozen Cadets already on top. When they started to come down, I appointed myself pilot and for my own amusement led them home by one of the most frightful ways which I knew, there is in reality not much danger in the path I chose, but it would make one not used to climbing feel somewhat queer. I pretended to lose my way and led them to the brink of a precipice some hundred feet high."

Many cadets carried images of the Hudson with them long after they left. Scholars have speculated that Edgar Allan Poe, in his story "Domain of Arnheim," was describing scenery he had enjoyed during his brief career as a West Point cadet:

> The usual approach to Arnheim was by the river. The visitor left the city in the early morning. During the afternoon he passed between shores of a tranquil and domestic beauty, on which grazed innumerable sheep, their white fleeces spotting the vivid green of rolling meadows. By degrees the idea of cultivation subsided into that of merely pastoral care. This slowly became merged in a sense of retirement—this again a consciousness of solitude. As the evening approached, the channel grew more narrow; the banks more and more precipitous; and these later were clothed in richer, more profuse, and more somber foliage. The water increased in transparency. The stream took a thousand turns, so that at no moment could its gleaming surface be seen for a greater distance than a furlong. At every instant the vessel seemed imprisoned within an enchanted circle, having insuperable and impenetrable walls of foliage, a roof of ultra-marine satin, and *no* floor.... The channel now became a *gorge*.... The crystal water welled up against the clean granite, or the unblemished moss, with a sharpness of outline that delighted while it bewildered the eye.[14]

While Superintendent Thayer is credited with developing the code of cadet life and the program of study that made West Point famous, Superintendent Major Richard Delafield did the most to change the post's physical appearance. When he assumed control, in 1838, the academy was expanding—and Congress provided a substantial budget for constructing new buildings. Delafield selected the Gothic-influenced English Tudor style of architecture, establishing the military motif, and designed several of the structures himself.

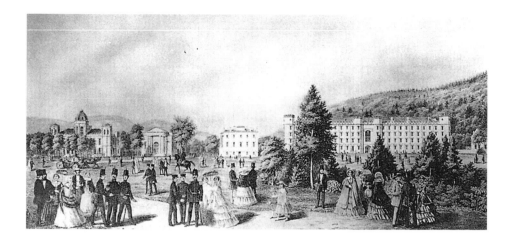

The Gothic style at West Point enhanced the region's romantic image. English Tudor developed from its military function in medieval England, when warring barons built fortlike homes. Battlements, corner towers, moats, and narrow windows contributed to a structure's defensive strength. They later evolved into more decorative characteristics that flourished during the reigns of the Tudor monarchs. In the first building Delafield designed, the library, the military character of West Point is emphasized in the use of castellated towers and battlements. The native stone helps the building blend with its surroundings. The First Division of the Central Barracks, featuring battlements, drip stones, and Gothic moldings, and the dean's quarters, a cottage with high gabled roofs, dormers, and barge boards, are two remaining examples of the Delafield era.[15]

If anything, West Point's Tudor architecture led to further comparisons between the Hudson Highlands and the Rhine Valley's "castled crags," However, no imitation of medieval European fortresses could compete with West Point's authentic ruin,

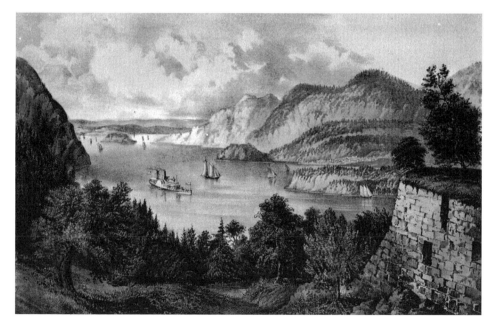

(top) L. Behrens and Fritz Meyer, *View of West Point, United States Military Academy.* 1857 engraving.
Courtesy of USMA West Point

(bottom) Currier and Ives, *View from Fort Putnam.* To the north is the northern gate to the Highlands, with Crow's Nest and Storm King on the west shore and Breakneck on the east shore. Newburgh Bay is visible in the distance.
Library of Congress

Fort Putnam. That citadel, perched on the highest point of the academy grounds and offering the most spectacular views, was the favorite of visitors. Although no battles were ever fought there, it became a symbol of the revolution and a classic outpost for viewing the Highlands gorge as part of the first stop on the American tour.

Leaving the Highlands, visitors with social connections might also be invited to visit the country estates of families in Fishkill or Hyde Park, or to stay at the manor house of the Livingstons at Clermont. The rest of the tourists continued north for fifty miles or so until the Catskill Mountains loomed large on the western shore.

The steamboat stopped at the village of Catskill, where tourists got off to board horse-drawn carriages for the twelve-mile journey to the renowned scenic overlook occupied by the Catskill Mountain House—a solitary and magnificent Greek Revival resort hotel, set high on a cliff in the midst of the wilderness. The trip up to the mountain house was difficult. The steep, rugged dirt road exhausted horses and travelers alike. On arrival at the hotel, guests refreshed themselves with tea, enjoyed a fine meal, and went to bed early so they could be fresh for the legendary sunrise, which revealed an ever-changing panorama from 5 a.m. until noon, in which the Hudson River would gradually become visible through fog and mist.

Facing east, the mountain house perched on the edge of a precipice that plunged 1,400 feet to the valley below, revealing a sweeping panorama of cultivated fields, woodlots, church spires, and villages. The Hudson River appeared as a distant ribbon of silver far below. Thousands of people made a special trip to see this vista at dawn. James Silk Buckingham described a typical experience:

> Our dwelling was like an aerial mansion suspended among the clouds. . . . On the morning of Monday the 18th of June, we were all stirring at daylight, in order to enjoy the prospect of the rising sun. On looking out of the windows, the scene that presented itself was most remarkable, and totally different from any thing I had ever before witnessed. The sky above us was bright clear blue. . . . But of the earth beneath us, nothing was to be seen except . . . a thick sea of perfectly white billows. . . . The in-

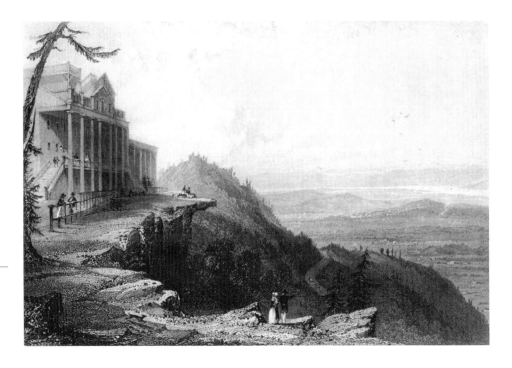

William Bartlett, *View from the Mountain House, Catskill*. The Hudson appears far below, a silver ribbon through the valley. In N. P. Willis, *American Scenery*, 1840.
Author's collection

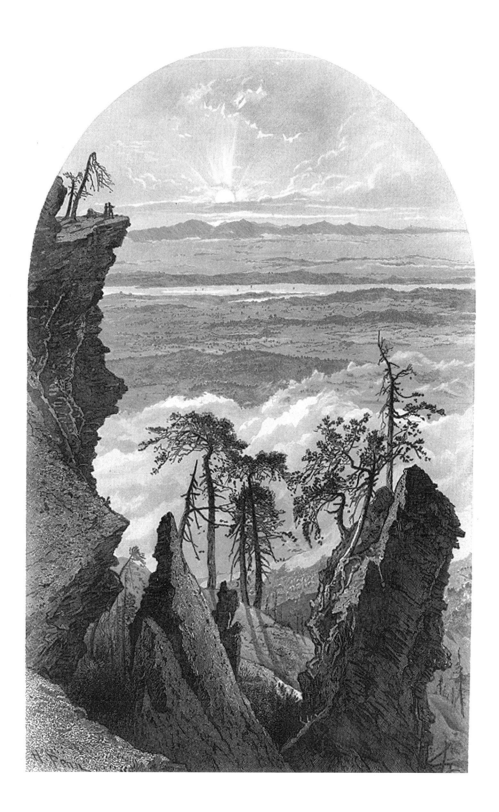

creasing light of the eastern horizon, betokened the near approach of the sun.... At ten o'clock the mist had so cleared away over the Hudson, that its stream became visible, but no portion of the green banks of the river could be seen on either side, so that it was like a mighty stream winding its way through a bed of clouds....

By noon, the whole of the clouds below us were dissipated, and the full glory of the meridian sun beamed down upon one of the most extensive and beautiful landscapes that could well be conceived. Behind us, to the westward, rose the peaks of

Harry Fenn, *The Catskills, Sunrise from South Mountain*. From Bryant, *Picturesque America*.

mountains. . . . To the east, however, the prospect was boundless . . . beneath our feet, commenced the cultivated plain, covered with cleared land, in farms of different sizes and in different degrees of cultivation. In the centre of the valley . . . flowed down the noble river . . . its surface was studded with at least a hundred sails, as white as the fresh-fallen snow, floating on its glassy bosom like so many buoyant pearls.

Altogether, the prospect was enchanting, and worth going a hundred miles to see.[16]

At the Catskill Mountain House, visitors could enjoy many other scenic views, as well as wonderful food and entertainment. The hotel served "turtle soup, ice cream, Charlotte Russe and other fashionable dainties." Activities included bowling, fishing, and boating. There were tea dances, formal balls, songfests, skits, and billiards to keep people entertained, but the foremost activity was exploring the scenery within a four-mile radius. For many, this required a stay of many days or even weeks.[17]

Hikes started at the mountain house and proceeded from one scenic spot to another, each known by a picturesque name such as Inspiration Point, Sunset Rock, Druid Rocks, Lemon Squeezer, Fairy Spring, Elfin Pass, Eagle Rock, or Lover's Retreat. Some destinations were intimate woodland glades. Other spots offered a view of the river or the mountains. Prospect Rock was about an hour's walk from the hotel and looked east over the village of Catskill, twelve miles away, and the Hudson beyond. From there, one could climb Jacob's Ladder to crevasses and caves such as the Bear's Den, where one could see the two lakes behind the mountain house and the Catskills and the Hudson in the distance. After the Civil War, carriage roads were built to make it possible to enjoy some of the favorite scenes without the effort of climbing or walking.

One of the most popular destinations for hotel guests was Kaaterskill Falls. Taller than Niagara Falls, it drops 260 feet in a secluded mountain ravine. About halfway down, a ledge juts out and guides the waterfall off to the side before it again tumbles over rocky steps to the stream below. The view of the falls complemented the view of the Hudson River sunrise. Just a short distance from the hotel, the glen and its falls provided a different experience of nature, more intimate but equally awe-inspiring. Hikers climbed down ladders and wooden staircases to reach a narrow shelf of rock that took them behind the falls into a kind of arched rock amphitheater about 100 feet high, with the water of the Kaaterskill Creek cascading over it. They would later emerge and climb down to the bottom for a view of the entire falls, which now dwarfed them from above.

At the top of the falls was a café, where a variety of refreshments—brandy punch, sparkling lemonade, and ice cream—were offered to help the visitor prepare for the physical exertions ahead. In the spirit of making a natural wonder even better, the owner eventually built a dam above the falls, and for 25 cents, he would release the pent-up waters so the cascade could be seen at its best for about a half hour. When visitors reached the bottom of the falls, they would give a signal, and he would open the flood gates and then lower bottles of French champagne over the falls for them to enjoy on the "mossy couch."[18]

Waterfalls punctuated many stops on the American tour. In the days before motion pictures, riding on a Hudson River steamboat was like seeing a movie, and getting off to visit a waterfall or climb a mountaintop added the excitement of a thriller. Leaving the Catskill Mountain House, many travelers went on by steamboat to Al-

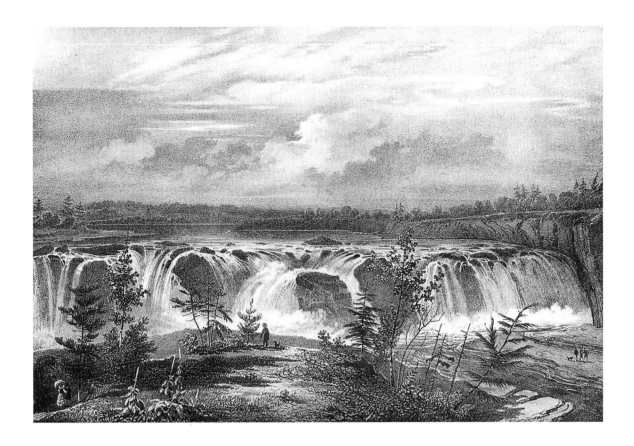

bany or Troy, where fine hotels awaited them, then took a carriage to Cohoes for the spiritual experience of hearing the roar of the huge cascade. This was a far different scene from the mountain streams they had just visited. The foaming Mohawk River poured over a 70-foot-high ledge to join the Hudson just below. Here, people experienced the transcendent aspects of nature—many writers noted that they heard the voice of the creator in the thundering of the falls. The Hudson River also changed its appearance. No longer so broad, it seemed more tranquil and less grand. Its still waters invited reflection. A visit to Cohoes also introduced the traveler to the engineering wonders of the Erie Canal and marked the beginning of the next leg of the journey, on a canal boat through the rural Mohawk Valley, considered one of the most picturesque areas in America.

Caroline Gilman described such sentiments on the final day of her tour of the Hudson before departing on the Erie Canal for points west:

> We arrived at the Troy House, wearied enough, at the close of this burning day. . . . Among the first pleasures was a visit to the Cohoes Falls. The romantic interest of the access is somewhat diminished by the utilitarians who have gathered about it; but when standing in front of the cataract, nothing is visible but the wildness of nature, harmonizing well with its ceaseless voice and ceaseless flow; and . . . the thought of Deity, which a waterfall almost necessarily awakens in a reflecting mind, comes over one in solemn reverie.
>
> I have never seen canal navigation before, and here the very majesty of canal-ism dwells, wielding his lazy sceptre over the Erie and Champlain channels . . . the slow canal boats . . . peep up from the banks like tortoises; while small boats—for no craft

Falls of the Cohoes of the River Mohawk.
From J. G. Milbert, *Picturesque Itinerary of the United States*, Paris, 1828.
Courtesy of New York Public Library

STATE PRISONERS.

of importance can navigate here—glide over the diminished Hudson, seen among the emerald islands that diversify its tranquil stream.

Nothing could exceed the beauty of our drive from the Falls. A sudden shower had dressed nature in a fresher robe of green and diamonds; a sunset rainbow formed a glorious arch over the villages of Lansingburgh [Troy] and Waterford, relieved by the sweep of hills beyond; while the sun gave a yellow tinge to the fields, sparkled on the river, and even lit up the canal with its parting glory.[19]

The American Tour was not just a trip to see scenery. Typically tourists also visited the cities of America, including Boston, Philadelphia, New York, Albany, and Troy, where they would ask to see a variety of institutions, including prisons, schools, asylums for the poor, the blind, and the mentally ill, and a variety of houses of worship—Quaker, Shaker, Unitarian, and Jewish—all to be found on the shores of the Hudson, if not close by. They were curious about everything. What was America really like? What did its form of government, its religious diversity, its social experiments foretell? How did its landscape offer clues about its people?

The experiences of Caroline Gilman and Charles Dickens were typical. In New York City, Gilman was given a tour of Bellevue Hospital, the Academy of Design, and the New York Lunatic Asylum. At the end of that visit, she climbed the cupola to catch her first exciting glimpse of the Hudson. Dickens visited courts of law, the customs house, an asylum for the blind, factories, the stock exchange, the almshouse, and the slums at Five Points—a place of appallingly wretched conditions. Similarly, in 1824, the French General Lafayette, who had fought for America in the revolution, visited Emma Willard's Troy Female Seminary on his triumphant return visit to the Hudson River Valley.

Travelers often commented on the contradictions of what they saw. While Dickens condemned the poverty of the slums, he praised some of America's prisons, including one on the shores of the Hudson at Ossining, where talking was not allowed. "The prison for the State at Sing Sing is, on the other hand, a model gaol [jail]. That, and Auburn, are, I believe, the largest and best examples of the silent system," he wrote in *American Notes*.[20] Harriet Martineau devoted two chapters of her book, *Retrospect of Western Travel* (1838), to the conditions of slaves and American attitudes toward slavery.

Sing Sing prison visit, from an 1866 guidebook.

Lossing, The Hudson from the Wilderness to the Sea, *1866*

Yet overall, their experiences were positive, and they returned home with fond memories. As Harriet Martineau said, "However widely European travellers have differed about other things in America, all seem to agree in their love of the Hudson. The pens of all tourists dwell on its scenery, and their affections linger about it like the magic light which seems to have this river in their particular charge."[21]

Fanny Kemble, the British actress, was particularly moved by the enchantments of the Hudson. The view from Fort Putnam on the rocky summit above West Point caused her to weep with ecstasy. Yet, she felt that many New Yorkers she met, caught up in their commercial dealings, seemed to take such scenes for granted. With frustration, she noted in her diary:

> Where are the poets of this land! Why such a world should bring forth men with minds and souls larger and stronger than any that ever dwelt in mortal flesh. Where are the poets of this land? . . . Have these glorious scenes poured no inspiration into hearts worthy to behold and praise their beauty? Is there none to come here and worship among these hills and waters till his heart burns within him, and the hymn of inspiration flows from his lips, and rises to the sky? . . . Yet 'tis strange how marvellously unpoetical these people are! How swallowed up in life and its daily realities, wants and cares; how full of toil and thrift, any money-getting labour. Even the heathen Dutch, among us the very antipodes of all poetry, have found names such as the Donder Berg for the hills, whilst the Americans christen them Butter Hill, the Crow's Nest, and *such like*. Perhaps some hundred years hence, . . . America will have poets.[22]

In fact, by 1832, the time of Kemble's visit, poets and painters were beginning to be recognized, and they took as their subject matter the very ground on which she stood. Nationalism and interest in scenery had combined to produce new art forms for which America and the Hudson would soon be famous, and the spiritual value of nature would be the aspect they most celebrated.

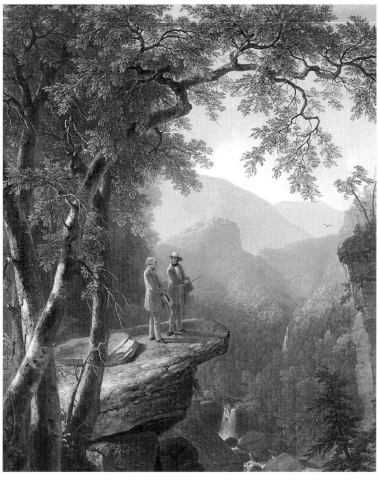

America's First Artists and Writers

*The Sacred River of Thomas Cole, the Mythic River
of Washington Irving and James Fenimore Cooper*

5

I N THE AUTUMN of 1825, while Sylvanus Thayer was still in charge at West Point, a young man named Thomas Cole visited the military post. An English-born itinerant artist, he had scraped together a living painting portraits and designing wallpaper to support his real passion: landscape painting. He had recently moved to New York City, and the scenery of the Hudson Valley captured his imagination. As a friend later wrote, "from the moment when his eye first caught the rural beauties clustering around the cliffs of Weehawken, and glanced up the distance of the Palisades, Cole's heart had been wandering in the Highlands, and nestling in the bosom of the Catskills."[1] At the first opportunity, twenty-four-year-old Cole embarked on a sketching trip up the Hudson Valley.

On reaching the Highlands, Cole rambled through the ravines and forested hills above West Point. In all likelihood, he carried with him his writing and sketching pads and his flute, pausing here and there to play a few notes as he sought to capture

Asher B. Durand, *Kindred Spirits*. 1849 oil on canvas, showing nature poet William Cullen Bryant and Hudson River School artist Thomas Cole in a setting in the Catskill Mountains, commissioned by art patron Jonathan Sturges upon the death of Thomas Cole.

Courtesy of Crystal Bridges Museum of American Art

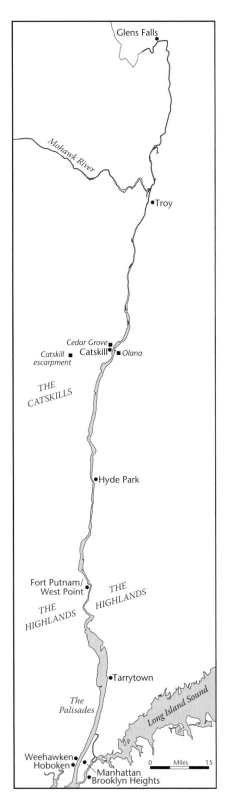

the mood of the place he intended to paint. Climbing to the highest vantage point, he probably pulled out pen and paper, as was his habit, to record his observations. "Mists were resting on the vale of the Hudson like drifted snow," he once wrote of a river scene. "The sun rose from bars of pearly hue. . . . The mist below the mountain began first to be lighted up, and the trees on the tops of the lower hill cast their shadows over the misty surface—innumerable streaks." He would refer to such notes later, when he returned to his studio to paint.

Cole found the ruins of Fort Putnam particularly interesting. Crumbling and overgrown with vines after forty years of neglect, the fort brooded over a panorama of spectacular beauty—bold and rugged mountains, the dark river far below, and to the north, in the distance, a broad bay and prosperous farm country. From this granite promontory, rich with history, Cole, like many other early nineteenth-century West Point visitors, must have felt close to God and country.

From West Point, Cole continued his journey upriver to the Catskills, where he traveled to Kaaterskill Falls and other nearby wilderness spots. Later, when he returned to his cramped apartment on Greenwich Street, he painted the scenes that had impressed him on his trip—dramatic portraits of wild scenery. The river focused the sense of divine presence Cole felt in nature. It awoke in him a deeper feeling, a sense of the harmony of creation. In the rural beauty of the Hudson Valley he found a fountain "where all may drink," and he was able to convey this in his art.[2]

A New York City frame maker put three of the canvases on display in his shop window. One of New York's leading artists, John Trumbull, was passing by, spied Cole's work, and admired it. Trumbull bought one of the paintings, *The Falls of the Caterskill*, which he hung in his own studio. The same day, he invited his friends, fellow artists William Dunlap and Asher Durand, to come see Cole's paintings and make the acquaintance of the artist, whom Trumbull had invited as well.

The encounter was embarrassing for Cole, "a slight young man whose eyes shone with a combination of eloquent brightness and feminine mildness." He was tongue-tied and nervous. He didn't know what to say when Trumbull exclaimed, "You surprise one, at your age, to paint like this. You have done what I, with all my years and experience, am yet unable to do."

Despite his reticence, Cole was pleased with the results of the encounter. Durand immediately purchased a painting of Fort Putnam, and Dunlap purchased the third canvas, titled *Lake with Dead Trees*. They paid $25 each. Dunlap soon sold his to Mayor Philip Hone, one of the city's most important collectors and a patron of the arts, who offered him $50 for it. Dunlap later wrote: "My necessities prevented me from giving the profit, as I ought to have done, to the painter. One thing I did, which was my duty. I published in the journals of the day an account of the young artist and his pictures; it was no puff but an honest declaration of my opinion, and I believe it served merit by attracting attention to it."

With such important backing, Cole's life and fortunes were transformed almost overnight. "His fame spread like fire," said Durand. Cole's solitary venture into the Hudson Valley wilderness and the discovery of his work launched a celebration of nature in art that became known as the Hudson River School of painting. Following Cole's lead, scores of artists would make pilgrimages in search of spectacular scen-

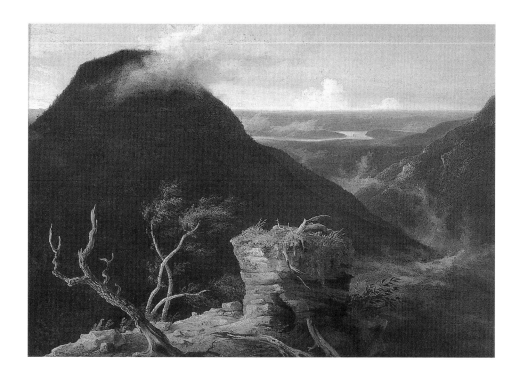

ery to paint. Like him, they found inspiration in the varied aspects of the Hudson: the sheer cliffs of the Palisades; the Highlands' crumbling ruins, rugged mountains, and dark river; the combination of distant vistas and intimate woodland scenes in the Catskills; the pastoral views of Albany; and the rushing waterfalls of the upper Hudson.

Thomas Cole presented nature in its raw beauty, full of the unexpected, the dramatic, and the intimate. He captured its mood and a sense of its mystery. On his canvases, streaks of ethereal light broke through luminous clouds, signifying divine creation, while twisted trees with gnarled roots seemed to hold the ancient secrets of the primeval forest in their grasp.

His work was new and fresh. Most painting at the time portrayed the families of wealthy patrons (who commissioned the portraits as proof of their status and distinction) or depicted historical events—such as the four famous Revolutionary War scenes Trumbull painted for the U.S. Capitol's rotunda. Landscapes appeared primarily as engraved illustrations in travel books or on military maps, or as the pleasant background of a portrait to convey a sense of property and wealth. They were functional works, not intended to stand alone as art.

Cole's painting struck a responsive chord in his viewers, and Durand soon emulated it. Others who joined the roster of Hudson River School artists included John Frederick Kensett, Sanford Gifford, Thomas Doughty, George Inness, Jervis McEntee, David Johnson, John Casilear, Thomas Rossiter, Jasper Cropsey, Robert Havell Jr., Robert Weir (professor of drawing at West Point), and Frederic E. Church (a student of Cole's). There were dozens of other less-known painters. Among them were several women, now being rediscovered—such as Julie Beers, Eliza Greatorex, and Laura Woodward—who exhibited at the prestigious National Academy of Design and the Brooklyn Art Association.[3] The term "Hudson River School" was first coined in a contemptuous article in the *New York Herald* meant to ridicule these landscape

Thomas Cole, *View of the Round-top in the Catskill Mountains.* Circa 1827. In this painting of the Hudson from the Catskills, the river is shown as a distant gleam of silver. Depicting such a big river dwarfed in the landscape added to the sense of awe that romantics called "sublime."

Courtesy of the Museum of Fine Arts, Boston. Gift of Martha C. Karolik for the M. and M. Karolik Collection of American Paintings, 1815–1865, photograph © 2005 Museum of Fine Arts, Boston

paintings.[4] However, these works attracted international attention and acclaim for the next fifty years.

The Hudson River School artists were united more by their reverence for nature and their desire to portray its spiritual and moral value than by a common style. A landscape painting "will be great in proportion as it declares the glory of God, by a representation of his works," declared Asher Durand.[5] Most, though not all, chose the Hudson River as a primary subject, and they portrayed it as a sacred landscape. Though they broke with artistic tradition, they were perfectly in tune with current notions of romanticism expressed in the writings of Rousseau in France and Sir Walter Scott in Britain. In their view, nature was God's finest work, and viewing scenery was a religious experience. By 1825, such ideas were beginning to take hold in America.

On the Hudson, nineteenth-century romantics found a landscape that moved them like a sermon. In 1832, Fanny Kemble, the British actress, expressed such feelings in her diary as she recounted her experience hiking up to the ruins at Fort Putnam above West Point—a place painted by Cole and many other Hudson River School artists—and looking down on the river below:

Saturday, November 10, 1832. . . .

Alone, alone, I was alone and happy, and went on my way rejoicing, climbing and climbing still, till the green mound of thick turf, and ruined rampart of the fort arrested my progress. I coasted the broken wall, and lighting down on a broad, smooth table of granite fringed with young cedar bushes, I looked down, and for a moment my breath seemed to stop, the pulsation of my heart to cease—I was filled with awe. The beauty and wild sublimity of what I beheld seemed almost to crush my faculties—I felt dizzy as though my senses were drowning—I felt as though I had been carried into the immediate presence of God. Though I were to live a thousand years,

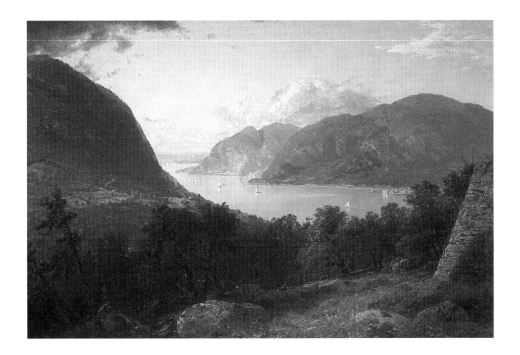

I never can forget it. The first thing that I distinctly saw was the shadow of a huge mountain, frowning over the height where I stood. The shadow moved down its steep sunny side, threw a deep blackness over the sparkling river, and then passed off and climbed the opposite mountain on the other shore, leaving the world in the full blaze of noon. I could have stretched out my arms and shouted aloud—I could have fallen on my knees and worshipped—I could have committed any extravagance that ecstacy could suggest. I stood filled with amazement and delight, till the footsteps and voices of my companions roused me. I darted away, unwilling to be interrupted.[6]

Two of the most important concepts of romanticism were the "sublime" and the "picturesque," words used frequently to describe and sanctify natural scenery. While people in the age of Enlightenment defined beauty as that which is logical and harmonious, the romantics valued the unpredictable. Wild aspects of nature that showed God's power—thunderstorms, rushing waterfalls, dense and tangled vegetation, plunging cliffs, and cosmic sky—caused them to take a deep breath and declare it "sublime." The tamer pastoral landscape, with scenes of cows and fields along a sail-dotted river, gave them sentimental pleasure. Noting the irregular forms, textures, or details of the scene, they would exclaim, "How picturesque!" Such scenes of human endeavor complemented God's handiwork.[7]

The qualities that the painters sought to capture on canvas could be readily found in the Hudson River Valley. Popular places to illustrate the "picturesque" included the harbor and surroundings of Brooklyn Heights, Staten Island, Hoboken, Weehawken, and, farther north, the view from river estate Hyde Park. These paintings often feature a broad expanse of water, with the setting sun casting shadows on a forest of masts or pastoral fields and distant mountains.

Paintings of sublime landscapes, in contrast, are more rugged and wild. The Highlands, particularly, conformed to the romantic ideal of the sublime landscape, with craggy precipices, wind-swept trees, and the river following a twisting, tortured

John Frederick Kensett, *Hudson River Scene.* 1857, oil on canvas. 32 x 48 inches.
Courtesy of the Metropolitan Museum of Art, New York, Gift of Mr. H. D. Babcock, in memory of S. D. Babcock, 1907 (07.162). Photograph © 1984 The Metropolitan Museum of Art.

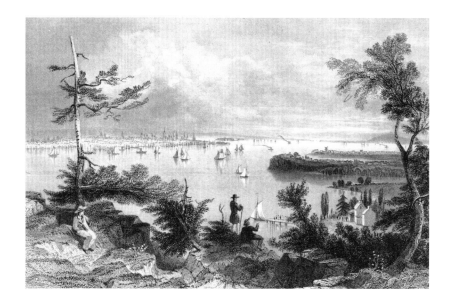

course through the gorge below moldering Revolutionary War forts. Paintings of the Catskills tended to show a remote wilderness of rocky ledges, cascading waterfalls, and dark, forested mountains with no evidence of mankind. Paintings of the Adirondacks revealed a Hudson that most Americans had never seen: in place of a broad estuarial panorama was a rippling trout stream surrounded by forest, with wild animals inhabiting its shores.

In all of the Hudson River School paintings, both sublime and picturesque, nature's grandeur was suggested by the extension of mountains, clouds, and rivers beyond the observer's vision. In the foreground, the artist might place small figures—their backs turned, leading the viewer to face the scene with them and share their sensation of vastness. For those who liked to think of America as a budding empire—a common concept at the time—such a scene cemented the image of the Hudson as an imperial river, a setting that spoke of American destiny.

(top) William Bartlett, *View of New York from Weehawken*. In N. P. Willis, *American Scenery*, 1840.
Author's collection

(bottom) View from Hyde Park, the country estate of Dr. David Hosack, some 80 miles north of Manhattan. With its extensive lawn sloping down to the river and the profile of the Catskills rising in the distance, the estate embodies the picturesque. In N. P. Willis, *American Scenery*, 1840.
Author's collection

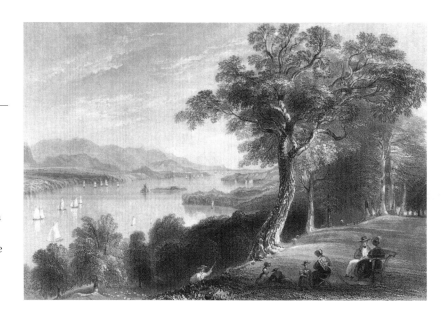

TENANTS OF THE UPPER HUDSON FORESTS.

Artists of the Hudson River School ventured deep into nature. They studied the play of light and shadow in the woods and over water and observed cloud formations. They carefully examined leaves, bark, and rocks in pencil sketches. Many adopted a rustic lifestyle, roughing it in the countryside and going to great lengths to find the right spot for their easels. They also searched for scenes that looked like paintings—that could portray the romantic ideals. If a scene in nature did not quite fit the formula, the artists sometimes interpreted. For example, the painter might add a northward-setting sun and celestial rays of light to illuminate the setting and imply a heavenly presence. The position of a mountain might be moved so the view of the river behind it could be seen.

Painters roamed far and wide in search of awesome wilderness, and the Hudson led them to other subject matter: the Catskills, Lake George, the Connecticut Valley,

(top) Lossing, *The Hudson from the Wilderness to the Sea*, 1866

(bottom) Thomas Cole's studio at Cedar Grove, owned by the Cole family until 1965. It has been restored to its condition when Cole lived there in the 1830s and 1840s. Among the exhibits are his paint box and portable easel, as well as some oil sketches.
Courtesy of the Thomas Cole National Historic Site, Catskill, New York

Frederic Edwin Church, *The Hudson Valley in Winter from Olana*. 1871, oil on canvas, the view from his studio in Greenport, New York.
Courtesy of Olana State Historic Site. NYS Office of Parks, Recreation and Historic Preservation

the White Mountains of New Hampshire, and Niagara Falls. One of Frederic Church's most famous paintings is of the Andes in Peru. Yet in the Hudson Valley, where the long ribbon of river links the harbor, the Palisades, the Highlands, the Catskills, and the Adirondack high peaks, artists found some of the most dramatic and varied scenery in eastern America. More than 500 oil paintings of the Hudson from this period have been preserved, including works by almost all major artists. Hundreds more are documented from nineteenth-century exhibitions, but have since been lost.[8] Thomas Cole always returned to the river, his friend Louis Noble said, "with the tenderness of a first-love."[9]

In the mid-nineteenth century, residing and painting in the Hudson Valley was considered essential to art education in much the same way as living and working in Paris was the ideal for the next generation of artists. Many of the Hudson River School painters established themselves in estates and studios on the shores of the river they loved, making a statement of affinity in their choice of location. Thomas Rossiter built a palatial mansion in Cold Spring, and Thomas Cole set up a modest studio in Catskill. Asher Durand painted from New Windsor, overlooking the High-

lands, and Albert Bierstadt had a great mansion on the river near Tarrytown. Robert Weir painted from the military academy at West Point. Jasper Cropsey fell on hard times and had to sell his country estate, but still managed to have a modest studio, Ever Rest, in Hastings-on-Hudson, which looked out over a highly industrial waterfront, the river, and the Palisades. By far the most elaborate studio was Frederic Church's Moorish castle Olana—itself a work of art, located high on a hill above the river near the city of Hudson, with a sweeping view of the Catskills. Several of these studios remain, and Cole's and Church's are now preserved as historic sites.

The painters' work struck a chord with hundreds of thousands of Americans, whose enthusiasm helped the artists pay their way. Exhibits at the New York Art Union between 1839 and 1851 drew as many as 250,000 people per year at a time when the population of New York was not even double that number. The visitors included "noisy boys and girls" and "working men by the hundreds," according to *Knickerbocker Magazine* in 1848.[10]

The achievements and world acclaim of the Hudson River School would not have been possible without the support of a growing merchant class. The opening of the Erie Canal, in 1825, brought great prosperity to New York City, and it became fashionable for businessmen to display their wealth through patronage of American artists. They not only maintained impressive art collections but also commissioned major works of Hudson River scenes and sent artists abroad to study. Jonathan Sturges, a New York merchant, financed Durand's 1840 trip to Europe, where he joined Kensett, Casilear, and Rossiter in copying old masters and painting Swiss and Italian landscapes. Cole had several important backers, among them Mayor Philip Hone and Luman Reed, a wholesale grocer and business partner of Sturges. Thomas Gilmor of Baltimore loaned Cole $300 in 1829 so he could travel abroad. James Pinchot, the owner of a wallpaper firm, befriended and patronized Sanford Gifford, Jervis McEntee, and Eastman Johnson.

The Hudson River painters were also aided by the "Knickerbocker" writers, so-called after Washington Irving's fictional *Knickerbocker's New York: A History of New York from the Beginning of the World to the End of the Dutch Dynasty by Diedrich Knickerbocker* (1809).[11] Almost two decades before Cole's historic sketching trip, Irving had made the American landscape a fashionable topic in literature, and other authors soon followed his lead, becoming the first Americans to make their living solely by writing. By 1825, when Cole took his historic sketching trip up the Hudson, the Knickerbockers had already published major works that popularized nature in America. Influenced by the same romantic concepts, they prepared the way for the painters' break with artistic tradition.

The Knickerbockers began to be published in the same year that Fulton and Livingston's steamboat *Clermont* was launched, 1807. Steamboat travel stimulated great national and international interest in the region, and the river appeared frequently as a subject and setting in the Knickerbockers' work. These writers created a body of legend, poetry, caricature, and supernatural lore about American scenery and landscape that helped to enhance the Hudson Valley's romantic image. Works such as the poem "The Culprit Fay"—a fairy spirit of the Highlands—soon appeared in steamboat guidebooks, helping to give the region definition and character.

Technically, the term "Knickerbocker" could apply to any author working out of New York City in the early nineteenth century. Washington Irving, James Fenimore

Cooper, and William Cullen Bryant were the brightest lights. However, the "Knickerbocracy" included some twenty lesser luminaries, such as Nathaniel Parker Willis, Fitz-Greene Halleck, Joseph Rodman Drake, James Kirke Paulding, and Washington Irving's brother William—writers who were popular in their day but whose reputations have faded with time. The reputation of America's literary romanticists only began to wane in the 1850s, as writers like Ralph Waldo Emerson, Herman Melville, Harriet Beecher Stowe, Walt Whitman, and Nathaniel Hawthorne emerged with new and different styles.

During these forty years, however, the Knickerbockers became as famous in the world of letters as the Hudson River School painters were in the world of art. Their numbers and prestige, the literary magazines they produced—such as the *New York Mirror* and the *Knickerbocker*—and the publishing businesses they fostered wrested cultural preeminence from Boston and Philadelphia, establishing New York as the literary capital of America. Between 1820 and 1852, 345 publishers operated out of New York City, more than twice as many as in Philadelphia. Influential people like DeWitt Clinton fostered the cultural life of the city as well, creating institutions such as the American Academy of Fine Arts and the Literary and Philosophical Society.

The works of individual Knickerbockers used literary forms as diverse as epic poetry, satires, and historical novels. Some were serious, some sentimental, and others downright funny. In addition to their romantic vision, these writings shared a nationalistic temperament—giving shape to the American character and helping to define an American identity. Born in the infancy of the nation's independence, these authors were stirred by tales of the Dutch explorers and Revolutionary War generals. Many used the history, landscape, and folklore of the Hudson River as their subject matter, making the rugged primitiveness of American life interesting and acceptable, even a selling point. The people and the landscape became as one, and the Hudson River became symbolic of American life.

Washington Irving was one of the acknowledged leaders in the movement, and he was the first to give river scenes a new kind of meaning. He wrote in the introduction to *Knickerbocker's New York* that he sought to "clothe home scenes and places . . . with those imaginative and whimsical associations so seldom met with in our new country, but which live like charms and spells about the cities of the old world, binding the heart of the native inhabitant to his home."[12] He left few spots untouched in this and future books. Irving reinvented practical Dutch place names with humorous retellings of local tales and populated places like the Highlands, the Catskills, the farm country, and the Tappan Zee with goblins and ghosts. He attributes the naming of the Hell Gate, a narrow strait between the East River and Long Island Sound known for its rocks and whirlpools, to Oloffe Van Kortlandt, who sailed up the East River, convinced that a pod of jolly porpoises was towing him to a fair haven, only to be brought to near disaster on the roaring waters. Later, Van Kortlandt was delighted to see the porpoises broiling on the Gridiron and the Frying Pan, other nearby landmarks.

Irving's writings often drew upon his youthful experiences. As a child, in 1793, he had been sent to Tarrytown for the summer to avoid the yellow fever epidemic in New York City. Westchester County was then farm country and still very Dutch (the name Tarrytown is based on the Dutch word *tarwe*, meaning wheat), and Irving spent the summer roaming the neighborhood and soaking up everything around him. Later, these scenes would burn bright in his memory. In 1819, while living in

Europe, he published *The Sketch Book of Geoffrey Crayon, Gent.*, containing "The Legend of Sleepy Hollow," which featured the people he had met, such as the Van Tassels, and places he had visited, such as the Dutch church on Pocantico Brook. It begins with the following scene:

> In the bosom of one of those spacious coves which indent the eastern shore of the Hudson, at that broad expansion of the river denominated by the ancient Dutch navigators the Tappan Zee . . . there lies a small market-town or rural port, . . . which is . . . known by the name Tarry Town. This name was given we are told, in former days, by the good house-wives of the adjacent country, from the inveterate propensity of their husbands to linger about the village tavern on market days. Not far from this village . . . there is a little valley . . . known by the name of Sleepy Hollow. . . . Certain it is, the place still continues under the sway of some witching power, that holds a spell over the minds of good people, causing them to walk in a continual reverie. They are given to all kinds of marvellous beliefs; are subject to trances and visions; and frequently see strange sights, and hear music and voices in the air. The whole neighborhood abounds with local tales, haunted spots, and twilight superstitions; stars shoot and meteors glare oftener across the valley than in any other part of the country. . . .

Washington Irving at the age of twenty-seven. Frontispiece to *Knickerbocker's New York: A History of New York from the Beginning of the World to the End of the Dutch Dynasty by Diedrich Knickerbocker*, 1861 edition.
Author's collection

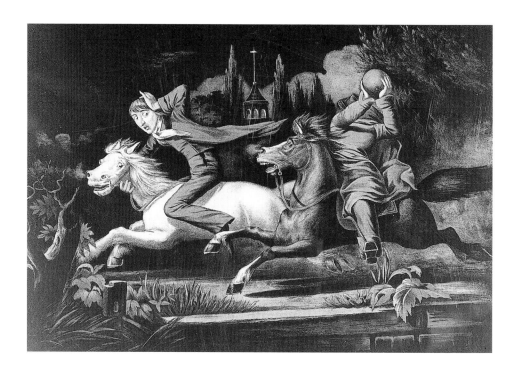

William J. Wilgus, *Ichabod Crane, Respectfully Dedicated to Washington Irving.* The Headless Horseman from Irving's *Legend of Sleepy Hollow.* Circa 1856. Photo by Mick Hales. *Courtesy of Historic Hudson Valley, Tarrytown, NY*

> The dominant spirit, however, that haunts this enchanted region, . . . is the apparition of a figure on horseback without a head . . . known, at all the country firesides, by the name of the Headless Horseman of Sleepy Hollow.[13]

Irving personally witnessed the Yankee invasion of New Englanders moving to New York. He played up the resulting culture clash in stories like this, where the ambitious Yankee, Ichabod Crane, comes to the Dutch village to teach—but is driven out by the locals and his fear of their superstitions.

The Hudson Valley of Irving's childhood was gradually changing from Dutch to English culture. Though the British took control of the Hudson in 1664, Irving grew up hearing Dutch spoken in many places. He studied Dutch heritage eagerly and became quite an expert on it. *Knickerbocker's History* is a fictional retelling of historic events, and authentic early histories of New Netherlands are cited in the footnotes. His stories include details gleaned from these accounts, such as the fireflies that lighted on the mast of Peter Kalm's ship in 1749 and the dolphins that sported about the ships of Dutch sailors, seeming to guide them through the harbor. Irving's books also contain faithful portrayals of Dutch customs in architecture, dress, food preparation, courting, smoking, and drinking—touching on topics such as demonism, witchcraft, songs, ghost lore, and tall tales with great accuracy.[14]

Unfortunately, his caricatures of pipe-smoking, round-bottomed Dutchmen, which were written to be funny, were so widely read and accepted that they came to be perceived as accurate. *Knickerbocker's History* obscured the other, industrious side of the Dutch personality, focused on commerce, trade, and reward for hard work. For generations to come, the book distracted the public from the great contribution of the Dutch to the history of America and New York and of leading Dutch citizens, Peter Stuyvesant, Adriaen Van der Donck, and others.[15]

Knickerbocker's History and *The Sketch Book* were popular and lasting favorites overseas, further cementing Irving's reputation as an American writer of note. Curi-

ous European readers enjoyed the novelty of the American scene and Irving's wit and satire. Lord Byron claimed to have memorized every word of *The Sketch Book*, Sir Walter Scott laughed uproariously on reading it the first time, and when Charles Dickens arrived in New York aboard a packet steamer in 1842, he reported happily: "I awoke from my nap in time to hurry up, and see Hell Gate, the Hog's Back, the Frying Pan, and other notorious localities, attractive to all readers of famous Diedrich Knickerbocker's History."[16]

Irving credited his love affair with the Hudson River to early boyhood, when he first traveled upriver by sloop. On this journey, black deck hands regaled him with frightening stories about the passing scenes, an oral tradition that he later wove into his books.[17] It was a time, he wrote, "before the steamboats and railroads had annihilated time and space," when a voyage to Albany "was equal to a voyage to Europe at present, and took almost as much time."[18] The passage through the Highlands delighted him, and he later recalled the heavy splash of the leaping sturgeon and the song of the whippoorwill echoing in the night as the sloop lay at anchor below those dark and mysterious mountains. As he continued his voyage, another river vista impressed him even more:

> Of all the scenery of the Hudson, the Kaatskill Mountains had the most witching effect on my boyish imagination. Never shall I forget the effect upon me of the first view of them predominating over a wide extent of country, part wild, woody, and rugged, part softened away into all the graces of cultivation. As we slowly tided along, I lay on the deck and watched them through a long summer's day; undergoing a thousand mutations under the magical effects of atmosphere sometimes seeming to approach; at other times to recede; now almost melting into hazy distance.[19]

From this mystical scene, he later wove the story of Rip Van Winkle, a reworking of a German lost-time folktale, in which Rip discovers the ghosts of Henry Hudson's crew playing ninepins in the Catskills, their bowling balls making sounds like "long, rolling peals, like distant thunder." Rip sneaks a drink of their beer, when no one is looking, and promptly falls asleep—for twenty years. Waking as if he has slept but a single night, he stumbles home to find his village completely changed. A painting of King George on the sign at the inn has been touched up and is now labeled George Washington. Indeed, "the very character of the people seemed changed. There was a hustling, bustling disputatious tone about it, instead of the accustomed phlegm and drowsy tranquility."[20] Rip spends the rest of his days at the inn, telling his story to any who will listen until every man, woman, and child knows it by heart.

> Some always pretended to doubt the reality of it, and insisted that Rip had been out of his head.... The old Dutch inhabitants, however, almost universally gave it full credit. Even to this day they never hear a thunder-storm of a summer afternoon about the Kaatskills, but they say Hendrick Hudson and his crew are at their game of ninepins; and it is a common wish of all henpecked husbands in the neighborhood, when life hangs heavy on their hands, that they might have a quieting draught out of Rip Van Winkle's flagon.[21]

This story helped imprint a new image of the valley as a place haunted by the spirits of the past, but also alive with the promise of a new country. Not until 1832—two

decades after it appeared in print—did Irving first set foot in the mountains that had bewitched him from the sloop's deck. Even so, the legendary sound of rolling thunder in the Catskills was well known to him.

In 1835, Irving returned to the pleasant summer home of his childhood and bought ten acres of land in Tarrytown. He remodeled a Dutch cottage along the Hudson River into the fanciful country house he called Sunnyside, where he kept the public's interest in Sleepy Hollow alive. He is buried in Sleepy Hollow Cemetery near the Old Dutch Church made famous by the Headless Horseman.

While Irving created a body of humorous folklore around the well-known features of the Hudson River landscape, the historical novels of James Fenimore Cooper were far more serious. For Cooper, love of country was strongly linked to appreciation of wild nature. His first best-seller, *The Spy: A Tale of the Neutral Ground*, set along the Hudson, contains moving descriptions of river scenes. Published in 1821, soon after Irving's *Sketch Book*, it tells the story of a double agent—an unsung hero of the American Revolution. The story inspires patriotic memories and reminds the reader that the Hudson Valley is historic ground where freedom was won at great cost. Soon thereafter, Cooper's Leatherstocking series explored the changing relationship of Americans to the land, chronicling the French and Indian War, the settlement of the frontier of central New York, and the westward migration to the prairie states.

In Cooper's books, the characters move from one scenic spot to another. The river, the woods, the hidden mineral springs are not just a backdrop—they become characters in the story, willful or secretive personalities, sometimes friend and sometimes foe. In *The Last of the Mohicans*, Hawk-eye, the scout, and his Mohican companions, Uncas and Chingachgook, have rescued Major Duncan Heyward, a British officer, and the two lovely daughters of Major Munro from an attacking band of Hurons (who were allied with the French). Hawk-eye guides his fleeing charges to the shelter of a hidden cavern on an island in the upper Hudson at Glens Falls, where they try to elude the pursuing Hurons. Night has fallen, and the scout describes the hiding place to Alice and Cora Munro, noting its personality:

> Ay! There are falls on two sides of us, and the river above and below. If you had but daylight, it would be worth the trouble to step up on the height of this rock, and look at the perversity of the Water! It falls by no rule at all; sometimes it leaps, sometimes it tumbles; there, it skips; here, it shoots; in one place 'tis white as snow, and in another 'tis green as grass; hereabouts it pitches into deep hollows, that rumble and quake the 'arth; and thereaway, it ripples and sings like a brook, fashioning whirlpools and gullies in the old stone. . . . After the water has suffered to have its will for a time, like a headstrong man, it is gathered together by the hand that made it, and a few rods below you may see it all, flowing steadily towards the sea.[22]

Cooper's books also explore nature's spiritual value. *The Pioneers* (1823), set in rapidly growing central New York a decade after the revolution, mentions the Hudson only briefly, as an example of the divine in nature. Written in 1823, just as the Catskill Mountain House was being built, the story takes place in 1793, when the spot is still an undiscovered wilderness. The scout, Hawk-eye—called Natty Bumppo in this story—describes a "paradise" to his friend Edwards:

"The place I mean is next to the river, where one of the ridges juts out a little from the rest, and where the rocks fall, for the best part of a thousand feet, so much up and down, that a man standing on their edges is fool enough to think he can jump from top to bottom."

"What see you when you get there?" asked Edwards.

"Creation," said Natty, . . . sweeping one hand around him in a circle: "all creation, lad. . . . The river is in sight for seventy miles, looking like a curled shaving under my feet, though it was eight long miles to its banks. . . . How should a man who has lived in towns and schools know anything about the wonders of the woods? . . . None know how often the hand of God is seen in the wilderness, but them that rove it for a man's life."[23]

Like the Hudson River School artists, the Knickerbockers were nature worshipers, and their high priest was William Cullen Bryant. "The groves were God's first temples," he wrote in "A Forest Hymn."[24] His first poem of importance, "Thanatopsis," written at the age of seventeen, ushered in a new approach to the contemplation of nature in American poetry, with a sincere style that contrasted sharply with the platitudes of the day. Published in 1817, the poem describes the mental and spiritual solace to be found in nature and urges the reader to "Go forth, under the open sky, and list / To Nature's teachings":

> To him who in the love of Nature holds
> Communion with her visible forms, she speaks
> A various language; for his gayer hours
> She has a voice of gladness, and a smile
> And eloquence of beauty, and she glides
> Into his darker musings with a mild
> And healing sympathy that steals away
> Their sharpness ere he is aware.[25]

Bryant, who grew up in the Berkshires of Massachusetts, moved to New York City and eventually owned and edited the *New York Evening Post*. He loved exploring the Hudson Valley and wrote many poems about the Palisades, the Highlands, and the Catskills, as well as other spots such as the Delaware Water Gap—places where nature spoke to him in its clearest voice.

Bryant's poems, and the work of other Knickerbockers, began to be published at a time when a great intercontinental debate raged in the popular press, questioning the ability of America to produce any art of merit. In 1817, when Bryant submitted "Thanatopsis" to the *North American Review*, the editor, Richard Dana, is said to have remarked, "No one on this side of the ocean is capable of writing such verse."[26] Curiously, the growing American and European acclaim enjoyed by this group of writers did nothing to stem the controversy. In 1832, when Fanny Kemble looked out over the Hudson from Fort Putnam, she lamented, "Where are the poets of this land!" Critics like Sydney Smith focused on America's cultural and intellectual deficiencies. Writing in 1820 for the *Edinburgh Review*, he said bluntly: "In the four corners of the globe, who reads an American book? or goes to an American play? or looks at an American picture or statue?" This comment produced "paroxysms of wrath" in the American press, but to some extent, this feeling of cultural inadequacy

was shared by Americans and persisted for decades, long after the Knickerbockers and the Hudson River School painters had won wide acceptance in the United States and abroad.[27]

Comparisons between Europe and America extended beyond art and literature to the merits and defects of the American landscape, and the river became part of the debate. To Europeans—who were accustomed to traveling in Greece, Egypt, Syria, and Germany's Rhineland—landscape was far more beautiful if cloaked in legend or improved by picturesque ruins or other signs of human endeavor. In this, America was considered seriously deficient; however, the Knickerbockers had began to change that perception with volumes of legends, history, ghost stories, and poetry about every battlefield, mountain, stream, and rock of the Hudson Valley, works that both Europeans and Americans enjoyed. Rip Van Winkle, the Headless Horseman, Natty Bumppo, and the Culprit Fay established the history that Europeans had found wanting. On the river at Fort Putnam and in the forest along the shores could be found a replacement for Old World ruins. "Those vast aboriginal trees," Sir Walter Scott commented to Washington Irving, "are the monuments and antiquities of your country."[28]

The Knickerbockers also played up the moral power of sublime scenery, as found on the shores of the Hudson. If wild country was the medium through which God spoke most clearly, America was obviously blessed. "We claim for America the freshness of a most promising youth," wrote Cooper, "and a species of natural radiance that carries the mind with reverence to the source of all that is glorious around us."[29] Wild nature, which had been scary to earlier generations, was becoming America's big selling point.

The Hudson River School painters joined the Knickerbocker writers in this debate. For them, the Hudson Valley was not just equal to Europe—it was better, especially the sky. Many had traveled to Europe, painted the Alps, and admired the blue horizon of the Mediterranean. They felt qualified to compare the American landscape to the finest scenes of Europe. In 1835, Thomas Cole addressed this issue in his "Essay on American Scenery":

> And if he who has travelled and observed the skies of other climes will spend a few months on the banks of the Hudson, he must be constrained to acknowledge that for variety and magnificence American skies are unsurpassed. Italian skies have been lauded by every tongue, and sung by every poet, and who will deny their wonderful beauty? At sunset the serene arch is filled with alchemy that transmutes mountains, and streams, and temples, into living gold. But the American summer never passes without many sunsets that might vie with the Italian, and many still more gorgeous—that seem peculiar to this clime. Look at the heavens when the thunder shower has passed, and the sun stoops behind the western mountains— there the low purple clouds hang in festoons around the steeps—in the higher heaven are crimson bands interwoven with feathers of gold, fit for the wings of angels—and still above is spread that interminable field of ether, whose color is too beautiful to have a name. It is not in the summer only that American skies are beautiful; for the winter evening often comes robed in purple and gold, and in the westering sun the iced groves glitter as beneath a shower of diamonds—and through the twilight heaven innumerable stars shine with a purer light than summer ever knows.[30]

Nearly two centuries earlier, in 1656, Adriaen Van der Donck had sung the praises of New Netherlands, commenting on the useful abundance of healing herbs, nut trees, lime and clay deposits, boundless fish and wild game, as well as the winds—"swift and fostering messengers of commerce." Cole focused on entirely different features of the Hudson Valley, qualities that infused his art and that of his fellow painters—waterfalls, fall colors, clouds, and sky that created a special kind of light.

Nevertheless, the national inferiority complex lingered on, and both painters and writers continued to address it. Knickerbocker essayist Nathaniel Parker Willis sought to cast a different spell of romance over the landscape. In a piece published in the *Home Journal*, he advocated changing the name of Butter Hill to Storm King:

> The tallest mountain, with its feet in the Hudson at the Highland Gap, is officially the Storm King—being looked to, by the whole country around, as the most sure foreteller of a storm. When the white cloud-beard descends upon his breast in the morning (as if with a nod forward of his majestic head), there is sure to be a rain-storm before night. Standing aloft among the other mountains of the chain, this sign is peculiar to him. He seems the monarch, and this seems his stately ordering of a change in the weather. Should not STORM-KING, then, be his proper title?[31]

The notion appealed to Willis's readers, and public sentiment led to the rapid adoption of the new name.

The Knickerbockers formed a close-knit community of people who took delight in writing about the river. A fun-loving group, they met frequently, consuming great quantities of food and drink. One friend reported that after a festive evening Irving fell through an open grate on the way home. His solitude and depression was relieved after several guests joined him there, where they sat and laughed until dawn. They also rambled together along the river and challenged one another to come up with new ways to fill the New World with old-time legends.[32] The poem "The Culprit Fay" resulted from such a conversation among Washington Irving, Fitz-Greene Halleck, and Joseph Rodman Drake while hiking in the Highlands. According to the story, Drake called his friends together three days later and read them the poem, which begins with these lines:

> Tis the middle watch of a summer's night,—
> The earth is dark, but the heavens are bright . . .
> The moon looks down on old Cro'Nest,
> She mellows the shades on his shaggy breast,
> and seems his huge grey form to throw
> In a silver cone on the wave below.[33]

"The Culprit Fay" is a lengthy epic tale, the story of a fairy, or fay, who has broken his vows of chastity and fallen in love with an earthly maid. It takes place at midnight on the summit of Crow's Nest, to the south of Storm King. The assembled spirits of the forest impose a penance whereby the "culprit fay" braves the cold waters of the Hudson, captures a drop of spray from the leaping sturgeon, and eventually succeeds in returning to the mountaintop just as dawn is breaking, and so recovers his fairy powers.

The Knickerbocker writers also developed close friendships with Hudson River School painters, with whom they shared a romantic philosophy and a common interest in the river. When Thomas Cole died in 1848, William Cullen Bryant delivered the eulogy, recalling Cole's paintings "which carried the eye over scenes of wild grandeur peculiar to our country, over our aerial mountain tops with their mighty growth of forest never touched by the axe, along the banks of streams never deprived by culture and in the depth of skies bright with the hues of our own climate; skies such as few but Cole could ever paint, and through the transparent abysses of which it seemed that you might send an arrow out of sight."[34]

Deeply moved by Bryant's testimonial, art patron Jonathan Sturges commissioned a painting by Asher Durand. *Kindred Spirits* portrays poet Bryant and painter Cole on a rocky ledge in the Catskills wilderness. The painting is a lasting testament to the respect that these artists, writers, and patrons had for one another, and the bonds of friendship that grew from a shared love of the Hudson and its landscape.

Both artists and writers felt anxious about changes they observed. America's ancient forest was rapidly disappearing—even as it was being celebrated in art and song—causing Knickerbocker George Pope Morris to write his famous poem "Woodman, Spare That Tree." When mills turned wild waterfalls into tame trickles and resorts sprung up around mineral springs that had once bubbled quietly in the forest, the artists and writers began to wrestle with conflicting feelings. In *The Last of the Mohicans*, after Hawk-eye has described the waterfall to Cora, Alice, and Heyward, Cooper provides a footnote:

> The description of this picturesque and remarkable little cataract as given by the scout [Hawk-eye], is sufficiently correct, though the application of the water to the uses of civilised life has materially injured its beauties. The rocky island and the two caverns are well known to every traveller, since the former sustains a pier of a bridge, which is now thrown across the river, immediately above the fall. In explanation of the taste of Hawk-eye, it should be remembered that men always prize that which is least enjoyed. Thus, in a new country, the woods and other objects, which in an old country would be maintained at great cost, are simply gotten rid of, simply with a view of "improving" as it is called.[35]

William Bartlett, *Bridge at Glen's-Falls, on the Hudson*. Engraving in N. P. Willis, *American Scenery*, 1840.

Author's collection

Some of the Hudson River School artists painted scenes where the forest had been logged. Sanford Gifford's *Twilight at Hunter Mountain* shows a clear-cut stand of hemlocks in the Catskills. This painting is thought to have profoundly influenced Gifford's friend and patron James Pinchot, a New York merchant whose family had harvested wood on large tracts of forest in Milford, Pennsylvania. Pinchot later became an advocate for forest conservation and steered his son Gifford toward a famed career in forestry.[36]

For artists, writers, and patrons alike, it was hard to reconcile the abundance and richness of natural resources that God had so manifestly given America for its people to use with the destruction that accompanied that use. Most of the artists and writers saw progress as necessary and good. They did not oppose it; rather, they watched the wild forests fall, wistfully commenting that a truly civilized country should appreciate its waterfalls, woods, wildlife, and scenery, and undertake the kind of improvement that enhances beauty rather than destroying it. Cole expressed this concern in 1835, writing:

> Where the wolf roams, the plough shall glisten; on the gray crag shall rise temple and tower—mighty deeds shall be done in the now pathless wilderness. . . . Yet I cannot but express my sorrow that the beauty of such landscapes are quickly passing away—the ravages of the axe are daily increasing—the most noble scenes are made desolate, and oftentimes with a wantonness and barbarism scarcely credible in a civilized nation. The wayside is becoming shadeless, and another generation will behold spots, now rife with beauty, desecrated by what is called improvement; which, as yet, generally destroys Nature's beauty without substituting that of Art. This is a regret rather than a complaint; such is the road society has to travel.[37]

The loss of wild nature in the countryside did not interfere with their enjoyment of life in the artistic, literary, and mercantile capital of the nation. New York City was their gathering place. At the time it was a relatively small city, noted for its congeniality. In 1827, a group of these "kindred spirits" founded the Sketch Club, which later became the Century Association.[38] Membership, by invitation only, included leading artists, writers, and their patrons. Originally, Sketch Club meetings were devoted to impromptu drawing and writing. The evening's host provided a subject, usually from literature, and the artists and writers then spent an hour on it. At the end of the evening, the host would collect the sketches and keep them. Occasionally communal authorship was tried, whereby three members would compose a single poem on a topic such as "The Sublime" or "Character."

Although the club members took themselves seriously, they used the gatherings for fun and entertainment as well. The group met on Friday evenings, in an aura of secrecy. The club had no official address; it met in members' homes. Meetings were announced cryptically in newspapers under the initials of the host for the evening. The January 14, 1830 announcement in the *Evening Post* was typical: "S.C.; H.I. 49 Vesey St." To members it was clear that this meant that Henry Inman was entertaining; however, to the *Post* readership it was intriguingly provocative.

William Emerson, the club's secretary, described the atmosphere of the meetings as a "peaceful, social, laughing, chatting hubbub." Amid discussions of politics and the economy were interspersed speeches on such matters as the "domestic economy . . . of Bull-frogs," and the "combustion of pea nut shells," which was explained by

Thomas Cole. The club also watched demonstrations of phrenology, performed magic tricks, and on one evening, at the home of Robert Weir, raised a ghost. Mock punishments were also meted out, as in the case of William Cullen Bryant, who was instructed to write and publish an account of an art exhibition he had not yet seen. The article appeared, unsigned, in the *Evening Post* the next day.[39]

Soon the Hudson began to be featured in new works, as the club members collaborated on a number of books about American scenery that they sold to an eager public. *The Homebook of the Picturesque* (1852), for example, contained engraved prints based on paintings by Thomas Cole, Asher Durand, Robert Weir, Jasper Cropsey, and Frederic Church. Vignettes written by Knickerbockers James Fenimore Cooper, William Cullen Bryant, Nathaniel Parker Willis, and others accompanied the engravings. Selling at $7, clothbound, the book was a popular gift item. Another such publication, *Picturesque America* (1872), edited by William Cullen Bryant, contained hundreds of illustrations by Hudson River School painters. *American Scenery*, a two-volume set written by N. P. Willis in 1840, contains 119 illustrations of commonly painted scenes engraved by Englishman William Henry Bartlett. Each is accompanied by a legend, poem, anecdote, or essay. All three books featured the Hudson as the preeminent romantic landscape in America and further enhanced the region's reputation abroad.

These books were popular for decades, allowing even armchair travelers to become familiar with America's natural wonders along the Hudson and in other parts of the country. The images published in them found their way into American homes in other ways as well. They were used as patterns for Staffordshire pottery and in British blue ware and pink ware, produced in great quantities beginning in the 1820s. Jean Zuber printed a popular set of scenic wallpapers in 1834 and exported them to the United States from his headquarters in Alsace. The set, called "American Scenery," based on engravings of the 1820s, was printed from wooden blocks. It showed views of nineteenth-century America particularly admired by Europeans: Niagara Falls, Virginia's Natural Bridge, Boston harbor, New York Bay, and the Hudson River Highlands at West Point.

In 1961, when First Lady Jacqueline Kennedy remodeled the oval Diplomatic Reception Room of the White House, she chose a set of Zuber wallpaper that had recently been removed from a mansion about to be torn down. She noted that the oval shape of the reception room seemed particularly suited to the panoramic sweep of the scenic views, and it would be "the room people first see when they come to the White House." Though the White House paper was antique, the same wallpaper design was still being manufactured from the original wooden blocks.[40]

The international interest in American nature and scenery kept the best of the Knickerbocker writers and Hudson River school artists employed until after the Civil War. By 1850, however, new American authors who were preoccupied with entirely different issues began to publish books like *The Scarlet Letter* (Hawthorne), *Moby-Dick* (Melville), and *Uncle Tom's Cabin* (Stowe). Meanwhile, ideas about nature also began to shift from romantic and emotional to a more studied approach. The arrival of Swiss scientist Louis Agassiz in America taught a generation of people to "read nature" through meticulous exploration and so learn to appreciate God's creation. A new transcendental view urged by Emerson and Henry David Thoreau suggested the contemplation of common things—berries, blue jays, flowers, and ponds—as a route to discovery of the miraculous and a path to spiritual growth.

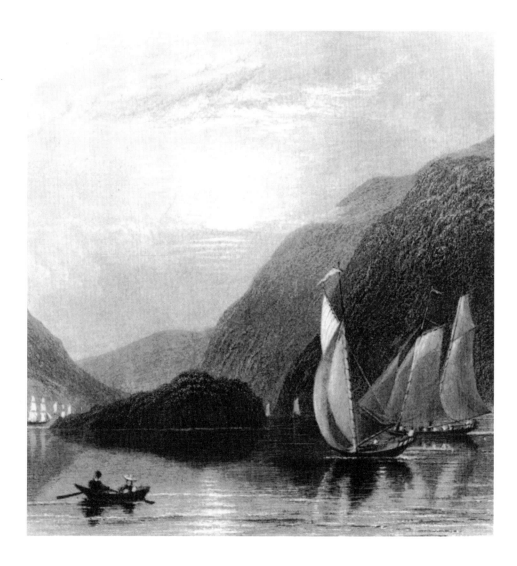

"Nature is the symbol of the spirit," wrote Emerson.[41] For these writers, it was not necessary to view sublime scenery to experience the divine, and the focus shifted away from the Hudson to less dramatic landscapes. Even so, it was on a visit to the Catskill escarpment that Thoreau first got his idea for living at Walden Pond.

The Hudson River School painters enjoyed fifty years of celebrity, roughly from 1825—the date of Cole's first sketch trip—to 1875. The eclipse of the Hudson River in painting began after 1860, when a second generation of artists discovered the monumental scenery of the West. Painters such as Thomas Moran and Albert Bierstadt painted large canvases of Yellowstone, the Grand Canyon, the Grand Tetons, and Yosemite. Their work is sometimes known as the Rocky Mountain School.

Attracted by the novelty of these images, American interest in oil paintings of the Hudson Valley waned. However, two new artists working in different media provided a fresh perspective on the Hudson after the Hudson River School had seen its last glory days. In 1873, engraver Winslow Homer began to paint watercolors with a free-spirited brilliance that shook the art world much as Thomas Cole's work had done five decades earlier. Though he eventually concentrated on seascapes of the Maine coast, his works include glorious scenes of the upper Hudson in the Adirondacks, near Blue Ledge, places he visited in the 1860s and 1870s. About the same

William Bartlett, *Entrance to the Highlands, Near Newburgh*. Frontispiece of N. P. Willis, *American Scenery*, 1840.
Author's collection

Cooper's Cave. Photograph by Seneca Ray Stoddard of the site at Glens Falls made famous in *Last of the Mohicans.*
Courtesy of the Chapman Historical Society, Glens Falls, NY

time, Seneca Ray Stoddard, of Glens Falls, experimented with the emerging art of photography. His artistic career had started when he painted murals on railroad cars for the Troy-based Gilbert Car Company in 1862, but by 1867 he had developed a portfolio of thousands of photographs. Many of them were sold to tourists as stereographs. He became nationally known when he exhibited his photographs at the Philadelphia Centennial exhibition.[42] Stoddard's images of nature were like the Luminism adopted by some of the Hudson River School painters. His photographs of the Hudson are discussed in chapter 12.

From 1807 to 1875, when the Knickerbocker writers and Hudson River painters dominated the cultural scene, the Hudson emerged as a powerful image, an icon well known to the public. Melville used it confidently as a metaphor in *Moby-Dick*: "Human madness is oftentimes a cunning and most feline thing. When you think it

fled, it may have but become transfigured into some still subtler form. Ahab's full lunacy subsided not, but contracted; like the unabated Hudson, when that noble Northman flows narrowly, but unfathomably through the Highlands gorge."[43]

Located at the artistic and literary capital, New York, accessible by steamboat, and providing the backdrop for both Dutch folklore and Revolutionary War history, the Hudson served romantic artists and writers well as subject matter. Together they succeeded in establishing the river as sacred ground, a "vast cathedral," in the words of N. P. Willis: "The Hudson a broad aisle, the Highlands a thunder-choir and gallery."[44]

In stark contrast, while this romantic image was being popularized in New York and abroad, up and down the river a period of intense industrial growth had begun—capitalizing on the abundant iron, limestone, water power, and forest resources of the river and its shores, as well as the transportation advantages of the Erie Canal and the seaport to which it connected. Gouverneur Kemble of Cockloft Hall, a friend and patron of the artists and writers, was one of the leaders of this business boom, a man who lived in both worlds. Kemble moved to the Highlands in 1817 or 1818 and, in the words of his friend Washington Irving, "turned Vulcan" and began "forging thunderbolts."[45] His new enterprise, a gun foundry, was just one of many factories that lined the Hudson in the age of iron. Like many business leaders of his day, he celebrated nature with artists and writers even as he was rapidly destroying it.

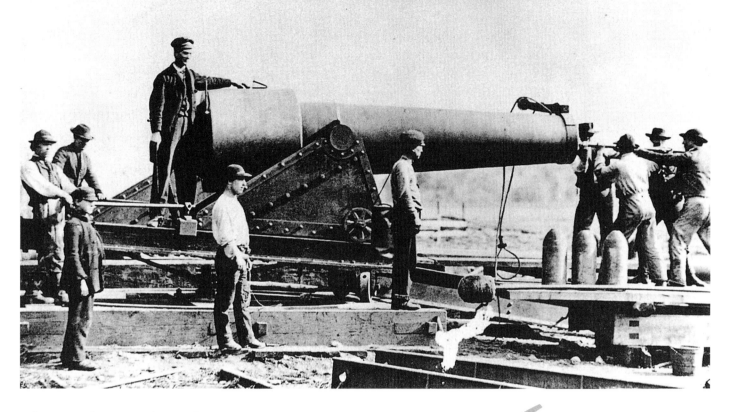

The Industrialized River

*Gouverneur Kemble's Weapon Works, Henry Burden's Iron Foundries,
and Colonel Stevens's Engine Factory*

VISITOR TO COLD Spring today would hardly guess that
this picturesque village, across the river from West Point,
could have been the site of the largest and most modern
iron foundry in the United States. But it was—with all the
noise, smoke, and grime that entails. In one of the great contradictions of the nine-
teenth century, the Highlands region, which symbolized scenic beauty and brought
humanity into close spiritual contact with nature, was also a leader in an industrial
movement that laid waste to the surrounding forests, tamed vast expanses of wilder-
ness, and turned generations of farmers into servants of the machine. For decades, as
West Point imported worshipers to its shrines of history and scenery, Cold Spring ex-
ported pipes, cranks, gears, cotton presses, railroad engines, and cannonballs.

The Revolutionary War cloaked the Highlands with history and romance, but
the War of 1812 set in motion the region's industrial development. Nearly a disaster,
the conflict proved one thing to President Madison: heavy artillery was the key to

Proving a Parrott gun on the grounds of
West Point.

Courtesy of the Putnam County Historical Society.
Rephotographed by Michael Spozarsky, 1979.
Collection of Edward Rutsch

modern warfare. He lost no time in establishing foundries to supply the government with guns and munitions. Cold Spring was one of four sites in the nation selected for a federally subsidized foundry, and its location on the Hudson proved crucial to its success, due to its natural assets and local expertise. West Point's military brass, just across the river, were men who understood armaments.

In 1817, General Joseph Swift—a graduate of the academy who later became commandant of the post—approached Gouverneur Kemble with a proposal for the establishment of a foundry. Kemble, then 31 years old, had traveled to Spain as a consul in the Monroe administration and had studied methods of casting cannons there. Together, Swift and Kemble raised $100,000 in capital from investors and, in 1818, incorporated the West Point Foundry Association, with Kemble in charge. They signed a contract with the federal government to supply cannons, round shot, grape shot, and "Turning and Chuggling Guns." From the day it opened until the end of the Civil War, the foundry expanded steadily, producing the best cannons in the United States.

At first, the foundry employed about 100 men. By the Civil War, 1,400 were working there, supporting a high level of prosperity in the village. Doctors, lawyers, architects, carriage makers, druggists, and milliners are among those listed in the 1867 *Beers Atlas* as residents of Cold Spring and neighboring Nelsonville. Blacksmiths, butchers, tailors, and grocers all set up shop to serve the needs of a growing village. Churches were built. Offices, stores, inns, and homes sprang up. Carpenters did unprecedented business.

Gouverneur Kemble—gentleman, bachelor, two-term congressman, and president of the foundry—was the village's most celebrated citizen. Mrs. Elmira Southard captured the local sentiment in a letter she wrote to her mother about his return to Cold Spring from a winter trip abroad:

> Mr. G. Kemble has arrived from Europe tonight. The Village has welcomed him with bonfires and illuminations. A procession met him at the Cars and escorted him across the street where the Kemble Guards received him. An address was spoken by Lawyer Dykeman and responded to by him. He then passed down the street among the Citizens, and to a carriage in front of our house, which was drawn by six White Horses. The Procession carried torches and we had fine music from the band. It was a fine Sight, I wish you could have seen it. The whole village joined in the welcome and honored his Grey Head. I have never seen such a turn out in Cold Spring.[1]

Key to Kemble's success was his choice of Robert Parrott as superintendent of the foundry. Parrott had started a military career at West Point, where he specialized in artillery. Later, as "Assistant of Ordinance" in Washington, he became an expert on modern weapons. Hired by Kemble in 1836, Parrott spent the next twenty years indulging his major interest—the development of artillery. To test the effectiveness of his new cannon, he shot at Crow's Nest and Storm King across the river. As steamboat passengers enjoyed the scenery of the Highland's venerable hills, Parrott and his men were busy blasting away at it. However, these efforts paid off when the foundry produced a cast-iron weapon that had a longer range than any other of the period—a simple and efficient rifled cannon that would prove its effectiveness in the Civil War. The Parrott gun's fame was so great that French author Jules Verne, in his 1865 novel

West Point Foundry.
New York.

Arrangement of Vacuum Pan with
Hepworth's patent Centrifugal Machines.
Erected in 1872 for J. S. Stewart on his
estate in Carolina Jurisdiction Cienfuegos Cuba

Paulding, Kemble & Co.
30 Broadway.

From Earth to the Moon, portrayed the West Point Foundry at Cold Spring as the manufacturer of a cannon that was to fire a projectile into outer space.[2]

Guns and cannons were not the only products made at the foundry. With government orders providing a steady flow of income, the company expanded its business to include box stoves, milling machinery, plowshares, bells, sash weights, and a variety of machine components such as shafts and cranks. The development of the steamboat and then the railroad created new markets for more sophisticated iron products, which Kemble's firm pursued. The company won contracts for producing steamship engines as well as the first iron ship made in the country, the cutter *Spencer.* The engine for the first American-made locomotive in regular operation, the Best Friend of Charleston, was also cast in Cold Spring (though it exploded six months later), as were the locomotives DeWitt Clinton, West Point, Phoenix, and the record-setting Experiment—which, in 1832, was capable of speeds up to 80 miles per hour. The factory also supplied iron pipes to replace the wooden water systems of New York, Boston, and Chicago; sugar mills for the West Indies; cotton presses for the South; and decorative garden benches for an increasingly affluent population at home.[3]

The West Point Foundry thrived for many reasons, among them expanding local, national, and global markets for iron products, as well as the availability of investment capital in New York. Also, with the best technicians, it was in the forefront of technology in production and design. Government contracts for armaments subsidized a continual process of modernization. However, none of this would have mattered if nature did not provide everything needed for iron making, including sources

Sugar machinery produced by the West Point Foundry, circa 1873. An intact sugar mill produced in 1861 at Cold Spring is now preserved as a landmark at the Hacienda La Esperanza in Puerto Rico.
Courtesy of the Putnam County Historical Society. Rephotographed by Michael Spozarsky 1979. Collection of Edward Rutsch.

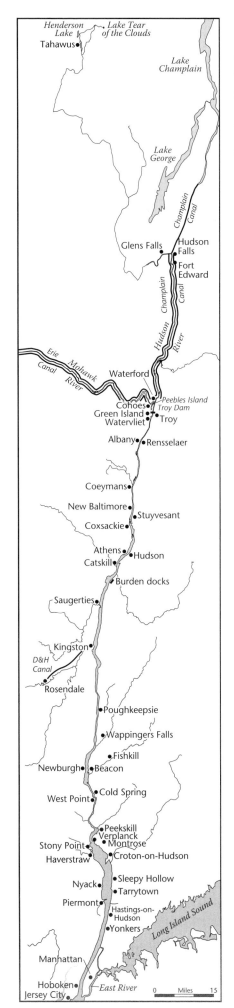

of quality iron ore, limestone to fuse the ores, coal or charcoal for heat, water to provide a source of power, and a water route to transport raw materials coming in and finished products going out.

The advantages of raw materials and geography that helped the foundry grow also boosted industries all up and down the Hudson, where quality iron ore could be found nearby in all directions and conditions were perfect for its use. Beds of limestone, laid down 350 million years ago when the Hudson Valley was at the bottom of a vast tropical lake, could easily be mined. Hardwood forests provided an abundant source of charcoal to fuel the furnaces. Mill streams plunging through the hills supplied water power to drive the bellows. The Hudson offered 150 miles of flat water for sloops, canal barges, and steamboats to carry products to market. It connected to the world's most rapidly growing city and international port on one end, and the Erie and Champlain canals at the other.

When Pennsylvania coal replaced charcoal as a source of fuel, the Hudson River location proved to be a continuing advantage, as the Delaware and Hudson Canal connected the Pennsylvania coalfields to the port at Kingston. Financed by New York City investors, among them Mayor Philip Hone, the canal assured the Hudson's continuing industrial dominance. The Morris Canal, in New Jersey, connected Pennsylvania mines to the harbor, providing another source of cheap coal.

Ironworks in parts of the Hudson Valley predated the Revolutionary War, but with the dawning of America's industrial revolution, the Hudson became the nation's most industrial river, and its ironworks were among the foremost in the nation. The river attracted entrepreneurs who understood the genius of the place. It spoke to them in the language of money. It inspired visions that lifted them to new heights.

Foundries sprang up everywhere—including Manhattan, Jersey City, Hoboken, Hudson, Poughkeepsie, Kingston, Newburgh, and Troy, as well as in the Adirondacks, near Sanford Lake and Henderson Lake, not far from the Hudson's headwaters. Like the West Point Foundry, they provided many of the innovations of the era. Later, some of these ironworks pioneered the production of American steel as well. The Hudson became a river of invention, a hotbed of technological ferment, driving the work of inspired men and women.

The waterfall-rich area where the Mohawk River joins the Hudson, in particular, developed as an industrial area, due to the geographic advantages of waterpower and transportation connections to the Champlain and Erie canals. Located close to the state capital at Albany—a city known for continuous commerce and trade since 1624—the area had many politically connected entrepreneurs who understood how to capitalize on the changing economy. Many of them maintained important business relationships in New York City and abroad.

After work on the two canals started in 1817, the Mohawk-Hudson communities—now Rensselaer, Troy, Watervliet, Waterford, Green Island, and Cohoes—developed rapidly as manufacturing sites, not only for iron products but also for brass and textiles, making the entire area both a nationally important transportation gateway and one of the leading industrial regions in America.[4]

As with the West Point Foundry, leadership and innovation were crucial in transforming geographic assets into successful businesses. Indeed, innovation was the defining characteristic of the leaders of this technology revolution, and their reputation was recognized throughout the region. "The Trojans are proverbial for their en-

terprise and public spirit. Everything they take ahold of 'goes ahead,'" reported the *Buffalo Gazette*.[5] One inventive Trojan, Henry Burden—an immigrant mechanic from Dunblane, Scotland—became one of the most important iron masters in this country. In his day, Burden was ranked with Eli Whitney, Samuel F. B. Morse, and Robert Fulton among the greatest inventors in America.[6]

Burden achieved great success by patenting improvements to common products and finding ways to make them by machine. In 1835, he developed a completely mechanized process for making horseshoes, and he updated the patents through 1862. Interestingly, the use of horses increased with the transportation revolution in steamboating and railroads, because of increased on- and offloading from ships and trains as well as the growth of cities, where carriage and horseback were still the main ways to get around. Burden's factory produced finished horseshoes from iron bars at the rate of one per second—enough for as many as twelve million horses. His continuous improvements in horseshoe design won him contracts from the army to produce the shoes for all its horses and mules. In Europe, after 1850, the rights for the machine were purchased by England, France, Germany, and Russia to equip their armies—making possible large-scale wars such as the Crimean and Austro-Italian wars. Even more important was a machine he built in 1840 to compress balls

Henry Burden. Portrait in *American Artisan,* 1 February 1871.
Library of Congress

of puddled iron into rolled cylinders. This rotary concentric iron squeezer replaced the forge hammer in tempering iron and was described by the U.S. Patent office as "the first truly American invention in iron-making."[7]

As he developed his company, Henry Burden pioneered business practices as well as mechanical inventions. He operated one of the first integrated ironworks in America, owning the iron mines and limestone quarries that provided raw materials; processing the iron into pigs, bars, and blooms at his foundry; and finally converting these to finished products that included not only horseshoes but also nails, railroad spikes, wrought-iron chairs, clamps, keys, bolts, and hardware for ships. His properties included large tracts of land in Vermont, which provided iron ore and marble used for flux in fusing ores. He brought in raw materials from Columbia County, shipping them to his Troy factory from the Burden dock, on lands owned by the Livingstons. During its years of peak production, Burden Iron Works employed 1,400 men. By 1871, when he died, Burden's company was the largest of its kind in America and possibly the world.[8]

Yet Burden's was only one of several important factories in the Mohawk-Hudson gateway area. Ironworks in Albany and Troy produced most of the cast-iron stoves in America; Troy boasted seven such factories. At Watervliet, the Meneely Company operated America's most important bell factories. Dozens of companies made other products, such as bridge trestles and railroad cars. By 1891, these sold to markets far and wide, as Arthur J. Weise reported:

> Troy stoves have been sent to distant parts of the world. Llamas have carried them across the Andes to the farther coast of South America, camels to the shores of the Black Sea, and ships to Northern Europe, Turkey, China, Japan and Australia. . . . The sound of church bells made in Troy daily circles the globe. Its waves flow from thousands of belfries in America, and from others in Polynesia, Australia, Japan, China, India, Armenia, Syria, Egypt, and Africa. . . . The [Eaton, Gilbert, & Co.] company not only manufactures sleeping, parlor, general passenger, and freight cars for many railroad companies in the United States, but also for others in England, South America, Australia, and New Zealand.[9]

Immigrant labor was key to the growth of most Hudson River industries. Strict British emigration laws prevented skilled mechanics from leaving England, Scotland, and Ireland. However, Hudson River industrialists found ways to circumvent this. They were not above smuggling when necessary. M. Wilson, a Hudson Valley resident during those years, recounts how it was done: "Laboring men, but not mechanics could leave Europe. It required sharp practices for mechanics to leave. Con-

Lower Works of the Burden Iron Company. Now the site of the Burden Iron Works Museum.

Reproduced from Arthur James Weise, City of Troy and Its Vicinity *(Troy, NY: Edward Green, 1886). Library of Congress*

sequently a company of laboring men was put on board a ship in the harbor of Belfast, Ireland, to sail to the United States, but on the eve of starting, mechanics were substituted for the laborers."[10] When the deception was discovered, a British war ship set off in pursuit, but failed to catch up with them.

It seemed that the timing of disasters in Europe could not have been more fortunate for manufacturers in the vicinity of America's principal port of entry. Ireland's 1847 potato blight caused millions of its starving citizens to leave their homeland over the next two decades—arriving in America just when they were most needed for expanding foundries, cotton mills, brickyards, quarries, breweries, and other industries along the Hudson, and for public works projects such as the expansion of the canals. From 1840 to 1880, large numbers of Germans arrived at the immigration center at the tip of Manhattan; they were joined by Scandinavians after the Civil War. By 1860, three of five Troy residents were immigrants, mainly from Ireland. French Canadians settled in Cohoes. After 1880, poverty in Italy, Austria, Hungary, and Russia sent new waves of immigrants to America—and to the factories on the Hudson. In 1890, 40 percent of Hoboken inhabitants were foreign born, over half of them German; by 1920, Italians outnumbered Germans.

Large numbers of immigrants worked in foundries around the harbor, including the Delamater Iron Works—established on the west side of Manhattan between Twelfth and Fourteenth streets, in 1839—and others in Brooklyn, Hoboken, and Jersey City. As ships made the transition from sail to steam and shipbuilding changed over from wood to iron, New York harbor became second only to Glasgow, Scotland, as a site for construction of ships, marine engines, boilers, clocks, thermometers, and other nautical hardware. The four largest foundries were the Novelty Works on the East River (employing 1,000 men in 1847) and plants operated by three rivals: James Allaire, Theophilus Secor, and Pease, Murphy & Co. (with 800 employees each at that time).[11] Smaller shipbuilders also operated out of river cities like Newburgh, Kingston, and New Baltimore.

Like the factories in Troy and Cohoes, foundries downriver produced national leaders in the developing field of engineering, including Charles B. Stuart, Charles H. Haswell, Benjamin F. Isherwood, James Allaire, Cornelius Delamater, George Quintard, and John Ericsson. Chief among these were members of the Stevens family, who operated a foundry in Hoboken and whose contributions spanned several generations.[12]

Delamater Iron Works, Thirteenth Street, New York City, on the west shore of Manhattan. Nearby were the Empire City Iron Works and Eagle Iron Foundry, as well as lumberyards and sawmills. From 1841 until at least 1886, the company produced boilers, engines, and iron devices.
Courtesy of Leo Hershkowitz

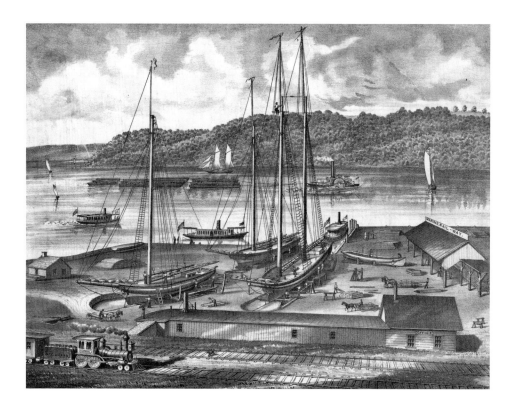

This 1876 lithograph of a shipyard in Poughkeepsie shows the transition from wood to sail to steam.

Historical Atlas of Dutchess County New York, Illustrated *(Reading Publishing House, 1876).* *Collection of Julia McClure Dunwell*

John Stevens III, a one-time soldier in the Revolutionary War, later known as Colonel Stevens, designed a hundred-foot steamboat, the first in the world to sail the ocean seas, soon after Fulton's creation made its maiden voyage. He also invented the first screw propeller for a steamboat. In 1825, he designed and built the first American-made steam locomotive—a small model that ran on a circular track in front of one of his Hoboken resorts on the shores of the Hudson.

His son, Robert Livingston Stevens, is credited with originating the most new features for river steamboats of his day, including the first concave waterlines on a steamboat (1808), and many railroad inventions, such as the cowcatcher and the T-shaped iron rail. Together, Robert and his brother, Edwin, pioneered the field of railroading in America, finding ways to connect trains with their family's steam ferry lines to reduce the travel time from New York to Philadelphia, an idea that began with their father. Edwin also designed ironclad vessels for the navy. In his will, he provided the land and an endowment to create Stevens Institute of Technology, the oldest college of mechanical engineering in the United States, which opened in 1870.[13]

The Hudson River foundries played a key role in the industrial advantage of the North over the South in the Civil War. In Watervliet, across from Troy, a federal arsenal had been built during the War of 1812. Now it expanded, with 2,000 workers producing 33,000 bullets per day for the Civil War effort: men, women, and children working around the clock, by gaslight. The Troy-based firm of Uri Gilbert & Son made 500 gun carriages for the federal government, and another local company—W. & L. E. Gurley—made brass fuses for artillery, brass sights for cannons, and brass fittings for army saddles. The owners of the Albany Iron Works and the Rensselaer Iron Works (companies that later merged) urged the government to produce an iron-

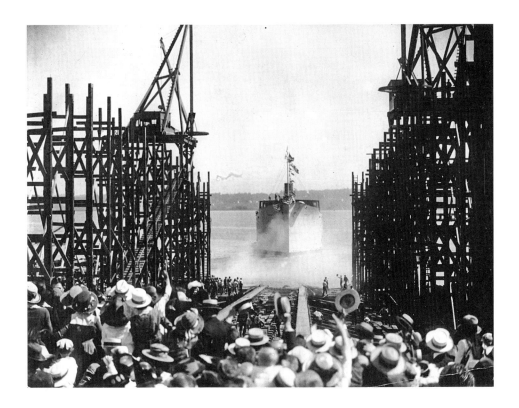

clad boat for the navy. In October 1861, they secured a contract to build the *Monitor* with rolled-plate armor to be produced in Troy. With a boiler and propeller produced in Greenwich Village at the Delamater Iron Works on the Hudson and other parts from nearby foundries, the ship was assembled in Brooklyn shipyards. Exactly 101 days after the contract was signed, on January 30, 1862, the boat was launched in New York harbor, and in March 1862, it battled the Confederate ironclad *Virginia* (formerly the *Merrimac*) to a draw and, from that day on, prevented further attacks on Union ships.[14]

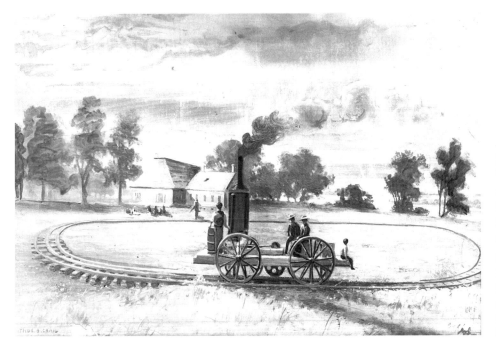

(top) The launch of a freighter built for World War I cargo transport, Newburgh Shipyards, 1918. Twelve of these were built at Newburgh between 1918 and 1920. The shipyard was in existence only between 1917 and 1923.
Photo courtesy of Richard Fenwick

(bottom) Colonel Stevens's 1825 steam locomotive operating on a circular track at his estate in Hoboken, New Jersey.
Courtesy of Stevens Institute of Technology, Library Special Collections, Castle Point on Hudson, Hoboken, NJ

Burden's machine-made horse and mule shoes, used by all Union forces, also played a role, as Confederate cavalry made frequent raids on Union wagon trains to seize supplies of them. A plot to obtain secret drawings of the Burden machines for use in building a horseshoe plant in Atlanta, Georgia was aborted in late 1864, when General Sherman marched to the sea. Some experts credit the Parrott gun (developed at the West Point Foundry, to shoot accurately over long distances) with turning the tide of the Civil War in favor of the Union.[15]

Both before and after the Civil War, economic growth along the Hudson led to a rapid expansion of its cities, creating a demand for housing materials that could be supplied from natural resources found near the river. After the devastating fire of 1835 that destroyed much of New York City's financial district, the need for fireproof building materials established a booming market for bricks on Manhattan and in growing river towns and villages. By 1860, 83 brickyards on the Hudson extracted clay from extensive deposits around Haverstraw, Grassy Point, Stony Point, Verplanck, Montrose, Croton, Beacon, Newburgh, Fishkill, Kingston, Saugerties, and most of the shoreline of Greene and Columbia counties. They fired the bricks in huge kilns on the river shore. In one decade, 1860–1870, the value of bricks produced upriver grew by as much as 500 percent.[16]

Quarries expanded along the Hudson just as the brickyards had. The Palisades provided trap rock (basalt) for roads and highways, and the Catskills yielded bluestone (a tough arkose sandstone) for the sidewalks of New York. Limestone from Rosendale was discovered in 1825 to yield high-quality cement—later used in the Brooklyn Bridge (1883), the pedestal of the Statue of Liberty (1886), and Grand Central Terminal (1913), as well as the bottom of the Washington monument and two wings of the Capitol in Washington, DC. Sing Sing marble (actually a form of limestone) got its name when it was used to build the prison in Ossining.

Turning bricks to dry at a Haverstraw brickyard.

Library of Congress

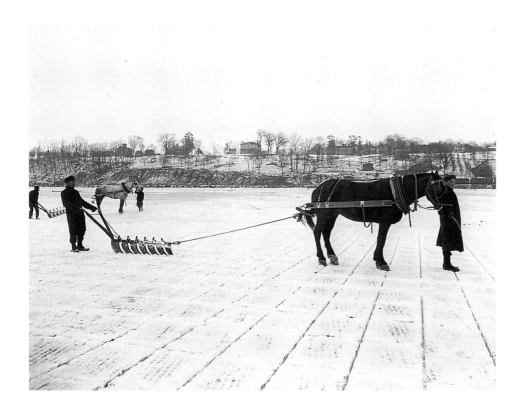

The demand for lumber increased at this time as well. Albany developed as the largest East Coast lumber port, on a par with Chicago, handling about 400 million board feet of lumber by the 1870s. Forty lumber companies rented slip space at Albany from the Van Rensselaers, whose yearly rental income rose from $7,000 in the 1830s to $80,000 in 1877. From 1850 until the 1870s, the Hudson River's Adirondack watershed supplied increasing amounts of wood to the dealers at Albany, with over one million logs processed at 11 Glens Falls lumber mills. Yet even this did not suffice to supply downstate markets. Increasingly, lumber was imported into Albany from Canada and Michigan via the Erie and Champlain canals and from more remote parts of the Adirondacks. As much as 60 percent came from out of state in 1870, when the mills on the upper Hudson operated at peak production.[17]

Yet another type of industry developed in Cohoes after 1834, when Canvass White, Stephen Van Rensselaer, and others organized a company to build a canal on the Mohawk River at Cohoes Falls to provide power for manufacturing. With a 120-foot head, dropping in a succession of 6 falls, each 18 to 23 feet high, the power canal was designed to feed 1,000 cubic feet of water per second to waterwheels capable of powering 3 to 4 million cotton spindles. The new power canal attracted Egbert Egberts and his associates Timothy and Joshua Bailey, who established America's first power knitting mills at Cohoes in 1832.[18] Eventually more than 20 textile mills would be built there, including the Harmony Mills, described in 1866 as "the richest, the largest, and the most complete Cotton Manufacturing Establishment on the American continent." At the time, a new turbine-powered system drove 70,000 spindles and 1,500 looms. By the 1880s, it employed 3,000 people and operated 2,700 looms.[19]

Nearby, in Green Island and Troy, the manufacture of collars, cuffs, and shirts employed tens of thousands of people. In 1891, one writer noted that in Troy "twenty

Ice harvesting, Stuyvesant. The remains of an old ice house can be seen at Nutten Hook, Stuyvesant.
New York State Archives

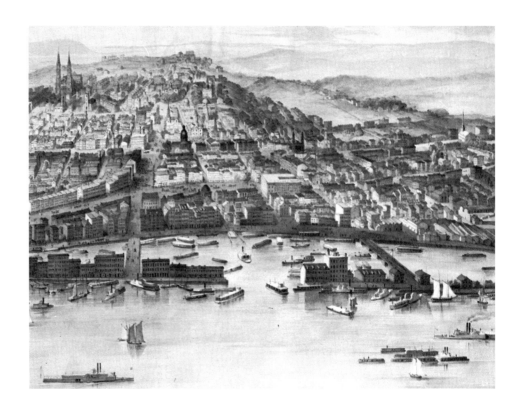

two factories employed seven thousand girls and women living in the city and as many more residing elsewhere [who] . . . earn not less than three million dollars annually."[20] Horace Greeley, who visited the George Cluett collar and cuff factory on Peebles Island around 1870, described "a linen snowstorm of tens of thousands of flakes, in cuffs and wristlets, and collars and fronts and habits for ladies and gentlemen in every conceivable pattern at the rate of acres per day."[21]

It was not unusual for women employed in Troy factories to work 14-hour days in sweatshop conditions, putting their hands into boiling water mixed with bleaching agents such as chloride of soda and diluted sulfuric acid. Union activity grew strong in the gateway area, and in 1864, 300 women led by Irish immigrant Kate Mullaney organized the first female labor union in America, the Collar Laundry Union. Following the example of the men in the Iron Moulders Union, they struck against 14 commercial laundries, and within two years won concessions that increased their weekly wages from $3 to an average of $14.

In 1891, Troy's historian Arthur J. Weise, in *Troy's One Hundred Years 1789–1899*, described the scope and scale of industries that had developed in the century since the city's founding in 1789. In addition to ironworks, steel mills, and brass foundries, he mentions dozens of other companies and notes their technological advancements. One, the W. & L. E. Gurley Company, made award-winning precision instruments used in North and South America, Asia, and the Middle East. Orrs & Co., one of numerous paper mills, introduced a cylindrical printing machine capable of printing 9,000 yards of 3-color wallpaper each day, as well as newsprint and book paper.

Many industries on the northern reaches of the Hudson did business with factories around New York City's harbor. For example, steel rolled in Troy was assembled as ship's hulls in Brooklyn, with engines and boilers built at other nearby ironworks.

John William Hill, *Albany, New York.*
Lithograph by Hatch and Sevryn, printed by F. Michelin. This image is a detail of the Albany basin, circa 1850.
Collection of the New-York Historical Society (#27623a)

SECTION OF MILL SHOWING TURBINES AND BELTING.

Cotton mills shipped their products downriver to the garment district in the growing city on Manhattan. The Adirondack Iron and Steel Company shipped high-quality ores from its mine at Adirondack Village to its cast-steel plant downriver on the outskirts of Jersey City—the first of its kind in America. (The tragic death of the mine's manager, David Henderson, in 1845, gave Calamity Brook its name.)

As industry expanded, support for the arts flourished among successful business leaders, for whom appreciation of nature was the mark of a true gentleman. New York City became the leading cultural site in the country, and Hoboken, Poughkeepsie, Cohoes, Troy, and Cold Spring became cultural satellites for artists, writers, and the social elite.

Gouverneur Kemble, owner of the West Point foundry at Cold Spring, made his elegant home, Marshmoor, into a hub of such social activity. Washington Irving, James Kirke Paulding, and other Knickerbockers gathered often at the Cold Spring estate, as did artist Asher Durand, who painted the view from Kemble's lawn in the mists of dawn. On Saturday nights, visiting dignitaries at West Point ferried over for the weekly open house, enjoying the company of Hudson Valley gentry such as President Martin Van Buren, as well as the other prominent men and women who were

View of the turbines and belts of Harmony Mill No. 3 in Cohoes. From *Modern Cotton Spinning* (London, 1873). The Harmony Mill still stands and has been adapted to new uses. *Library of Congress*

Kemble's guests. Their host took them to see Indian Brook Falls and other nearby scenic spots.

The summer home of George Pope Morris, one of New York's leading spokesmen on cultural affairs, was not far from Marshmoor. With his friend and business partner N. P. Willis, Morris published the *New York Mirror*, a weekly magazine of literature and the fine arts. The *Mirror* printed works by Knickerbocker writers and engravings of Hudson River School paintings, as well as columns of commentary on European culture and articles about Hudson River scenery and how best to enjoy it. Sheet music for new songs appeared on the last page.

Two Hudson River School artists, Robert Weir and Thomas Rossiter, kept frequent company with the businessmen across the river. Weir, an acclaimed landscape painter, taught drawing at West Point. Rossiter lived in Cold Spring in 1860, in a house of his own design. His painting, *A Pic-Nic on the Hudson*, testifies to the close relationships among the officers of West Point, the members of Cold Spring society, and the artists and writers who gathered in the town. It portrays Rossiter's friends and neighbors, including Morris, Weir, and Kemble.

John Stevens III of Hoboken, the colonel who pioneered marine engineering and railroading with his sons, was another industrialist who fostered the arts and enjoyment of scenery in the vicinity of his factory. In 1784, when Tory lands were confiscated after the war, he had acquired at public auction the William Bayard property below the Palisades, which now comprises most of the city of Hoboken. Colonel Stevens made his river estate into a tourist destination with a hotel, a pavilion, and a six-mile long "river walk." He cleared the woods and landscaped the grounds to form what he called the Elysian Fields, and established a mineral water spa, known as Cybil's Cave. On weekends in the 1820s and 1830s, as many as 20,000 people visited Hoboken to enjoy the scenery, riding one of Stevens's fleet of steam ferries from Manhattan. Many painters also featured this scene, and William Cullen Bryant and Robert Sands wrote works of prose and poetry describing the romantic beauty of rural Hoboken. The colonel's sons hired architect Alexander Jackson Davis to build a castle on the grounds in 1859, calling it Castle Point.[22]

Troy, Cohoes, and Albany also evolved as centers for the arts, though not at the same level of brilliance. From 1858 to 1862, Troy's business leaders hosted five annual art exhibitions at the Troy Young Men's Association (YMA), featuring works by all the best-known artists of the Hudson River School. Like the American Art Union in New York City, the Troy YMA sponsored lotteries for works of art. George B. Warren, a bank president and iron manufacturer, organized the 1860–61 YMA exhibition and commissioned paintings and sculptures for the lottery. In a letter to artist John Kensett, he explained: "A few gentlemen have clubbed together here with a view of securing some pictures for our next Winter's exhibition and for distribution in this city, each subscribing $100 and after the Exhibition to distribute by lot the pictures among the subscribers—no profit to anyone except the artists and the person drawing the picture to pay for the frame." He offered Kensett $250 for a painting.[23]

Troy coach maker Eaton, Gilbert & Co. employed artists to paint murals on stagecoaches, omnibuses, and railroad cars, giving several artists their start, among them William Richardson Tyler, who later became a successful landscape painter, and Seneca Ray Stoddard, who became a painter and then a noted landscape photographer. Across the river to the south, the Albany Institute of History and Art de-

veloped as a place for businessmen, artists, and writers to gather and discuss natural science, history, and the arts.

The Hudson Valley today has several fine music halls built in manufacturing cities soon after the Civil War, including one in Troy (1875), another in Cohoes (1874), an opera house in Hudson (circa 1880), and in Poughkeepsie, the Collingwood Opera House (1869). Renamed the Bardavon—for Shakespeare, the bard of Avon—it was scheduled to be demolished in 1976 for a parking lot, but saved by the community. Kingston added an opera house on the Rondout in 1875 (now a restaurant).

Thus, the mid-nineteenth century was a time of prosperity and optimism for the communities beside the Hudson River, supported by a solid economic base. But while the effects of the industrial boom on the arts and employment were positive, the impact on the river and on the surrounding countryside was not. As the Erie Canal moved ever more freight west and brought grain east, the state and federal governments joined forces to dredge the river channel for shipping. Much of the effort went into removing the sandbars near Coxsackie, a stretch of grassy river habitat known as the Overslagh, where ships would commonly run aground at low tide. In 1866, Benson Lossing described how numerous long, low islands divided the river into channels that blocked river traffic: "the immense passenger steamers sometimes find it difficult to traverse the sinuous main channel. These, and the tall-masted sloops, have the appearance, from the Castleton shore, of passing through vast meadows, the water that bears them not being visible."[24]

Thomas Pritchard Rossiter, *A Pic-Nic on the Hudson.* 1863 oil on canvas, showing the friends and neighbors of the artist, who stands at the far left. Others include Professor Robert Weir (on rock), George Pope Morris (white beard) and his wife (wearing a hat, to his left), Gouverneur Kemble (seated far right, without hat), and Robert P. Parrott (far right). *Courtesy of the Butterfield Memorial Library, Cold Spring, NY*

Eventually, the Army Corps of Engineers succeeded in digging a straight, deep, wide channel through the shallow water all the way to the ports at Albany and Troy. In the process, they connected the spaces between islands with sand and soil from the river bottom and disposed of it in marshes and shallows, until a third of what had been riverbed between Kingston and Albany was filled and became dry land. Army engineers built dikes to harden the shoreline and force river water into the channel—turning braided channels into a single, smaller, straighter, and faster-moving one, eliminating significant spawning habitat for American shad and destroying feeding areas for migratory birds.

Companies like the Burden Iron Works picked up where the government left off. As Burden's daughter recounts: "This property has river frontage of nearly a mile in extent. . . . The depth of water in the river adjacent to the works was shallow and full of bars, but by dredging, an average depth of about fourteen feet has been obtained and made H. Burden & Sons' docks accessible to the largest vessels plying the upper Hudson."[25]

In the city of Hudson, Elihu Gifford's Hudson Iron Co. constructed its factory in 1850 and proceeded to dump ash, slag, and cinders from the blast furnaces into South Bay, filling in ten to twelve acres of a thriving tidal marsh, merely one example of what happened up and down the river in the industrial era. Lush salt marshes were filled in Jersey City, Hoboken, and Hackensack. In New York City, dumping of construction debris in river shallows was encouraged to make more land along Manhattan's west side. Most river cities dumped their garbage in wetlands that lined the river.[26]

The construction of the Hudson River railroad line had dramatic effects as well, virtually severing the river's bays, inlets, and tributaries from the main stem and placing rock riprap over soft shorelines. The railroad formed a steel barrier between the land and the river and blocked the sloop trade from access to markets. Where once the wharf had been the center of activity, it was now the train station, and development began to take on a linear character, as straight and unswerving as the rails themselves.

The forested lands along the shores of the Hudson also changed in response to the region's industrial growth. Enormous fires were required to melt down the 50 tons of pig iron that were typically used for a single foundry casting. To fuel the furnaces, trees from the surrounding countryside were felled and the wood turned to charcoal at an astonishing rate. By mid-century, much of the forest cover of the Hudson had been removed for charcoal. Without the discovery of Pennsylvania coal, the fires at the foundries might well have been extinguished, with contracts and orders unfilled. Trees also provided cordwood for home heating and timber for shipbuilding. Hemlocks were cut in large numbers to produce tannin, used in making leather.

Indeed, the signs of industrial activity along the Hudson must have been hard to ignore. The smoke from charcoal kilns, the roar of the blast furnaces, the heat of brickyards, the smell of the tanneries, the steady sound of the axe, and the ring of mammoth trip hammers were constant reminders of the river's industrial presence.

This makes it all the more interesting that poets and artists tended to omit industry from their descriptions and paintings of the Hudson River landscape. The views that appeared in Hudson River School paintings and guidebooks focused instead on the elegance and natural beauty of rural scenes—meadows and waterfalls, country

estates, and panoramas of the Storm King gorge and the Palisades. The smoke and physical presence of industry, if they were noticed at all, were shrouded in mist or clouds. Mountain slopes appeared cloaked in lush vegetation, dark with the shadows of ancient trees that at the time could only have been imagined, since the forests of the Hudson had been repeatedly cut.

For those who did paint factories, the foundry at Cold Spring, set in the sublime scenery of the Highlands, was an occasional subject. In a painting by David Johnson around 1870, *Foundry at Cold Spring*, the smokestacks are so dwarfed by the surrounding scenery that without its title, viewers might think the foundry was a barn surrounded by resting cows. A painting by Victor de Grailly includes the Cold Spring Foundry as a small, fiery glow, seen from across the river and overshadowed by an imposing mountain scene.

One of the few traveler/writers to remark on the foundry was Fanny Kemble, the British actress, who was given a tour by her American host in 1833. But far from lamenting its intrusion on the scenery, she found sublimity in the "dark abodes and their smouldering fires, and strange powerful-looking instruments."[27] In 1866, when the Cold Spring Foundry was at its peak of activity, author Benson Lossing wrote a 460-page book, *The Hudson: From Wilderness to the Sea*, in which he devoted 70 pages to descriptions of the Hudson Highlands—but only one sentence to the foundry. Like Fanny Kemble, he remarked on the sound of "deep breathing furnaces, and the sullen, monotonous pulsation of trip-hammers."[28] A footnote offered a short description of the facilities.

Not until the Civil War era did romantic artists recognize industrial America in their paintings, using images similar to those described by Kemble and Lossing. By then, the sparks, smoke, and power of industrial machinery could inspire the same feelings as sublime landscape, as well as pride in industrial progress. *The Gun Foundry*, painted in 1866 by John Ferguson Weir, is noted in the art world as one of the first works of "industrial sublime," and contributed to the image of machines as a civilizing force. The artist, son of West Point art professor Robert Weir, used Kemble's ironworks as the subject for this work, which won him lasting critical acclaim. Among the cavernous shadows of the forge, the molten iron casts a powerful glow on the human figures toiling beneath the huge crane and cauldron. At a distance, a group of visitors stands in awe.

By 1904, this sublime image was firmly established. In a book about her father and his Troy ironworks, Margaret Burden Proudfit wrote:

> Stepping upon the platform of the "elevator" . . . [the spectator] is soon carried upward until the fuming breath of the heated furnace fills his nostrils and warns him of the internal fires raging within its capacious depths. Here . . . is a heated blast of air pouring night and day the year round. . . . [In] this temple of Vulcan—the puddling forge—the visitor beholds a scene of stirring activity . . . hundreds of brawny men . . . nude to their waists . . . turning, thrusting, pulling, and piling the molten . . . iron. . . . [Pieces of crude iron are] passed through the roll trains, whence they issue, like long fiery serpents, in narrow bars . . . to the horseshoe machines.[29]

By then, the glory days of iron and steel on the Hudson were over. After the Civil War, industries began to consolidate, and many of them moved their center of operations. Textile manufacturers moved closer to the cotton fields. In 1865, steamboat

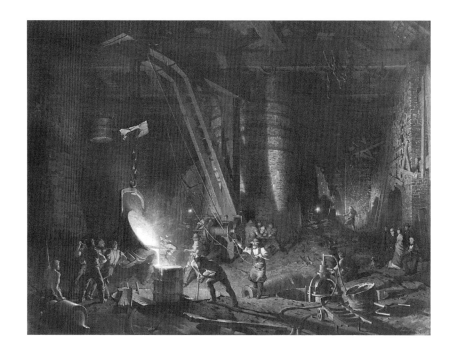

construction shifted from the Hudson River and its surrounding harbor to the Delaware, where hulls and machinery began to be constructed together.

The 1873 depression stopped everything in the manufacturing sector for a time, and only the strongest companies survived. The Cold Spring Foundry continued to operate, but never again at wartime levels. It closed in 1911. In 1882, stove manufacturing ceased in Troy. Similarly, the other ironworks on the Hudson struggled to survive. The discovery of iron ore in Minnesota and other places forced many of the iron mines in New York, Massachusetts, and New Jersey to close.

As steel began to replace iron, Hudson River manufacturers attempted, but were unable, to maintain a lead. Alexander Lyman Holley introduced the Bessemer process of making steel from pig iron, building the first steel plant in America at Troy, but by the early twentieth century, steel was centralized in the Pennsylvania coal regions, where Andrew Carnegie had established dominance. Investing in improvements during economic downturns and emerging stronger with every uptick in the economy, he built—with technical assistance from Holley—what would become the monopolistic U.S. Steel Corporation.

The shift of freight from barge to rail also affected the economy. In 1872, freight on the Erie Canal peaked at 6,673,730 tons and began a long decline. Seeking to regain its shipping advantage, New York State upgraded the barge canal once again from 1905 to 1918, building the world's highest flight of lift locks at Waterford (170 feet) and further deepening and expanding the Hudson River channel. However, this investment was not enough to stop the decline of shipping.

In the twentieth century, new industries eventually replaced the old ones on the Hudson. General Electric in Hudson Falls and Fort Edward, Louis de Chevrolet's automobile factory in Tarrytown, and IBM's early computer plant in Poughkeepsie are just a few of the many manufacturing enterprises that followed as old ones went out of business.

One can still see the occasional remains of the iron foundries, textile mills, coal yards, brickyards, and other industries of the era when waterfalls on the tributaries

and transportation on the Hudson made this a birthplace of the Industrial Revolution. In 1969, the Smithsonian Institution searched for a region to document America's engineering record using techniques of industrial archaeology. It settled on the Mohawk-Hudson area, where a variety of early structures associated with leading nineteenth-century engineers could be found. The report, published in 1973, helped lead to the permanent protection of many of these sites.

In 1982, New York State passed legislation to establish Urban Cultural Parks, now called Heritage Areas, where history and nature can be interpreted—places that tell the story of New York's vital role in American history. The Mohawk-Hudson Heritage Area was the first designated, followed by others on the Hudson in Kingston, Albany, Ossining, and New York City. Today, the Erie and Champlain canal systems are being rediscovered as recreational waterways. Other sites are being transformed into parks and residential areas. In the 1970s, New Jersey citizens lobbied to transform the derelict waterfront of Jersey City, once a major railroad hub, into what is now the 700-acre Liberty State Park, which opened in 1976. More recently, Catskill and Hudson tore down the empty oil tanks on their shores and opened municipal parks in their place.

In the nineteenth century, however, the rapid expansion of cities and factories was in full swing. With no benefit of pollution control and little sanitation, plenty of people got sick. In one of the many contradictions of this era, while parts of the Hudson developed as industrial areas, other parts emerged as resorts where city folks could escape for a cure.

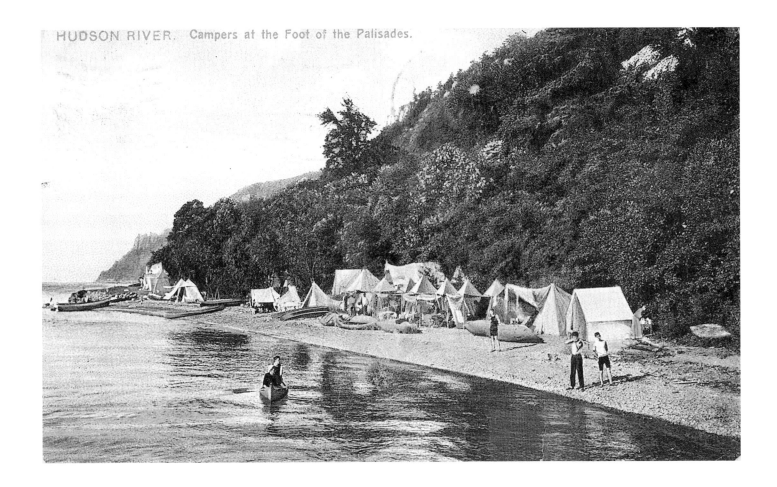

Going up the River for Health and Fun

*New York City Journalist N. P. Willis Survives TB and
Discovers an Idle Wild*

7

CHOLERA, YELLOW FEVER, and tuberculosis ravaged New York
City and other cities repeatedly throughout the eighteenth and
nineteenth centuries. The contagion was widespread, horrifying,
and indiscriminate—claiming young and old, rich and poor, fa-
mous and obscure—and precipitated a health crisis of major proportions. The causes
and the cures for these ailments were unknown, but it quickly became clear that con-
ditions in the city were very unhealthy. In 1800, the rural Hudson Valley began to de-
velop a reputation as a refuge from disease and a place with healing powers. This
image solidified in the 1850s—when one doctor reported that certain places along the
Hudson had escaped the cholera epidemics, and a well-known journalist publicized
his cure from tuberculosis in the Hudson Highlands—and lasted until about 1910,
when health-seekers ventured to other spots, more distant from the city.

Yellow fever, named for the jaundice it causes, struck first, in 1702. A swift, ago-
nizing death characterizes this tropical, mosquito-borne virus, which arrived with

Campers at the foot of the Palisades.
1908 postcard, author's collection

slaves from Africa and the West Indies. It then swept through New York City again in 1732, 1743, 1798, and 1822. Soon after the yellow fever epidemics subsided, cholera followed, claiming the lives of 3,500 people in 1832.

Drinking sewage-polluted water led to the intestinal infection cholera, causing cramps, thirst, and spasms. Its victims came to resemble blue-tinged "living corpses" before dying of heart failure. In New York City, where wells were polluted and sewage treatment did not exist, cholera spread quickly. The 1832 outbreak was part of a worldwide epidemic carried from India to Europe along trade routes, and then to Canada on refugee boats from Ireland. Cholera swept down Lake Champlain, following trade routes once more, to Albany and villages along the Hudson until it reached Manhattan and the seaport. In 1848, a second outbreak entered the United States by way of France. The final outbreak reached New York in 1854, on immigrant ships.[1]

Public water supplies, developed in the 1840s along the Hudson, reduced the cholera outbreaks, especially in New York City after the Croton Aqueduct was built in 1842. However, soon another disease took its place as the leading cause of death— tuberculosis, or TB. Fever, bloody cough, pale skin, and wasting away are symptoms of this ancient bacterial illness. It is transmitted by infected milk and by spitting and coughing. TB took a devastating toll in the eighteenth and nineteenth centuries, and was known by a variety of names—pulmonary consumption, phthisis, and King's Evil. It was also known as "white plague" because of its victims' pallor. Their haunted look is thought to have influenced vampire tales. Because it severely affected the urban poor, the term "lung blocks" arose to describe those New York slums with the highest death rates from the disease. The fatalities rose steadily in New York until, by the 1890s, TB caused up to one of every four deaths—surpassing the death rates of Old World cities.

Scientists discovered the causes of most of these diseases in the second half of the nineteenth century, when they came to understand the role of germs, but finding a cure would sometimes take much longer. It was not until the 1940s, when antibiotics were developed, that diseases like tuberculosis could be predictably cured. In the early 1800s, doctors believed that a gas called "miasma" ("bad air" in Italian) caused malaria, yellow fever, cholera, and TB. This bad air was thought to be "produced by the operation of solar heat upon vegetable and animal filth,"[2] particularly prevalent in lowlands, swamps, and around brackish or saltwater areas. In contrast, fresh water was thought to be safe, and the cool, pine-scented air of high elevations particularly healthful.

Medical journals published papers supporting the miasma theory. A typical one was "Evergreen Forests as a Therapeutic Agent in Pulmonary Phthisis," by Dr. Alfred Loomis, a prominent physician specializing in lung disease. Other theories, popular at the time, attributed such diseases to causes like sin, immorality, debauchery, and poverty.

To escape the toxic effects of miasma, city dwellers fled to the Hudson Valley countryside on the advice of their doctors. When yellow fever hit New York City in 1794, as many as half of the residents left.[3] The parents of young Washington Irving sent him up the Hudson to Tarrytown. Soon the words "absolutely free from malaria" began to appear in advertisements for country hotels like the Catskill Mountain House.[4] In 1838, steamboat traveler James Silk Buckingham—who had twice contracted yellow fever—reported: "I was advised by my physician to embark at once

upon the Hudson river and go straight to the village of Catskill, without halting at any intermediate point, but on landing there, to ascend the mountains, and pass a night or two at the Mountain House, the elevation of which secures a cool and bracing atmosphere, while all the other parts of the country are steeped in sultry heat."[5] For health seekers, stepping onto the steamboat was the first step on the journey to recovery, as the "delightful sail" would refresh their spirits right away.

Ideally, "going up the river" meant a trip at least as far north as the Highlands, 50 miles from the harbor. As one writer noted in 1855, the Hudson Highlands offered the "nearest mountain air, which is completely separated from the sea-board," being north of a "death-line" on the Hudson:

> At the meeting of salt water and fresh, there is an *infusorial cemetery* . . . the myriads of insects which belong to each realm of the element dying with the touch of the other, and precipitating at once to the bottom—thus producing the twenty-five per cent. of animal remains found in the mud of all Deltas at the mouth of rivers. Whereabouts is this death-line on the Hudson? The water is brackish even as high as West Point; but there must be a broad margin, a mile or two in extent, where the full tide of the sea meets the perpetual down-flow of the stream—an insect "valley of the shadow of death" hitherto unrequiemed and un-named.[6]

Actual experience seemed to support the miasmatic theory. Doctors began to report cures in the Highlands. In 1850, Dr. Robert Southgate, an army doctor at West Point, published an article in the *New York Journal of Medicine* that compared the effects of the cholera epidemics at the military academy and in other locales. He reported that West Point had escaped the 1832 epidemic and felt only minor effects of the 1848 epidemic, as a result of its distance from "marsh miasmata" and the beneficial effects of its mountain air.

Knickerbocker writer Nathaniel Parker Willis, author of *American Scenery* (1840), went to the Highlands and made a miraculous recovery. Before this, failing health had sent Willis on trips to Bermuda and the West Indies with little result. On instructions from his physician, Dr. Gray, he spent the summer of 1851 at the Sutherland House in Cornwall in the hope that the mountain air would cure his tuberculosis. He improved so much that he purchased property in Cornwall in 1853, setting up a country seat. Through his weekly letters to the *Home Journal*, which were later compiled into a book, *Outdoors at Idlewild*, he began to publicize the healthful surroundings of the area he described as the "Highland Terrace."

> To many the most essential charm of Highland Terrace, however (as a rural residence in connection with life in New York), will be the fact that it is the *nearest accessible point of complete inland climate*. Medical science tells us that nothing is more salutary than change from the seaboard to the interior, or from the interior to the seaboard; and between these two climates the ridge of mountains at West Point is the first effectual separation.[7]

The move to Cornwall prolonged Willis's life by another fourteen years, a fact not lost on his readers. He was a popular man, and large numbers of people read his articles. In his time, Willis ranked just behind Cooper and Irving as the most famous

American man of letters abroad, and was known not only for his literary prowess but also as a colorful figure on the New York scene. Oliver Wendell Holmes wrote that twenty-five-year-old Willis was "young . . . and already famous. . . . He was tall; his hair, of light brown color, waved in luxuriant abundance. . . . He was something between a remembrance of Count D'Orsay and an anticipation of Oscar Wilde. Lowell described him as 'the topmost bright bubble on the wave of the town.'"[8]

Willis carried on a lively correspondence with some of his readers, and when he spoke, people listened. He became one of the leading advocates for the idea that living on the shores of the Hudson could be healthy. In the December 1853 issue of the *Home Journal,* he quoted the following letter he had received from a reader:

> Mr. Willis.—*Dear Sir:—*
> I followed you to Idlewild with much interest, having a fellow-feeling on one point, at least, and watched to see whether you could get the mastery of disease. In your last letter, you say that you are no longer to be classed among consumptives. Alas! I can't say as much for myself, I fear. And on reading your lines, I resolved to write to you, as a once fellow-invalid, and ask, *What has cured you*? The doctors advise me to go South and take cod-liver oil, but their prescriptions do me no good. . . .
>
> . . . with true respect, A.D.G.

To this, Willis responded by detailing his philosophy and daily regimen:

> The patient who troubles himself least about his disease . . . but who perseveringly *outvotes it* by the high condition of the *other parts* of his system is the likeliest to recover. . . . I, for one, came very near dying—not of my disease, but of what my doctors took for granted. . . . I went to the Tropics, as a last hope to cure a chronic cough and blood-raising, which had brought me to the borders of the grave. I found a climate in which it is hard to be unhappy about anything—charming to live at all—easy to die. . . . I reached home in July, thoroughly prostrated, and, in the opinion of one or two physicians, a hopeless case. . . . After an unflinching self-examination, I came to the conclusion that I was myself the careless and indolent neutralizer of the medicines which had failed to cure me—that one wrong morsel of food or one day's partially neglected exercise might put back a week's healing. . . . There was not a day of the succeeding winter, however cold or wet, in which I did not ride eight or ten miles on horseback. With five or six men, I was, for most of the remaining hours of the day, out-of-doors, laboring at the roads and clearings of my present home. . . .
>
> With all this—and looking like the ruddiest specimen of health in the country around about—I am still . . . troubled occasionally by my sleep-robber of a cough; and, in Boston, the other day, on breathing that essence of pepper and icicles which they call there "East Wind," I was seized with the old hemorrhage of the lungs and bled myself weak again. But I rallied immediately on returning to this Highland air, and am well once more—as well, that is to say, as is consistent with desirable nervous susceptibility. The kiss of the delicious South Wind of today . . . would be half lost upon the cheek of perfect health.[9]

The *Home Journal* had 50,000 readers and, with a terrible health crisis in New York, everyone who could afford to do so followed Willis's example and came up the Hudson for the cure. Many river communities benefited, though Cornwall, where

Willis lived, became one of the most famous river towns for people seeking the cure or hoping to avoid getting sick by being outdoors. In 1866, Benson Lossing wrote that Willis's pen had been "as potent as the wand of a magician" in attracting summer residents from New York City.[10] When Willis first stayed at the Sutherland House in 1851, there were only a handful of boardinghouses in Cornwall. By 1873, there were dozens of them, hosting 6,000 visitors—both healthy and sick—for the summer season, which lasted from May 1 to November 1. Near Cornwall, in the Moodna Valley at Orr's Mills, almost a dozen boardinghouses sprang up.

Summer boarders arrived in ever-increasing numbers over a period of sixty years, the most prosperous time in Cornwall's history. Local residents wasted no time in taking advantage of the demand for housing. In the words of one observer, "the widow of modest means; the mechanic or laborer with a room or two to spare; the farmer in his old fashioned but comfortable home—all open their doors, during the season, to the city guest."[11] Today, many of these boardinghouses can still be seen in Cornwall and other Hudson River Valley communities, although most are now private residences. They are recognizable by their size and their nineteenth-century architecture.

At river resorts, the cure included rest, good food, exercise, and year-round exposure to sun and the outdoors. The same regimen was good for prevention of disease

House in Cornwall once used to accommodate summer boarders.

Copyright © 1990 by Robert Beckhard

as well, and the healthy mingled with the sick. This was not deemed to be a problem, since diseases were caused "by bad air." For healthy guests, and those who were ill but not bedridden, a typical day consisted of long walks through wooded glens and carriage rides along shaded drives, salt baths, and doses of cod liver oil. For the seriously ill patient, pills and syrups replaced daily exercise. Fresh foods—milk, meat, fruits, and vegetables—that were part of the health package so valued by city visitors contrasted starkly with their usual fare.

The notion of healthful mountain countryside had many promoters. Although physicians were the first to recommend Hudson River resorts, it was not long before steamboat and railroad companies spread the word to their customers. They sponsored guidebooks providing the names of hotels and boardinghouses and listing railroad and steamboat schedules, along with descriptions of the history and folklore of the sites to be seen by the traveler—all aimed at heightening the river's mystique. Such advertising had the desired effect, creating an economic boom for the transportation industry. Steamboats carried passengers from Europe taking the American tour, but also city residents heading up the Hudson for the cure.

Tourists would travel great distances upriver to enjoy the health benefits of outdoor life. A 1873 guidebook, *The Hudson by Daylight* by Wallace Bruce, suggested a trip to "Deserted Village," at Tahawus, site of the former McIntyre iron mine not far from the headwaters of the Hudson, where a connection

> can be made *via* the Adirondack railroad, from Saratoga to North Creek, [on the Hudson] and then 30 miles by wagon road: There is no place in the Adirondacks more accessible to all points of interest, and no place where a party of friends could well find health and pleasure so well combined. Two beautiful Lakes here are close at

Timetable for the steamboat *Mary Powell.*
Courtesy of Constantine Sidamon-Eristoff

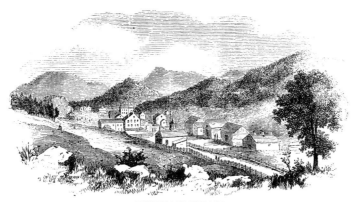

ADIRONDACK VILLAGE.

hand; Mount Marcy, the highest peak of the mountains, about seven miles distant, and the Hudson flows through the village. It speaks well for the health of the place that Mr. Moore brought his wife here an invalid, and now she often walks, in the winter, twelve or fifteen miles on snow-shoes; and we will add, by way of postscript, that she can shoot a rifle better than Murray. Mr. and Mrs. Moore will care for guests who visit them, at reasonable rates.[12]

Notably, four years later, in 1877, this property became a fish and game club for well-to-do men—the first of many to be organized in the region. The Adirondack Club leased the land from the iron company, and in 1898 the group changed its name to the Tahawus Club.[13]

The same guidebook suggested that Glens Falls, located on the upper Hudson between Saratoga and North Creek, was a "place to secure a game dinner, a dish of trout, and a 'taste' of the wilderness." There was "no healthier town in the state." It was also a place to experience the romance of the river by visiting the spots made famous in *The Last of the Mohicans*, where Alice and Cora Munro hide from the Huron braves who are trying to capture them. "A short distance from the Village, the Hudson River makes a descent of 72 feet in a succession of leaps over rugged rocks; and here is the famous cave so graphically described by Cooper. The width of the river at this point is about 900 feet."[14]

The works of local authors also contributed to widespread recognition of the healing powers of the lands along the Hudson. In *The Hills of the Shatemuc*—a best-seller by Susan Warner, who lived on Constitution Island in Cold Spring—one of the characters sends his children to the Hudson River Highlands for their health because "he knows that this is just the finest country in the world, and the finest air, and he wants them to run over the hills and pick wild strawberries and drink country milk, and all that sort of thing."[15] The book describes a common experience for families of means. Theodore Roosevelt, a sickly child who suffered from asthma, was sent to stay with relatives on the shores of the Hudson at Spuyten Duyvil near Riverdale (just north of Manhattan) in 1870. He had also stayed at the country home of John Aspinwall, farther north in Barrytown on the Hudson, near Rhinebeck. In 1868, when he was nine, he kept a diary of the visit to Barrytown, where he enjoyed long pony rides before breakfast, caught crayfish, eels, and water bugs in a brook, discovered fox burrows and weasel holes, and took trips to Cruger's Island (actually a peninsula in the Hudson).[16]

Adirondack Village, also known as "Deserted Village."

Lossing, The Hudson from the Wilderness to the Sea, 1866

There were also numerous mineral springs near the river, such as one in Columbia County, 4 miles from the city of Hudson, and, most famously, at Ballston and Saratoga, in Saratoga County. Adriaen Van der Donck may have been the first person to write about them when in 1656, he described how the Native Americans told him of places where mineral waters "are good for many ailments and diseases."[17] Resorts were developed in all of these locations, but Saratoga became the most famous watering hole in America; in 1876, over 100,000 people visited in the summer season. The Mohawk and Hudson railroad linked the steamboat landings of the Hudson with the resort areas at Saratoga and nearby Ballston, and eventually this line connected with railroads along the Hudson River shoreline, south to New York City and north to the Adirondacks. These two spas were not in sight of the Hudson, but getting to them required a trip alongside it, contributing to the notion of going up the river for health.

After the Civil War, improved railroad and steamboat connections made it possible to go into more remote parts of the Adirondacks, outside the Hudson's watershed. Dr. Edward Livingston Trudeau cured himself of a very serious case of TB through outdoor living in the Adirondacks, and in 1876, he established a sanatorium at Saranac Lake where people of modest means could come for the cure.[18] This added to the popularity of the lake regions, as did a growing number of popular guidebooks, and getting to any part of the Adirondacks still required a train ride up the Hudson's shores.

Theodore Roosevelt's father took him camping in the Adirondacks in 1871, in hopes that it would build his health and strength—which it did. The family rowed for miles in lakes and streams, took shelter from thunderstorms under their boat, caught trout for dinner, and camped in the wilderness. By the light of the campfire, Roosevelt's father read *The Last of the Mohicans*, putting the son into a sound sleep. Young Roosevelt, a budding naturalist at age twelve, kept a diary of the birds he saw, noting their species names.[19] His interest in birds would last a lifetime, and this visit to the north woods would later affect his policies on the Hudson and elsewhere when he served in public office as a state legislator, governor, and president.

Not all of the summer visitors who went up the Hudson were ill. Eventually the river attracted a variety of institutions to address urban woes, such as hospitals, orphan homes, and institutions. Vassar Hospital and the Hudson River state mental hospital in Poughkeepsie are examples. Sing Sing prison, in Ossining, later gave the term "going up the river" yet another meaning.

The out-of-doors movement, which gained a following from the 1830s through the 1850s, also boosted the reputation of the Hudson. Prior to this, outdoor sports were generally thought to be frivolous and irresponsible, "not fit for a Christian."[20] There were exceptions, of course. Ben Franklin, who pioneered so many things, urged swimming and outdoor activity. Books and magazines published around 1800 judged sports to be a waste, perhaps sinful—certainly not suitable for a serious businessman. James Fenimore Cooper helped change this idea through his novels, in which figures like Natty Bumppo, the skilled woodsman, were people of great moral character. In the 1840s, the books and essays of Henry William Herbert, using the pen name Frank Forester, glorified the life of the skilled woodsman as someone "truly representative of his country."[21] He urged businessmen to get out of their offices for the physical, spiritual, and moral benefits to be found in tramping through forests and fields. His books were very popular and encouraged people to explore the

woods. Locally, this led to new interest in hunting and fishing in the Adirondacks, both on the upper Hudson River and on the lakes and streams of the interior. Adirondack guides, the ultimate skilled woodsmen, were soon sought out to accompany wealthy people into the forest. As a result, Americans deepened their relationship with nature and the outdoors. Viewing waterfalls and grand scenery didn't require much effort. Tracking a deer or understanding the habits and preferences of a trout well enough to catch one required study, experience, and time.

The idea of taking a summer vacation got started in this period—as did popular interest in summer camping, hiking, hunting, fishing, swimming, bicycling, rowing, boating, and yachting. Croquet, which made its debut in 1866, was soon considered a healthy form of exercise.[22] America also woke up to the need to preserve green spaces in cities, and the idea of going to a park for recreation took hold. Edwin L. Godkin, in *The Nation*, urged doctors to prescribe long walks instead of rest. "They

(top) Hudson River State Hospital in Poughkeepsie, New York.
1907 postcard, author's collection

(bottom) Sing Sing prison in Ossining, New York.
1905 postcard, author's collection

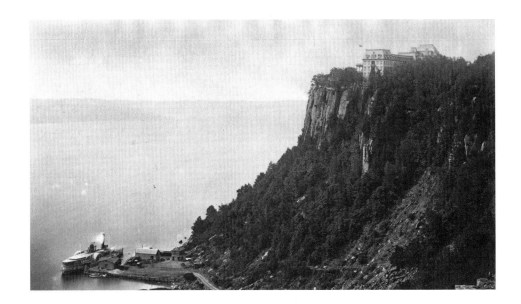

should insist that a patient walk from NY to Niagara or urge him to help the Appalachian club build its trails."[23]

Because of these changing ideas and the increase in the number of middle-class people with time and money to spend, resort and recreation development surged all along the river, accessible by rail and by steamboat, not only from New York City but also from Boston, Philadelphia, and the Midwest. Fine hotels were built in every major city. In rural areas, boardinghouses expanded—and expanded again.

Most interesting were the "mountain houses." Modeled after the original Catskill Mountain House, built in 1824, large numbers of them appeared on the shores of the river in the six decades that followed. They were America's first resort hotels, and they served the new leisure class. Large grounds for hiking, croquet, and other outdoor activities set them apart from the numerous other hotels that sprang up on the river shore at the same time. Any spot with magnificent vistas, cliffs, waterfalls, and wooded glens was sure to develop its own mountain house, and such places stretched all the way from the Palisades into the Highlands, the Catskills, and the Adirondacks. Close behind the Catskill Mountain House in popularity, for people from home and abroad, were the Palisades Mountain House in Englewood, New Jersey, and Cozzens' Hotel, in the Highlands. Another famous mountain house overlooked the Cohoes Falls in Waterford, on the Mohawk River, near where it flows into the Hudson.

Built in 1869, the Palisades Mountain House enjoyed a brief but glorious history before it burned in 1884. With Victorian towers, a mansard roof, and a dozen or more Greek columns at the entrance, the hotel perched on the cliff's edge, 350 feet above the Hudson, near a spot known as Devils's Elbow, just 9 miles from Manhattan. The Palisades Mountain House could be reached by rail or by a short trip on one of two daily steamboats. It was a popular summer getaway for businessmen and politicians. From the porch, the views of the valley were outstanding. In the far distance, the visitor could see Staten Island and the harbor; closer in, Spuyten Duyvil Creek and New York City, "with its miles of docks and groves of masts." The view directly below the veranda looked out on the Tappan Zee, dotted with sails. An access road, which zigzagged up the cliffs from the steamboat landing, provided a rare opportunity for visitors to ascend the steep cliffs of the Palisades.

The Palisades Mountain House, Englewood Cliffs, New Jersey, photographed by Seneca Ray Stoddard. The hotel was later destroyed by fire.
Courtesy of the Chapman Historical Museum, Glens Falls, NY

Cozzens' Hotel opened in 1849, on the grounds of West Point, a year after the railroad station opened across the river at the Garrison ferry landing. When the original building burned down in 1861, the hotel relocated to a promontory on the Hudson just south of West Point's Thayer Gate in adjacent Highland Falls, where it became part of the picturesque landscape shown in guidebooks. It grew into one of the largest summer hotels in the Hudson Valley, hosting such dignitaries as the Prince of Wales and serving as the summer headquarters of West Point Commander Winfield Scott.

Many wealthy New York businessmen moved there for the summer, bringing their wives and children and commuting to the city by ferry to Garrison, and thence by rail to Wall Street. J. Pierpont Morgan was a frequent entry on Cozzens' guest list—he found Buttermilk Falls (as Highland Falls was known in those days) to be so lovely that he later purchased a large estate on the Hudson River bluffs just down the road and became one of the area's more celebrated residents.

Far from the Hudson, but still part of the Hudson Valley mountain house tradition, is Mohonk Mountain House in the Shawangunk Mountains at New Paltz, New York, along the Wallkill River, a tributary of the Hudson. Built in 1869, it is the only remaining mountain house of this era still in operation. Because the owners of Mohonk, a Quaker family, sought to ensure the stewardship of the land as part of their resort management goal, a hotel guest or day visitor today can enjoy many aspects of the nineteenth-century experience. Like the Catskill Mountain House site, Mohonk is about 12 miles from the river, although it has no view of the Hudson. Instead, it perches on gray-white ledges above a mountain lake overlooking the Catskills. With miles of carriage roads and walking paths, magnificent scenery, and numerous rustic gazebos that offer breathtaking views, it is a reminder of the kind of resort and pleasure grounds that once lined the shores of the Hudson. For many decades, visitors arrived by trolley from a steamboat landing on the Hudson in Highland, and traveled the rest of the distance by horse and carriage. Today, the steamboat landing and the trolley are gone, but the mountain house experience remains.

Fire, changing fashions, and boom-and-bust cycles of the economy destroyed most of the other mountain houses of the era. After the Civil War, and partly in reaction to it, other, more distant resort areas—such as West Virginia and Florida—gained popularity. However, the Hudson still retained its reputation as a healthy place and a vacation destination, where numerous hotels competed in elegance. Garrison had a fine hotel, the Highland House, known for its "healthy" setting on a picturesque plateau above the river, where brooks, glens, and waterfalls offered the guest ample opportunity to explore. It was so popular that it doubled in size after the Civil War. South of the Highlands, resorts spread atop the Palisades on the west shore of the river, from Englewood Cliffs to Haverstraw. In the summer, resort hotels and boardinghouses doubled the population of the Village of Nyack.

For those who couldn't afford to spend a night, a week, or a season at a hotel, there were daytrips up the Hudson to picnic grounds and amusement parks, where playing became a form of therapy. The Elysian Fields at Weehawken near Hoboken were famous for strolling and offered fine views of the harbor. Iona Island, in the Highlands, became a favorite retreat for day visitors in the 1870s. It eventually had a Ferris wheel, carousel, and picnic ground in addition to the pleasure grounds of its resort hotel and the vineyards of its former owner, Dr. Grant (who developed the Iona grape there).

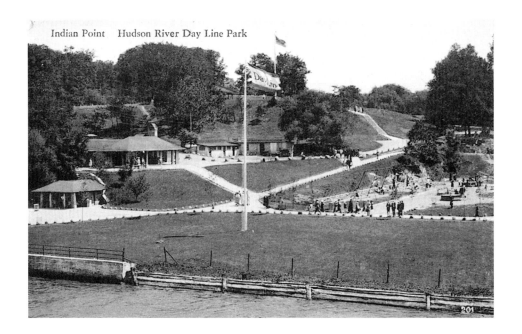

Drinking was often encouraged at such parks, and they attracted large, noisy crowds. A beer garden and a public beach for swimming in the Hudson sat below the Palisades. In 1898, the Palisades Amusement Park opened atop the cliffs in Cliffside Park, New Jersey. One of the largest amusement parks in the United States—featuring a saltwater pool with waves, three giant Ferris wheels, and roller coasters—it closed in 1971, to be replaced by high-rise apartment houses.[24]

Boisterous crowds of a very different kind flocked to revival camps on the shores of the Hudson, where "thunderous preaching" in the beautiful natural surroundings was meant inspire a deeper relationship with God's creation. Methodists assembled at Camp Woods, on the Van Cortlandt property, at the mouth of the Croton River, in 1805. By 1831, the retreat had grown so popular that it moved to a larger site, 3 miles upstream from Ossining, on another Hudson tributary. There, people from Long Island, New York City, and New Jersey celebrated week-long religious jubilees at the "Cathedral in the Woods." In August 1868, 15,000 people attended the camp meeting. For Swedish immigrants living in Brooklyn and Lower Manhattan, Camp Woods was not enough; they had a floating church on the Hudson—the *Bethelskeppet* (Bethel ship)—moored in New York harbor.[25] Other popular religious retreats included Dudley Grove, in Hastings, and Riverside, a Methodist camp on the upper Hudson at what is now Riparius, still in operation. The Jesuits established a retreat in West Park in 1876, and later purchased the estate of John R. Stuyvesant, in Hyde Park, which became St. Andrews-on-the-Hudson (now owned by The Culinary Institute of America). By 1939, there were many more religious retreats, monasteries, camps, and colleges on the shores of the Hudson, of which many remain.

Throughout the nineteenth century, the Hudson came to be associated with physical and spiritual health and developed as a resort area, playground, and retreat. The steamboat, the railroad, ideas about health and disease, as well as the fad for touring—and the guidebooks that promoted the tours—all made this possible. However, it was the powerful pen of the Hudson's key publicist, Nathaniel Parker Willis, that may have done the most to spread the word to an eager public and bring city people up the river in large numbers. His own cure was an example to the world.

Indian Point Park, Verplanck, New York.
1930 postcard, author's collection

As a Knickerbocker writer, he also publicized the romantic appeal of the river. In his letters to the *Home Journal*, he first advanced the idea of changing the names of some of the more picturesque mountains, rivers, and villages. "In the varied scenery of our country," he wrote, "there is many a natural beauty, destined to be the theme of our national poetry, which is desecrated with any vile name given it by vulgar chance." He set an example by changing the name of his own property in Cornwall. He wrote: "When I first fell in love with it, and thought of making a home amid its tangle of hemlocks, my first inquiry as to its price was met with the disparaging remark, that it was of little value—*'only an idle wild!*—of which nothing could ever be made.' And that description of it stuck captivatingly in my memory. 'Idle-wild!' 'Idle-wild!'"[26]

Willis soon dreamed up new names for other places, drawing on Indian legends or poetic images, and proposed them in his column. Near his Idlewild estate, he found several places bearing offensive names, such as Murderer's Creek. Others, like Bull Hill, he considered to be uninspiring descriptions of the grand scenery they identified. So he began to refer to them with new names in the weekly columns, and it was not long before the public and the mapmakers joined in. Under his persuasion, Murderer's Creek became Moodna Creek, Cold Spring's Bull Hill became Mount Taurus, and Cornwall's Butter Hill became Storm King Mountain. In bestowing evocative names on mountains and streams, Willis enhanced the emotional appeal of the Hudson's scenery and helped assure its preservation a century later. The battle cry to "save Storm King," the subject of a future chapter, would not have been so powerful if the mountain were still called Butter Hill.

Others joined the fun. Resorts gave romantic names to every rock and vista. Lover's Rocking Stone, Giant's Haunt, Erlin's Bluff, Home of the Fairies, Natural Bridge, Poised Rock, and Giant's Slipper are among the "walks and drives" listed in Beach's book *Cornwall*. Similar names can be found for sites around the Catskill Mountain House and the Mohonk Mountain House. The tradition of renaming places to capture the romance of the Hudson continues to this day—in 1997, the village of North Tarrytown officially became Sleepy Hollow to capitalize on its connection to the romantic Hudson River Valley portrayed by Washington Irving.

Riverside, on the Hudson, now Riparius, New York, site of a Methodist camp.
Undated postcard circa 1910, author's collection

The pursuit of the cure amid inspiring scenery lasted long after Willis's death in 1867, permanently changing the pattern of land development along the Hudson. Resorts, cottages, boardinghouses, picnic grounds, swimming beaches, beer gardens, and amusement parks filled in the open spaces between the industrial cities. Many farms started producing specialty crops—grapes, raspberries, and other fresh produce—to supply the needs of summer visitors. The demand for fresh milk, fruits, and vegetables to serve at resorts helped preserve the pastoral landscape of farms, vineyards, and orchards that might otherwise have disappeared due to competition from the fertile Midwest after the Erie Canal opened.

After the Civil War, as rail transportation and changing fashion favored other resort and health spa regions, a new type of development began along the Hudson—estates and summer homes for wealthy New Yorkers. This started modestly in the 1840s but blossomed in the 1880s, so that the eventual decline in resorts was replaced by an increase in country seats, where successful businessmen and their families could imitate the European aristocracy while enjoying the healthy surroundings. During these years, the value of river property rose as increasing numbers of city dwellers built houses in the rural, nonindustrial areas along the river—where they were close enough to commute to New York on their own yachts or by railroad. Farmers sold their property and moved inland, as Willis noted in the April 1853 issue of the *Home Journal*:

> I met one of my neighbors yesterday, seated in his wife's rocking-chair on top of a wagon-load of tools and kitchen utensils, and preceded by his boys, driving a troop of ten or fifteen cows. As he was one I had always chatted with, in passing, and had grown to value for his good sense and kindly character, I inquired into his movements with some interest. He was going (to use his own phrase) "twenty miles farther back, where a man could afford to farm, at the price of the land." His cornfields on the banks of the Hudson had risen in value, as probable sites for ornamental residences, and with the difference (between two hundred dollars the fancy acre, and sixty dollars the farming acre) in his pocket, he was transferring his labor and his associations to a new soil and neighborhood. With the market for his produce quite as handy by railroad, he was some four or five thousand dollars richer in capital, and only a loser in scenery and local attachments. A Yankee's pots and kettles will almost walk away on their own legs, with such inducement. . . .
>
> A *class who can afford to let the trees grow* is getting possession of the Hudson; and it is at least safe to rejoice in this, whatever one may preach as to the displacement of the laboring tiller of the soil by the luxurious idler. With the bare fields fast changing into wooded lawns, the rocky wastes into groves, the angular farm houses into shaded villas, and the naked uplands into waving forests, our great thoroughfare will soon be seen (as it has not been for many years) in something like its natural beauty. It takes very handsome men and mountains to look well bald.[27]

The transition from woods and farms to fancy estates changed the character of the landscape along the Hudson in dramatic ways. It was well under way in 1853, when Willis wrote his commentary, and continued until the turn of the century, turning rural shores on both sides of the Hudson into a "velvet ribbon."

By contrast, during much of this same period, the industrial activity in river villages and cities surged. Along the Hudson, brickyards, lumberyards, iron foundries,

bone mills, sugar mills, shipyards, and textile mills expanded significantly in the Civil War era.[28] From the Adirondacks to the harbor, quarries, mines, smoke-belching factories, and piled-up logs alternated with the natural scenery. With this expansion came even greater prosperity for the region's successful businessmen—wealth that allowed many of them to purchase estates, build expensive new homes, and plant lush gardens where their families could enjoy the healthy outdoor life and escape from noise and pollution.

This "new class who can afford to let the trees grow" created a unique business opportunity for the Downing nursery in nearby Newburgh—for the new country squires required not just trees and shrubs but also advice on landscaping. For the nurseryman, a person who had spent his youth exploring the romantic scenery of Newburgh Bay and the Highlands, the new clientele offered a way to test the ideas he was developing. The result was the birth of a new American art form: the landscape garden.

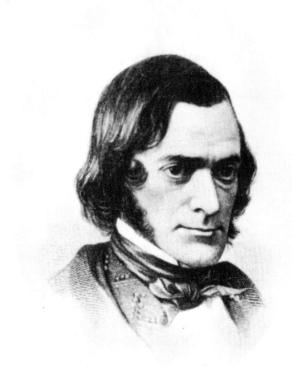

Design with Nature

The Landscape Gardens of A. J. Downing, the Architecture of A. J. Davis, and the Inspiration for Central Park and Riverside Drive

8

ON SATURDAY, MARCH 14, 1835, an unsigned article appeared in the *New York Mirror*, titled "America Highland Scenery. Beacon Hill." The article urged lovers of the picturesque to discover the scenery from a "commanding" summit where beacon fires had been lighted during the Revolutionary War. The sunset seen from Beacon Hill, the author said, surpassed the renowned sunrise seen from the Catskill Mountain House, and the Hudson—a bare line in the distance from the Catskills escarpment—flowed majestically below the summit. The scenery was more cultivated and luxuriant than the bleak and savage countenance of the Catskills, as well:

(top) Andrew Jackson Downing (1815–1852). He was described by a friend as a tall, dark-eyed, Spanish-looking gentleman who carried himself with quiet dignity and a certain aristocratic hauteur. *Downing*, Architecture of Country Houses, *1969*

(bottom) The Horticulturist and Journal of Rural Art and Rural Taste, *reproduced in Haley, ed.*, Pleasure Grounds, *1988*

> The Hudson—the prince of rivers! It appears to you that you see it rising like a silvery rivulet, thirty miles north of you in those distant hills, gradually widening, meandering, spreading life and freshness around, until here it loses itself, a deep, broad, powerful torrent in the rent chasm of the Highlands. . . .

In every direction the country is full of beauty, and presents a luxuriant and culti-vated appearance which is rare in mountain views in America. . . . Neat farm-houses are profusely scattered over the green and fertile fields, and here and there along the river is seen the beautiful and costly villa. . . . But ah! the eye wanders to that glorious spectacle, the noble chain of hills which forms the boundary, the frame, the setting to this superb picture.[1]

The author was Andrew Jackson Downing, a nineteen-year-old nurseryman from Newburgh, who loved to explore the countryside of Newburgh Bay and visit the fancy estates springing up here and there along the shores of the Hudson, where he would sell his trees. This essay in the *New York Mirror* was an early attempt to com-municate his thoughts about the scenery he loved so well. The cultivated country-side that he saw from Beacon Hill inspired him with a "superb picture" in which the noble hills framed a setting of "neat farm-houses" and "beautiful and costly villas" along the river.

Downing wrote this essay just ten years after Thomas Cole's sketching trip up the Hudson, which whetted the public thirst for landscape painting, an enthusiasm he shared. Over the coming years, as Downing climbed and rambled, his imagination took flight. Could the beauty of nature, so evident along the Hudson, be enhanced as if the landscape itself were a work of art? Like an artist who might draw a boulder here and a twisted branch there to give balance to a painted scene, perhaps a gar-dener could arrange the features of the landscape in an expressive, beautiful, and uplifting design. Trees could be placed to combine harmoniously with the natural scenery, and farms and villas could be designed with an eye to improving the view.

His nursery business provided the opportunity to test these ideas on the shores of the river. Then, at age twenty-six, Downing published the first of several books that would change the face of America. His passion would persuade generations of his countrymen to design and landscape their homes in harmony with nature. Follow-ing his advice, countless communities planted trees along their barren streets, and villages established public parks where people without land of their own could enjoy nature, restore their health, and refresh their spirit. Along with Knickerbocker poet William Cullen Bryant, Downing would be a leading advocate for the creation of New York's Central Park, and his followers would lead the way in establishing state and national parks. Downing saw this as a pathway to a larger purpose. He hoped to improve the moral fiber and character of his countrymen, exposing people to the civilizing effects that come from enjoying natural beauty. He was moved by patriotism.

Downing set about defining a new art form—the landscape garden—through which he would elevate the taste of the nation. Steeped in the romanticism of his day, he applied ideas of the sublime and the picturesque to the design of homes and home landscaping. He showed people how to bring the beauty of nature into their own backyards. He teamed up with architects to illustrate new designs for homes that would complement their setting in nature, giving them the stamp of American character.

Born in October 1815, Andrew Jackson Downing was the son of a wheelwright-turned-nurseryman. When he was seven years old, his father died, and his older brother, Charles, took charge of the family and the Newburgh nursery. Poverty pre-vented Andrew from going to college, so at age sixteen, he joined his brother in the

management of the family business. Their clients were wealthy New Yorkers who purchased plants, trees, and shrubs to landscape their fine country seats on the banks of the Hudson. Andrew visited these estates often, admiring the "pleasure grounds" and offering suggestions on how to use his nursery plants in landscaping them.

Soon, Andrew began to train himself in landscape design. He read the works of famous English landscape gardeners who promoted the naturalistic style that was becoming popular in England. He visited the famed Hudson River estate, Hyde Park, where he saw one of the first such romantic landscape gardens in America. It had been designed by André Parmentier, of Brooklyn, for the country home of Dr. David Hosack—Governor DeWitt Clinton's physician and sponsor of one of America's first botanical gardens. The 700-acre landscape afforded panoramic views of 60 miles of the Hudson's course and was legendary among those who enjoyed scenery. It was a favorite stop on the American tour for wealthy travelers fortunate enough to have a letter of introduction. Hudson River School artists loved to paint and sketch on the grounds.

Without question, nature had amply blessed this place; however, what interested Downing most was the way Dr. Hosack and Mr. Parmentier had used the "hand of art" to make it even more beautiful. He saw how newly planted clumps of trees and winding carriage roads through fields and forests could be "laid out in such a judicious manner as to heighten the charms of nature." He lingered at pavilions where the best vistas could be seen, and he admired a pretty bridge over a lively stream. Certainly, for its time, this was "the finest country seat in America," he concluded.[2]

Downing visited other estates, up and down the Hudson River, developing his expertise while selling apple trees, raspberry bushes, and exotic plants such as the night-smelling jasmine and Scotch rose. At one of these summer villas, Downing had the good fortune to meet a foreign nobleman who took an interest in him and introduced him to society. Baron de Liderer, an Austrian consul general, shared Downing's passion for botany and mineralogy, and the two became fast friends. As the friendship grew, Downing was welcomed into the company of the baron and his neighbors. In their homes he encountered a grace and refinement that fascinated him throughout the rest of his life. Downing began schooling himself, shedding his country manners and developing a gentlemanly polish. He also became friends with Raphael Holye, an artist who showed him how painters compose landscape elements on canvas—ideas that young Downing could then apply to his living works of art.

At one of the beautiful estates along the Hudson, Locust Grove in Fishkill, he also met and wooed the beautiful young heiress Caroline de Windt; they married in 1838, when he was twenty-three. It was a happy marriage of two people who shared a love of books and ideas, and an appreciation of nature.

Soon, he was consumed with designing a house and its grounds for himself and his bride as a work of art equal to any painting or statue. He built a Gothic villa on 11 acres overlooking the Hudson in Newburgh, a design unlike anything that had been seen in the area—one he thought would complement the scenery of the Highlands, echoing the forms of the mountains. He adorned the landscape with arabesque flower beds, wisteria arbors, and views of the distant Hudson wreathed by foliage as if in a picture frame. On the parklike lawn he placed classical stone vases and urns of flowering plants.[3]

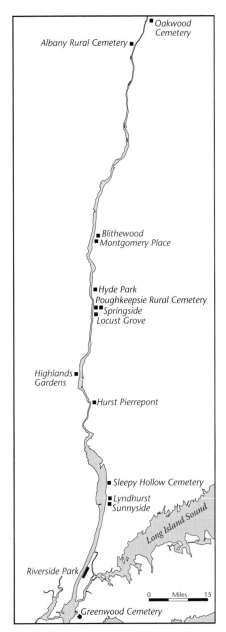

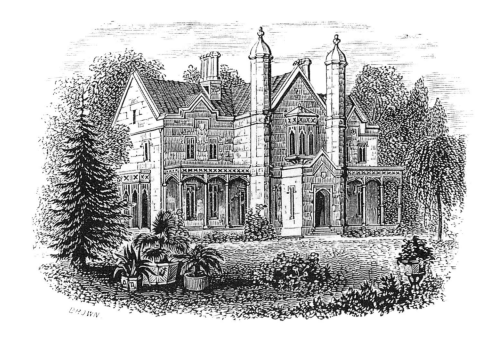

So successful was this experiment that Downing decided to encourage others to
do the same. He began to set his thoughts on paper and proposed a book on land-
scaping and architecture to several publishers.

About this time, he visited Robert Donaldson at Blithewood, in Annandale-on-
Hudson (now part of Bard College), where he provided plants and landscaping ad-
vice. Donaldson suggested that Downing meet Alexander Jackson (A. J.) Davis, a
prominent New York City architect, and provided a letter of introduction. Davis
specialized in the Greek Revival style and designed such famous buildings as the
customs house in New York (now Federal Hall) and the North Carolina state capitol
in Raleigh (both designed with his firm, Town and Davis). He had recently started
designing country homes for wealthy clients in the Hudson Valley, where he experi-
mented with picturesque styles of architecture to harmonize with the settings of
wild nature along the river. In 1836, he had designed two Gothic Revival gatehouses
as well as romantic landscaping for Blithewood, and—with a loan of $135 from Don-
aldson in 1838—had published *Rural Residences*, a book of architectural design that
offered alternatives to the popular Greek Revival style. He suggested that most
American rural homes were "bald and uninteresting" and lacked a connection to
their site.[4] In place of the symmetrical box or the temple with rows of columns, he
proposed "villas" with towers, gables, pinnacles, bay windows, and verandahs. He
suggested putting decorative wooden brackets under the eves of the roof, an innova-
tion that became known as the American bracketed style (memorialized by Edith
Wharton in her novel *Hudson River Bracketted*), and the use of stained-glass
windows.

Here was a man after Downing's heart, and the two struck up an immediate
friendship. In Davis, Downing had found someone who shared his enthusiasm for
picturesque landscape, as well as a talented artist and architect. Downing asked Da-
vis to illustrate the book he was writing.

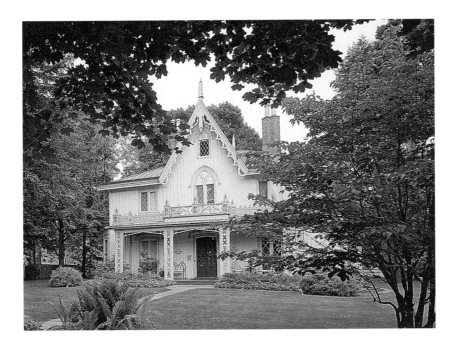

In 1841, Downing's book appeared in print—a work of more than 400 pages, illustrated with engravings of houses and landscapes drawn by A. J. Davis. The full title gives an indication of its scope and style: *A Treatise on the Theory and Practice of Landscape Gardening, Adapted to North America with a View to the Improvement of Country Residences Comprising Historical Notices and General Principles of the Art, Directions for Laying Out Grounds and Arranging Plantations, the Description and Cultivation of Hardy Trees, Decorative Accompaniments of the House and Grounds, the Formation of Pieces of Artificial Water, Flower Gardens, etc. with Remarks on Rural Architecture*. The book was wildly successful and established Downing as the chief American authority on landscaping. Over the next 80 years, 10 editions were published, the last one in 1921. The success of his book catapulted Downing to international celebrity. He was elected to the Royal Botanic Society of London and to the horticultural societies of Berlin and the Netherlands. After reading it, Queen Anne of Denmark sent him a magnificent ring.

Downing's book also furthered the career of A. J. Davis, as large numbers of people tried out the fresh new styles of architecture they saw on its pages. For decades, clients eagerly sought out Davis, commissioning him to design villas, castles, college campuses, state capitols, and public buildings in many states from Massachusetts to North Carolina.

In the *Treatise*, Downing explained the ideas of landscaping and architecture that he and Davis had developed in discussions with clients on Hudson River estates. Instead of the formal, geometric, and highly stylized landscaping then in vogue, the book promoted a fluid and graceful "natural" approach that does not set itself apart from nature but echoes the forms to be found in the surrounding landscape. Downing suggested that the natural style, which had originated in England, could be adapted to North America, improving the American scene and uplifting the spirits of the citizenry. At the time he was writing, landscaping was done primarily

The Delamater House (1844), designed by Alexander Jackson Davis, now part of the Beekman Arms Inn, Rhinebeck, New York. Davis invented the roof bracket style that became particularly associated with Hudson Valley architecture and popularized the use of board-and-batten siding, first used at Robert Donaldson's gatehouse for Blithewood and shown here. He also pioneered the Gothic style with its use of peaked gables, decorative vergeboards, bay windows, chimney pots, finials, towers, and verandahs.
Courtesy of the Dutchess County Planning Department, photograph by John Clarke

on the large landed estates. It was his belief, expressed in the *Treatise*, that landscaping could be applied equally well to small cottages. Home beauty was an outward expression of inward good, he wrote, and for that reason possessed a moral and spiritual value that would benefit all of America. While the Hudson River School painters searched for wild scenery to guide them spiritually, Downing saw how people could bring this relationship with nature into their own homes and lawns.

Along the banks of the Hudson River, where the constantly varying forms of water, shoreline, and hills offered a variety of home sites and distant views, the natural style was taking hold, Downing said. By studying the examples offered by several of these properties, the principles of landscape gardening could be learned. Donaldson's Blithewood estate, where Davis had designed both the grounds and some of the structures, was one of the best:

> The natural scenery here, is nowhere surpassed in its enchanting union of softness and dignity—the river being four miles wide, its placid bosom broken only by islands and gleaming sails, and the horizon grandly closing in with the tall blue summits of the distant Kaatskills. The smiling, gently varied lawn is studded with groups and masses of fine forest and ornamental trees, beneath which are walks leading in easy curves to rustic seats, and summer houses placed in secluded spots, or to openings affording most lovely prospects. . . . In various situations near the house and upon the lawn, sculptured vases of Maltese stone are also disposed in such a manner as to give a refined and classic air to the grounds.
>
> As a *pendant* to this graceful landscape, there is within the grounds scenery of an opposite character, equally wild and picturesque—a fine, bold stream, fringed with woody banks, and dashing over several rocky cascades, thirty or forty feet in height. . . . There are also, within the grounds, a pretty gardener's cottage, in the rural cottage style, and a new entrance lodge by the gate in the bracketed mode; in short, we can recall no place of moderate extent, where nature and tasteful art are both so harmoniously combined to express grace and elegance.[5]

A chapter on "Rural Architecture" suggested that the design of a country home should harmonize with its setting. Picturesque scenery required a picturesque

Examples of the beautiful (left) and the picturesque (right) from Andrew Jackson Downing, *A Treatise on the Theory and Practice of Landscape Gardening*, 1859 edition.

Author's collection

house. The book included sketches of Swiss, bracketed, and castle styles, as well as illustrations of Gothic Revival villas designed for Hudson River country seats by Davis and others, including Montgomery Place, the home of Mrs. Edward Livingston in Barrytown; Kenwood, the estate of Joel Rathbone in Albany; and Beaverwyck, the estate of William P. Van Rensselaer on the east shore of the river above Albany. Such styles were new in America, and only the most adventurous architects had attempted them, often for clients on the Hudson.[6]

Downing intended his *Treatise* to provide advice to hundreds of individuals who wished to ornament their house and grounds but lacked the knowledge to proceed. Studying the example of tasteful Hudson River estates would teach them what they needed to know. Through the works of the Hudson River school painters and the Knickerbocker writers, the Hudson Valley was already becoming associated with American identity and national pride. The American tour gained popularity at the same time that the first edition of the *Treatise* appeared. Downing rode the crest of this wave. He would make the Hudson a model for the nation in a new way, using the same principles that guided the painters and the writers, but applying them to the home landscape.

"Weeping Ash." *Downing,* A Treatise on the Theory and Practice of Landscape Gardening

Using the ideas of romanticism, he distinguished two types of gardens: the "beautiful" and the "picturesque." The beautiful landscape garden, he said, was organized and symmetrical. The picturesque one, on the other hand, was irregular, designed to heighten the sense of power in nature's struggle with opposing forces—the upheaval of mountains by convulsion, and valleys broken by chasms.

In Downing's view, the design of the beautiful landscape was to be achieved through easy, flowing curves, soft surfaces, and rich, luxuriant growth. Trees should be smooth-barked varieties with rounded heads of foliage, such as ash or elm, planted apart, so their forms could develop to the fullest. Walkways should follow the natural lay of the land. Lakes should have masses of flowering shrubs on their borders. Lawns should be mowed soft like velvet. The house should be of classical design—Italian, Tuscan, or Venetian.

By contrast, the house in a picturesque landscape setting should have "bold projections, deep shadows, and irregular outlines," such as those found on an Old English or Gothic mansion or a Swiss cottage. The grounds should be characterized by spirited irregularity, abrupt and broken surfaces, and growth "somewhat wild and bold in character." The picturesque was the form Downing preferred, perhaps in response to the wild scenery that had influenced his childhood. For this style he suggested massed plantings of rough-barked pines, larches, and other trees of striking, irregular growth. Walks and roads should turn at sudden angles, preferably offering glimpses of distant views. Lawns should be mowed less frequently. Streams cascading in secluded dells were to be imitated and preserved.[7]

The choice of a beautiful or picturesque landscape design should reflect both the architecture of the home and the setting, Downing suggested. He urged readers to select sites that not only offered the best views but also enhanced the view in which the home itself was framed. To blend houses into their natural surroundings, he advocated the use of earth colors such as cream, fawn, drab, or stone gray instead of the white paint that had become fashionable with the rise of Greek Revival style. "*White* is a color which we think should never be used except upon buildings a good deal surrounded by trees, so as to prevent its glare."[8] For the same reason he preferred the use of natural materials such as timber and stone.

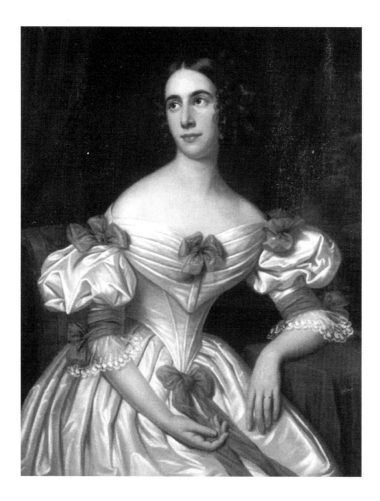

Coralie Livingston Barton. Attributed to Jacques Amans.
Courtesy of Historic Hudson Valley

Drawing on Davis's ideas, he also urged that a house should have porches to provide a transition from indoors to outdoors, and windows should be oriented toward the best vistas.

The remodeling of Blithewood, which focused on capturing river views, provided much of the inspiration for these ideas. Davis added a decorative veranda around Donaldson's blocky Federal-style house, and in 1845, with Davis's help, Donaldson built a "picture room" for his collection of oil paintings, adding a special 3-by-4-foot oval plate-glass window overlooking the river and the Catskills on the west side of the gallery. He framed the window with rich moldings as if the view were a painting, and called it a "landscape window," displaying a work of art by the ultimate "Old Master," the creator.[9]

Though Blithewood provided the inspiration for ideas on architecture, it was at neighboring Montgomery Place where Downing found the best example of landscape design. Cora Livingston Barton, a descendant of the "Lord of the Manor," began to transform the grounds to create a variety of experiences like those Downing described in 1847, in *The Horticulturist* (of which he had become the editor). The Morning Walk, said Downing, took the visitor down a path that led from the house to the river and a rustic pavilion. Deeply shaded, it wound along the Hudson's rocky shore to the music of gently dashing tide waves. "At numerous points, vistas or long reaches of the beautiful river scenery burst upon the eye."[10] Nearby, a boat was moored to provide a chance to see the scenery of Montgomery Place from the water. From the dock, a path led into The Wilderness, a grove of old forest, mountain lau-

rel, and evergreens. There, the sounds of waterfalls drew one to The Cataract, and below it The Lake, where another little vessel named *Psyche's boat*, with a giant butterfly on its prow, lay waiting for the visitor to enjoy the spirit of repose. From The Lake, a leaf-carpeted path along the stream guided the visitor out into the sunny, open pleasure grounds, with an arched greenhouse conservatory and flower gardens full of specimens purchased from the Downing nursery. Beyond that was The Drive, a route through 50 acres of oak and chestnut woods meant to be traveled by carriage or on horseback. In all, about 5 or 6 miles of roads and walks wound through the grounds.

Downing's guiding principle was design with nature—the harmony of buildings and scenery. A country residence and its grounds should make "such a composition as a landscape painter would choose for his pencil."[11] Americans proved very sympathetic to the notion of the home landscape as a work of art, and soon others began to promote it. A year after the publication of the *Treatise*, Edgar Allan Poe wrote a piece for the *Ladie's Companion* called "The Landscape Garden." This essay was later incorporated into the tale "Domain of Arnheim," which Poe completed in 1847. A man has inherited $450 million is faced with the decision of how to spend it. Should he indulge in the fashionable extravagances? Perhaps, instead, he should invest in political intrigue, or the purchase of nobility, or patronage of the arts and letters. Ultimately, the heir decides to use his fortune to create his own supreme work of art—a landscape garden. The place he chooses for this is Arnheim, a fictional spot described earlier in images strongly recalling the Hudson River Highlands, where Poe had been a West Point cadet.

In addition to its influence on art, architecture, and literature, Downing's *Treatise* also fostered tremendous public interest in new species of trees, shrubs, and flowers. Although Downing did a great deal to promote the use of native species, he also discussed numerous "new discoveries" from around the world, which he sold at his

Montgomery Place, Annandale-on-Hudson, New York.
Courtesy of Historic Hudson Valley, Tarrytown, NY

Downing, A Treatise on the Theory and Practice of Landscape Gardening

nursery. The Downing Botanic Garden and Nursery offered such imported greenery as gingko, weeping cypress, incense cedar, stinking yew, palm, Patagonian Fitzroya, Baffin's Bay borealis, and African tamaris. The Hudson River's traders brought these species—new to Americans—to Newburgh.[12] Downing's naturalistic landscape designs were, in fact, highly domesticated.

Part of Downing's success can be attributed to changes that shaped the Victorian era. Before that, there were city dwellings, homes in country villages, and isolated working farms, with little in between. The colonial farm of his day was rarely landscaped at all; trees and shrubs were uncommon near a house.

In New York, expanding industry and commerce dramatically increased the number of people who could afford to build and maintain a home, and by midcentury, the construction of the railroad also made commuting to the city from the surrounding countryside possible. More and more prominent businessmen built villas on the shores of the Hudson and, by 1853, "working men" were building "out-of-town houses" as well, according to *Harper's Magazine*.[13] The times were right for Downing's ideas to be tried by America's expanding middle class, but there was something else that made his book so appealing. Like the painters and the poets, Downing felt torn between admiration for America's frontier spirit and concern for the destruction of nature that went with it. In the preface to his book, he noted the need for a counterpoint to the "tendency towards constant change, and the restless spirit of emigration, which form part of our national character," a tendency he found necessary for national prosperity but opposed to domestic happiness. Following his

principles, he suggested, would make a person happier, more patriotic, and a better citizen, and observing the examples of the Hudson Valley, of a "highly tasteful character" would be especially instructive.[14] Landscape gardening soon swept across the country—and with it a revolution in architecture. His books, said author Catharine Sedgwick at the time, "are to be found everywhere. Nobody, whether he be rich or poor, builds a house or lays out a garden without consulting Downing's works."[15]

A year after he published the *Treatise on Landscape Gardening,* Downing reached out to a middle-class audience with a book titled *Cottage Residences,* offering designs for simpler, less expensive buildings and their grounds. Unlike architectural books by other authors, it presented plans for the entire lot, not just a design for the structure. Downing showed the house in its setting, discussed paint colors, and suggested the layout of the grounds to provide for a kitchen garden and beautiful landscaping. He identified the varieties of trees to plant for the best visual effects and suggested sweetly fragrant flowers and shrubs that would bloom through all seasons.

Downing recognized that the most inexpensive shape to build was a square or a rectangle, but he suggested adding bay windows, verandahs, and decorative trim to make a house look more irregular and richer in appearance, with little extra expense. Bay windows became a fad thanks to his writings, as did gables, turrets, towers, ornamental roof slates, and fanciful chimney tops. Decorative vergeboard—thick planking carved with Gothic motifs and often referred to as gingerbread for its lacy, frostinglike appearance on the eaves of a house—is another feature Downing promoted. All of these principles were extensively applied by homeowners everywhere, but especially on the Hudson, where his message resonated with people who were

Design for the layout of the grounds for a riverfront property intended to complement a moderate-sized villa on about 150 acres of land from Andrew Jackson Downing, *Cottage Residences,* 1873 reprint.
Courtesy of Dover Publications

deeply aware of the scenic beauty around them and wanted to make a statement about their part in it. In the Hudson Valley, the styles, colors, settings and ornamental details he advocated were incorporated into nearly every nineteenth-century home—modest farmhouses and great estates alike, many still standing. In 1850, Matthew Vassar, the founder of Vassar College, hired Downing to design the residence and grounds for Springside, in Poughkeepsie. The site, with its intact gatehouse, is the only one he personally designed and has been designated a National Historic Landmark. Downing's greatest role was as a promoter of ideas.

Downing's work also propelled the career of A. J. Davis and created a demand for the styles Davis designed; indeed, neither would have enjoyed such success without the other. Davis studied books on English cottage architecture to create his own form of picturesque country home that would harmonize with the wild state of nature found in America. He dispensed with the traditional shape of a house to develop bold, asymmetrical forms that echoed the spirit of the Hudson Valley landscape. He collaborated with Downing for eleven years, enhancing his own reputation by drawing illustrations for articles in *The Horticulturist* and in Downing's other books. Davis's styles, combining high, peaked gables, bay windows, verandahs, towers, gingerbread moldings, and sometimes board-and-batten siding and roof brackets, can now be found throughout America, as far away as Mendocino, California. Downing's *Treatise* continued to sell many copies throughout Davis's career.

Another book, *The Architecture of Country Houses*, published in 1850 with drawings by Davis, promoted the Italian, Venetian, Swiss, rural Gothic, and bracketed styles that Downing and Davis both favored, and offered fourteen villa designs for the wealthy homeowner in addition to designs for cottages and farmhouses. One of these, a "Villa in the Pointed Style," was built in Garrison for Edward Pierrepont.

In the same year, Downing decided to set up his own architectural firm and traveled to England, where he met a young architect, Calvert Vaux, whom he persuaded to return with him to Newburgh to form a partnership. Although Vaux was only twenty-seven years old, he had already achieved distinction as a landscape painter and architect. His talents and philosophy complemented Downing's, and together they designed and constructed the houses and grounds of numerous estates along the Hudson and on Long Island, as well as city residences, including many still standing in the Grand and Broad Street residential area of Newburgh.[16] Two years later, Downing returned to England, where he recruited Frederick Withers to work for him. Vaux and Withers both became nationally known as architects, an important aspect of Downing's legacy.

Meanwhile, Downing began to expand his ideas from the landscaping and design of homes to landscaping plans for towns and villages—which, at the time of his writing, had no parks and little greenery. One observer described the New England countryside as "a wild common over which the November winds swept with a pestilent force, with nothing to break them, except a pair of twin churches. . . . The tollgate, the churches, the store lay strewn along a high-road three miles away. . . . And yet so bare of trees was the interval that . . . I could see the twin churches, the tavern, and, with a glass, detect even a stray cow."[17] Downing suggested the creation of tree-planting societies to improve the barren countryside. In the 1840s and 1850s, following his advice, many began planting their streets with stately native elms, maples, oaks, ashes, tulip trees, and magnolias. In the Hudson Valley, mature maples, planted in Downing's day, line many roads.

One of Downing's greatest contributions was his advocacy for the creation of public parks in cities. His ideas on this subject were sparked by Mount Auburn Cemetery, in Cambridge, Massachusetts—the 1831 creation of Dr. Jacob Bigelow, who broke with the tradition of the church graveyard and laid out an 80-acre naturalistic landscape as a resting place for the dead. It alternated lawns and monuments with masses of native trees on rolling hills. It was so popular as a place of quiet recreation for the living that 20 years later, nearly every town and village had its own rural cemetery. The cholera epidemics, which led to overcrowding of burial grounds,

(top) The Porter's Lodge designed in 1850 by Andrew Jackson Downing as the gatehouse for Matthew Vassar's summer estate, Springside. The grounds of the estate, which are open to the public, form the only extant Downing-designed landscape that remains largely intact. Due to fire and the ravages of time, the Porter's Lodge is the only building remaining. It is currently occupied and is now part of the Springside National Historic Landmark in Poughkeepsie, New York.
Photograph by Lorrayn Pickerel courtesy of Springside Landscape Restoration

(bottom) Hurst-Pierrepont, in Garrison, designed by A. J. Davis, is similar to Davis's design for a "Villa in the Pointed Style" for Downing's *Architecture of Country Houses.* The plan was modified slightly in 1867 for a brick villa commissioned by Edward Pierrepont for his estate in the Highlands.
Copyright © 1990 by Robert Beckhard

Poughkeepsie, N.Y. The Lake in Rural Cemetery.

also contributed to this movement, as did the growing notion of nature as a sanctuary from the city.

Rural cemeteries along the Hudson dating back to this era include the 467-acre Albany Rural Cemetery, the Poughkeepsie Rural Cemetery, Troy's Oakwood Cemetery, and the Sleepy Hollow Cemetery, next to the Old Dutch Church Burying Ground of Washington Irving's tales. Echoing the ideas of both Downing and Bigelow, most of them have vistas of the river and naturalistic plantings, as well as tombs and monuments by noted sculptors, honoring the memory of the Hudson Valley's most prominent families. Brooklyn's 1838 Green-Wood Cemetery, one of the first two rural cemeteries in New York State and an early example of this tradition, overlooks New York harbor.

In 1848, Downing noted, tens of thousands of people had flocked gaily to such parklike burial grounds. With such evidence of public interest, Downing argued, the taste for public parks would spread rapidly. He published articles about parks in *The Horticulturist*, including some by Frederick Law Olmsted, who would later follow Downing's example and become the nation's leading landscape designer and park builder. Downing also advocated that New York City set aside 500 acres for a park to give its citizens breathing space and a recreation ground for rural refreshment. In this campaign, he joined poet William Cullen Bryant, who published editorials in the *Evening Post*; Downing wrote about the parks he had seen in England. Together they were responsible for the passage of the 1851 Park Act, which created Central Park. Downing and Calvert Vaux collaborated on the first design for the park. Sadly, Downing did not live to see Central Park built. In 1852, at the height of his fame, he boarded the steamboat *Henry Clay,* bound for New York City. Twenty miles from their destination, the *Henry Clay* began racing with a rival boat, the *Armenia*, and caught fire. Calm in the face of disaster, Downing assisted his friends and began throwing wooden chairs overboard to help those who had leaped into the water float to safety. Downing's efforts saved his wife, Caroline, and many others, but numerous passengers burned or drowned. Downing, who was an excellent swimmer, jumped into the water to rescue the beautiful young widow Matilda Wad-

The Lake at Poughkeepsie Rural Cemetery on the Hudson.

Undated postcard, author's collection

sworth. With the widow and several others clinging to him, he slipped below the surface and drowned.

Downing had introduced Vaux to Olmsted, and after Downing's death, in 1858, the two teamed up to submit the winning design for the layout of Central Park, using ideas they had developed together with Downing, emphasizing both naturalistic design and accessibility to all citizens—then a novel idea. When Olmsted moved to California's Yosemite Valley, these ideas about parks and nature laid the foundation for Yosemite to become a state park in 1864 then, in 1890, a national park. After Olmsted returned to New York in 1865, he formed a partnership with Vaux, and the two designed many more precedent-setting parks, parkways, and suburban master plans. These include Prospect Park, in Brooklyn; Niagara Reservation, the nation's oldest state park; master plans for Riverside, Illinois and Tarrytown, New York; and college campuses for Harvard and Vassar. Their last collaboration, which also involved their sons, was a design for Downing Park in Newburgh, New York (opened 1897), which they donated to the city in memory of their friend and mentor.

Both men designed projects on their own as well. On the Hudson, Vaux developed the plans for The Point near Staatsburg and assisted artist Frederic Church in the design and execution of Olana. With his son, Downing Vaux, he designed the grounds of Wilderstein (the Suckley estate in Rhinebeck). Among Olmsted's outstanding projects is Riverside Park and Riverside Drive, a 4-mile-long landscape on the Upper West Side of Manhattan (Seventy-second Street to 158th Street), a concept he developed in 1870 using Downing's principles. The drive is a serpentine boulevard with river views, connected to a terraced park of lawns, trees, and rock outcroppings leading down toward the Hudson River, which at the time was still edged by train tracks. The park, which opened in 1910, was further extended in the 1930s by Robert Moses, who put the tracks underground.

Other men Downing chose as his collaborators also went on to brilliant careers. His other partner, Frederick Withers, designed many notable Gothic churches, which served to emphasize the spiritual quality of "life lived in harmony with nature," including St. Luke's Episcopal Church in Beacon, New York.[18] A. J. Davis became America's leading designer of Gothic and Italianate villas. The best surviving

Burning of the steamboat Henry Clay, *Riverdale,* July 28, 1852. From H. R. Murdock, *The Hudson River,* vol. I.

Collection of the New-York Historical Society (#16380a)

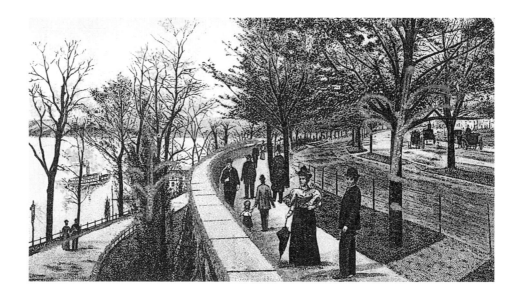

example of his work is Lyndhurst on the Hudson in Tarrytown, built in 1838 and enlarged in 1864. It is now a National Historic Landmark. Davis also designed Locust Grove, the Poughkeepsie estate of Samuel F. B. Morse, inventor of the telegraph and a painter of renown. Davis transformed the house from Federal style to Tuscan Gothic in 1852. A fine example of a Gothic villa he designed is the Delamater House, part of the Beekman Arms Hotel in Rhinebeck, New York.

In tribute to Downing's memory, friends erected a monument in Washington, DC. It was in the shape of a vase and bore the inscription: "He was born and lived and died upon the Hudson River." On the other side of the monument was a quote from one of Downing's essays: "The taste of an individual as well as that of a nation will be in direct proportion to the profound sensibility with which he perceives the

(top) Riverside Park, designed by Olmsted.
Undated postcard, author's collection
(bottom) Locust Grove, designed by A. J. Davis in 1852 for artist and inventor Samuel F. B. Morse in Poughkeepsie, New York, now open to the public as a privately operated museum and nature preserve through the generosity of Annette Innis Young, the last private owner.
Photo courtesy of Locust Grove

beautiful in natural scenery."[19] This philosophy—that all Americans shared the landscape and that design with nature was something to which every patriotic individual could contribute—was Downing's legacy.

By the time of his death, Downing's books on landscaping and architecture had begun to transform the American countryside. His approach continued to spread to every part of the country; yet nowhere are his principles and philosophy of landscaping and architecture more evident than in the Hudson Valley, where nearly every nineteenth-century style he popularized can be found. Hudson River towns and villages grew tremendously in the years when Downing's ideas held sway, and much of this Victorian architecture is still standing.

In the decades after Downing's death, residents continued to think about the relationship of their homes to the landscape, echoing its forms, colors, lines, and textures, guided by principles of the artist. The imprint of Downing on the landscape of the Hudson Valley remains very evident today in the gables, brackets, and gingerbread of city neighborhoods; in the rural cemeteries and village parks; and in the picturesque grounds of river estates. Neil Larsen, a former New York State historic preservation officer in charge of the Hudson Valley region, wrote:

> [Here] the natural and the built environment have become as one. The tree-line is frequently interrupted by towers and rooftops; the shoreline by fortifications against the harsh elements. . . . The scenery is as much a part of the architecture as the architecture is part of the scenery. Everywhere the mountains are obvious to the eye. . . . Bold massive buildings set upon stone foundations reminiscent of cliffs, . . . [the] setting [is] carefully determined to both capture a view and be captured in one. . . . [T]he dramatic quality of the natural environment influenced a craftsmanship which is unsurpassed in any other place.[20]

Downing brought an appreciation of landscape—once the province of artists and writers—into the realm of the average homeowner. His ideas were embraced by all segments of society, including the most powerful business and political leaders. Some of them would take his principles to greater heights during the post–Civil War era—when railroad presidents reigned like kings and built palaces along the Hudson. The construction of a railroad along the river near the time of Downing's death ushered in this new trend.

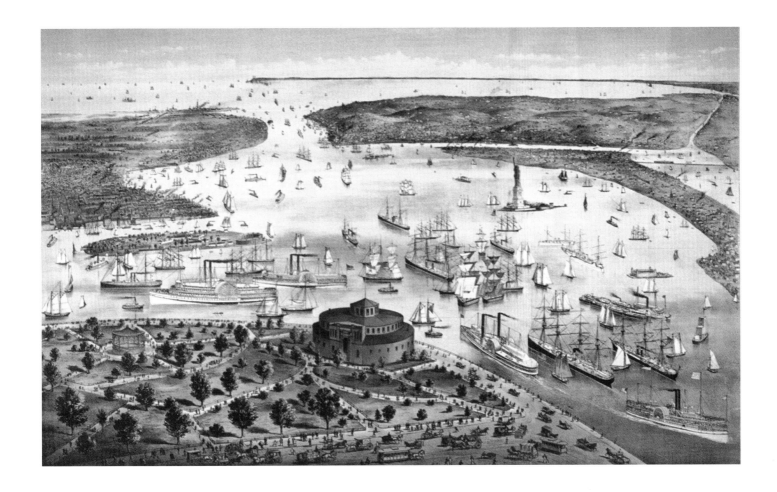

Gateway to America, Escape Route to Canada

Immigrants Greet a Beacon of Liberty, John Jervis Creates a
New River Route, and a Railroad Goes Underground

9

ASTLE CLINTON AT the tip of Manhattan, where the Hudson officially ends, has seen many uses: fort, beer garden, restaurant, promenade, opera house, aquarium, state immigrant processing center, and federal museum. The land on which it stands was once an island and is now on the mainland, surrounded by landfill that typifies much of the expanding edge of the city where it meets the water. A tunnel runs under it. Once nearly demolished, Castle Clinton was later resurrected. Like so much along the Hudson, it has been reinvented to suit the changing needs of the city, the state, and the country. Today, it is preserved by the National Park Service as an interpretive center, but its time of greatest renown was the period from 1855 to 1890, when it was known as the Castle Garden Emigrant Depot, the place where two out of three arriving immigrant families first set foot on American soil.

Castle Garden has welcomed more than 8 million immigrants to the United States. More Americans trace their family history to this arrival point than to any

Currier and Ives, *Port of New York: Bird's Eye View from the Battery looking South.* Circa 1872, showing the harbor as Bartholdi would have seen it, and Castle Garden, where immigrants arrived. In the distance is The Narrows, and in the right foreground the Hudson flows past the Battery. Bedloe's Island is right of center.

Library of Congress

other. Along with nearby Ellis Island, which replaced it as an immigrant receiving center in 1890, Castle Garden has made the Hudson a gateway to America. The Irish came fleeing the potato famine; Germans, Swedes, and Norwegians were drawn by offers of cheap land. Later, Italians and Asians looking for work, Eastern European Jews fleeing the pogroms, and Russians seeking to escape persecution, along with people of many other countries, all arrived at the mouth of the Hudson, where they hoped to find a better life and live the American dream. This steady influx has helped maintain the high level of ethnic diversity along the Hudson, a tradition that began with Dutch settlement in the 1600s. The descendants of some of these settlers would become keepers of the river's future in generations to come.

The geographic advantages and economic entrepreneurship of New York port and the Hudson River were attracting newcomers from all around the world as early as 1646. By 1825, when immigration began to significantly increase, the opening of the Erie Canal established the Hudson River as the first leg of the journey for people wanting to settle the American Midwest. After the passage of the Homestead Act in 1862, which offered 160 acres of public domain land in any of 30 states west of Buffalo for $18 to any homesteader who would farm it for 5 years, this flow of immigrants turned into a flood. The expanding industrial use of the river, as well as a near-constant civic works program of canal improvements, aqueduct building, and laying of railroad tracks, provided a reason for immigrants to stay and find employment. Finally, the reputation of Manhattan as a city with streets paved with gold stimulated the imaginations of hopeful immigrant families. The Hudson River acquired potent symbolism that helped draw people from all over the world to its shores, and its useful qualities kept them there.

It was this sense of the harbor as a gateway that caught the attention of the French sculptor Frédéric Auguste Bartholdi. He visited America in 1871 to search for a place where he might build a grand statue that would celebrate the friendship of the French and American people, in recognition of the ideals of liberty and equality to which both countries aspired. The statue had been commissioned by his friend and patron Édouard de Laboulaye. It would commemorate the centennial of the American Revolution, in which France came to the aid of the struggling new nation after the defeat of Burgoyne on the Hudson in 1777. Bartholdi would build it, with funds to be raised through contributions. Though the sculptor and his sponsor had no commitments from anyone in France or America to finance, construct, or receive the statue, they were convinced that they would succeed. The timing seemed right. France had just sent Emperor Napoleon III into exile as Bartholdi set sail for New York, and many French citizens hoped to form a democratic government. Surely the Americans would embrace the idea too. Bartholdi just needed to talk it up and find a good spot.

When his ship entered the harbor at the mouth of the Hudson River, Bartholdi sensed that he had already found the perfect location. In a letter to his patron, Laboulaye, he wrote: "surely my statue should be erected here, where men have their first glimpse of the New World, where liberty shines on both worlds." A little island in the upper bay, near the Jersey City shore, particularly caught his artist's eye. With a star-shaped fort built during the War of 1812, Bedloe's Island offered a sweeping view of the harbor. Furthermore, everyone entering New York harbor passed by it— the immigrants, the tourists, and the businesspeople of the world. Best of all, he told Laboulaye, it was publicly owned: "The island belongs to the government, it is on na-

tional territory, belongs to all the states, just opposite the Narrows, which are, so to speak, the gateway to America. There could be no better situation than this busy harbor for Liberty, for nowhere else could it be seen by so many people."[1]

The statue was not intended to be a salute to American immigrants. French immigration was not significant here in the nineteenth century. Even so, Bartholdi recognized that thousands of people arrived at the immigration center at Castle Garden, and the idea that his statue would welcome them made the symbolism even more powerful. He could not know that even larger numbers of immigrants would soon follow and that his statue would become even more meaningful to them as the sign that one journey had ended and another was about to begin.

Bartholdi traveled across America to drum up support for his idea and then returned to France to work on a design, a process that took years. In 1874, he and Laboulaye announced their plans, and in 1875, they unveiled a 4-foot model of Bartholdi's sculpture of Libertas, the Roman goddess of freedom, holding a tablet inscribed with the date July 4, 1776, in honor of the birth of the American republic—independence that France had helped the new nation achieve. Laboulaye organized the Franco-American Union to raise funds for the project, with the idea that French citizens would pay for the statue and Americans would build the pedestal. The idea caught fire among their countrymen, who were establishing their own republic after deposing Napoleon III. When Bartholdi showed them his design, he raised half the funds needed to build the statue—200,000 francs—in the space of a few months, and the work began. "Liberty Enlightening the World" would be constructed in stages over the next 12 years, with donations coming in from both sides of the Atlantic. Joseph Pulitzer, publisher of *The World*, who had immigrated to New York in 1864 through Castle Garden, raised $100,000 for construction of the base through publicity in his Manhattan newspaper.

On October 28, 1886, President Grover Cleveland presided over the unveiling of the completed statue. Rising magnificently over the waters of the harbor—305 feet tall from pedestal to torch—she was placed to face the ocean, welcoming those arriving by

Statue of Liberty As it Will Appear, sketched by sculptor Frederic Bartholdi.
Library of Congress

ship. The people of France and the people of America had created a grand gesture of friendship, recognizing their common commitment to freedom and self-government.

Soon after, Castle Garden closed (it would be reborn later as the New York Aquarium), and in 1892 the federal government opened a new immigration center at Ellis Island, even closer to the statue. The largest immigration wave in world history now passed beneath Liberty's torch. By the beginning of the twentieth century, nearly a million immigrants per year arrived at Ellis Island, which some have called the "Second Plymouth Rock."[2] Sometimes as many as 10,000 per day came to America's gateway, many arriving by steamship from Europe after a voyage of several weeks, and for them, the Statue of Liberty and the river to which it led became symbols of hope.

The meaning of the statue and the river gradually shifted, from the shared liberation goals of America and France and the symbolism of lighting the path of democracy for aristocratic Europe to a different context of liberty. The Hudson was the "golden door" for people of Europe and the rest of the world to leave oppressive conditions, and the statue became a welcoming beacon of light on American shores. Emma Lazaru's poem was added to the base of the statue in recognition of this: "'Give me your tired, your poor, / Your huddled masses yearning to breathe free, / The wretched refuse of your teeming shore; / Send these, the homeless, tempest-tost to me, / I lift my lamp beside the golden door!'"

The statue provided a lofty symbol; however, its meaning would never have grown so powerful if not for the gritty realities of the river's growing economy, which exerted a magnetic pull. Arriving at New York harbor was just the beginning of the journey for immigrant families. The Hudson River welcomed and absorbed them. For some, it was just a gateway to the Erie Canal and points west; however, many others stayed and found work in the iron foundries, sugar refineries, cotton mills, brickyards, shipyards, and resorts along the Hudson and in the garment factories, slaughterhouses, and meat-packing businesses of Manhattan Island. Without them as a source of cheap—and usually exploited—labor, the river valley could not have made the transformation into an industrial powerhouse. With them, the canal ex-

"Immigrants landing at Castle Garden,"
drawn by A. B. Shults, from *Harper's Weekly*,
May 29, 1880.
Library of Congress

2056—Ellis Island, New York.

pansions, aqueducts, railroads, and other works of civil engineering that contributed to the rise of New York became possible, indeed necessary. The Hudson was a great confluence of the needy and the needed.

The Erie Canal as a route west and the D&H canal as a provider of coal for home heating and industrial use were key features that enabled the river to attract immigrants and grow. Maintaining the Hudson's role as a vital transportation route depended on keeping the system modern and up to date, and that meant building railroad networks to connect with, serve, or compete with waterborne traffic. Curiously, on a river of industrial and transportation firsts, the building of tracks was close to last. Nationwide, more than 15,000 miles of track had been laid before the east shore Hudson River line from New York to Albany was completed in 1851. A west shore line was constructed about thirty years later. Though the Mohawk and Hudson line, completed in 1831, became one of the earliest successful passenger lines in America, it was an overland route, built from Albany to Schenectady to bypass the time-consuming locks on the Erie Canal. The Camden and Amboy Railroad (1833), operated by the Stevens family of Hoboken, was another overland route, connecting lower New York Bay to the Delaware River and Philadelphia from docks on the Raritan River.

The reason for this delay was that the project was deemed impossible, "like building a railroad to the moon." However, the threat that railroads connecting the Erie Canal route with Boston might funnel midwestern goods to Massachusetts instead of down the Hudson to the harbor inspired a few people to search for a solution. The growth of river industries and the supply of immigrant labor that supported it also depended on such rail links, to avoid the shutdown of water transport that came with winter ice. Construction of a railroad along the Hudson posed engineering, political, and marketing difficulties, and when the directors of the Hudson River Railroad Company first proposed, in 1842, to build tracks between New York and Albany on the east shore of the Hudson, investors were skeptical. Construction conditions were much more challenging than on inland lines. The steep mountain slopes of the Highlands had always been a barrier to overland transportation. A shoreline route

Ellis Island. From 1892 to 1954, four out of five immigrants arrived in America through the port of New York. In 1954 the immigration center at Ellis Island closed; it fell into disrepair until 1990, when it was restored and reopened as a museum of the immigrant experience, funded substantially by the descendants of immigrant families. It is thought that about 40 percent of Americans have at least one ancestor who arrived in America through Ellis Island on the Hudson. In 1921, stricter immigration laws, passed under pressure from labor unions, turned this flood into a trickle.

1908 postcard, author's collection

THE HIGH BRIDGE.*

would have to carve a foothold at the base of the mountains. It would also need to cross open coves of tidewater and span numerous streams.

The power of the steamboat operators had to be considered as well. They held an effective transportation monopoly on the river—and they had friends in high places, including the state legislature, where any railroad corporation would have to be chartered. Most problematic was the question of whether a railroad could successfully compete for passenger traffic against the luxury steamboats so adored by the public. At the time the railroad was being considered, steamboats carried about a million passengers per year, making as many as twenty daily trips between New York and Albany. Steamboats offered everything in the way of food and drink and were noted for their lavish saloons and dining rooms. It would be decades before the railroad car would offer similar comforts.

Building a railroad along the Hudson was a financial long shot, and the difficulty of raising the necessary $3 million in capital was sufficient to discourage most from trying. The issue was discussed in 1842 by a group of Poughkeepsie investors, who attempted to obtain a charter from the legislature. However, steamboat interests quashed their efforts. Undaunted, they regrouped in 1845 and asked engineer John B. Jervis to assist them.

Jervis had distinguished himself as a self-trained engineer on the Erie Canal, and after that from 1826 to 1828 as chief engineer for the Delaware and Hudson Canal. From 1836 to 1842, he gained worldwide acclaim as the chief engineer for the 40-mile Croton aqueduct, which brought a large supply of pure water to New York City for the first time. It crossed the Harlem River, near Spuyten Duyvil, on a high, multiarched stone bridge 116 feet above tidewater. At the time, the structure was the world's third longest aqueduct, exceeded in length only by two Roman water systems, built in 144 B.C. and A.D. 52. The High Bridge rivaled the famous Pont du Gard in length and was among the grandest stone arch bridges in the world. Jervis, already on his way to becoming one of the leading civil engineers in America, was therefore among the

High Bridge of the Croton Aqueduct, across the Harlem River, designed by John Jervis.
Lossing, The Hudson from the Wilderness to the Sea, *1866*

E. C. Coates, *View from Weehawken.*

Courtey of the New York Historical Association,
Cooperstown, NY

Sanford Robinson Gifford,
Sunset on the Hudson, 1876.

Courtesy of the Wadsworth Atheneum,
Museum of Art, Hartford, CT, Ella Gallup Sumner
and Mary Catlin Sumner Collection Fund

Jasper Cropsey, *Evening on the Hudson*.
1885 watercolor.

Courtesy of the Newington-Cropsey Foundation

Robert Havell Jr., "View of the Hudson
from Near Sing Sing," circa 1850.

*Courtesy of the New-York Historical Society,
John Jay Watson Fund (#1971.14)*

Unknown artist, *The Palisades.*
Courtesy of the Fruitlands Museum (G-1946-138)

John Frederick Kensett, *The Hudson River.*
1865 oil on canvas.

Courtesy of the Baltimore Museum of Art,
Gift of Mrs. Paul H. Miller (BMA 1942.4)

Thomas Chambers, *View of the Hudson River at West Point, 1855.*
Courtesy of the Albany Institute of History and Art

Robert Weir, *View of Hudson River
from West Point*, 1869.
Courtesy of the Fruitlands Museum

Thomas Cole, *Storm King of the Hudson,*
circa 1825–27.
Courtesy of Ball State University

Victor DeGrailly, *Hudson River*, undated,
circa 1844. DeGrailly, a Frenchman, never saw
the Hudson River landscapes he painted. His
works copied engravings by Bartlett and
others and demonstrate the international
popularity of the American landscape in
the nineteenth century. This view shows the
Hudson River and distant Catskill Mountains,
as seen from the estate Hyde Park.
Courtesy of the Fruitlands Museum (G-1946-149)

Wilhelm Heine, *View of Tivoli Bay*, 1854.
Courtesy of Rokeby

William M. Hart, *Distant View of Albany, 1849.*

Courtesy of the Albany Institute of History and Art

most qualified men for the job. The Poughkeepsie investors offered only a small fee for his consulting services, but guaranteed that he and his assistant engineers would be employed if the project should succeed in getting financing and a charter.

Jervis agreed to undertake a financial analysis, which he presented in a report to the committee on January 20, 1846, projecting a 7 percent return for the capital invested. He noted the railroad's advantage in being able to operate all year round, compared to the steamboats, which could only run about nine months of the year, when the river was not frozen or choked with ice. More urgently, he noted that rail links were being built between Lake Erie and Albany along the canal route, and from Albany overland to Boston. Without a railroad from Albany to New York City, sellers of western produce might move to Boston's port in winter when the river was frozen, and such trade relations, once established, would continue in summer, leading to the loss of New York's preeminence:

> The high commercial character hitherto enjoyed by the city and the state of New York, is owing mainly to the fact, that the Hudson River, passing through the great chain of Highlands, opens an easy navigation to the . . . North and West: but this navigation is so obstructed by ice, that it cannot be relied upon for more than about eight months in a year. An improvement, therefore, that will make this . . . reliable at all seasons of the year is obviously of great importance to all interested in this avenue of commerce.[4]

However, the meeting failed to produce what Jervis described as the "one element essential to such projects—that is, confidence in its ability to recoup the outlay required. All were ready to speak favorably, but very few ready to take any pecuniary responsibility."[5]

In the public mind, Jervis noted, it was a "wild, visionary, and unpromising enterprise."[6] Yet he could imagine it. He could picture a river lined with railroad tracks, and the work needed to accomplish it. He understood the transformative power of the idea and the urgency of it for New York State.

In February, Jervis became the leading champion of the project and personally took the proposal to Albany, seeking an act of incorporation. At the capital he faced opposition by both the steamboat interests and the backers of the New York and Harlem railroad, a potential competitor. After three months of political struggles, the act was passed, and in June 1846, a board of directors was formed that included Jervis and Cold Spring's foundry president, Gouverneur Kemble, among others. They issued a prospectus comparing the railroad's superior rate of speed to that of the steamboat (35 mph), its access to manufacturing establishments and agricultural areas for freight service, and the potential for growth of commuter traffic through development of the Hudson Valley:

> The banks of the Hudson afford . . . the most beautiful situations for country residences. The proposed Road will afford to a numerous class of our citizens, who for themselves or families, desire to reside in the country during the summer, the greatest possible facilities to do so; allowing them to reside 20 to 80 miles from the city, and still *be* in it during the business hours of the day, and return to their families at evening.[7]

Jervis and his backers still had some convincing to do, however. Except for themselves, the stock had no takers. It was not until the spring of 1847, after a lengthy

Hudson River Railroad, Anthony's Nose.
Anonymous woodcut, 1853.

Author's collection

publicity campaign, that they were able to raise $3 million and construction began, with Jervis as chief engineer.

Work commenced first on the 53 miles from Thirty-second Street in New York City to Breakneck Mountain in Cold Spring, the most difficult stretch. To lay tracks across the Hudson's bays and inlets, Jervis had to place rock fill in long stretches of the river. In places like the Highlands, where the mountains dropped steeply to the water, he had to cut tunnels. By 1848, railroad service opened from New York to Cold Spring and points in between, providing a great benefit to investors like Gouverneur Kemble, whose West Point Foundry could now ship products in and out year round, even when the river was frozen.

North of the Cold Spring station, however, the tunnel through Breakneck Mountain proved especially difficult, slowing the progress of the tracks to Poughkeepsie. The Highlands' granite was harder to drill than any rock Jervis had previously encountered. Workmen drilling all day only cut one to two feet into it. Numerous contractors started the work and were forced to give it up. Eventually, H. D. Ward & Company stepped in and completed the job in seventeen months. Soon after, in December 1849, the tracks reached north to Poughkeepsie, and by 1851 they extended all the way to Greenbush, across the river from Albany. By 1866, a bridge connected the two lines.

Passenger traffic quickly exceeded Jervis's estimates of 500,000 per year. In 1850, flush with triumph, he wrote that the experiment:

has settled the great question, that a well built railroad can successfully compete with steamers on the very superior navigation of the Hudson River, in the transportation of passengers; and consequently they will be required along all the great channels of steamboat navigation. We shall no longer look to the steamer, as heretofore, as the perfection of traveling.[8]

Jervis boasted too soon, however. Despite the success in attracting passengers, fares were set so low to compete with the steamboats that the Hudson River Railroad did not turn a profit for 15 years. Per mile, it had been the most expensive railroad ever built: each of its 143 miles cost about $80,000. In 1862, the corporation declared its first profitable year. Stock prices, which had been $17 per share in 1855, rose to $140 in 1864.[9] When it issued its first dividend, the Hudson River Railroad was finally declared a success, causing Thurlow Weed to write in the *Albany Journal* in 1863:

> We were originally among those who could not believe it would ever be built—who thought it irreverent to attempt to rival God's munificent, glorious highway, the Hudson River. If our files were searched we should be found expressing our opinion that the idea of a "Railway to the Moon" was scarcely less preposterous than the projected one along the banks of the Hudson River.[10]

While the construction of the Hudson River Railroad, like the introduction of steam navigation forty years earlier, had a certain romantic appeal, it produced the first known public outcry over the loss of scenery and the intrusion of industry on the Hudson. Although James Fenimore Cooper, Thomas Cole, and others had expressed their personal nervousness about these issues in their novels, paintings, and essays, public opposition to construction projects in scenic places did not crystallize until plans for the railroad were drawn. In an article for Hunt's *Merchant's Magazine*, Jervis remarked on the intensity of the reaction his proposal had inspired: "To adopt a river route, was claimed in the style somewhat of the Spanish Don, to be a *desecration* of the river, marring its beauty, and subverting the purpose of the Creator."[11] This was one of many instances to come when passions collided among people pressing very different ideas about the appropriate future of the river and its shores. Jervis summarized his own views in his *Reminiscences*: that the railroad was an ornament, not an injury:

> The landed proprietors along the route were in general very hostile to the enterprise, declaring that it would destroy the natural beauty of the country as well as fail in its commercial object. On this point I had claimed that the natural scenery would be improved; the shores washed by the river would be protected by the walls of the railway; and the trees, no longer undermined and thrown down by the surf, would grow more beautiful; and that the railway thus combining works of art with those of nature would improve the scenery. For this I was freely reproached as scarcely less than a barbarian.[12]

One of his opponents was Washington Irving, whose Tarrytown property, Sunnyside, lost its river frontage to the railroad. Another, William J. Blake, wrote in 1849:

The greedy, sordid, and avaricious spirit of man is making sad havoc among the beautiful mountain scenery of the Hudson. Where it will stop is more than we can tell. The sound of the ax and the railroad excavator's pick, with the steady click of the quarryman's hammer, is daily sounding in our ears, and slowly, though steadily, performing the work of demolition.[13]

Opponents said nothing about another result of the project—its effect on the river itself. Building the railroad tracks on the edge of the river required bringing in tons of rock riprap, straightening the curved shoreline, hardening it, and cutting bays off from the open flow of the river, with only culverts to provide a way for water and fish to pass through. The effect on river habitats was substantial, particularly in the bays, which began to silt up, but no one foresaw that or worried about it.

The railroad provided crucial links in an expanding transportation network that gave New York State a competitive advantage. In 1853, two years after the Hudson River Railroad reached up to Albany, industrialist Erastus Corning organized 10 independent railroad lines into one system from Albany to Buffalo to form the New York Central, which Commodore Cornelius Vanderbilt acquired by a deft coup in 1867. He had recently bought control of the Hudson River Railroad as well, and would soon build Grand Central Depot (later redesigned as Grand Central Station), which he opened in 1871. Vanderbilt established a water-level route from New York's Grand Central to Chicago by 1875. It was the first four-track long-distance railroad in the world and made Vanderbilt even richer than before. Born poor, he died in 1877 the wealthiest man in America, leaving an estate of $100 million.

Tracks also extended down the shore of Manhattan to Thirty-second Street, and in 1864, the Central Railroad of New Jersey (CRRNJ) filled in extensive wetlands to build a terminal in the Communipaw section of Jersey City. This became an important strategic link for transport of troops and equipment in the Civil War, and after Ellis Island opened, about 300 trains per day departed from it, carrying tens of thousands of immigrants daily to points south and west.[14]

Railroads on the Hudson also connected to the transcontinental railroad, which opened for business in 1869. In 1871, fish culturist Seth Green carried a new Hudson

THE NEW LACKAWANNA STATION, SHOWING FERRY SLIPS, HOBOKEN, N. J.

River product across the country by railroad: shad eggs and fry destined for the Sacramento River, where California officials hoped to establish a new fishery (to their regret, it succeeded, with adverse effects to valuable native species up the Pacific coast as far as Oregon).

Another great benefit was to the businessmen who operated factories on the Hudson. The Hudson River Railroad brought new industry to the shoreline of Manhattan north of Thirty-second Street, and other railroads did the same on the New Jersey side. Freight crossed the river between them in barges, and large rail yards occupied both shores. Upriver businesses profited as well. In 1880, Alexander Lyman Holley and Lenox Smith described how the Albany and Rensselaer Iron and Steel Company gained advantages from the growing system of water highways and railroads around it:

> A remarkable pass at West Point in the Appalachian chain . . . carries tide water and the Hudson River Railway into the great plateau which extends without mountain breaks, to the Mississippi Valley. . . . [At Troy,] the New York Central [Railroad], Boston & Albany, Delaware and Hudson, Troy and Boston, Boston Hoosac Tunnel, and western [rail]roads radiate respectively in every direction—to anthracite and bituminous coal fields 200 miles west, to the remarkable Lake Champlain ore mines 100 miles north, limonite beds 30 to 60 miles south and east, and to market on every hand. The Erie Canal provides cheap transportation to the great lakes and to the west. The thickly settled and manufacturing districts surrounding Troy, especially in New England, present a vast market for merchant and special steels and irons, as well as for railway materials.[15]

There was one railroad on the Hudson, however, that wasn't talked about: the Underground Railroad. After 1850, when President Millard Fillmore signed the harshly punitive Fugitive Slave Act—which required the return of runaway slaves caught in free states and set bounties that encouraged the kidnapping of African Americans even if free—large numbers of slaves and some free blacks attempted to gain freedom

Erie–Lackawanna rail terminal in Hoboken, New Jersey, with commuter ferries connecting to Manhattan.
1908 postcard, author's collection

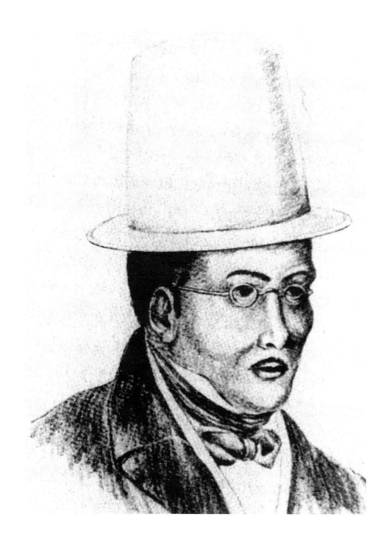

David R. Ruggles, organizer of the Underground Railroad in Manhattan, who assisted Frederick Douglass on his journey to freedom.

Courtesy of the Negro Almanac Collection, Amistad Research Center, Tulane University

in Canada, where they would be allowed to vote, own property, and have the full rights of citizenship. The Hudson became an important section of the Underground Railroad, influenced by the presence of Quakers.[16] Some had arrived from Nantucket after the revolution, seeking a safe place for their whaling business (Poughkeepsie, Hudson, and Newburgh were important whaling cities in the early nineteenth century, sending ships around the world to collect whale oil and baleen). The Quakers were the first group to organize against slavery, on moral grounds, and they sheltered many fugitives in the Hudson Valley and elsewhere. Troy, a center of state and national abolitionist meetings in the 1840s, also became an important station on the Underground Railroad, as did Peekskill.[17] In 1835, New Yorker David Ruggles, a free-black grocery store owner, formed a Vigilance Committee to defend against kidnapping. Ruggles became central to the Underground Railroad on Manhattan, assisting Frederick Douglass, among hundreds of others, sending him to friendly Quakers in New Bedford, Massachusetts. Douglass went on to become a great orator, publisher, and social reformer, the father of the civil rights movement.

Yet the Hudson was no haven for the escaping slaves. It was merely a route to Canada, a gateway out of America. After the Civil War, when slavery had been abolished, the Underground Railroad became a thing of the past, yet true liberty for black Americans, as well as many immigrants, would take decades to win. Economic equality remains a problem in river cities to this day.

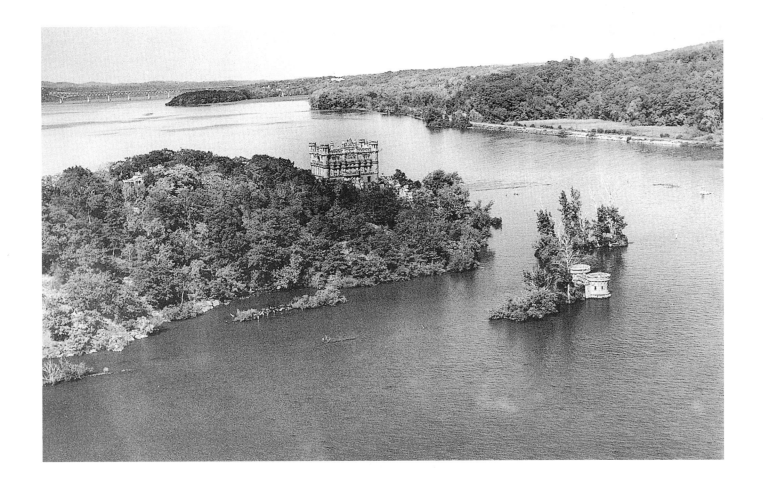

Millionaires' Row

The River Castles of J. P. Morgan, John D. Rockefeller, Jay Gould, and Frederic Church, and the Floating Palaces of Manhattan's West Side

IO

HE YEARS FOLLOWING the Civil War have been called the bare-knuckle era—the roughest period in the history of American capitalism. This was the age of the "robber barons," whose objects of desire and source of wealth were railroads, oil fields, and steel mills. Men like John D. Rockefeller, J. P. Morgan, Jay Gould, Andrew Carnegie, and Edward H. Harriman battled their way to the top, many from junior positions as office boys, messengers, and clerks. Combining cut-throat competition with strategic alliances, they built corporate conglomerates and emerged as the richest men in America.

Mark Twain's neighbor, Charles Dudley Warner, dubbed it the Gilded Age. This was when the word "millionaire" entered the American vocabulary, and the nation's capital for millionaires was New York City. From Ohio, Pennsylvania, Connecticut, and New York City itself, ambitious industrialists converged on Manhattan's financial district. They built stately town houses on Fifth, Madison,

Bannerman's Castle, built on Pollepel Island by Francis Bannerman in 1908 for use as a "baronial" castle and as an arsenal for his New York city surplus weapons business. Now part of Hudson Highlands State Park.
Copyright 1990 by Robert Beckhard

or Park Avenue, and soon they looked north to the shores of the Hudson for a place to escape from pressure and stress. By 1900, a velvet ribbon of estates lined the bluffs along the river on choice parcels all the way from the Palisades in New Jersey to the hills above Troy.

Oil, steel, and railroads were the engines of capitalism, but it was the railroad industry that developed first. Fueled in wartime by the transport of troops and supplies, the railroads' growth was later sustained by westward migration and the creation of new markets for goods that had previously been too costly to ship. Literally hundreds of rail companies, formed with government subsidies, earned fabulous fortunes for their owners and promoters. To be a railroad president was to be king—with more power in state politics than governors, and more wealth than anyone could have imagined. Today we would call them billionaires.

The building of the railroads was characterized by periods of speculative boom punctuated by panics and periods of depression. Railroad finances affected the national economy profoundly, and changing railroad fortunes set off the panics of 1857, 1873, 1893, and 1907. The owners were cynical and often unscrupulous. The kings were those who emerged stronger after each panic, many of which they instigated. Retaining power and control often required access to huge personal or corporate financial reserves in order to maintain the credit of the railroad lines, which were frequently overcapitalized and underutilized. Separate lines were built serving the same territory, and the railroad barons resorted to ruinous competition to capture the market. Companies would slash their rates until one of them collapsed. The survivor would buy out the defeated rival, usually at discount rates, gaining more power with each conquest.

By the late 1800s, the same competitive practices dominated the oil and steel industries. In fact, the railroad kings played a key role in the rise of big oil. After the Panic of 1893, at least 156 railroad companies collapsed, including some of the greatest in the country—the Erie, the Union Pacific, and the Northern Pacific. Most steel companies folded due to devastating competition. A decade earlier, dozens of oil refiners had gone bankrupt, crushed by railroad rates.

However, from the broken pieces, a few men assembled unprecedented power. By 1880, a single refining company, Standard Oil, had managed to either buy or destroy almost all of its competitors. The press referred to its leader, John D. Rockefeller, as the "Mephistopheles of Cleveland," and they likened his company to a snake, the anaconda.[1] In 1897, most of the steel business went to Andrew Carnegie's company, and in 1901 it was further centralized under one giant conglomerate—U.S. Steel—when Carnegie sold his mills to J. P. Morgan. By 1906, two thirds of American railroads had been consolidated into seven great and several minor systems, each controlled by either Morgan or E. H. Harriman (and his banking associates in Kuhn, Loeb & Co.). Along with Jay Gould, who manipulated the gold market, these were among the richest and most notorious businessmen of the time. Decades later, in 1934, the game Monopoly turned the companies they built and the properties they owned into household words for a new generation, as players felt the thrill of buying and selling one's way to fabulous wealth or precipitous ruin.

No matter where they started out, all of these companies and the men who ran them, moved their headquarters to New York City, where the financial district and the booming port together exerted a powerful allure. Gradually, they build mansions on Fifth Avenue, Madison, and Park, and in the summer they looked to the

Hudson River as a healthy and beautiful place to escape from the city, a place where body and spirit would be refreshed.

Many of the most powerful titans of the new capitalist order established summer homes along the Hudson, among them John D. Rockefeller, J. P. Morgan, Jay Gould, and many of their deputies, competitors, relatives, and friends. Their vision of country life was as great as their thirst for business conquest. World travelers, they could have built country estates anywhere, but they imagined the Hudson as their Rhine. As Wagner's operas echoed in German auditoriums, with the Valkyries riding to Valhalla, America's new nobility constructed castles on the Hudson's shores, choosing sites with the most superb views. They spent their weekends and their fortunes sculpting the land to perfect what nature had given them.

During the years that the newly rich made the Hudson their home, they participated in a total transformation of the American economy that was matched by their remaking of the river's shore. Eventually, changing fashions, stock market crashes, trust-busting, and new tax laws would cause many of them to sell their fancy homes. However, the legacy of their residence on the Hudson would far outlast them. They would develop a love of nature and scenery that would be passed on to generations to come—sons and daughters who later campaigned to save river scenery and the natural environment. They also added a new architectural element to the river shore, their mansions and castles, and then helped to preserve them as part of the romantic heritage of the river valley landscape. Without question, the Hudson today is far different than it would have been without them.

In their professional lives, the millionaires were consumers of resources. The companies under their control developed the prairie, mined ores, prospected for crude oil and minerals, milled steel, and laid track by the thousands of miles. At their leisure on the Hudson, these men communed with nature—joining their workmen in tilling the soil, collecting specimens of birds, fish, and plant life, and molding the landscape of their country estates into fine examples of the natural style espoused by Downing, Vaux, and Olmsted. Although Downing had died decades earlier, they clearly found continued inspiration in his idea that creating natural beauty in one's home environment expressed culture and good taste. From turreted flights of architectural fantasy to understated clapboards, their buildings and grounds carried out the picturesque ideal. They gave their estates romantic names such as Oulagisket, Cragston, Castle Rock, Kykuit, and The Squirrels.

One of the most popular places for a country estate after the Civil War was the Hudson Highlands region. Decades earlier, country homes had been established elsewhere on the Hudson, including Irving's Sunnyside, Merritt's Lyndhurst, Hosack's Hyde Park, Donaldson's Blithewood, and Livingston's Montgomery Place. However, in the 1880s, with the great fortunes that grew after the war, the number of palatial residences in the Highlands exploded, and many who established themselves there were railroad men.

There were a number of reasons this group of people moved to the Highlands. The healthy mountain air made it a good place for their wives and children to escape from the disease-ridden city, and after 1848, there were good railroad connections for commuting. A businessman could live in the Highlands with his family during the sweltering summer months, arrive in the city in time for business hours, and be back home in the country in the evening. Even better, land was cheap. The Highlands remained largely undeveloped due to poor soils for farming, and land with fine

Some of the many river estates.

vistas was very affordable. Most important, the growing popularity of sublime scenery made a country estate in the Highlands fashionable.

In all, seven railroad barons established estates on the shores of the Hudson in the Highlands at this time. Samuel Sloan, head of the Hudson River Railroad and later of the Delaware and Lackawanna, built a country estate in Garrison, as did William H. Osborn, president of the Illinois Central, and John M. Toucey, general manager of the New York Central. Just up the river, in Cold Spring and Nelsonville, lived Guy Heustis, controller of the Delaware and Lackawanna Western Railroad; James Heustis, president of the Boston and Maine; and Frederick P. James, who dealt in western railroads. Across the river was another railroad man, J. P. Morgan, who bought land on the river in Highland Falls. Of all those who moved to this part of the Hudson, he would become the richest and most powerful. Known as the Jupiter of Wall Street, Morgan came to control most of the nation's railroad lines as well as about fifty major corporations and conglomerates. In 1901, his U.S. Steel Corporation was the largest corporation in the world, and by 1910, he was the undisputed financial power in this country.

Like many of his peers, Morgan purchased his river estate just as the era of mergers and profiteering was heating up, a time of intense wheeling and dealing when his power and influence were building, although his enormous wealth was still decades away. In 1873, the year he bought river property, he gained renown by breaking the monopoly of a Philadelphia firm, Jay Cooke, and establishing his own company, Drexel, Morgan & Co. (later J. P. Morgan and Co.) as the leader in government financing. Four years earlier, he had defeated Jay Gould and James Fisk in a contest for control of the Albany and Susquehanna Railroad.

Morgan's interest in the Highlands began when he visited the West Point Hotel, where he vacationed as a summer boarder with his childhood friend William H. Osborn. Osborn had purchased land in Garrison earlier, in 1855. The Morgans remained good friends with the Osborns—their children used to try to fly homing pigeons across the river with messages to each other.

A community of powerful and wealthy people developed. The railroad monarchs were not the only ones to build in the Highlands. The estates of statesmen, financiers, and renowned professionals lined both shores of the river. People called it Millionaires' Row. Hamilton Fish—who owned property in Garrison—was Governor of New York from 1848 to 1851 and later served in the U.S. Senate and as Secretary of State in the Grant administration. His son, Stuyvesant Fish, who built a house nearby, succeeded William Osborn as president of the Illinois Central. Down the road lived Edward Pierrepont, minister to the Court of St. James. Richard Upjohn, noted architect of American Gothic-style churches, including Trinity Church in New York, purchased Mandeville, a colonial house in Garrison that had quartered American troops during the revolution. John Bigelow, an eminent lawyer and journalist who campaigned against slavery, lived on one of the Highland Falls estates near the Morgans.

The new country squires were often related by business, marriage, or both. Osborn and Morgan married sisters—Virginia and Amelia Sturges—though Morgan's wife, Amelia, died soon after of TB. Morgan's second wife, Frances Tracy, was the sister of Charles Edward Tracy, who married John Bigelow's daughter Jenny. Osborn's father-in-law, Jonathan Sturges, was one of the incorporators of the railroad that Osborn managed.

Among the landed gentry of the Highlands, close relationships with friends and family evolved around a shared love of the Hudson. At their country homes, Osborn, Morgan, and the other millionaires of the era delighted in the outdoor life, which provided a pleasant contrast to the cutthroat dealings of Wall Street. Many stayed in their country homes as long as six months of the year, returning to New York City only when the weather turned cold.

Although much time was spent in dining, partying, and paying calls, the primary activity was enjoyment of the land and the river. Though Andrew Jackson Downing and N. P. Willis had both passed away (Downing in 1852, Willis in 1867), their ideas were still very much alive and in vogue. Indeed, Downing's book continued to be issued in new editions until 1921, encouraging Americans to express love of country by echoing the picturesque forms of nature surrounding them and making the Hudson an example for the world. Willis had shown that even horseback riding and carriage outings could ward off tuberculosis—then still prevalent, especially in the city—and could provide the spiritual benefits to be found in romantic scenery. Futhermore, the idea that city men should engage in manual labor on a farm, as an antidote to the effects of industrialism, had been gaining a following since the 1840s. In the Highlands, where the land was not suitable for farming, the gentry literally created new soil, moving mountains of earth and hauling in manure by the boatload. J.P. Morgan turned the thin, gravel-strewn soil of Cragston, near Bear Mountain, into a lush estate complete with fruit trees, vineyards, flower gardens, and a dairy, enhanced by breathtaking river vistas. This was no small task. Scores of laborers carted out rocks and brought in humus and topsoil until his 675-acre farm was one of the fattest, most splendid, and most picturesque. Morgan delighted in entertaining his friends on river trips on his 300-foot boat, the *Corsair*, and treating his city guests to the fine produce of his country estate—fresh cream, butter, pears, and apples. Such farm products were very hard to come by in the city, where standards of quality had sunk to the lowest levels (milk, for example, was watered down, and produce was usually rotten). This further enhanced the idea of the Hudson Valley as a healthy place. The air was good, the scenery uplifting, and the food fresh and wholesome.

The Squirrels.
Copyright 1990 by Robert Beckhard

Down the road, at The Squirrels, John Bigelow was fond of pitching in with the farm laborers. Bigelow's son Poultney described him in his book, *Seventy Summers*, as entering "enthusiastically into the joys of amateur farming—blooded stock, the building of stone walls, erecting new buildings, draining swamps, planting orchards. . . . My father delighted in swinging an axe and helping with a crowbar when rocks were being removed and a wall built."[2] Bigelow came from farming stock in Malden-on-Hudson, about 50 miles north, and never lost his interest in agriculture. He also used his estate as a way to show his respect for the French philosopher Voltaire. As a statesman, he traveled a great deal, and visited Voltaire's garden in France. There he picked up a horse chestnut seed, which he planted at The Squirrels, where his descendants fondly report that it is still growing. A love of nature, a sense of place, and an appreciation of the river's beauty is something that many of the millionaires with estates on the Hudson River passed on to their children and grandchildren as part of their inheritance.

The river gentry who established these estates liked to emulate the Swiss scientist Louis Agassiz, whose teachings at Harvard University urged people to learn to "read Nature" through meticulous collections of specimens and studies of the natural world. They collected for naturalists such as John Burroughs, who lived for a time in Highland Falls and later moved up the river to West Park, and Edgar Mearns, whose monographs on birds and fish of the Hudson Highlands would be published by the Essex Institute in the 1870s and 1880s. Mearns notes that Osborn's son William provided him with an American goshawk, and Miss Anna B. Warner obtained another on Constitution Island. In attempting to document the speed at which an oldsquaw duck was flying, Mearns observed that the bird went at exactly the same rate as a passing train. John Toucey, superintendent of the railroad, was pleased to provide the times and distances to Mearns, who then figured that the duck was flying at the rate of about one mile per 1.43 minutes. Burroughs, through his popular essays, helped readers see exploration of nature as a path to self-discovery, suggesting that "man can have but one interest in nature, namely to see himself reflected or interpreted there."[3] His essays focused on the birds, the clouds, or the flowers on the path, not the sublimity of scenery, and offered a way to see nature "with the freedom of love and old acquaintance."[4] As a boy, Theodore Roosevelt, who spent part of the summer on the shores of the Hudson, at Barrytown in 1868, and at Spuyten Duyvil near Riverdale in 1870, was part of this tradition, collecting birds, gardening, fishing, and exploring weasel holes.[5] In 1871, on a visit to the Adirondacks, he wrote a monograph on the species of birds he saw there. Later, as president, became a frequent visitor at Burroughs's cabin, Slabsides. Roosevelt's fifth cousin Franklin Roosevelt, who grew up on a river estate in Hyde Park, also maintained a collection of birds. Such close observation of nature offered a way of connecting to it both spiritually and intellectually.

Reverence for nature did not preclude killing wildlife. Procuring specimens generally involved shooting them, something both Roosevelt boys did. Mearns describes the sighting of a laughing gull near Constitution Island that "was so gentle that a boatman attempted to strike it with an oar." The gull wisely flew away.

For the residents of Millionaire's Row, the wildlife of the Hudson added romantic effect. Mearns offers this description of the bald eagle, which he found to be a permanent breeding resident:

The White-headed or Bald Eagle constitutes a marked and romantic feature of the superb scenery of this part of the Hudson, lending another charm to a scene already grand and impressive, but rendered sublime and awe-inspiring by the presence of this noble bird, seen perched upon some blasted tree above the massive cliffs, or soaring in higher atmospheric regions, far above the reach of the coming tempest, while its scream falls faintly upon the ear, answering the loud, quavering cry of its nearer mate.

In winter, when the river is frozen, the Eagles are seen soaring above the mountainside, searching for the scanty prey upon which they are obliged to subsist when fish, their favorite food, is unattainable; but later, when the ice is in motion in the Hudson, carried swiftly by the current, numbers of them may be seen sitting in pairs upon trees low down by the river's edge, watching for their finny prey, or else floating upon the ice in the stream, in company with Crows and Gulls. In summer, their favorite perch is upon some withered tree on the mountain's side, from which, at intervals, they descend to the river, or some secluded lake, to seek their food. When the ice first breaks up in the Hudson, the Eagles are sometimes extremely abundant. At that season I have counted more than twenty-five that were in view at once.[6]

Most other entries in Mearns's Hudson Highlands monographs are the matter-of-fact observations of a naturalist. However, the above passage, published in 1880, shows that the concepts of the sublime and picturesque, which took hold in mid-century, still prevailed on the Hudson. Eagles added to the appeal of the Highlands as a place to build a country seat.

Grace Tracy Cook, who describes the Bigelow and Morgan households in her memoirs, has beautifully recorded family life at the great estates. A granddaughter of Bigelow and a niece of Morgan, she spent her childhood at Stonihurst in Highland Falls at the turn of the century, when activity at the estates was at its height. She recalls that "Uncle Pierpont" Morgan was given to a royal display of wealth at Cragston, creating sumptuous experiences for friends and guests, all of which began with a trip up the river in his extravagant boat, *Corsair*, with servants dressed in striped waistcoats and gorgeous livery. She wrote:

Cragston was kept open for weekends a good many years and there was a great deal always going on there when the house was open. They lived in the most lordly English style. In the spring and summer Uncle Pierpont came up for the weekend on the Corsair, the palatial yacht which we could see at anchor from Stonihurst. He used to drive a coach and four horses to church and often picked us up. . . . Sunday morning everyone trooped down for a seven-course breakfast at ten. After a gigantic lunch served for guests (which he never ate) there would be an English tea spread. That was followed by Sunday evening supper, equally gigantic to which family and neighbors were invited. All this was followed by Hymn Singing which he chose. Any hymn was acceptable except "Nearer My God to Thee."[7]

During the time Morgan summered in the Highlands, his power grew steadily. Out of the chaos of panics and mergers, he forged his own brand of order and control in the transportation and banking industries. He connected railroad and steamboat lines and created the first regional, then national, train systems. He financed the Edison Electric Illuminating Company, and with the help of his banker, James

Stillman, he merged many smaller utilities into the Consolidated Gas Company. After his death in 1936, these companies merged to become the Consolidated Edison Corporation, which would play an important role on the Hudson, as would another company he formed, General Electric. He also dominated or controlled U.S. Steel, American Telephone and Telegraph, and scores of other companies. Edward Mitchell, editor of the *New York Sun*, wrote of him: "The lesser monarchs of finance, of insurance, of transportation, of individual enterprise, each in his domain as haughty as Lucifer, were glad to stand in the corridor waiting their turns like applicants for minor clerkships in the anteroom of an important official, while he sat at his desk in his library within."[8]

In contrast, life at John Bigelow's estate, The Squirrels, was more down to earth. Bigelow was not in Morgan's financial league, but he was an eminent political and literary figure. In 1856, when he first purchased the 12-acre property, Bigelow was owner and editor of the *Evening Post* along with William Cullen Bryant. He shunned the financial wheelings and dealings of his wealthy friends and relatives, opting for a more straightforward approach. Grace Tracy Cook remembered that the Bigelow grandchildren ran barefoot in homemade brown linen dresses and were quite awed by the pomp and ceremony at Uncle Pierpont's.

Morgan's and Bigelow's were two of nine estates that extended from West Point south to Fort Montgomery. Except for one, all belonged to friends, relatives, and business associates of Charles Edward Tracy. The exception was Pine Terrace, the estate of General Roe, son of the proprietor of Roe's hotel. Roe was somewhat excluded from the social scene—no one knew where he got his money.

Each of the estates in Highland Falls and Fort Montgomery had extensive gardens, and it was customary to allow "The Village" to walk through them all on Sunday afternoons. It was possible to walk from one to the next continuously, through all nine.

West Point was an important part of the social scene and another reason the captains of industry found the region attractive. One could enjoy the outdoors and at the same time socialize with the elite group at the academy. Young officers paid their calls on horseback and remained for supper.

Enthusiasm for boating also added to the pleasure of living in the Highlands. The steamboat made it possible to entertain summer guests and visitors, and the estates also had their own docks for yachting. Again, Grace Cook offers a clear picture:

West Point was at that time considered an ideal summer residence for young ladies. It was easy for chaperons, and the steamer Mary Powell, alluded to by every writer about the Hudson, furnished a cool and comfortable means of transportation from New York. I remember the Mary Powell well. Horses and carriages could be put on board her, and it was an easy way to travel as far as Albany and the Catskills and even the Adirondacks, although they were not discovered until later. There were weekly dances at Cranston's; the proprietor probably had fewer headaches than the management of a summer hotel has today. Most of his food supply was local. Beginning after the Civil War, Highland Falls came to be considered fashionable, if you can believe it, and little by little summer-houses were built near it—or existing farm houses bought and adapted by people who came for the summer. In the 1840s country-houses were built by three members of the Pell family. They were the first to put up what was then considered "handsome" houses with docks fronting on the River.[9]

Scenic Cornwall was another favored location for river estates. James Stillman, who had become rich investing in cotton, oil, and railroads, had moved to this part of the Hudson Valley in 1885, shortly before becoming president of National City Bank (in 1891), later called Citibank. He purchased a large tract on Storm King Mountain that he hoped to transform into an artists' colony and country hideaway for family and friends. Artist colonies in scenic settings became popular after 1860, the most famous in the Hudson Valley being Byrdcliff at Woodstock, in the Catskill Mountains, established in 1903. Stillman named his country home The Ridge. It was a "low, rambling comfortable house," though Stillman himself was stiff and over-bearing.[10] He commuted from Cornwall to New York on his boat, the *Wanderer*. For his departure, he required his family and servants to line up in the main hall at eight in the morning while he marched past. Afterward Mrs. Stillman, who found life with her husband unbearable, would reportedly rush to the home of a neighbor and madly play the piano until she got him out of her system. She later left him and moved to Europe.

Stillman was a business ally of E. H. Harriman and William Rockefeller. These men were adversaries of J. P. Morgan until 1907, when rivalries were set aside in favor of the "community of interest." E. H. Harriman owned a sizeable estate in the Highlands, which he called Arden, but it was quite a distance from the river, located to the west, near the Sterling iron mines that had been so useful in the American

1891 map of the Hudson Highlands, showing property ownership in Highland Falls and Fort Montgomery, Orange County.
F. W. Beers, Atlas of the Hudson River Valley: From New York City to Troy, including a section of about 8 miles in width *(New York: Watson and Co., 1891)*

Revolution. William Rockefeller owned an estate, Rockwood Hall, on the east shore of the Hudson in Tarrytown, next door to his brother John D. Rockefeller, the oil magnate. Stillman, Harriman, Osborn, Morgan, and Rockefeller would later play a key role in conserving the Hudson, an interest rooted in these country estates, as would many of their friends, colleagues, neighbors, and descendants.

John D. Rockefeller bought his estate in 1893, assembling nine contiguous properties on a hilltop above Tarrytown at Pocantico. He shared this property with his son, John D. Rockefeller Jr. ("Junior"). Like Morgan and Harriman, John D. Rockefeller Sr. ("Senior") was one of the richest men in America. In 1893, when he bought the Pocantico land, he was already notorious for ruthless competitive tactics that bankrupted many smaller businesses. A year later, this reputation became much worse, as the muckrakers went after him. Between 1894 and 1904, a series of books, including Henry Demarest Lloyd's *Wealth Against Commonwealth*, Ida Tarbell's *History of the Standard Oil Company*, and John Moody's *The Truth About Trusts* pointed to Rockefeller as the worst of the exploiters of the American public. "Senior's" company, Standard Oil, refined 95 percent of America's petroleum. In 1884 he moved his corporate headquarters from Cleveland, Ohio to Manhattan, where the large port gave him advantages for foreign trade that he fully utilized in developing the company. He also established refineries around the harbor, in places such as Newtown Creek in Brooklyn. As a measure of his wealth, it is interesting to note that in 1885, his share of the Standard trust's annual dividends amounted to $40 million, and that was not his only investment.

The spot the Rockefeller family picked for a country estate was breathtaking. Unlike other estates of this era, Kykuit, Dutch for "lookout," was several miles away from the river, but it was situated on high ground with a sweeping view of the Hudson from the Palisades to the Tappan Zee and the Highlands, a feature that strongly appealed to him. Rockefeller's great-granddaughter, Ann Rockefeller Roberts, beautifully described the setting at Pocantico:

> These full, rolling hills stretch back from the river; morning mist drifts among them, storms bear down along the river with sudden speed and power, evenings can be still and sweet or brilliant with the riotous colors of the setting sun. Gazing at the uninterrupted vistas, one has a startling sense of how this land must have looked before the first European settlers arrived—miles of deciduous and evergreen forest, the river a ribbon of undulating silver cutting through it.[11]

In time, Rockefeller would assemble thousands of acres. It would be the place where he spent winter weekends and parts of every summer and fall, recharging himself spiritually. He noted: "At Pocantico Hills, New York, where I have spent portions of my time in an old house where fine views invite the soul and where we can live simply and quietly, I have spent many delightful hours, studying the beautiful views, the trees, and fine landscape effects of that very interesting section of the Hudson River, and this happened in the days when I seemed to need every minute for the absorbing demands of business."[12]

When he first moved in, he lived in an old wooden farmhouse, a modest structure for a person of his means and one that suited his taste for simplicity. Rockefeller had built his fortune through a lifetime of thrift combined with a knack for the well-timed, bold, ambitious move. Three years after buying the property, in 1896, at age

57, he entered a period of semiretirement that allowed him to concentrate his efforts on his new project, the Pocantico estate. With the same attention to detail and grandness of vision that he applied to his business, he methodically explored every inch of his land and considered how best to develop its potential. In 1894, Rockefeller Sr. had engaged a landscape architect from the firm Olmsted, Olmsted and Eliot to design the property roads and grounds and to find a situation for a new house to be built on the hilltop, where it might capture the best light at all seasons as well as the best views of the river. Two years later, when excavation was well under way, he began to take over control of the work himself, and by 1897, he had fired the landscape designer, Warren Manning, taking full charge of the landscaping and grounds. Of this time, he later recalled:

> Others may be surprised at my claim to be an amateur landscape architect in a small way, and my family have been known to employ a great landscape man to make quite sure that I did not ruin the place. . . . I had the advantage of knowing every foot of the land. . . . In a few days I had worked out a plan so devised that the roads caught just the best views at just the angles where in driving up the hill you came upon impressive outlooks, and at the ending was the final burst of river, hill, cloud and great sweep of country to crown the whole; and here I fixed my stakes to show where I suggested that the roads should run, and finally the exact place where the house should be.[13]

If it seems odd that such ruthless businessmen would be such enthusiastic nature lovers, perhaps there is an answer to be found in the theories of park planner Frederick Olmsted, who stated in 1865 that enjoyment of scenic beauty enhanced "the health and vigor of men" and improved their intellect.[14] He noted that the more civilized a man was, and the more cultivated his taste, the greater the power of scenery would be to affect him.[15] Thus, when the captains of industry like Rockefeller, Morgan, and Osborn spent hours building rock walls and trimming trees to enhance

John D. Rockefeller and John D. Rockefeller Jr., circa 1916.
Courtesy of the Rockefeller Archive Center

river views or planting fruit trees and flowers, they could feel that they were honing their physical and intellectual skills and demonstrating their high level of taste and civilization. Contact with nature seems to have also filled a void for these hard-driving men, offering a way to refresh themselves spiritually. As Rockefeller Sr. commented, he seemed to spend more time enjoying the river views when the demands of work were most pressing.

During John D. Rockefeller Sr.'s early retirement, he devoted himself to the Pocantico property and began another big endeavor: deciding how to use his money for good causes. In 1889, he was inspired by Andrew Carnegie's essay "Gospel of Wealth," published in the *North American Review*, which suggested that wealth comes with responsibility to society. "The man who dies rich dies disgraced," Carnegie wrote. Rockefeller wrote a letter to Carnegie, saying: "I would that more men of wealth were doing as you are doing with your money, but please be assured your example will bear fruit."[16]

In 1913, after undertaking a number of important charitable projects, he created the Rockefeller Foundation, endowed with $100 million. Its mission, simply stated, was to "promote the well-being of mankind throughout the world." Eventually, Rockefeller's gifts to charity would amount to about $500 million. However, he assumed the mainly passive role of investor. He encouraged his son, John D. Rockefeller Jr., to handle the strategy and the details. Eventually, Rockefeller Jr. would make foundation giving into a career.[17]

Many other millionaires took up philanthropy, among them several other owners of country homes on the Hudson, including J. P. Morgan, William Henry Osborn, Stuyvesant Fish, Jay Gould, and James Stillman. Indeed, after Carnegie's article appeared, such giving was expected. Men and women of great wealth began to consider their role in society, concluding, as Carnegie suggested, that they had a responsibility to use their money "so the ties of brotherhood may still bind together the rich and poor in harmonious relationship."[18] They sought to apply their knowledge and experience to help the poor do what they could not do for themselves. Among this class of donors, Rockefeller and Carnegie stood out for their organized giving, and for creating models for the modern charitable foundation.

With so many of the nation's wealthiest people now living on or near Manhattan Island, cheek by jowl with multitudes of the nation's poorest people, New York would soon emerge as the headquarters of foundation giving. These organizations addressed themselves to medicine, education, and help for the poor, often supporting the establishment of fresh air camps on Hudson River shoreline properties. Many of the camps occupied estates and mansions that had become white elephants for their wealthy owners, no longer in fashion. Poor children from the city, many of them immigrants, now roamed where once the elite kept them out. Eventually some of the New York foundations began supporting conservation of the Hudson River itself.

In 1889, when Carnegie launched this charitable movement, the millionaires living on the shores of the Hudson were just beginning to build their fancy homes. The designs were extraordinarily varied. Some, like Morgan, moved into existing farmhouses and converted them to their needs. Cragston, The Squirrels, and Glenclyffe were houses originally constructed in the 1840s and '50s and remodeled by their new owners. John D. Rockefeller Sr. also lived in a farmhouse until it burned down; then he and his son turned their attention to building something new.

Whether the newly rich built a new house or remodeled an old one, the choice of architectural style had to complement the scenic landscape, following the guidelines promoted decades earlier in Downing's books, which were still in print. William Henry Osborn, president of the Illinois Central, took this notion to the extreme. Castle Rock was not just Osborn's home, it was his fantasy. Built on a mountaintop in Garrison, it is tall, turreted, and whimsical—a stunning example of picturesque architecture. At an elevation of about 800 feet, it looks down on a sweeping panorama of the river and its Revolutionary War sites, and on a clear day, the Catskills and the Shawangunks are visible. Silhouetted against the sky much like a romantic castle on the Rhine, an example of the picturesque ideal so popular among Americans at that time, Osborn's castle is two and a half stories high, constructed of rough-cut granite masonry. Asymmetrical in shape, it is dominated by a round tower in the center and capped by a red slate roof. Porches and galleries on the west and south sides frame the views of the valley below.

Castle Rock, built by William Henry Osborn in 1881.

Copyright Charles H. Porter 1990

When Osborn built Castle Rock, some thought he was lording it over the Fish family, who lived at Glenclyffe, which was situated on lower ground in Garrison. While that may be the case, the location and design were clearly influenced by Hudson River School painter Frederic Church, a childhood friend of Osborn's. The two had grown up together in Connecticut and remained close throughout their lives.

It was Church who suggested the location for the castle, which Osborn built in 1881, and he took a strong interest in its design. In 1868, Church wrote to Osborn from Rome: "Don't settle any plans about building a house until I return—I am conceited enough to wish to thrust my finger into that pie and offer my opinions on domestic architecture." Less than a week later, he wrote again, "I should be almost as much interested in your house as my own and as I have scraped together some good ideas, as I think—I want you to have the benefit of them." Another letter states: "When you build, build of stone." He made a pencil sketch of the proposed Osborn castle.[19]

Castle Rock, designed by architect Jarvis Morgan Slade, was completed in 1881. In 1882, upon Osborn's retirement, the family took up permanent residence there. His son, Henry Fairfield Osborn, added a north wing and library in 1906. When completed, the castle boasted thirty-four rooms and four interior chimneys. Guests were invited for stays of a week at a time, and no sooner would one set of guests leave than another arrived.

The renowned artist Susan Hale (a daughter of Boston's Nathan Hale), who was close friends with Frederic Church, visited the castle three years after it was built and noted how hard Osborn worked at developing new spots to enjoy river vistas. Afraid of heights, she was not enthusiastic about staying there, in spite of the estate's obvious scenic beauty. She described her visit at length in a letter to her sister Lucretia:

"Castle Rock" on the Hudson

Tuesday, July 29th '84.

Dear Luc,

. . . Emulating Mr. Church's palace, Mr. Osborn (who is a "Railway King") has built a castle. I think it is a dreadful place, for I could scarcely bear the Churches being up so high . . . 'tis wearisome to get up here by the long winding road. . . . The Hudson, to be sure, is at our feet, and West Point just opposite affords a human interest not got at Olana; but they say here that often, thick clouds below the house hide the whole landscape and the sun is shining here while from below come the lamentation of cars and cows where it is raining. I fervently long to be on terra firma, and have a kind of permanent vertigo, which you see affects my spelling. The minute we had finished our 1 o'clock dinner, Mr. Osborn took me in the buckboard to see everything. We didn't get back until 6! It is an immense place; in fact, he owns the whole mountain, and he is busy opening vistas and making roads. Of course, the view up and down is perfect.[20]

The "palace" of Mr. Church that Susan Hale referred to was Olana, a Moorish castle that Church personally designed, using architect Calvert Vaux to help execute his ideas. Built of brick and locally quarried stone in 1872, it is a place full of artistry and effects. Light and colors change from room to room. Every window offers a

striking vista. Indoors, stencils of gold, salmon, purple, and green adorn the walls, echoing the outdoor patterns of red, yellow, and black bricks in the tower walls and the decorative red and gray slates of the roof. "I designed the house myself," Church wrote to a friend.

> It is Persian in style adapted to the climate and the requirements of modern life. The interior fittings are all in harmony with the external architecture. It stands at an elevation of 600 feet above the Hudson River and commands beautiful views of sky, mountains, rolling and savannah country, villages, forest and clearings. The noble River expands to a width of over two miles forming a lakelike sheet of water which is always dotted with steamers and other craft.[21]

Church paid the same close attention to the grounds as he did to the house and its furnishings. "I have made about 1 3/4 miles of road this season, opening entirely new and beautiful views. I can make more and better landscapes in this way than by tampering with canvas and paint in the studio," he said.[22]

The Hudson's hills and shores were particularly appealing for castle building, which added to the romantic character of the river and conferred a sense of nobility. The sheer number of castles—there were dozens of turreted mansions, including several that explicitly called themselves castles—made the river landscape almost a copy of Germany's Rhine, American style.

In 1903, a Moorish castle appeared on the shores of the Hudson—built by Evans Dick and his wife, using modern construction methods and cast concrete. Located on a mountaintop in Garrison, its design was inspired by the Alhambra, Granada's palace. The plan called for 52 rooms, including a ballroom. During the construction, more than 100 artisans and workmen camped on the mountainside for about 8 years. In 1907 a stock market crash depleted the Dick family's wealth, and in 1911 work was halted with $3 million spent of the projected $7 million cost. Building materials, ladders, and workmen's tools were left on the site as if work would resume the next day. However, the castle remained incomplete after Mr. and Mrs. Dick died.

Olana, the home and studio of Frederic Church, in Greenport, New York, designed by the artist and executed by Calvert Vaux, 1872. In the 1960s, General Frederick Osborn, grandson of railroad baron William Henry Osborn, was instrumental in securing its preservation as a State Historic Site under Governor Nelson Rockefeller. It has been described by Frank Kelly, director of the National Gallery of Art, as the "single most important artistic residence in the United States and one of the most significant world."

Photograph by Stan Ries, Partnership

It was not until the 1990s that it was roofed and renovated and, after that, turned into condominiums.

Francis Bannerman chose a Scottish style for the "ancestral" castle he began building on Pollepel Island in 1908, but he died in 1918, before it was completed. Bannerman was one of the world's largest dealers in secondhand military equipment, and used the castle as both a home and an arsenal. His company stored powder and ammunition there until 1920, when an explosion destroyed part of the castle. It continued to serve as a warehouse and remained under Bannerman family ownership until 1967, when the property was sold to the state as park land, though in 1969, a fire destroyed all the buildings, leaving only a picturesque ruin.

Jay Gould—the unscrupulous "robber baron" who tried to manipulate the gold standard and nearly wrecked the Erie railroad in a battle with Cornelius Vanderbilt—

(top) Architectural detail of Dick's Castle, made of concrete. The property has been remodeled and turned into large condominium apartments.
Copyright 1990 by Robert Beckhard

(bottom) Lyndhurst, Tarrytown, designed for retired New York City Mayor William Paulding by A. J. Davis in 1838, and remodeled by Davis in 1864 for the new owner, George Merritt, adding a tower and north wing. In 1880 it was purchased by "robber baron" Jay Gould. In 1961, Gould's youngest daughter, Anna, Dutchess of Tallyrand-Perigord, bequeathed it to the National Trust for Historic Preservation.
Gottscho-Schleisner Inc. photograph, Library of Congress

moved into a ready-made castle at Lyndhurst, on the riverfront in Irvington, next door to Sunnyside.[23] Gould purchased the mansion in 1880. He added to the estate until he owned 429 acres; however, he left the house virtually unchanged. Built of Sing Sing marble, with vaulted ceilings, enameled diamond-pane windows, and pinnacled towers, it is one of the best examples of the Gothic Revival style.

Unlike many of the other millionaires of his day, Gould did not have other mansions in Newport, Rhode Island or the Berkshire Mountains. He was snubbed by New York society for a degree of ruthlessness in business practices that stood out even in the bare-knuckle era. Gould lived there only a few years. After his death, his daughter Helen bought the property and added many new buildings and gardens, but she also kept the house intact as built by A. J. Davis. Eventually, in 1961, her sister Anna bequeathed it to the National Trust for Historic Preservation. The Gould family was one of many who sought to preserve the castles and estates on the Hudson, so that today, many of these properties are in public or nonprofit ownership.

In nearby Tarrytown, John D. Rockefeller Jr. built the castlelike mansion Kykuit to replace the farmhouse that burned. This decade-long project first produced a three-story, steep-roofed and many-chimneyed stone villa with a colonial revival porch. However, the structure had many design flaws that became evident in 1908, when the Rockefellers moved in. Remodeling commenced in 1911, but by then Victorian styles had become old-fashioned, and the house was redone in a four-story classical Beaux Arts design, completed in 1913. Like Lyndhurst, this property was given

Aerial view of Kykuit façade with Adam and Eve statue in foreground, home of the Rockefeller family in Sleepy Hollow, New York, as redesigned by Bosworth and completed in 1913.
Photograph by Mary Louise Pierson

to the National Trust, in 1991, ending five generations of family occupancy. The house is open for public tours, and the coach barn serves as a conference center, supported by the Rockefeller Brothers Fund.

Farther up the Hudson are two other castles now in public ownership—palatial Beaux Arts homes built in the 1890s by two families who both remodeled smaller Greek revival houses into imposing mansions. When Ruth Livingston married newly rich Ogden Mills—whose father, Darius, had made his fortune in the California gold rush—she was able to completely redesign her modest 25-room Doric-columned home, Staatsburgh, into an immense house that required 100 men to build and 24 household servants to maintain—among them English butlers and footmen, Irish maids, French lady's maid and chef, and German or Swedish governesses.[24] Mrs. Mills was the great-great-great-great-granddaughter of Robert Livingston, the original "Lord of the Manor," and Staatsburgh, in what is now Dutchess County, was part of the royal land patent given to Henry Beekman in 1697.

Stanford White, of the firm McKim, Mead and White, designed the house and interior, lavishing it with heavy oak paneling, marble, and gilt. It is probably the model for Bellomont, the estate described in Edith Wharton's 1905 novel, *House of Mirth,*

in which a young woman seeks to secure her future by marriage to an eligible but otherwise dull society bachelor.

Ruth Livingston Mills and her husband, Ogden, persuaded their good friend Frederick Vanderbilt, grandson of the Commodore, to buy the nearby estate Hyde Park. This was the site once owned by Dr. David Hosack and visited by Downing, inspiring him to his life's work. The property had passed from Hosack to Dorothea Langdon, the daughter of John Jacob Astor. It was now owned by the estate of Walter Langdon Jr., and was on the market. Vanderbilt bought the property and hired McKim, Mead and White to refurbish the Greek revival house, a project that cost about $3 million, including furnishings. He also had mansions in Newport, Bar Harbor, and the Adirondacks.

Dorothea Langdon was not the only Astor to have a country house on the Hudson. John Jacob Astor IV was born at Ferncliff, the family's country estate in Rhinebeck, and died tragically in 1912 on the *Titanic* as it sailed for the Hudson River, though his young wife survived. Descendants of Margaret Ward Astor Chanler still reside at Rokeby in Rhinebeck.

The march of mansions up the Hudson was accompanied by the creation of another Millionaire's Row on Manhattan's Fifth Avenue—designed by some of the same architects—where many of the landed gentry of the Hudson had their primary residence. Eventually more than 70 mansions would line the avenue, a palatial collection of ornate town houses and neo-Renaissance multistoried apartment houses. In a sense, the river had become an outdoor extension of this urban social enclave.

Meanwhile, to the south, the great skyscrapers were rising, and in 1898, the five boroughs of Manhattan had been consolidated into one great city surrounding most of the harbor, except for the west shore, in New Jersey. Andrew Haswell Green, who would play a key role in another chapter of the river's history, was the spark plug for this. The port was now busier than ever, with castlelike refineries of Rockefeller's Standard Oil adding to the features of the skyline in the boroughs and in Jersey. It was the era of big everything.

Staatsburgh, built in 1896 for Ruth L. and Ogden Mills and given by Gladys Mills Phipps to New York State in 1938. Staatsburgh is thought to be the model for Bellomont, the Hudson River estate in Edith Wharton's 1905 novel *House of Mirth*, where the upper crust of society gather for house parties, a site of romantic intrigue. Ruth Livingston Mills, a society hostess in real life, was likely the model for the novel's Mrs. Trenor. Wharton wrote of the view from Bellomont: "Beyond the lawn, with its pyramidal pale-gold maples and velvety firs, sloped pastures dotted with cattle; and through a long glade the river widened like a lake under the silver light of September."
Courtesy of Staatsburgh State Historic Site, NYS Office of Parks, Recreation and Historic Preservation

On the Hudson River itself another kind of castle could be found, the oceangoing steamboats like the *Great Eastern*, built in 1860, a passenger ship six times larger than any ever built before. It was used to lay the first transatlantic cable in 1865. By the 1890s, such luxury liners were so common that new, larger piers had to be built on the west side of Manhattan. Often, land that had earlier been created by filling in the shallows now had to be excavated to make room for ships like the *Olympic*, built in 1911, a sister ship of the doomed *Titanic*, and the *Lusitania*, which berthed at the Chelsea Piers on the Hudson before it was torpedoed at sea, losing all 1,200 passengers and crew—an incident that prompted American involvement in World War I.

The ultimate Hudson River castle, of course, is West Point, and when the academy was expanded in 1902, castle building on the Hudson was operating at full throttle. The academy was then celebrating its centennial, and a design competition was planned. Invitations were extended to leading architectural firms across the country with expertise in the styles characterizing the academy at that time— English Tudor, classic, and eclectic. The competition became known as "the battle of the styles." The choice of a style and plan for the expansion of West Point would have a lasting impact on the river because of its size and location.

In 1903, a West Point jury selected the Boston firm Cram, Goodhue and Ferguson for their plan in the Gothic style, which differed from any of the existing buildings at the academy but captured the romantic and naturalistic qualities of the river site. In their winning proposal, the architects noted that their aim was to preserve the "natural features which give West Point an extreme distinction of landscape," and to "emphasize rather than antagonize the picturesque natural surroundings of rocks, cliffs, mountains and forest and be capable of execution at the smallest cost consistent with the monumental importance of the work."[25]

Construction began in 1903 and was completed in 1914. Among the most notable structures are the Administration Building, which resembles a medieval dungeon,

Cunard liner *Lusitania* departing New York. The luxury liner left on her last voyage May 1, 1915. Six days later, May 7, she sank in 18 minutes after being torpedoed by a German submarine. The Germans had issued a warning to all vessels because of the war, but the *Lusitania* paid no heed.
(© CORBIS/Bettmann) Donated by Corbis-Bettman

complete with pointed arches, stone window tracery, ribbed and vaulted ceilings, buttressed walls, and Gothic ornamentation; the East Academic Building; the Riding Hall; and the North Barracks. In the Riding Hall, ramparts of stonework rise from the water's edge like the Hudson Palisades south of the Highlands. Nearly all the buildings erected during this period utilized rough-cut stone from local quarries, allowing the structures to harmonize with the prevailing colors of the locality.

However, even as West Point began to refurbish the grounds, vandals began to damage the nearby historic Revolutionary War forts. Threats to the river's history, scenery, and natural resources suddenly appeared to be everywhere. Quarrying threatened to destroy the river's most legendary features: the basalt cliffs of the Palisades and the rocky crags of the Highlands. On the upper reaches of the Hudson, loggers cut more and more trees, and the river began to flood.

By the turn of the century, public opinion began to crystallize in opposition to this destruction, and protecting the Hudson's natural beauty and forested watershed became a matter of statewide interest. The Hudson—home of the nation's leading industrialists, the place where once painters and poets had dined with manufacturers, finding sublimity in the smoke and noise of its foundries—became a battleground where industry and scenery were no longer thought to be compatible. By the turn of the century, the captains of industry (Harriman, Morgan, Rockefeller, Perkins, and Osborn's son William Church Osborn) were among the most outspoken advocates and liberal donors for a new conservation policy. Their years on the river had instilled a love of nature that they passed on to the next generation. By the 1930s, their children would be joined by descendants of the Livingstons—and their neighbors at Springwood, the Roosevelts—in imagining a new future for the Hudson, one that returned the river to nature and preserved and celebrated its historic sites.

West Point from Garrison.
Undated postcard, author's collection

A Forest to Protect a Commercial River

*Land Surveyor Verplanck Colvin, Photographer Seneca Ray Stoddard,
and the New York Board of Trade Campaign to Safeguard the Hudson
in the Adirondacks*

11

FOR MUCH OF the nineteenth century, nature was worshipped—
but was freely sacrificed to the demands of a growing popula-
tion and burgeoning commerce. However, by the end of the
century, environmental abuse was taking its toll and could no
longer be ignored. Nationally, the passenger pigeon had been hunted to extinction,
and thundering herds of buffalo were all but destroyed. In the Northeast, wild game
was disappearing, the commercial fisheries off the Atlantic coast had become criti-
cally depleted, and the forests were falling to a lumber industry that marched
through the states "like an army of devastation," leaving the woodland soil exposed
to erosion by wind and weather.[1] By 1900 the beaver—the basis of the economy of
New Netherlands—had been extirpated in New York. Americans began to realize
that the earth's capacity for renewal had limits, and those limits were being reached.

As the pace of destruction became ever more rapid, the need for public action be-
came dramatically apparent. The loss of natural resources endangered food, water,

recreation, and commerce. For a country that found great spiritual value in nature, the threats to scenery and wild country caused no less alarm. With characteristic energy, Americans responded, and from about 1870 to 1910—while the railroad barons were developing their country estates—sweeping new initiatives were launched to assure that the public interest in natural resources would be protected, resulting in numerous new state and federal laws, new government agencies, and the formation of clubs, associations, and citizen groups.

Over a forty-year period, from 1870 to 1909, active environmental conservation took hold on the Hudson from its headwaters to its harbor. Efforts were made to protect the forest and water supply of the upper Hudson and then the scenery and historic sites of the Palisades and the Highlands, and after that, to address the pollution in New York harbor. During this time new models for conservation were formed, interstate cooperation launched, and sweeping new conservation measures adopted; hundreds of thousands of acres were conserved. The region's millionaires provided political and financial support, and the state's business leaders—through the Chamber of Commerce and the Board of Trade—organized a potent lobbying effort for conservation. Artists, writers, and outdoorsmen dramatized the need for action. Dynamic people led these initiatives, and the force of their personalities proved key to success.

What happened on the Hudson was part of a broader national movement that began at the close of the Civil War. At the federal level, agencies created during this era included the Game and Fisheries Commission, established by Congress in 1871, and the U.S. Geological Survey, formed in 1879. In 1872, Yellowstone became the first national park when Congress set aside two million acres, mostly in Wyoming. The federal government created a Division of Forestry in 1881, then established a system of

national forests in 1891. The Antiquities Act, passed in 1906, allowed areas of scientific or historical interest on federal lands to be set aside and preserved as National Monuments, resulting in the protection of the Grand Canyon in 1908.

This growth in federal programs was matched by the formation of public interest groups such as the American Forestry Association, chartered in 1875, followed by the Appalachian Mountain Club (1876), the New York Audubon Society (1886), the Boone and Crockett Club (1887), the Sierra Club (1892), the Association for the Protection of the Adirondacks (1901), and the National Audubon Society (1905). A new attitude was becoming more widely shared among Americans—the idea that the public interest in natural resources could outweigh that of the individual—though these groups differed on what exactly that might mean. They had many different objectives.

Yet, the question of how to go about protecting water, wildlife, woodlands, and scenery remained to be worked out. Both nationally and at the state level, advocates and political leaders struggled to find effective methods. Should natural areas be used for parks or managed for forestry and pasture? Should trees on public land be cut or not? How could scenery be protected? What role should the government play? Could solutions that worked in Europe be successful here?

Winslow Homer, *Lumbering in Winter.*
Engraving, 1871.
Courtesy of the Adirondack Museum, Blue Mountain Lake, NY

On the Hudson, concern over forest destruction in the Adirondack Mountains provided the first focus for conservation, as the link between forests and water became more widely understood. At the close of the Civil War, the high peaks area was still a remote region of lumber camps and iron mines. Occasionally, gentlemen vacationing at Saratoga would venture into the woods to hunt and fish while the ladies took the spa waters, but for nearly everyone else, it was a "realm of mystery" and a "primeval forest" to be visited only on the pages of magazines like *Harper's Weekly* and *Ballou's Pictorial*.[2] There one might occasionally see engraved images of fresh-caught trout and antlered bucks or the hard-bitten faces of lumberjacks, trappers, and guides.

The stony Adirondacks grew only one truly profitable crop—trees—and after 1850, the pace of harvesting sped up, not only along the Hudson and its watershed but also on other parts of the mountain range and adjacent Lake Champlain. Along the Hudson and its tributaries, selective cutting removed millions of the tallest spruce trees but left everything else standing. The logs were floated out of the woods on Adirondack streams to downstream mills. From 1850 to 1872, the annual number of saw logs cut at Glens Falls jumped from 132,000 to 1 million.

None of this might have been seen as a problem, but for the arrival of the tourists and the trains. A guidebook published by a Boston minister inspired the first rush of tourists to the Adirondacks in 1869. Then, in 1871, the Adirondack Railroad Company extended its tracks from fashionable Saratoga all the way to remote North Creek on the upper Hudson. Railroad tracks began to converge on the mountains from other directions as well, bringing visitors from as far away as Boston, Philadelphia, New York City, and the Midwest to hunt, fish, hike, and camp in the woods. Tourists were shocked to see a panorama of forest destruction. Indeed, it was happening most rapidly wherever the roads and railroads went.

River Driving on the Hudson, late nineteenth-century photograph, likely by Seneca Ray Stoddard.
Courtesy of the Adirondack Museum, Blue Mountain Lake, NY

There was a time when a cleared forest had been a symbol of progress to most Americans, but in 1864, George P. Marsh's book, *Man and Nature*, got people thinking about it in a new way. Marsh described in painstaking detail how human actions had changed and were still changing every aspect of the natural world—the climate, the flow of water, the richness of the soil, the number and diversity of plants and animals, the predator species, and the pests. These changes sometimes made things better and sometimes made them worse, Marsh said, but there were almost always unintended consequences. The danger was in not understanding that some resources crucial for the survival of mankind could be destroyed forever.

In a chapter devoted to the forests, Marsh described the cascading problems that end in disaster when too many trees are cut. Water no longer seeps into the ground but runs off the land, carrying the topsoil into the nearest stream and river; groundwater is depleted; and surface waters are polluted. In some climates, desert conditions set in, and once-thriving agricultural areas are abandoned, unable to support human populations of any size. Marsh cited the work of leading scientists as well as his own observations, giving examples of places once fertile and populous that now were barren. Areas in Greece, North Africa, the Middle East—the cradles of civilization—had been destroyed by loss of trees. The same disaster struck the islands of the Caribbean and the high slopes of the Alps. There are places where "man has brought the face of the earth to a desolation almost as complete as that of the moon," he wrote, and sometimes in the space of just one human lifetime.[3] He then suggested things that could be done to prevent such disasters and, where possible, to restore environments that had been destroyed. One solution, he said, would be for states that own large acreage of forests to hold onto them instead of trying to sell them. Education about all this was key.

Marsh's book was widely read in America and abroad, and his ideas were talked about in widening circles for at least forty years (reprints continued through 1907). *Man and Nature* is known today as the book that launched conservation in this country. The notion that forest conservation is crucial for protecting water supplies is now widely accepted, but the book brought this issue to the fore at a time of mounting problems on the Hudson River, problems Marsh himself observed. In the 1860s, mills were still powered by water, and droughts had closed some of them for extended periods of time, with a devastating effect on the manufacturing economy. Shallow water in the rivers and canals also slowed transport of goods. Ambitious and expensive channel-deepening projects were launched, but the problems didn't go away. Marsh, who lived in nearby Vermont, suggested that the decreased water flow might be related to the destruction of the forest in the upper Hudson watershed, and he proposed that New York conserve what remained of its tracts of primitive woodland. The main benefit would be to protect the commerce of the Hudson, but these lands could also serve as a refuge for wild animals and native plants and a "garden for the lover of nature." Managing the forest properly for timber, he said, would also provide the state with annual income.[4]

Verplanck Colvin was a teenager when *Man and Nature* was first published in 1864—and it's very likely that he read it. The young man from Albany established himself as a talented nature writer and an engaging public speaker, and many of the ideas that Marsh had discussed found their way into his work. Colvin was also obsessed with the north woods and with maps, and he soon landed a job as the state's chief land surveyor, the beginning of a long career of protecting the upper Hudson and its Adirondack watershed along lines that Marsh had suggested.

When he was eighteen, Colvin began a five-year wilderness odyssey to explore places few men had gone. From 1865 to 1870, he traversed the Adirondacks, usually alone, sleeping underneath his canoe on the riverbanks, climbing mountains, and exploring the woods. He sought places "where rivers rise from mountain springs, and where deer and panther, bear and wolf roam through the forest solitude."[5] He reveled in the sight of northern lights and the tracks of wild animals. He was astonished and awed by the grandeur and vastness of the numberless peaks that rolled to the horizon like waves in the sea. He delighted in the play of colors in crystals of feldspar. He studied the species of plants on the forest floor. Discovering that most maps were useless, he searched for deer paths to guide him and listened for the distant cry of a loon to lead him to unmarked lakes. Soon, he began assembling his own maps of the region, using a barometer and compass to chart the height of mountains and ridges, many of them as yet unnamed.[6] Colvin found his true calling in life during his treks into the woods. The wilderness was his muse.

He also gave lively speeches and wrote stirring essays about his adventures. He aspired to be "an artist and a literary man," to have a "superior knowledge of the wilderness," to be the first to discover uncharted areas, to become a celebrity.[7] He was inspired by the example of men like Albert Bierstadt and Thomas Moran, who had explored and painted the grand western landscapes of Yellowstone, Yosemite, the Grand Canyon, and the Rocky Mountains.

On December 16, 1870, Colvin spoke to the members of the Albany Institute about his recent three-day trek up remote Mount Seward in the Adirondacks—a challenging climb that left him soaking wet from clambering on hands and knees through the carpet of spongy mosses that clung to the mountainside. When night fell and he needed water to drink, Colvin told them, he simply pulled out some moss and scooped up water from it as if from a bowl. Not only did the plants satisfy a hiker's thirst, they also formed springs that fed the streams of the state, including the Hudson River. However, he warned, the mosses were vulnerable to destruction, and their loss would have unintended consequences:

> I desire to call your attention to a subject of much importance. The Adirondack Wilderness contains the springs which are the sources of our principal rivers, and the feeders of the canals. Each summer the water supply for these rivers and canals is lessened, and commerce has suffered. The United States Government has been called upon, and has expended vast sums in the improvement of the navigation of the Hudson; yet the secret origin of the difficulty seems not to have been reached. The immediate cause has been the chopping and burning off of vast tracts of forest in the wilderness, which have hitherto sheltered . . . the thick, soaking, sphagnous moss, which at times knee deep, half-water and half plant, forms hanging lakes upon the mountainsides. . . .
>
> It is impossible for those who have not visited this region to realize the abundance, luxuriance, and depth which these peaty mosses—the true sources of our rivers—attain . . . its bulk being altogether water. . . .
>
> With the destruction of the forests, these mosses dry, wither, and disappear; with them vanishes the cold, condensing atmosphere which forms the clouds. Now the winter snows that accumulate on the mountains, unprotected from the sun, melt suddenly and rush down laden with disaster.

Colvin had come to the same ideas expressed in *Man and Nature* but in a deeply personal way, and echoing Marsh's own suggestion, he concluded his report by proposing:

> The remedy for this is the creation of an ADIRONDACK PARK or *timber preserve*, under charge of a forest warden. . . .
>
> The interests of commerce and navigation demand that these forests should be preserved; and for posterity should be set aside, this Adirondack region, as a park for New York, as is the Yosemite for California and the Pacific States.[8]

With these words, young Colvin began his campaign to conserve the forest in the Adirondacks. It would take twenty-five years, but by the power of his actions and his words, and by engaging influential people—governors, businessmen, photographers, and others—he developed a critical mass of support for his idea and altered the course of history on the Hudson to this day. The speech had an immediate effect—it was included in the annual message of Governor John Hoffman, and it was printed in the annual report of the state's Museum of Natural History.[9] That the speech could have such power stemmed in part from Colvin's personal history.

Verplanck Colvin was born in Albany in January 1847. He traced his ancestry to early Dutch settlers of the Hudson River Valley, the Verplancks. His great-great-grandmother, Ariantje Verplanck, inherited much of the large Coeymans land patent south of Albany. The Colvin name came from a Scotsman who immigrated to America in 1772 and moved to Coeymans in 1777. Both his father and his great-grandfather had served in the state legislature. Verplanck Colvin thus came from a family with deep roots in the Hudson Valley, as well some power and influence.

At an early age, he began to draw on these assets. In 1872, about a year after his speech to the prestigious Albany Institute was published, he made a pitch to the legislature for a proper survey of the Adirondacks. State officials agreed and passed a law that year calling for such a survey, naming him as the state surveyor. He was then twenty-five years old. He would keep the post for twenty-eight years.

That year, the state also appointed Colvin to a commission established to consider the possibility of creating a park in the Adirondacks, as he had suggested the year before. Yellowstone, in Wyoming, had recently been designated as America's first national park, and the idea of creating state and national parks was still in its infancy. Colvin was appointed to the study commission as its secretary and scribe, and the group wrestled with the idea of what a "park" should be. Colvin was likely one of the principal authors of the commission report, which was submitted to the state legislature on May 14, 1873. His ideas and his style echo throughout.[9] The commission considered a park that would be mainly for recreation, but rejected the idea because it might seem frivolous. Instead they suggested that the park should be useful. Protection of the forest was more important to them than public use, and a key reason was their desire to protect the waters of the Hudson River. The report proposed a "forest park and timber reserve," and suggested that the state consider focusing its efforts on the Hudson River watershed within the Adirondacks:

> Upon the Hudson river, the destruction of the Adirondack forest would have a calamitous effect. The deep winter's snows, accumulating upon the disafforested uplands, would remain unmelted till the thousand and three hundred square miles of

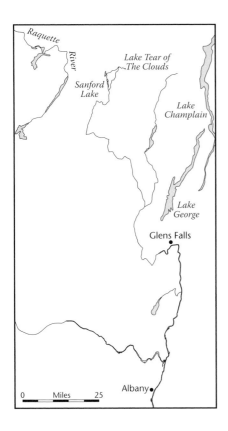

the present wilderness might have a compact covering of snow equal to twelve inches of water. Spring, with its sunshine and showers would suddenly release this latent ocean.... More than a quarter cubic mile of water hurled furiously into the narrow valley of the Hudson, it would sweep before it fields of ice, to crush and sink the strongest vessels, and ruin the warehouses on the wharves. While the Adirondack forests remain, these deep snows will be protected from the direct rays of the sun in spring, and will slowly and gradually melt away....

... the chief and very important influence which forests exercise upon the rainfall is their power to moderate storms and distribute the annual quantity of rain more equally throughout the year....

Here, by ruthless destruction of the forest, thoughtless men are depriving the country of a water supply which has belonged to it from time immemorial, and the public interest demands legislative protection. The canal interests of the state are very great, and are already suffering from this wrong. The water supply of the Champlain canal is entirely obtained from the streams of this wilderness, and the Erie Canal, from Rome to Albany, is almost entirely supplied from the same watershed. In the Hudson, near Albany and Troy, navigation, at midsummer, has become very difficult. The mill owners at Glen's Falls and at other points find that their water fails them; and the farming hands throughout the state suffer from the storms and droughts already noticed....

The question before your commission is one of great importance to the State.... For the present, we deem it advisable, and recommend, that the wild lands now owned and held by the State be retained until this question is decided.[10]

This last sentence referred to the approximately 400,000 acres of land that were held by the state. Much of this property had been logged. When all valuable trees had been cut, the timber companies abandoned the land, leaving the state to claim it for unpaid taxes. At tax sale, the land would be purchased for pennies per acre. The commission urged that the state keep these lands instead of selling them and allow the trees to grow back, and that the property be managed by a trained professional forester. Colvin personally delivered the report to John Dix, the state's new governor, on behalf of the commission, and was able to persuade him to include a proposal for the park in his annual message to the legislature.

Meanwhile, the summer before, the twenty-five-year-old Colvin had been hard at work in his other role as the state surveyor, leading a team of men up and down the high peaks as he recorded their altitude with his barometer and sextant. In August 1872, as he climbed down from the summit of the state's highest peak, Mount Marcy, he made a wonderful discovery. Below him, he saw "a minute, unpretending tear of the clouds—as it were—a lonely pool, shivering in the breezes of the mountains, and sending its limpid surplus through Feldspar brook to the Opalescent river, the well-spring of the Hudson."[11]

He logged its height at 4,293 feet and named it Summit Water; however, the name that stuck was Lake Tear of the Clouds. Until Colvin's survey, few people, if anyone, had climbed the area above Indian Pass, where the Hudson plunges down a steep, narrow gorge. In this same era, explorers had found the source of the Nile, yet the Hudson's headwaters remained a mystery. Colvin's *Report on the Topographical Survey of the Wilderness of New York*, published by New York State in March 1873, de-

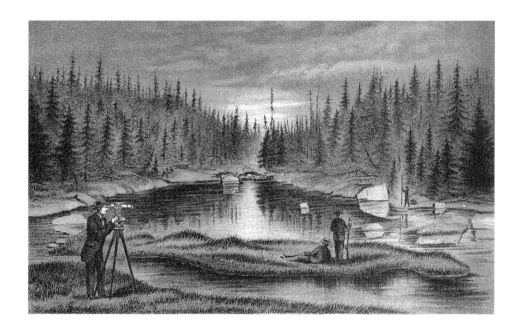

scribed this find. It also concludes with some now-familiar thoughts on public policy.

> It is now a question of political importance whether the section covered by this survey should not be preserved . . . as forest-farm and a source of timber supply. . . .
>
> The question of water supply, also is intimately connected with this proposition. . . . Within one hundred years, the cold, healthful living waters of the wilderness . . . will be required for the domestic water supply of the Hudson river valley.[12]

Both the park commission report and Colvin's topographical survey report were published in 1873. Although Governor Dix had voiced his support, the response from the legislature was minimal. Perhaps the return of rain after the drought of the 1860s had lulled state leaders into complacency. It took another water crisis to shake them from their slumber, and this was provided by the droughts and water shortages of 1881 and 1883. Two highly publicized forest fires in Michigan and Wisconsin added to the concern, since both resulted from lumbering practices. In 1883, the legislature took a first step in changing policy when it passed a bill halting the sale of state lands in 10 Adirondack counties. That is what the park commission had proposed, but by then, the amount of land abandoned for taxes and held by the state had grown from 40,000 acres to about 700,000. However, businessmen were getting quite alarmed about water shortages, and they suggested even stronger measures. Their spokesman was Morris K. Jesup, a banker and an active member of the state Chamber of Commerce.

A multimillionaire, Jesup had risen from near destitution, making his fortune first by selling railroad supplies and securities, then in banking. Keenly interested in conservation, Jesup served as president of the American Museum of Natural History and was the founding president of the Audubon Society of New York State.[13] As a business leader, he was concerned about low water levels in the Erie Canal and the Hudson, as were his colleagues at the chamber, because they depended so heavily on the canal system for commerce. They were especially worried

Lake Tear of the Clouds. The Source of the Hudson River. Lithograph by Weed, Parsons & Co. to accompany the State of New York's *Report of the Topographical Survey of the Adirondack Wilderness of New York*, seventh report, 1874, showing Verplanck Colvin surveying.
Courtesy of the Adirondack Museum, Blue Mountain Lake, NY

that shipping problems on the Erie–Hudson route would enable the railroads to gain a monopoly and raise rates.[14]

In December 1883, Jesup called a meeting of the state Chamber of Commerce and spoke about how New York's waterways were suffering from low flow due to forest destruction. "The effect of the diminution of water upon the Hudson is already so great that navigation above Troy is rendered almost impossible in dry seasons," he said. Jesup proposed that his colleagues call on the state government to use its powers of eminent domain to condemn four million acres of forest "and keep it for all time as a great forest preserve, and in this way insure abundant water to the Hudson and the Canal."[15] The chamber later reduced this goal to one million acres.

Following Jesup's presentation, the state Chamber of Commerce appointed a committee, led by Jesup, to seek passage of such a law in the state legislature, and circulated a petition to gather signatures in support throughout the state. The chamber also secured the support of the New York Board of Trade and Transportation and the Brooklyn Constitution Club.[16] The latter group added a new angle to the debate by expressing concerns about the effects of sediment washing down from the clear-cut forest of the Adirondacks and ending up in the Hudson, where it would fill in the harbor and harm the world's greatest port. Their report noted that sandbars were suddenly appearing in the river.[17]

In early 1884, Governor Grover Cleveland's Message to the Legislature recommended that existing and future state forest lands be retained as park, and the state Senate Committee on Forest Lands held hearings on the chamber's proposed bill for the state to acquire at least a million acres of forest land for preservation. The proposal won the ardent support of young Theodore Roosevelt, now an assemblyman.[18] As a youth, Roosevelt had camped in the Adirondacks with his father, honing his already extensive skills as a nature observer and outdoorsman and listening to James Fenimore Cooper by the light of the campfire. At twenty-five, he was already known across the state as a daring leader, an enemy of machine politics, and an activist legislator prepared to change the way things were done. He did not carry the day this time, however. Decades later, he would return to the issue. The Senate Committee on Forest Lands killed the bill due to lobbying by the lumber industry. The legislature instead established a committee to study the issue and report their findings in 1885.

Jesup and his colleagues at the Chamber of Commerce were discouraged. Public apathy and political opposition seemed insurmountable; nevertheless, the New York Board of Trade continued to press its case for state ownership of all forests in the Adirondacks.[19] In February 1885, the board invited the eloquent Verplanck Colvin to address its annual banquet and inspire its members. Colvin had a flair for the dramatic gesture. He brought a huge block of ice from the upper Hudson down to the Board of Trade meeting in New York, where he exhibited a chunk of it in the banquet hall. The rest he broke into pieces that were served in the water glasses for the banquet. As dinner began, Colvin offered the following toast:

> I ask you to drink this health in the clear, cold water of the mountain springs. The ice that tinkles in your goblets, and the pure water that upholds the ice, are both fresh from the headwaters of the Hudson. . . .
>
> We must guard our water supply . . . and maintain the forests which protect the springs at the river sources. . . .

> The influence of forests . . . has led many to regard State ownership of all the forest lands at the sources of the Hudson as essential to the maintenance of that water supply upon which the commerce of our canals depends.[20]

Images of forest destruction began to play a role in public opinion, as well. A month before Colvin's speech, *Harper's Weekly* had published dramatic engravings by Julian W. Rix showing before and after scenes of a Hudson River tributary, the first cloaked in shady forest and the second scorched by fire and barren, stripped of its trees. An article by Charles Sprague Sargent in the same issue explained the importance of the Hudson River watershed as a source of water supply.

A few months later, with lobbying from the powerful Board of Trade, the legislature again took action, but not as the board had suggested. In 1885, the state designated 681,374 acres of state-owned forests in the Adirondacks as "Forest Preserve," to remain as "wild forest lands" under the management of a state Forest Commission.[21] Now the state would not just own forest lands, it would manage them. For good measure, the state included 33,000 acres of Catskill Mountain land in the new forest preserve. The Catskills were added as an afterthought; there was a general feeling that they were not important because they safeguarded no water supply of any significance. Ironically, two decades later, New York City would decide to locate its water reservoirs in the Catskill Mountains, and this forest protection would become important.

Julian W. Rix, "Forest Destruction in the Adirondacks. The Effects of Logging and Burning Timber. A Feeder of the Hudson —As It Was. A Feeder of the Hudson— As It Is." *Harper's Weekly*, January 24, 1885. *Courtesy of the Adirondack Museum, Blue Mountain Lake, NY*

Thus, New York State established hundreds of thousands of acres as forest preserve to protect the waterways that were its lifeblood. These lands were also to be managed for sustained yield of timber, using scientific principles. At the time, forestry was a new field. Just four years earlier, in 1881, the federal government had established the first Division of Forestry. However, forest management—as practiced by the Forest Commission—proved to be anything but scientific. By 1890, five years after the commission was established, official corruption and timber theft were rampant, and the pace of forest destruction increased. Pressure mounted to better manage the state land holdings.

As the campaign to preserve the forest heated up, photographer Seneca Ray Stoddard began a public speaking tour of the state to educate people about the need to conserve the forest. Stoddard had accompanied Colvin on at least one of his topographical survey expeditions and had become an artist of great renown.[22] He also published an annually updated guidebook called *Adirondack Illustrated*. Like Colvin, he was passionate about halting the destructive practices of the lumber companies, and in the 1891 edition of his guidebook, he added a "greeting" to the reader that suggested state control of the entire forest:

> The section where the great Hudson River and its higher tributaries rise are less known to the public than almost any other part. It is also a fact that this section is being gradually stripped of its valuable trees far up into the rugged Indian Pass and around its wild head waters, except where an occasional narrow belt is left untouched around the more important lakes. All this section, with a good part of the western water-shed, should be under control of the State, and would be cheap at almost any price, *now*, before irreparable injury is done.[23]

The same year, Stoddard began giving speeches about the Adirondacks using lanterns to create a slide show, which he illustrated with his photographs, including many taken on his survey assignments with Colvin. He showed images of the Hudson River from its source at Lake Tear of the Clouds all the way to the Atlantic Ocean, and he spoke to the need for action.

For decades, tourists and visitors had come to the Hudson and the Adirondacks forest in search of the spiritual refreshment to be found in sublime scenery, and people began to suggest that the state should make a park of its vast forests, to be used for the health and pleasure of the public. Actions in New York reflected a nationwide trend.

In 1891, the Forest Reserve Act had been passed in Washington, and large tracts of federal land would soon be set aside as managed forest.[24] Early in 1892, the state Forest Commission responded by beginning to organize support for an Adirondack Park. It invited Stoddard to give a presentation of his lantern slide show to the State Assembly in February. Stoddard projected 225 hand-tinted slides onto a 30-foot-square canvas screen. He then read an original poem describing the course of the Hudson from Tear of the Clouds to the sea.[25] It won many legislators to the cause of conservation. The Board of Trade continued to push for action as well.

By May 1892, these combined lobbying efforts produced results. Governor Roswell Flower signed a bill creating the Adirondack Park, consisting of an area defined by a blue line on a map, about 2.8 million acres in the high peaks region—of which only 551,093 acres were owned by the state.[26] The boundary of the new Adirondack

Park included private lands as well as state forest preserve. The idea was that the state would buy the remaining private lands, though in the end, this would not happen, leaving the "park" a patchwork of public and private lands.[27] Its purpose, as stated by the legislature, was to protect "forest land necessary to the preservation of the headwaters of the chief rivers of the state, and as a future supply of timber." However, the forest now had a second purpose: to serve as "a place where rest, recuperation and vigor may be gained by our highly nervous and overworked people." Attitudes about the purpose of parks and preserves were changing as the Industrial Revolution ramped up.

Creating a park, however, did not settle the issue of how the forest was to be managed. In 1893, the governor and the legislature, over strenuous objections from the Board of Trade, passed a bill allowing timber to be sold on the forest preserve lands within the Adirondack Park, and in 1894, Governor Roswell Flower proudly announced the sale of spruce timber on 17,468 acres, which enriched the state coffers to the tune of $53,400. The woods had been preserved, but not the trees.

Seneca Ray Stoddard, *River Above Lake Sanford.*
Courtesy of the Adirondack Museum, Blue Mountain Lake, NY

Seneca Ray Stoddard, *Drowned Lands.*
This image, taken outside the Hudson River
watershed, helped influence a change in
the language of the constitutional amendment
for the Forest Preserve that would prevent
destruction of forested lands by flooding.
*Courtesy of the Adirondack Museum, Blue Mountain
Lake, NY*

Perhaps the story would have ended there, but bad droughts in 1893 and 1894 spurred business leaders to continue the fight. In spring 1894, the New York Board of Trade called a committee meeting to assess its next step. Frank S. Gardner, the board secretary, was one of several members who expressed great frustration. At one point in the meeting, he told his colleagues, "I am convinced that the forests will never be made safe until they are put into the State Constitution!"[28]

No doubt, this thought was inspired by the approaching state constitutional convention, set to begin on May 5. No sooner had he uttered this statement than the assembled group began to discuss the possibility of doing just that. A draft of a constitutional amendment was formulated to make it illegal to cut any trees on state land in the forest preserve. In July 1894, convention delegate David McClure, an assembly Democrat, presented the proposed amendment to leading members of the state legislature on behalf of the Board of Trade.

Forest conservation was not a topic envisioned on the agenda of the 1894 state constitutional convention. Nonetheless, in early August, a committee was established to look into the matter. Within weeks, the issue gained critical support from

GLEN'S FALLS.

legislative leaders, assisted by Verplanck Colvin, who took members of the state assembly on a tour of forests on state land in the Adirondacks.[29] When delegates debated the measure on September 8, so many people wanted to speak in favor of it that the chairman imposed a five-minute time limit. McClure opened the debate and framed the issues for his fellow delegates:

> Mr. Chairman, my somewhat accidental connection with this forest preservation matter and its introduction at a very late day in the Convention, at first induced the idea of a lack of importance in the subject. But I have been wonderfully impressed, Mr. Chairman, by the importance, the magnitude of this question.... As I look at it now, Mr. Chairman, it seems to be almost the only great and important subject ... of this Convention.... What is the value of these woods and why should we try to preserve them intact? ... First, as a great resort for the people of this State.... There if [a man] is possessed of great veneration, he may find some consolation in communing with that great Father of all.... And then again, Mr. Chairman, for the wants, the actual physical wants of the people in general, we need the waters of those mountain streams and lakes, and of the rivers that are fed by them.... You will not have your steamboats patrolling the rivers, not even on this majestic Hudson, very long, if you do not preserve the watersheds. At this day, as my neighbor from Troy tells me, it is at times impossible for the large steamboats to reach their wharves and load them at the city of Troy, and I am told by a delegate from Glens Falls that the great Hudson at that point, which use to be even in midsummer almost impassible, was so reduced that he could walk across it on the day the upon which this Convention convened without wetting his shoes. Bars have risen in the Hudson on account of the washing down from these mountains from which trees have been taken, and everywhere we have seen the falling of the waters to an extent that has been dangerous....
>
> What shall we do, Mr. Chairman? ... First of all we should not permit the sale of one acre of land. We should keep all we have.... We should not sell a tree or a branch of one.... We should prevent the lands being taken by corporations.... Finally, the Legislature should purchase all of the forest lands both in the Adirondacks and the

Glens Falls at full flow, 1866.
Lossing, The Hudson from the Wilderness to the Sea, 1866

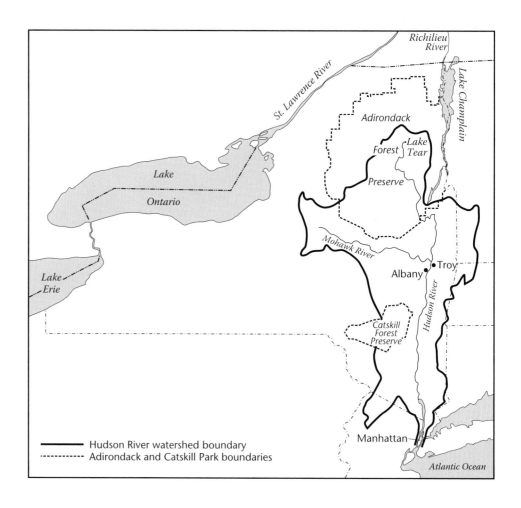

Hudson River watershed boundary
Adirondack and Catskill Park boundaries

The shores of the upper Hudson in the Adirondacks are now conserved as part of the 2.7 million-acre Forest Preserve under the state constitution. The 288,000-acre Forest Preserve in the Catskills protects much of the water supply for New York City. It is a patchwork of state-owned land within the boundaries of the Catskill and Adirondack parks, both of which contain a mixture of private and state lands. The state continues to acquire land in both parks, expanding the Forest Preserve.

NYS Department of Environmental Conservation

Catskills not now owned by the State, and should preserve them even though it costs millions of dollars to do it. The millions so invested will be well spent.[30]

On September 13, Article 7 of the state constitution was adopted, the only article approved by the unanimous vote of the entire convention. It declared: "The lands of the State now owned or hereafter acquired, constituting the forest preserves as now fixed by law, shall be forever kept as wild forest lands. They shall not be leased, sold, or exchanged, or be taken by any corporation, public or private, nor shall the timber thereon be sold, removed, or destroyed."

New York voters approved the amendment in November 1894, and on January 1, 1895 it went into effect. It was now illegal to cut any trees, "not even a branch," as Mc-Clure said, in the state Forest Preserve (in the Adirondacks and the Catskills). The two words "or destroyed" had been added to address the problem of forest destruction by flooding and would later throw a roadblock in the way of state engineers planning to construct hydropower dams on the Hudson River and its tributaries.

In 1897, when the U.S. Congress passed the Forest Management Act, a different approach was taken. The woods were opened for grazing, mining, and lumbering—causing wilderness advocates, such as John Muir, to organize the Sierra Club as a voice for preservation.[31] In New York, however, the need to protect the commerce of the state started a form of conservation that would eventually lead to wilderness protection for its own sake. Yet even that wilderness would be a creation of human design, protected as forest land under the state constitution.

Today the state Forest Preserve has grown to over three million acres, an area larger than the state of Connecticut, and, as predicted, it serves to capture rainwater and cloud moisture and filter it slowly into the state's waterways.[32] So the preserve now protects both the Adirondack headwaters of the Hudson and the city's water supply in the Catskills, a system fed by tributaries of the Hudson and Delaware rivers. It also protects part of the watershed of the St. Lawrence.

With the passage of the constitutional amendment, a new model for conservation was created. While its first purpose was to protect forest and water resources, the Forest Preserve is now known to most of New York's citizens as wilderness and a place of recreation. Its identity with the Hudson has been lost, replaced with the identity of the mountain ranges it protects.

Next, the campaign to conserve the Hudson moved south to the Palisades and the Highlands and engaged the states of New York and New Jersey. On this part of the Hudson, the romantic movement of the pre-Civil War era helped set the stage for preservation of a different kind. This time the topic was not water supply but scenery.

An Interstate Park for the Palisades and the Highlands and a New Progressive Vision

12

Elizabeth Vermilye's Women's Clubs, Edward and Mary Harriman's Park, Mrs. Olmsted's Fresh Air Camp, and Margaret Sage's Charity

IRONICALLY, WHILE New York millionaires built their castles and ruins to imitate those along the Rhine, few people gave any thought to the protection of the historic forts and scenery that had given the Hudson its reputation. The walls of Forts Clinton and Montgomery had crumbled and fallen unnoticed until the turn of the century, when a few concerned citizens realized that irreplaceable landmarks of the nation's early history might be lost. In 1894, an Englishman observed in a letter to the editor published in *The New York Times*: "I am astonished to find that the very scenery the Americans talk so much about is being defaced, desecrated and destroyed, and I cannot find any American who seems to care much about it."[1]

In 1908, William Thompson Howell, an avid hiker who knew almost every inch of the Highlands' rough terrain, began to campaign for the preservation of the scenic and historic mountain passes. He wrote:

A camping trip in the Highlands, photographed by William Thompson Howell.
Courtesy of the Palisades Interstate Park Commission, Trailside Museum, Bear Mountain

It would seem eminently fitting . . . that the Highlands should be preserved by the national government. Not only do they contain the great military school and naval magazine, together with the State encampment, but two famous battlefields. . . . There are also the "passes of the Highlands," a phrase that occurs again and again in the letters of Washington and other Revolutionary leaders. All along the range from New Jersey northeastwardly into Connecticut, the Highlands swarm in historic associations. . . . But most interesting of all, in the remoter hills and forests are sleeping the almost forgotten, overgrown military roads, ruined mines and forges, abandoned farms and other reminders of very early days in our national life.[2]

Howell also contributed articles about nature and conservation to the *Tribune* and the *Sun*. His diary, more like a scrapbook, is preserved in the archives of the New York Public Library and contains photographs he took on his Highland rambles, as well as his written observations on the natural history, local lore, and political events brewing in the region at the time. It includes copies of every article, every piece of proposed legislation, and every public relations document that appeared about the Highlands. The diary reveals a man who cared more passionately about protecting the Highlands than anything else. Written by someone who was not among the power brokers of the elite, his journal gives a clear picture of the politics of preservation at the turn of the century.[3]

By the time Howell set his idea for a national historic preserve down on paper, events had been set in motion in New York State, and nationally, to support the notion of historic preservation as a public policy. In 1850, Governor Hamilton Fish signed into law a bill preserving the Hasbrouck House in Newburgh, General Washington's headquarters in 1782–83. It was the first public act in the United States to preserve a historic structure for public visitation. Some twenty years later, Frederick Law Olmsted, creator of Central Park, began to discuss the concept of scenic re-

William Thompson Howell photographing in the Highlands.
Courtesy of the Palisades Interstate Park Commission, Trailside Museum, Bear Mountain

source preservation. In 1869, he proposed that the lands adjacent to Niagara Falls be made public, and in 1882, a group of leading citizens organized the Niagara Falls Association to seek enactment of a state preserve there. Through a media campaign with public speeches, pamphlets, and newspaper articles, this goal was achieved. The Niagara Reservation was dedicated in 1885. This was the first time a state had purchased property for purely scenic purposes.

The same individuals who formed the Niagara Falls Association then shifted their attention to the creation of a permanent body for the protection of scenic and historic places throughout New York State, and in 1896 the New York State Legislature chartered the Trustees of Scenic and Historic Places and Objects in the State of New York to act as a public entity caring for scenic, historic, and scientific properties on behalf of the state and municipal governments and of individuals who might deed or bequeath their properties to it. The organization's name was changed in 1901 to the American Scenic and Historic Preservation Society, and it became New York's first agency for general conservation purposes. Andrew Haswell Green—known as the "Father of Greater New York" for his role in consolidating Brooklyn, Staten Island, the portion of southern Westchester County that became The Bronx, and Queens with Manhattan into a single city—was also one of its founders. Its creation was based on the idea that historic landmarks and scenery constitute equal parts of a national heritage—a notion that would prove decisive later in the century.

The second great rallying call for scenic conservation was the Hudson's Palisades. They provided "trap rock" of high quality at low cost, near to ready markets and easily loaded onto railroads or river barges. For decades, quarrying on the Palisades had been destroying the cliffs, especially after the invention of dynamite in mid-century. In the 1890s, demand increased for paving stones, vessel ballast, and crushed rock in concrete to build the new skyscrapers of New York and for macadam and, later, concrete roads. This made the use of heavy machinery profitable, and quarrymen moved their operations to the tops of the cliffs. As one report noted, the river reverberated "morning, noon and night . . . with heavy explosions of dynamite as one after another of the most picturesque of the columns in the stretch between Edgewater and Englewood Landing toppled into ruin in clouds of gray dust." Near the site of the present George Washington Bridge, quarrymen blasted out 12,000 cubic yards per day. The American Scenic and Historic Preservation Society observed, "The effect was not only to destroy the perpendicular face of the great ramparts but, owing to the shallow nature of the west side of the River, to create a fill upon which industrial plants might easily have been built."[4]

Public sentiment began to crystallize in opposition to the destruction of the Palisades, and in 1895, the states of New York and New Jersey sought to have the federal government make a military reservation of the Palisades (modeling their plan after the German practice of acquiring large tracts of land for troop maneuvers). However, the House of Representatives Committee on Military Affairs of the United States rejected this proposal in 1897 and again in 1898, on the grounds that the Palisades had no military value, and the blasting continued.

While this debate in Congress took place, the New Jersey State Federation of Women's Clubs met in Englewood in 1897 to devise an alternative plan to protect the Palisades from quarrying. The turn of the century was a time of social

Old Rock Mountain Quarry, Hudson River, N. Y.

Quarry on the Palisades cliffs.
Postcard, author's collection

expression for women, especially women of means, and the Hudson Valley was a center of activity, where the concept of progressive reform acquired a new dimension as women became the driving force behind efforts to protect the natural, historic, and cultural heritage of the region. Though they did not yet have the right to vote, through groups such as the Federation of Women's Clubs, they became active members of the conservation movement. The wives of Earnest Thompson-Seton, W. A. Roebling, Frederick Lamb, and Ralph Trautman played important individual leadership roles.[5] Where they were less likely to be personally successful, they brought in their influential husbands.

In 1897, the New Jersey Federation sent a delegation, led by Elizabeth Vermilye, to meet with Governor Foster Voorhees of New Jersey to propose the creation of a New York–New Jersey commission to study opportunities to protect the Palisades and report on the possibility of joint action by the two states.[6] Andrew Haswell Green, of the American Scenic and Historic Preservation Society, approached New York State Governor Theodore Roosevelt with a similar proposal.

As a result, in 1899, after Congress had rejected the military reservation idea, a commission was created to work on a solution to the problems involved in the creation and management of an interstate park. No precedent for such a body existed, and the situation was made more difficult by the fact that the Palisades were located primarily in New Jersey, but their preservation primarily benefited the people of New York who viewed the Palisades from the opposite shore. Since New Jersey was unlikely to give up its land to New York and New Yorkers were unlikely to pay for parkland in New Jersey, a creative solution was needed.

The Study Commission proposed the creation of a ten-member permanent Palisades Interstate Park Commission (PIPC) with five members each to be appointed by the Governors of New York and New Jersey and a commission president alternating from each state. The PIPC would have the power to acquire whatever land was necessary to protect the Palisades. Two thirds of the operating costs would be paid by New York and one third by New Jersey.

Governor Roosevelt eagerly embraced the idea, and proposed to Governor Voorhees that the two states should cooperate in protecting the area. In 1900, bills were introduced in both state legislatures. In New York, the legislation passed easily. In New Jersey, quarrying interests lobbied against it, but the New Jersey State Federation of Women's Clubs mounted a spirited countereffort, and the bill passed there as well. Only two weeks apart, both governors signed laws establishing the Interstate Park.[7] An Act of Congress was required to allow an interstate commission—the first instance of this mechanism being used in the United States.

George W. Perkins Sr., first Vice-President at New York Life Insurance Company and a trustee of American Scenic, was appointed President of the New York Commission, and Colonel Edwin A. Stevens, of the Stevens Institute of Technology, became President of the New Jersey Commission. Like Morris Jesup, who had earlier campaigned for protection of the Adirondacks on behalf of the Chamber of Commerce, he was a leading businessman who strongly supported conservation.

The first objective was to shut down the Carpenter Brothers' quarry, where blasting destroyed over 1,000 cubic yards per day of Palisades rock. Perkins negotiated a $132,500 option with Carpenter, paying $10,000 down, and then sought an interview with J. P. Morgan (who was a trustee of American Scenic) to seek a donation toward the balance needed. The financier not only agreed but even offered to pay the full amount of $122,500 if Perkins would join his firm, an offer that Perkins in time

Elizabeth Vermilye.
Courtesy of the Woman's Club of Englewood

George W. Perkins Sr. Perkins rose from humble beginnings to become the right-hand man of J. P. Morgan. His effort to raise funds to save the Palisades provided his first introduction to Morgan and resulted in a job offer on the spot.
Courtesy of the Perkins family

accepted. He would soon become Morgan's right-hand man. Morgan's check, delivered on December 24, 1900, paid for the option on the property and stopped the blasting at Carpenter Brothers' forever.

Known for his ability to inspire philanthropy in men and women of wealth, Perkins secured gifts of property and money to complete the purchases of other properties for which he had secured options, including donations of $125,000 from Mr. and Mrs. Hamilton Twombly (she was a granddaughter of Commodore Vanderbilt), and several smaller donations, including $12,000 of his own money and donations from club women of New York and New Jersey.

In its first 10 years of operation, the PIPC preserved about 13 miles of the Palisades at a cost of $200 to 500 per acre and a total outlay of about $1 million. Of this amount, New Jersey paid $50,000 and New York paid $410,000—with private funds matching public contributions—all of it for the protection of land in New Jersey. Although New Jersey paid little up front for the preservation of the land, it gave up the commercial and tax values of the property. Constitutional issues concerning the expenditure of New York State funds to buy land in New Jersey were never raised.

The PIPC proved to be quite successful, and rapidly halted the quarrying that had threatened to destroy the Palisades forever. In 1906, the jurisdiction of the commission was extended farther into New York to include Hook Mountain, where quarrying was continuing at a furious pace, and Stony Point, the site of a major Revolutionary War battlefield. Eventually, the PIPC would acquire both sites—and, in later decades, protect the entire Palisades. The commission's early success soon led to a new problem, however.

The jurisdiction of the Palisades Interstate Park Commission extended up to the Highlands but did not include them, with predictable results. In a letter to Eben E. Olcott, a man named F. P. Albert—an ardent conservationist—wrote that "the stoppage of quarrying operations along the Palisades cliffs has had the effect of driving the quarryman to the nearest highlands above, and to spread rather than check the disaster."[8] Recognizing this threat, in 1907, the American Scenic and Historic Preservation Society turned its attention to the Hudson Highlands and began to discuss the possibility of state or federal legislation to protect the region. With the waning and eventual demise of the iron foundry and the closing of a chemical factory near Anthony's Nose, the population of the Highlands had declined to about a quarter of its Civil War–era level. In the words of William Thompson Howell: "The picturesque, quaint and altogether delightful village of Cold Spring had no industry of any importance, and is in fact the deadest town on the lower Hudson."[9] Except for the shoreline estates of millionaires, the Highlands, which had enjoyed a development boom for fifty years or more, were reverting to wilderness at a time when the public was in a frame of mind to protect the region's heritage of historic sites and scenery.

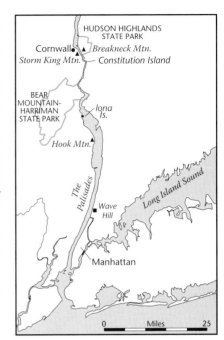

Members of American Scenic felt that federal legislation would be most appropriate, in view of the Highlands' role in the American Revolution. The federal government also had deeper pockets; its protection would "relieve the state of a financial burden." Reflecting the prevailing concerns of the turn of the century, the purposes of the legislation as identified by American Scenic would be: protection of natural beauty; preservation of historic landmarks; prevention of further pollution of the river; and protection of the forest cover for timber supply and watershed protection.[10]

Though the group had broad and ambitious goals, its focus was primarily protection of scenery. Undoubtedly its members were inspired by the size of the state's forest preserve when they proposed legislation to create a park between Peekskill Bay on the south and Newburgh Bay on the north, encompassing 65 square miles on the east side of the river and 57 on the west.[11] Because of the wild and mountainous character of the terrain, unimproved by cultivation, it was thought that the property could be acquired for a reasonable sum based on the stumpage value of the timber. The society suggested that some of the larger property owners might be convinced to sell what today we know as conservation easements, which would allow them the

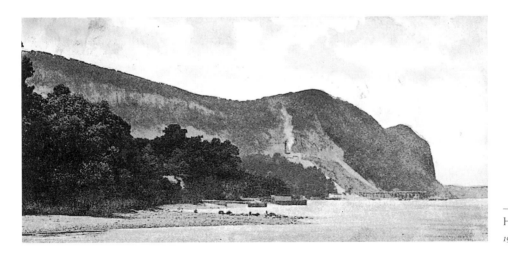

Hook Mountain.
1910 postcard, author's collection

continued ownership and use of their land but would prohibit forever any uses that might destroy the scenery.

One of the most vocal supporters of the preservation of the Highlands was Dr. Edward Partridge, a trustee of American Scenic, a PIPC commissioner, and a resident of Cornwall. Dr. Partridge wrote numerous articles on the topic for newspapers and magazines. This excerpt from *The Outlook* on November 9, 1907, was typical:

> The Hudson River presents, throughout the fifteen or twenty miles of its course in the Highlands, its most picturesque and boldly beautiful section. Every American, from near or remote parts of these United States, is influenced to visit the great Hudson, and here his eye is pleased and his patriotic feeling is strengthened as he realizes the difficulties, the hardships, and courage of the founders of this great Republic. . . . This region, created into a National preserve, would serve as a most suitable memorial of the war which yielded to us our National independence.[12]

In other articles, Partridge wrote of the Highlands' role in literary traditions: "This region has found its place in American fiction through Cooper and Irving, while its charms have been told by Morris and Bryant."[13] He proposed a commission to govern the national park, empowered to prevent disfiguring and offensive industries ("iron works, chemical works, etc."), and the implementation of scientific forest management and the acquisition of conservation easements.

Partridge was a prominent New York City obstetrician at the Nursery and Child's Hospital. He had purchased a large tract of land on Storm King Mountain, where he built a beautiful estate. The property offered a sweeping northwest view of Newburgh Bay, the Shawangunk Mountains, and the Catskills. Partridge organized some of his friends and neighbors—including J. P. Morgan, William Church Osborn (son of railroader William Henry Osborn), General Roe of West Point, Dr. George Kunz, Lyman Abbott, and others—to seek the creation of a national park in the Highlands.[14]

In the summer of 1907, a petition was drawn up by a Mr. Bush-Brown and circulated to the public—at Washington's Headquarters, the Hasbrouck House in Newburgh—and signed by people from many states. The petition requested President Theodore Roosevelt and the Congress to create a national park in the Highlands of the Hudson River. By this time, Roosevelt was in his second term and had a reputation for conservation—establishing, at the stroke of a pen, bird refuges and national parks. The petition noted the unsurpassed beauty of the region and the threat of quarrying moving in from both the north and the south, and concluded, "While the Federal Government has established many parks to commemorate the Civil War which was due to sectional dissensions now happily past, we have no National Park to commemorate the brave deeds of the Founders of the Nation which are the cherished heritage of the American people."[15] However, these efforts were unsuccessful. Authorities in Washington responded that there was nothing of spectacular importance to commemorate, and the idea had to be abandoned.[16]

Meanwhile, New Yorkers prepared for the 1909 Hudson–Fulton celebration, commemorating Henry Hudson's voyage in 1609 and Robert Fulton's steamboat launch in 1807. Plans for the event aroused a great deal of civic pride among river communities and stimulated a variety of local improvements—including the creation of many municipal parks. Having been rebuffed in Washington, the American Scenic and

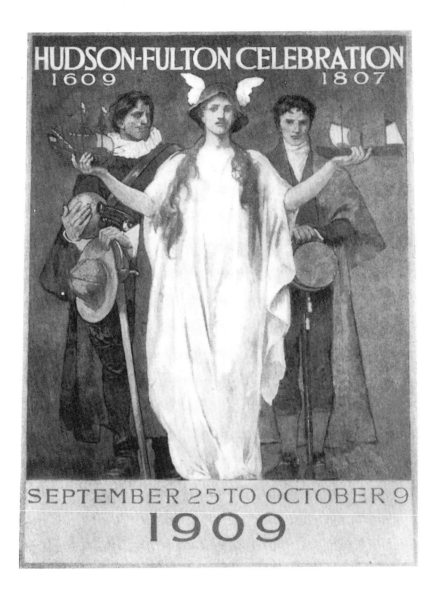

Historic Preservation Society and the Association for the Protection of the Highlands of the Hudson shifted their focus, seeing an opportunity to take advantage of the celebration. They circulated petitions and created a groundswell of support for the Hudson–Fulton Celebration Commission to consider the establishment of a state park in the Highlands extending from the Tappan Zee to Newburgh Bay. On September 23, 1908, the celebration trustees gave their nod of approval for the idea and established a special committee on Hudson River Scenery "to promote legislation, to encourage private generosity, to foster public sentiment, and to cooperate with other organizations with a view to securing the preservation of the natural beauty of the Hudson River."[17]

New York State Chief Judge Alton B. Parker—a Hudson riverfront resident in West Park and Democratic nominee for the presidency in 1904—was appointed Chairman of the Hudson River Scenery committee, and F. P. Albert was rewarded for his efforts by appointment as secretary. Among the other members were Ambassador John Bigelow, Dr. Edward Partridge, George W. Perkins Sr., and former Governor Benjamin B. Odell.

Hudson–Fulton Celebration official poster.
Author's collection

After a few months of work, the committee presented a report to the trustees seeking their endorsement of a plan to pass state legislation establishing a state park in the Highlands. They prefaced their remarks with references to the region's role in American cultural history and suggested that property owners in the area would support the efforts to protect the land:

> While it is true that this Commission is "Hudson–Fulton" in name, and is concerned with providing memorials to the man who discovered the Hudson River, and who sailed past the Highlands long before the establishment of our republic; also to the man who adapted steam to navigation; yet you are preserving a region full of the memories of our Dutch traditions, described in American poetry and fiction, and replete in associations with early American history.

The committee was concerned about the scenery, but was probably also influenced by the continuing publicity surrounding the constitutionally protected forest preserve, which was periodically being challenged. They considered measures to protect the woods as well as the view and recommended two pieces of legislation, which the Hudson–Fulton Celebration Commission voted to support. These were introduced in the state legislature in 1909. The Wainwright–Merritt bill addressed forest management, and the Bennett bill would establish a state park.

The Wainwright bill proposed creation of a state forest reserve in the Hudson Highlands, comprising about 75,000 square miles on each side of the river from the northern gate to the southern gate of the Highlands. The bill's purpose was to preserve the region's beauty, apply scientific forestry methods, and prevent clear-cutting. Its goal would be aesthetic beauty instead of timber for profit. The reserve was to be administered by the Forest, Fish and Game Commission (a predecessor of today's Department of Environmental Conservation), which was given the power to manage land, appoint a forester, impose fines, and buy land and easements. The bill would extend the police power of the state to privately owned forests for the first time, compelling management for sustainable timber harvest and for scenic beauty.

The Bennett bill proposed to conserve a much smaller area than the 122-square-mile park proposed in 1907 by American Scenic. It identified a strip one-half mile wide on each side of the Hudson River in the Highlands to be studied as a potential park; gave the state authority to acquire lands and required that a map of lands to be acquired be drawn up; and authorized the use of condemnation power for this purpose if necessary. The Bennett bill was viewed as the more urgent of the two, as it would strike at the heart of quarry operations and prevent scenic defacement of the Highlands. However, the forest reserve bill fit into the growing state and national movement of forest protection and addressed logging problems that plagued the region.

By 1908, deforestation in the Highlands had occurred repeatedly over more than a century. Descendants of Revolutionary War Hessian mercenaries stayed in the area and cut its timber to supply cordwood for conversion to charcoal to keep the iron furnaces burning. When the iron industry converted to coal after the Civil War, they began marketing cordwood to the Hudson Valley's brickyards. As American Scenic reported, "ownership was ignored largely and the forest was cut off as grass is mowed." In the more accessible spots, the lumber companies moved in to take the place of the small-crop foresters.

The Hudson River Scenery Committee received an appropriation of $250, of which it spent $229 to print and mail 15,000 illustrated pamphlets to organizations, clubs, and newspapers describing the two bills. This publicity blitz resulted in nearly unanimous press endorsement of the bills to preserve the Highlands, and the committee soon won widespread support for its efforts to create a state park and a state forest. The Federation of Women's Clubs of the State of New York, through their committee on forestry, took an active interest in the cause, and circulated the publications of the Hudson River Scenery Committee throughout the state. As the Hudson–Fulton Celebration Committee's Annual Report to the Legislature recorded, "No feature of the Celebration received more thorough endorsement by the press of the City and State of New York than that for the preservation of the romantic scenery of the river."

However, the Bennett bill was not universally favored by the influential residents of the Highlands. William Church Osborn opposed it, while his brother Henry Fairfield Osborn—Director of the American Museum of Natural History—supported it. Both were ardent conservationists. Senator Schlosser of Fishkill and Congressman Hamilton Fish of Rocklawn in Garrison, both east shore politicians, opposed it—but the latter's brother, Stuyvesant Fish, took no position on the measure. It was passed by the state assembly, but in spite of heavy statewide backing, never came to a vote in the Senate.

The Wainwright forest preserve bill passed both houses of the legislature on May 8, 1909, but not before the east shore of the Highlands was removed from its protection. In the end, it designated 75 square miles on the west side of the Hudson, in the Highlands, as a forest reserve, subject to management by the Forest, Fish and Game Commission. This was clearly not sufficient to protect the scenery from quarrying. All in all, it was a disappointing year for the committee, as the celebration came and went with no Hudson Highlands State Park to commemorate it, after public expectation had been raised to a very high level. However, pressure was still building for the preservation of a disappearing heritage, and the spark that ignited public action turned out to be a state proposal to build a penitentiary at Bear Mountain.

On March 15, 1909, William Thompson Howell was hiking through the woods when he came to a clearing with a signboard nailed to a tree. It read:

STATE PROPERTY
SING SING PRISON
TRESPASSERS MAY BE SHOT

A few months later, the State of New York had erected a stockade there—on the terrace of land where American militia had fought British and Hessian soldiers advancing on Forts Clinton and Montgomery. Within its walls were hundreds of convicts who were brought in by the government to clear the site for the relocation of Sing Sing Prison to Bear Mountain.

This desecration of historic ground shocked New Yorkers and moved two men to action: George W. Perkins Sr., and Edward H. Harriman. Perkins—now a banking partner of J. P. Morgan, and head of the newly formed Palisades Interstate Park Commission—had devoted the previous eight years to saving the Palisades from destruction by quarrymen. Harriman, the railroad magnate, possessed a strong interest in protecting wild land. He had extensive holdings in the adjoining Ramapo

Highlands and at his estate there, Arden, he had spent many hours discussing conservation of the Highlands with his friend Dr. Edward Partridge.

In 1909, as New Yorkers enjoyed the Hudson–Fulton festivities, Perkins and Harriman devised a grand plan to preserve the west shore of the Highlands chain from the Ramapos to the Hudson, including the famous battlegrounds at Forts Montgomery and Clinton, and to extend the jurisdiction of the PIPC north from Stony Point to Newburgh. Harriman presented the idea to Governor Hughes of New York in a letter dated June 1, 1909. Harriman proposed to donate 19 square miles of his own estate in the Ramapos, as well as a gift of $1 million to acquire property between it and the Hudson. His letter outlined the plan he and Perkins had envisioned: "I have thought that possibly some of the other property owners might join with me in this move," he wrote, "making it possible to secure practically the whole wild area between the Ramapo and the Hudson Rivers, extending from West Point down to below Stony Point, and again north of West Point, taking in the Crow's Nest. I feel that if this should be accomplished, the State's prison should be moved again to the other side of the river, so as not to destroy the natural beauty which can never again be replaced." He added that such a park would be of particular benefit to New York City, due to its easy access, and could be used as a health camp for sufferers of tuberculosis, where they could enjoy the outdoor life.

Governor Hughes responded soon after with a letter indicating his interest in the concept. "The creation of a public park embracing a wide expanse of this beautiful highland country, controlling a great watershed, and reserving for public uses a territory so accessible to New York City, would be of incalculable benefit to the people." He also expressed his support for "the great advantages such a reservation would present for health camps and for outdoor life, and the vast possibilities which would be opened up for those who are crowded within the great city so near at hand."[18]

Harriman died a few months later, before his plan could be executed. He left his entire $70 million estate to his wife, and it was she who converted his vision to reality. On December 15, 1909, Mary Harriman offered a gift of 10,000 acres and $1 million to New York State. She set out 5 conditions, specifying that:

- by January 1, 1910 (16 days later), a further $1.5 million in private donations be secured;
- New York State provide a match of $2.5 million for land acquisition, road building, and park purposes;
- construction cease on the prison at Bear Mountain;
- the jurisdiction of the Palisades Park be extended north into the Highlands and west to the Ramapos; and
- New Jersey appropriate an amount determined by the Interstate Park Commission to be "its fair share."[19]

Mary Harriman further specified that the state was to purchase river frontage to improve the park's accessibility to the inhabitants of New York City and neighboring counties who could reach the Highlands by steamboat.

All of the conditions were met, and 10 months later, the Harrimans' son Averell was summoned from Yale College to present the gift to the park commission. The state's $2.5 million was to be raised by means of an environmental bond issue, the first instance of using bond financing approved by the state electorate for park and

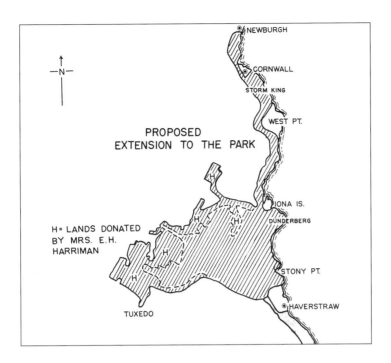

Palisades Park in 1909 with actual and proposed extensions.

Courtesy of the Palisades Interstate Park Commission, Bear Mountain

open space acquisition, a pioneering approach. The legislation adopted in 1910, extending the jurisdiction of the PIPC to the Highlands, also repealed the Highlands Forest Reserve.

George W. Perkins Sr., as President of the Palisades Interstate Park Commission, had secured promises of support from a number of prominent individuals. John D. Rockefeller Sr. and J. Pierpont Morgan each contributed a half million dollars. Morgan, who had contributed liberally to the preservation of the Palisades a decade earlier, not only was concerned for the protection of the Highlands but also had a direct interest in preventing the construction of a prison so close to his summer home. The remaining half million was donated by fourteen other subscribers, including Margaret Sage, James Stillman, William K. Vanderbilt, William Rockefeller, Henry Phipps, Helen Gould, V. Everit Macy, and George W. Perkins Sr. himself.

The creation of the Bear Mountain–Harriman State Park fit into an emerging pattern of conservation activism by some of the nation's most prominent political, industrial, and financial leaders—a critical mass of the wealthy, acting together to create a different vision for the river's future. Even so, Harriman's gift was an unprecedented act of philanthropy in terms of its magnitude and its effect in prompting other landowners to give land or money to complete the proposed acquisition. For the Harrimans, it was a natural progression in a history of conservation interest.

Although several of the railroad barons actively backed the federal park movement with a self-serving eye toward increasing passenger traffic, Harriman was one whose actions indicated more than a business interest. He and his wife both loved the outdoors and maintained a friendship with naturalist and Sierra transcendentalist John Muir. When Muir began his efforts to save the Yosemite Valley, the Harriman family came to his aid. In 1899 Harriman sponsored an expedition to Alaska with a team of scientists, painters, and photographers. Muir was among them.

The Alaska trip, which was recorded in thirteen volumes containing monographs by many of the participants, offers an interesting account of Harriman's personality and his views of the natural world. The financier organized the expedition when his doctor advised him to take a vacation. Having decided to go by steamer to Alaska, where he hoped to hunt the Kodiak bear, thought to be one of the largest in the world, Harriman came up with the idea of inviting eminent scientists to join him. As if preparing an ark for a great flood, he proposed taking two zoologists, two biologists, two botanists, and two geologists, among others, to record the natural history of the subarctic. The trip ultimately included three artists, two photographers, and twenty-five scientists, as well as naturalists Muir and John Burroughs, who wrote a narrative of the expedition.

Muir wrote: "I soon saw that Mr. Harriman was uncommon. He was taking a trip for rest, and at the same time managing his exploring guests as if we were a grateful, soothing, essential part of his rest-cure, though scientific explorers are not easily managed, and in large mixed lots are rather inflammable and explosive, especially when compressed on a ship. Nevertheless he kept us all in smooth working order; put us ashore wherever we liked, in all sorts of places—bays, coves, the mouths of streams, etc." Once, at a dinner on the expedition, Muir joked about Harriman, who was not present, "I don't think Mr. Harriman is very rich. He has not as much money as I have. I have all I want and Mr. Harriman has not." Harriman got word of this remark and told Muir, "I never cared for money except as power for work. . . . What I enjoy most is the power of creation, getting into partnership with Nature and doing good, helping to feed man and beast, and making everybody and everything a little better and happier."[20]

On Wall Street, Harriman had quite a different reputation. Biographer George Kennan described him as "cold, reticent and austere" when dealing with business, and cites the comment of a journalist who said, "He would be a wonderful character if only he had a heart." However, at home, Harriman was known to be kind and sympathetic, a side of his personality revealed to the scientists on the Alaska trip as well. John Muir clearly admired Harriman, describing him as a man who

fairly revelled in heavy dynamical work and went about it naturally and unweariedly like glaciers making landscapes, cutting canyons through ridges, carrying off hills, laying rails and bridges over lakes and rivers, mountains and plains. . . . Fortunes grew along his railroads like natural fruits. Almost everything he touched sprang up into new forms, changing the face of the whole country. . . . When big business plans were growing in his head he looked severe, with scarce a trace of the loving kindness that, like hidden radium or the deep-buried fires of ice-clad volcanoes, was everglowing in his heart. . . . None who came nigh him could fail to feel his kindness, especially in his home, radiating a delightful peaceful atmosphere, the finest domestic weather imaginable.

It was a twist of fate that brought the Harrimans to the neighboring western Highlands. In 1885 their friends, the Parrotts, sold their Orange County estate at auction. Harriman was in attendance. He was shocked at the thought of what might happen to the land—7,800 acres of standing timber, eagerly sought by representatives of lumber companies—and decided, on the spot, to buy it for a country estate. Thus the Harriman family established their summer residence in the Ramapo Hills,

as the western Highlands are known. There, Harriman operated a dairy farm where he "amused himself by giving personal attention to the details of farming and dairying, and pioneered the development of scientific methods for improving the quality of the milk supply." He also took an interest in forestry, "personally selecting the trees, or the kinds of trees, to be preserved."[21] He invited students from the Yale School of Forestry in New Haven—recently established by forestry pioneer Gifford Pinchot—to spend a summer at Arden studying forestry methods and getting practical experience.

In the following decade, the Harrimans expanded their land holdings to about 30 square miles of farms (about 40) and wooded tracts. Harriman felt that the original tract purchased from the Parrotts was already 2 to 3 times what he needed, but he expanded his holdings to "save the beautiful wooded hills on the west side of the Hudson River from falling into the hands of timber speculators and lumbermen and

Rangers give boys a physical at Bear Mountain Park.

Courtesy of the Palisades Interstate Park Commission, Bear Mountain

preserve them intact for the use and benefit of the public."[22] Parts of this package of land formed much of the initial gift to the state.

When the Harrimans donated 10,000 acres to New York State, they suggested that the park could do more than just preserve the land. They envisioned that it would provide fresh-air recreation and camping for the urban poor. The idea proved very successful, and Bear Mountain and Harriman State Parks rapidly developed on a grand scale. In 1913, the PIPC initiated a group camp program, the first in the nation, that became an example for the National Park Service when it was created in 1916. By 1914, it was estimated that over a million people were streaming through the park's gates annually. Three years later, the number of visitors had doubled. By 1919, there were 29 tent settlements, used by more than 50,000 people, mainly women and children. The average stay was 8 days. The park also provided camping sites for 1,600 Boy Scouts. The commission used such programs to create a sense of conservation and protection of the river environment. Bear Mountain and Harriman State Parks are immensely popular and remain so to this day. They receive more visitors annually than does Yellowstone National Park.

Over the years, the states of New York and New Jersey, and private donors, invested huge sums of money to expand the park. In 1929, the Harrimans' goal of a public preserve between the Ramapos and the Hudson was achieved, as the last parcels of intervening land were acquired. In later years, the remains of Revolutionary War strongholds were excavated and preserved, and on the site of Fort Clinton—with support from the Rockefellers—a historical museum was erected.

To accommodate the millions of visitors to Bear Mountain State Park, the PIPC began a vast construction program that included steamboat docks, roads, a bus shelter, and a variety of buildings and lodges. Everything was built of natural materials obtained from the park: stone from old fencerows and wood from the forest, primarily chestnut, which was then dying of blight. Park structures were designed to complement the natural surroundings. Instead of the Gothic style of architecture so popular in the nineteenth century, planners adopted a rustic style (which later became the model adopted for architecture by the National Park Service). The best example was the Bear Mountain Inn, built in 1915, described as "a rugged heap of boulders and huge chestnut logs assembled by the hand of man, and yet following lines of such natural proportions as to resemble the eternal Hills themselves."[23] Originally it was an open-air restaurant, with a luncheon counter on the first floor and a full dining room on the second. The interior is built of chestnut wood as well and was designed in the architectural style of the Adirondack "Great Camps." No windows or doors interfered with the experience of the outdoors, although provisions were made to glass in the second story in spring and fall. Dining was said to be a culinary experience rivaling any in New York City.

As the park underwent this development, a grand new idea was emerging in the mind of Benton MacKaye, a U.S. Labor Department policy maker charged with creating jobs through better use of natural resources. In 1921, MacKaye, an avid hiker, was concerned about the negative effects of urbanization on the human spirit and advocated enjoyment of the outdoors as a means of spiritual regeneration. He teamed up with two friends at the American Institute of Architects who shared his philosophy—Clarence Stein, chairman of the committee on community planning, and Charles Whitaker, editor of the *AIA Journal*, and mapped out the idea for a footpath along the entire Appalachian Mountain chain from Maine to Georgia. The concept, pub-

lished in an *AIA Journal* article by MacKaye, captured the imagination of hiking groups, government agencies, and scouting organizations along the entire proposed route. MacKaye found a particularly enthusiastic audience at Bear Mountain State Park, where Major William A. Welch was general manager. Welch, who was already working on a trail system for the park, began to organize a new project to create a section of the proposed Appalachian Trail at Bear Mountain that would take hikers in the direction of the Delaware Water Gap to the south. The Bear Mountain section of the trail, opened on October 7, 1923, was the first created, and became the pattern for other trail sections. Each was to be developed independently by local and regional groups and linked to the next section according to the plan mapped out by MacKaye. In 1925, a corporation was formed to complete the trail along its entire 2,025-mile length, a goal accomplished in 1937.

Today, the Appalachian Trail has official state and federal protection. However, for its first thirty years, it depended solely on cooperative agreements among the many landholders along its route. In 1984, the National Park Service assumed responsibility for its management, yet it was built by volunteers and continues to be maintained by the volunteer Appalachian Trail Conference.

The Palisades Interstate Park, Bear Mountain State Park, and the Appalachian Trail were created at a time when interest in conservation and historic preservation coincided with concern for social welfare (1890–1913). The region's most prominent businessmen and politically active women, leading government officials, and numerous citizens joined together to realize part of a broader progressive social vision, which sought to improve living and working conditions for the poor, reform government, promote social justice, and sustain natural resources for

Camp Olmsted, established as a fresh air camp, now a Methodist retreat.
Copyright © 1990 by Robert Beckhard

the future. During the early decades of the twentieth century, many properties on
the Hudson would be preserved by the convergence of the social reform move-
ment and the conservation movement, especially when river estates began to fall
out of fashion. The larger ones were white elephants, costly to heat and maintain,
and required many servants. In many cases, the owners did not want the responsi-
bility or could not support the burden of expenses, and they bequeathed their
family estates to newly formed social welfare institutions that would adapt the
property for their uses. The idea was to help the urban poor by getting them into
the country, where the air was fresh and the temptations for vice were few, offer-
ing a chance for moral improvement, no matter how brief. The estates and man-
sions on the Hudson were ready-made facilities in an area known for its healthful
and spiritual environment. Typical was the 234-acre University Settlement Camp
in Beacon, given by Eliza Howland in 1911. Camp Olmsted, in Cornwall, was pur-
chased in 1901 by Rhoda Olmsted in cooperation with the Five Points Mission of
New York City, a project of the Methodist Episcopal Church, to make a vacation
home in the country for children, mothers, and babies from city slums. Immi-
grant children would take a steamboat up the river and then walk a mile to the
camp. Over the next 40 years, many other estates were purchased for similar pur-
poses, becoming hospitals, fresh air camps, orphan homes, and sanitariums.

In New York City, the progressive movement led to the development of recreation
piers, bathhouses, and playgrounds on the shores of the Hudson, where people could
enjoy cool river breezes in summertime. The steamboat dock at Pier 43 (Barrow
Street) became a two-story recreation building that attracted thousands of urban
visitors. Another such pier on Christopher Street was popular (1908–1928). This was

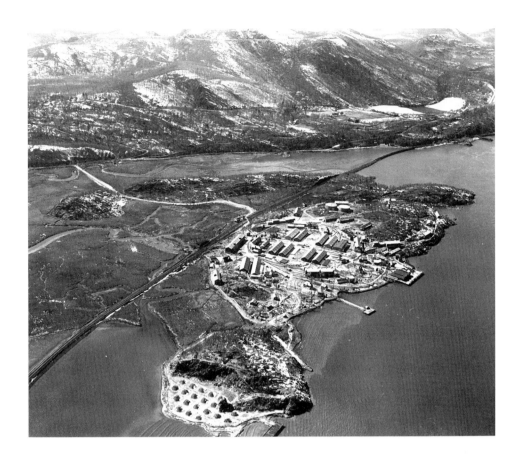

the beginning of a long transformation of the riverfront to park uses that continues to this day.

The leaders of the social reform movements that prompted new uses of the Hudson River shoreline were often women. Margaret Slocum Sage was a noted philanthropist and activist in support of women's suffrage and education. In her 1905 article "Opportunities and Responsibilities of Leisured Women," published in the *North American Review*, she presented her ideas about helping the unfortunate by providing them with a good environment, opportunity for self-support and individual responsibility, and protection from the unscrupulous. She was the second wife of Russell Sage, who built his fortune in banking, railroads, and money lending. When her childless, misanthropic husband died in 1906, he left her $63 million, which she began to distribute to charities. The Russell Sage Foundation, which she devised and ran, was a prototype of the modern American charitable foundation. This ex-schoolteacher became one of the most influential women in American history.

Among her conservation-related activities were the creation of a 70,000-acre bird refuge on Marsh Island in Louisiana and the purchase of Constitution Island on the Hudson. Jutting into the river at World's End, the rocky island created the narrow passage that lent such strategic importance to that part of the Highlands. The owner, Anna Warner (who wrote the hymn "Jesus Loves Me, This I Know"), had offered the 280-acre island to West Point, but the offer had not been accepted, and a group of promoters proposed an amusement park there. Mrs. Sage intervened, purchasing Constitution Island in 1908, and, after considerable effort, persuaded the federal government to accept it on behalf of the cadets—subject to the condition that it may never be used for another purpose. The site is now open to visitors. The Constitution

Military barracks replaced the pleasure grounds at Iona Island after 1900, when the navy acquired the island. The Palisades Interstate Park Commission (PIPC) acquired the property as parkland in 1965. It is now designated a National Natural Landmark and a Research Reserve and serves as a winter sanctuary for bald eagles. Most of the military buildings have been removed and the site is reverting to its former wild character. Prickly pear cactus is one of many interesting plants that grow there. Bald eagles roost there in winter, because the river is usually free of ice and the birds can catch fish more easily.
Courtesy of PIPC Archives

Island Association was the first nonprofit organization in the country devoted equally to historic preservation, conservation of nature, and protection of Revolutionary War fortifications.

The actions of the Harrimans, Mrs. Sage, and those who joined them through gifts of land or money or through the power of their passions and their pens—Colvin, Stoddard, McClure, Perkins, Partridge, Howell, Bigelow, Olmsted, Morgan, Rockefeller, Stillman, Osborn, Albert, and many others—preserved a great deal of the Hudson River scenery in public ownership. This marked the culmination of twenty years of efforts to preserve the Hudson's shoreline, first in the Adirondacks and then extending into the Palisades and the Highlands. During this time, nature and scenery were embraced as a vital part of our historic heritage, and new institutions, for which there was no legal precedent, were created to protect them. Vast sums of public and private money were spent to preserve, for future generations, a legacy of lands that today would cost not millions but billions to purchase for the public domain.

While the efforts of these men and women set the stage for continued public spending to support expansion of the interstate park, it would be decades before public interest in conservation would reach such levels again. In the early 1900s, as the ideas of a national park, a state park, and a state forest reserve in the Highlands were being debated, plans were being drawn that would usher in a new era on the Hudson—a time when technology would flex its mighty muscle and the military river would expand its reach. In 1900, the navy bought the "pleasure ground" at Iona Island and erected barracks on it. Nearby bridges, tunnels, and highways reflected a new way the river challenged the imagination. The Hudson–Fulton celebration, which gave so much impetus to the movement to preserve the Highlands, marked a shift in priorities. The coming decades would be the age of the engineer, and the Hudson would again be reshaped to meet the needs of the Empire State. It was a turning point, a celebration of both the old and the new.

Over, Under, Across, and Through

Civil Engineers Triumph Over Nature, Except in New York Harbor

I3

THE HUDSON–FULTON CELEBRATION was as grand as any ever held. The commission, whose membership included more than 800 citizens and public officials, spent more than 4 years preparing for it, at a cost of over $1 million. The festivities, lasting from September 25 to October 9, 1909, were a nonstop succession of parades, fireworks, concerts, art shows, historical and art exhibits, light shows, and boat races. The numerous ceremonies included public lectures, receptions for foreign guests, and the dedication of parks and monuments. It was a celebration as much of New York's scenery as of its history. Preparations helped to establish state and local parks at Bear Mountain, Inwood Hill in Manhattan, and Verplanck's Point near Peekskill, as well as dozens of smaller parks. A major feature of the event was the official dedication of the Palisades Interstate Park that now encompassed the entire waterfront of the Palisades in New York and New Jersey.

Warships outlined in light and fireworks during the 1909 Hudson–Fulton Celebration. New York State Hudson–Fulton Celebration Commission.
Author's collection

The focal point of the two-week festival was a procession from New York to Albany of full-sized replicas of Hudson's ship and Fulton's steamboat. The Dutch government conducted research on the original plans and design of the *Half Moon* and built the 80-ton replica at the Royal Ship Yards in Amsterdam as a gift to the state of New York. A replica of the *Clermont* was built by the Staten Island Ship Building Company, at a cost of $15,865.15—paid for by the New York–based celebration commission. At 1:15 on September 25, under the eyes of more than a million spectators, the *Half Moon* sailed and the *Clermont* steamed through the harbor to a 21-gun salute, leading the naval parade. They were followed by 5 squadrons totaling 800 boats—yachts, steamers, tugs, tenders, gunships, submarines, and other vessels of U.S. and foreign fleets—to the Official Landing at 110th Street in Manhattan. There the crews, dressed in period costumes, came ashore for a ceremony with the Hudson–Fulton Commission. The Dutch crewing on the *Half Moon* and their captain, dressed as Henry Hudson, presented an illuminated manuscript by which the *Half Moon* was bestowed to the state of New York; the Reverend C. S. Bullock, representing Robert Fulton, gave a short speech about the *Clermont*; and then a delegation of Japanese residents of New York presented a gift of 2,100 cherry trees from Japan to be planted along Riverside Drive.

The ceremony was not without incident. At 10:30 that morning, as the two boats left their anchorages to join the squadron, the *Clermont* slipped a setscrew and came to a stop. The *Half Moon* bore down on the disabled ship and, unable to maneuver away in time, rammed the *Clermont* near the boiler. The *Half Moon*'s anchor locked into the *Clermont*'s sail, and while the tugboat *Dalzelline* was helping to separate the two vessels, it collided with the main boom of the *Half Moon*. Apparently, the collision "caused more amusement than damage," and by the time of the opening ceremonies, both ships were seaworthy. After the inaugural parade in New York harbor, the *Clermont* and the *Half Moon* headed upriver for a series of community festivals timed to coincide with their arrival. The ships arrived in Albany on October 9 and in Cohoes (the northernmost point of navigation on the tidal Hudson) on October 11 for the close of the celebration.

Other events commemorated achievements in technology and civil engineering. Among the highlights was a demonstration of airplane flight by Wilbur Wright, who amazed the crowd with 4 flights over New York harbor, the longest of which lasted an incredible 33 minutes and 33 seconds, covering a distance of about 20 miles at an average altitude of 200 feet. To demonstrate advances in the use of electrical power, the commission put on spectacular light shows that included nightly "chromatic illumination" along Riverside Drive, produced by a machine called the "Ryan Scintillator." The committee also arranged for the masts and waterlines of the international sailing fleet assembled in the harbor to be strung with thousands of sparkling globes, which by prearranged signal would be lighted at eight o'clock. A historical pageant, consisting of 53 horse-drawn floats, featured public works achievements such as the construction of the Erie Canal and the Croton public water supply system.[1]

The Hudson–Fulton Celebration marked a high point in public appreciation of the river's history and scenery, as well as a shift in the public mood. Enthusiasm for technology and a desire to solve a variety of problems involving the river would dominate the interests of citizens, businesses, and government until the onset of

World War II. Now, the river and its shores were again sketched on drawing tablets—not by artists but by engineers.

Beginning in 1902, numerous laws were passed appointing study commissions to propose ways of solving problems of water pollution, flooding, drinking water shortages, and navigation. In New York State, this included the 1902 Water Storage Commission, the 1903 New York Bay Pollution Commission, the 1905 State Water Supply Commission, and the 1906 Metropolitan Sewerage Commission. In 1902, New Jersey organized the Passaic Valley Sewerage Commission. These commissions proposed grand construction projects, though many were delayed by the advent of the World War I. With the return of peace came a flurry of construction activity that lasted until the stock market crash of 1929 and the start of World War II. Some of these projects were triumphs of science and engineering, ranking in difficulty with the original Aswan Dam then under construction in Egypt and the Panama Canal then beginning construction in Central America. Others were hardly challenging at all. Worldwide, this was the age of the engineers, and their work soon changed the shape and the flow of the river itself. Between 1907 and 1931, new dams went across the Hudson, tunnels went under it, bridges went over it, and deeper, straighter channels went through it. A river that once raged and boiled in springtime was calmed, though certainly not tamed. As an unintentional result, habitats were destroyed, the movement of salt water into the estuary was altered, stream flows were rerouted, and the rural countryside was developed.

The river also began to be seen in new ways, as both a problem and an opportunity. Until now it had been an obstacle, foiling most attempts to get over, under, and through it. After 1908, that changed. It posed challenges that could be solved. Government reports also now spoke of the Hudson in terms of potential, such as "latent water power." Floodwaters, once a hazard, were now thought of as a resource to be captured and stored, to be harnessed as a source of energy that could propel manufacturing to even greater levels of productivity. The river was now measured by its energy output.

Engineers are problem solvers, and on the Hudson in 1900, as in many places around the world, teams of professionals set to work to address a variety of problems and opportunities of the day. Inventions in technology and advances in science made it possible to proceed on a grand scale. However, one of the first projects to be proposed (and one of the last to be built) was one that was hardly difficult at all, though its effect on the river was quite profound: the Sacandaga Reservoir.

Most rivers flood, and the Hudson was no exception until the Sacandaga was built. Spring flooding was a particular hazard for the low-lying industrial communities of Troy, Albany, Watervliet, and Green Island—where the nontidal Mohawk and upper Hudson Rivers join the tidal Hudson. As warming weather cracked the ice that covered the river, the movement of tides would pile huge floes atop one another, making an ice dam that blocked the swelling waters gushing out of the thawing Adirondacks. Then the river spilled over its banks, causing widespread disaster. In 1818, Troy families lost their livestock and had to be rescued by boat as floodwaters covered a quarter of the city. In 1857, the river rose 3 to 4 inches a minute, covering wharves with as much as 14 feet of water. During the flood of 1913, the level of the Hudson rose 28 feet above mean low water and reached the window sills of the Cluett Peabody Mill on Green Island. A local pamphlet described the devastation:

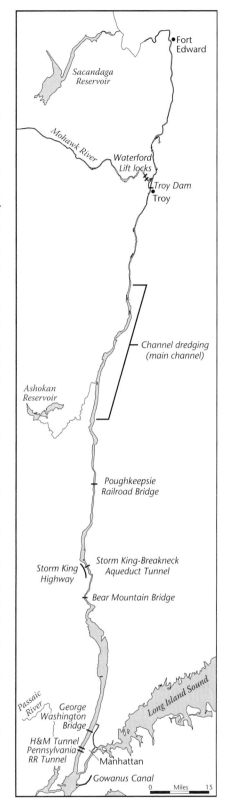

March 26 the tributaries were roaring torrents and the great arm of the ocean began to reach over the land ominously. Homes were invaded and carried away; hotels and stores were, in some instances, demolished and sent on their long journey to the sea; impounded logs and lumber in the north woods country were wrenched from their controlling barriers and passed out on the crest of the swift tide; bridges collapsed like paper structures; fires started in many sections; railroads suspended their schedules and abandoned their tracks to the inexorable force of the rising water; electric light, telegraph, and telephone plants and the water supplies of many cities gave out, and dire distress threatened the inhabitants. The flood had broken all records and the public mind was frightened with the possibilities of its damaging effects.[2]

In 1905, New York State established a Water Supply Commission to investigate ways the state might both solve its flood problems and make its water resources more productive, while also generating an income. After Wisconsin pioneered the first hydroelectric power plant, designed by Thomas Edison, in 1882, New York officials realized there were almost limitless possibilities of producing power on their own waterways. Though flood problems plagued river cities, it was hydroelectric power that really interested the commission, since summer droughts increasingly forced manufacturing mills to shut down for lack of water to power the turbines. In 1907, it reported:

Rivers are natural sources of material wealth, since their waters furnish power that can be easily and accurately measured, and because they are constantly replenished by natural laws. Their flow is not uniform, however, and on this account, many streams are unsatisfactory for power purposes, and are growing more so as the forests are cleared and fields improved. While nature has been generous, therefore, in providing our State with many and important rivers, she has also imposed a duty upon us if we would avail ourselves of these natural advantages.... The surer and better the water power the greater the manufacturing industries and the more thriving the communities depending on them.... It has been estimated ... that water

Flooding in Fort Edward, March 28, 1913.
New York State Education Department Lantern slide, New York State Archives

power in [New York] State could be made to produce an annual profit of $18,000,000, which equals, if it does not exceed, the net profits of agriculture in this State.[3]

The idea was to build reservoirs throughout the state to store the water and release it when needed to power the mills. These would not be drinking water reservoirs; their purpose was solely to regulate the flow of rivers and streams and to generate electricity at their own dams and on power dams downstream. In 1909, two thirds of the water power then used on the upper Hudson was devoted to pulp and paper manufacture, and several paper companies petitioned the Water Supply Commission to regulate the flow of the Hudson for their benefit by building a water storage reservoir on the Sacandaga River in the Adirondacks. The Hudson Valley Railway Company, the Hudson River Power Company, and the City of Albany also submitted petitions.[4] Flood control would be a secondary benefit.

Now, for the first time, the Hudson was being described in terms of the horsepower it could produce. "After the construction of the Sacandaga reservoir, by the proposed enlargement of the Indian Lake reservoir . . . the economic power of the Hudson will be increased . . . [for] a total gain in the economic capacity of the stream . . . of 53,070 H. P."[5] State engineers calculated that the combined power produced by reservoirs on the Sacandaga River and the Indian River, and at Lake

Seneca Ray Stoddard, *Junction of the Hudson and Sacandaga.*
Courtesy of the Chapman Historical Museum

Pleasant and Lake Piseco, would generate 162,330 H.P. The commission noted that dependence on water power would likely decrease over 20 years as electric power was developed.

Despite these compelling statistics, it was not until after World War I, when New York State set about becoming a national leader in water power development, that the Sacandaga project moved forward. Mill owners on the upper Hudson joined forces with communities subject to flooding to develop the necessary political support for the proposed reservoir. It would not just provide hydroelectric power. In summer droughts, its gates could be opened to provide a stable flow of water to power the mill turbines; in spring, the gates could be closed to hold back floodwaters.

By 1925, the state had devised a formula to divide the cost among those who would benefit. The cities of Troy, Albany, Rensselaer, and Watervliet, as well as the Village of Green Island, would pay a modest amount for flood control, while the remaining costs would be borne by 21 companies, many of them paper producers, as well as a new business that now occupied the upper Hudson—the Ford Motor Company. The project was financed with $412 million in bonds, paid by public and private beneficiaries, with the advance work and coordination provided by the state.

In 1927, engineers finalized plans to construct the Sacandaga Reservoir, collecting the rainfall and snowmelt of a 1,044-square-mile watershed in the lower Adirondacks, and construction began on a dam that was 115 feet at its highest, 720 feet thick at the base, and 40 feet across at the top. In 1930, the gates to the dam at Conklingville closed, and the water of the Sacandaga River rose behind it to fill a 29-mile-long valley with water up to 70 feet deep. Later that year the first water from the reservoirs was released, supplying hydroelectric power and providing factories with a steady water flow in the dry days of summer. In July 1949, during the worst drought in the river's history, three quarters of the Hudson's flow at Glens Falls was water released from Sacandaga. The Hudson had become a managed river. The reservoir prevented floods as well. In 1936, it contained a flood that would have been worse than the disastrous deluge of 1913. Although flooding was not completely prevented, the damage was greatly reduced.[6]

As an engineering project, the construction of the dam was a modest achievement. Such dams were straightforward to build in the 1930s. However, in re-engineering the flow of the river itself, its effects were profound. Today, when drought moves ocean salt water farther up the estuary, threatening the water supplies of

The Conklingville Dam, on the Sacandaga River near its confluence with the Hudson, created the Sacandaga Reservoir.
Courtesy of the New York State Archives

Poughkeepsie and Port Ewen (that take their drinking water from the Hudson), water is released from the Sacandaga to push the brackish water south, governing the movement of fresh and salt water in the estuary—once controlled solely by nature.

In 1915, while state engineers were debating and planning the Sacandaga project, federal engineers with the U.S. Army Corps were hard at work on relocating the dam across the Hudson at Troy. Originally designed for the Erie and Champlain canal system, it would now produce electric power as well. Downstream, corps engineers continued the seemingly endless task of updating and modifying the river channel. In 1819, as the Erie Canal was being constructed, one engineer described the roughly 20-mile stretch of the tidal Hudson between Albany and New Baltimore as a flat basin containing "a true archipelago of islands, shoals and bars . . . the channel is extremely circuitous, resembling perfectly the sinuous curves of a serpent; and at several places presenting to the ablest pilots difficulties almost insurmountable, unless the most favorable circumstances concur to assist them."[7] Fifty years later, engineers began to build dikes to straighten it out. By 1892, with the Erie Canal still going strong and larger ships using the Hudson, dredges dug ever-deeper channels, and the silt and sediment they removed was deposited behind the dikes in the spaces between islands, in the shallows, and on mudflats. Eventually, over one third of what was once river between Kingston and Troy became dry land, and the archipelago and serpentine channel were no more. Dredging and filling destroyed biologically important wetlands and shallows and turned many little islands into big ones or connected them to the shore. What the railroad had started, with its shoreline straightening, hardening, and filling, the Army Corps of Engineers completed, greatly reducing the river's ability to support its legendary fish populations.

In New York City, a different problem demanded the attention of engineers: pollution. By the turn of the century, in the harbor, 80 million cubic feet of sewage per day mingled with grease balls from oil refineries and tons of garbage.[8] In 300 years, the river that Henry Hudson had described as "clear, blue and wonderful to the taste" had been transformed into a black and gaseous cauldron of sickness and death. Dumping had ruined the river for other human needs. On top of that, in New Jersey, state officials were proposing to collect the sewage of over a million people (some 630 million gallons per day) and pipe it into the harbor to control pollution in the Passaic River basin.[9] Once adored, the river was now abhorred.

In 1903, Governor Odell established the New York Bay Pollution Commission to investigate the problem. Its 1905 report spurred the support of leading citizens and organizations to clean up the river, including the Chamber of Commerce of the State of New York, the Merchant's Association of New York, the Board of Trade and Transportation, the Maritime Association of the Port of New York, the Produce Exchange, the City Club, the American Scenic and Historic Preservation Society, and the Municipal Engineers of the City of New York.[10]

For the next eight years (1906–14), sanitary engineers, health officials, biologists, and other experts examined every aspect of the pollution problems in the harbor. They measured the oxygen, calculated rates of flow, and examined the status of fish populations and oyster beds. "New York is practically alone in not possessing either a system of main drainage and sewage disposal or a plan and policy for the sanitary conservation of its water highways,"[11] the commissioners reported. In places they found that the harbor supported no fish life at all. It was "polluted beyond the limits of toleration."[12] Every quart of harbor water, they estimated, contained at least an

ounce of human waste.[13] "Practically the whole bottom of Upper New York bay is covered with black, ill smelling mud in which particles of sewage are distinguishable. In places these deposits have been found to attain a depth of over ten feet,"[14] they wrote. Oysters were smothered in their beds. "Gasses of putrefaction rise in innumerable bubbles from the deposits at the bottom. . . . On the outgoing tide, grease and excreta are left adhering to the dock walls and piers."[15] Balls of grease clogged the few sewers. "Nuisances frequently result where steam and hot water are discharged into the sewers, since hot vapors rise and issue through the manhole covers disseminating odors of cooked sewage."[16] Eating shellfish could cause typhoid. Collecting driftwood for fuel posed the same risk. Over 2,000 people swam in floating pools like houseboats through which river water flowed, they said, and many got sick afterward.

Industrial pollution also caught the commission's attention, particularly from the oil refineries—many part of the Standard Oil conglomerate: "There are many industries situated on the shores of New York harbor which produce oil and grease and discharge it as waste into these waters. . . . Manufacturing establishments, slaughter houses and, in fact, most factories, refineries, gas houses and industrial establishments empty their liquid wastes into these waters."[17] Such waste included sulfuric acid and caustic soda. Ships dumped oil from their boilers, and petroleum slicks floated on the water, coating the feathers of ducks and geese, killing a great number of them. Later, during World War I, the slicks occasionally caught fire.[18]

In 1914, the commission completed its work and laid out its recommendations. An interstate project was needed and, if necessary, New York should sue New Jersey to force its cooperation—since that state had not responded to any of the commission's overtures. The city should collect the sewage and pipe it out to the ocean.[19]

Swimming in the Hudson in a floating pool on the shore of Manhattan Island.

Photograph from the 1910 report of the Metropolitan Sewerage Commission. Courtesy of the Hudson River Foundation

However, the problems were far greater than the city could tackle. Industries played one community off another, threatening to take their jobs with them and move. They pitted New York against New Jersey, and they used their power in the state capitols to prevent meaningful enforcement against pollution.[20] The problems of factory waste only got worse as metal and wire producers, chemical and fertilizer companies, textile mills, and machine works set up shop in the region. From 1860 to 1900, the number of factories in the city grew from 5,000 to 35,000.[21] The population was growing at the rate of a million people per decade, making New York the world's second largest city.

The sewage problem got worse before it got better. Though five sewage treatment plants were built between 1924 and 1938, including one at Passaic Valley in New Jersey, one at Yonkers, and three on the East River, they merely removed the solids from the waste, and raw sewage continued to pour into the harbor in many places.[22] In 1936, the Interstate Sanitation Commission was established by New York, New Jersey, and Connecticut to clean up the greater harbor area, including the Hudson River up to the Highlands, and modest improvements followed. Yet decades would pass before the worst pollution problems of the Hudson and the harbor were solved. The challenge was too big for the engineers to make a meaningful impact. In 1944, gas-filled bubbles the size of basketballs still rose to the surface of the river and the surrounding creeks and bays. Joseph Mitchell, the river's most devoted chronicler at the time and a writer for *The New Yorker*, described how such bubbles would make the water "seethe and spit" so much that people would stand and stare at it.[23]

Pollution affected the fishermen most. After an outbreak of typhoid in 1916, traced to eating oysters, the Board of Health shut down the harbor's legendary oyster fishery. Shad fishermen had kept going, but the fish tasted like kerosene if they weren't caught early in the spawning run. Yet, even when the Hudson was at its worst, the rivermen found beauty in the water's depths. This breed of man, wrote Mitchell, "not only works on the river or kills a lot of time on it or near it, he is also emotionally attached to it—he can't stay away from it."[24] The rivermen fished for shad, set pots for eels, or cast for catfish, tomcod, striped bass, and lafayettes, fish that survived in spite of the pollution. Mitchell listened as they argued about the prospect that the river would rebound:

"I don't know, Roy," said Mr. Zimmer. "They've stopped dumping garbage out in the harbor approaches, where the tide washes it right back, and they're putting in a lot of sewage-disposal plants. The water's getting cleaner every year."

"I've read that," said Mr. Poole, "and I've heard it. Only I don't believe it. . . . They used to say that the smell in the Gowanus [Canal] would make the flag on a mast hang limp in a high wind. They used to tell about a tug that was freshly painted yellow and made a run up the Gowanus and came out painted green. I was up there last summer, and I didn't notice any change."

"Seriously, Roy," said Zimmer, "don't you think the water's getting cleaner?"

"Of course it isn't," said Mr. Poole. "It's getting worse and worse. . . . When I was young I used to dream the time would come when we could bed oysters in the harbor again. Now I'm satisfied that time will never come. I don't even worry about the pollution any more. My only hope, I hope they don't pollute the harbor with something a million times worse than pollution."[25]

Prophetically, as Mr. Poole foresaw, the river would remain polluted for decades, and a future chapter of the river's history would require its citizens to address problems "a million times worse."

Back in 1906, when the Metropolitan Sewerage Commission was first formed, another problem had also started to occupy the attention of engineers. New York City, surrounded by salt water, faced a critical water shortage. Water consumption had leaped from 165 million gallons per day (mgd) to 183 mgd between 1891 and 1895, and a new source of fresh water supply had to be found.[26] From 1905 to 1907, the State Water Supply Commission considered alternative sites. They briefly considered using Hudson River water from freshwater reaches above Poughkeepsie but rejected the idea due to the pollution.

> That the city of New York might secure its waters from the Hudson appears to the casual observer to be the simplest solution of its difficulties. This solution has been carefully studied by the State Commission, . . . and it finds that the Hudson river receives the sewage and drainage of a large and populous area . . . which makes it unfit for use and more or less objectionable even if filtered . . . although the first cost of the Hudson river project might be less than that of the plan proposed, it is not wise for the city to acquire this contaminated supply while pure upland water supply can be obtained.[27]

The city wasted no time in zeroing in on a new source of water. It would develop reservoirs in the Catskills, to the west of the Hudson, and pipe it to Manhattan and the boroughs. The Hudson River now became the location of one of the most significant engineering achievements of the time. In the Highlands, previously impenetrable mountain terrain was challenged and conquered.

Of the all the engineering projects from 1900 to 1930, the Hudson River tunnel of the Catskill Aqueduct best illustrates the technological advances characteristic of this period and the changing attitudes that accompanied them. The tunnel crossing under the Hudson River in the Highlands was the most challenging part of one of the most ambitious water supply systems ever constructed. It also left the smallest visible imprint on the river despite its massive effects. Only a mysterious stone tower at the base of Breakneck Mountain marks its presence.

The Catskill Aqueduct was conceived in 1905 as a grand plan to flood 24 square miles of Catskill Mountain watershed. It would be the longest (92 miles) and most expensive aqueduct in the world. A 20-year project, it would tap the watersheds of two Catskill Mountain streams, the Esopus and the Schoharie, collecting their waters in two reservoirs.

The aqueduct would be designed to operate on the same principle utilized by the Romans thousands of years ago. Starting in the high ground of the Catskills, it would be constructed on a gradient so that the water would flow ever so slightly downhill until it reached New York. The water pressure would be such that no pumps would be required for the entire length. The Ashokan Reservoir, when filled, would reach an elevation of 590 feet above sea level (also flooding homes and communities). Its destination, the Hill View Reservoir on the northern border of New York, would be 300 feet lower than the Ashokan, an elevation sufficient to permit gravity flow and a self-delivering system.

On its route to New York, the aqueduct would have to pass through tunnels, around and through hills, and across valleys, using a variety of construction methods. It would follow the contours of the land but never rise above the hydraulic gradient, since this would require pumping. Tunnels would have to be driven through hills and mountains that could not conveniently be circumvented by the earth-covered concrete trenches used for most of the system. However, it was impossible to follow topography all the way to the city. At some point, stream valleys and the Hudson River had to be crossed. Advances in mechanical power and the use of dynamite made it possible to construct tunnels under the valleys, using water pressure to bring the water back up to the appropriate level on the other side. This technique was to be tried for the first time.

The engineering of the aqueduct depended directly on an accurate analysis of the geology of the Catskills and the Hudson Valley. A team of trained geologists, headed by Charles Berkey, was assembled to assist in determining the least costly route. Fault zones, as well as bedrock and channel conditions, ruled out all choices but one—a Storm King–Breakneck crossing, where a band of granite fairly uniform in quality and comparatively free of groundwater intrusion was found to extend across the river valley. On the advice of the geologists, the engineering team drew up plans for a U-shaped tunnel leaving the gradient near Cornwall at an elevation of 418 feet above sea level, dropping vertically below the surface of the Hudson, crossing through solid rock under the gorge, and resurfacing on Breakneck Ridge north of Cold Spring at the gradient—395 feet above the river's surface. It would operate as an

Stone structure at Breakneck Mountain, Cold Spring, New York, part of New York City's Catskill aqueduct system. This building, often thought to be a pump station, protects a large manhole cover and is the only remaining visible evidence of the Storm King–Breakneck aqueduct tunnel. No pumps were used on the aqueduct.
Copyright 1990 by Robert Beckhard

inverted siphon: water pressure would power the rise up Breakneck, and from there the downhill flow would begin again. The tunnel would have to be buried at least 150 feet deep in solid rock to resist a bursting pressure estimated at 480 pounds per square inch.

Groundbreaking ceremonies were held near Cold Spring on Thursday, June 20, 1907. New York City's Mayor McClellan, using a silver spade, cut out a square of sod from the Newell Farm, where the first 2 acres of land for the aqueduct had been acquired by the city, and declared the project begun. In a full-page Sunday feature on June 23, *The New York Times* reported on the difficulties that would be encountered in constructing the aqueduct system and offered the following observations about the Storm King crossing: "of this gigantic undertaking . . . the dip under the Hudson is the most striking of the numerous engineering problems. . . . No such tunnel or siphon has ever been built, yet the engineers are confident of the success of their plans, drawing on experience in the constructing of mine tunnels, a science which has developed very rapidly in recent years."

For engineers working on the Storm King shaft, the first challenge was to determine the depth to bedrock of the granite seam underlying the river channel. Using drills mounted on pile-driving scows, kept in position by ten anchors each weighing two to three tons, contractors bored through the muck, gravel, and boulders of the channel in an attempt to find solid bottom. Division Engineer Lazarus White described it as the most difficult task involved in the construction of the entire aqueduct system:

> The severe gales and rough water encountered at times make it hard to keep the scow exactly in position, while any movement, if it is toward the hole, is likely to bend the standing casing and destroy the borings. . . . No work known to the writer requires a greater degree of patience, ingenuity and perseverance than boring through hard surface under the conditions prevailing at the Storm King crossing. In addition to swift tides and heavy river traffic, various governmental restrictions . . . etc., there is a short working season, entirely too short to put down a 700-foot hole. This made it necessary to disconnect at the river bottom and cap the hole, recovering it if possible in the spring. . . . When at last one hole was supposed to have reached bottom at the depth of about six hundred feet, a river steamer which had broken a propeller drifted on the boring rig, bending the casing when only a few feet of core had been pulled.[28]

Four years later, after many attempts, the bedrock of the Hudson had yet to be reached. Public confidence in the project began to flag, and rumors began to circulate. White reported, "The difficulties of the boring came to be associated with the entire work and people began to believe the river bottomless." The *World* published a cartoon of a man squirting the aqueduct—a hose full of water—from the top of Storm King for another man atop Breakneck to catch in a tub.

Despite all adversity, the crews persisted in their explorations, and the results of the drilling profiles provided sufficient information for geologist Berkey to guess at the likely depth and profile of the channel. Work on the aqueduct tunnel was the first opportunity to study the subsurface geology of the river. It showed that the Hudson through the Highlands was a deep canyon filled with rubble. Berkey, looking at the core borings, was the first to conclude that glacial scouring, not stream erosion, had created the channel. This was an important finding. Ice valleys erode in

a different profile than stream valleys, affecting assumptions about the shape of the riverbed. Ice valleys are generally U-shaped and flat-bottomed, while stream valleys have a deep notch in the bottom. If the gorge was an ice valley, its depth could be determined as soon as one part of its floor was touched; if a stream valley, the slopes of the two sides would help determine the slope of the bedrock floor.

Berkey suggested another method to determine the depth to bedrock: by drilling at an angle, from each shore down toward the center beneath the river. In those days, vials of hydrofluoric acid were used to obtain the angle of the holes. After every hundred feet of drilling, the vials were inserted into the borehole. The acid etched a line in the glass tubes showing the angle of the hole, so that any necessary corrections could be made. This new method provided critical information. The first set of cores passed through solid rock at a depth of 1,200 feet, proving that the river bottom did not extend below that depth and might even be considerably higher. A second round of borings commenced, crossing at an elevation of 955 feet below sea level, and these cores also showed continuous, sound granite. The engineers concluded that the tunnel could safely be constructed 1,100 feet below the surface, allowing at least 150 feet of sound rock clearance at the lowest point in the gorge, to resist the enormous bursting pressure of the water.

Construction of the tunnel shafts began immediately, and men excavated the tunnel from both sides, working toward the center. Crews could often hear each other approaching through hundreds of feet of rock. When they broke through the headings, their survey lines met within fractions of inches.

However, construction of the tunnel was not without its hazards. In places, rock that appeared sound when first exposed later snapped off the tunnel wall in flat, wedge-shaped layers, resulting in several accidents and at least one death. "Popping rock" was confined to the Storm King side and appeared only in greenish granites,

Drilling for bedrock.
New York City Board of Water Supply, 1928 report

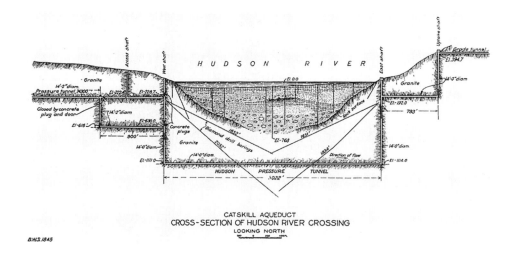

CATSKILL AQUEDUCT
CROSS-SECTION OF HUDSON RIVER CROSSING
LOOKING NORTH

never in the pink varieties. Eventually the popping rock was stabilized with steel plate. When the Storm King tunnel was finally filled with water, however, the granite shifted, causing leaks. The entire works had to be pumped out and a new shaft drilled, bypassing the fractured zone. Some fifty years later, concern that blasting on Storm King would cause new leaks in the aqueduct lent support to the movement to preserve the mountain.

Engineers supervised the work, each responsible for a section of the aqueduct's route. They had to move to the location of construction, and some of them took advantage of their posts to enjoy the scenery. William Thompson Howell, who campaigned for the preservation of Bear Mountain in 1908, recorded in his diary for September 7 through 19, 1910 a camping trip to Cedar Pond in the Highlands.

> We had one visitor that day who had come to see us the night before—James F. Sanborn, Division Engineer with the New York Board of Water Supply, in charge of the construction of one of the northern sections of the great Catskill aqueduct, with a headquarters at New Paltz. He had come down to Monroe via the Wallkill Valley and Erie railroads, and walked in to our camp from Monroe. He turned off, after leaving Arden, on the wrong wood road, and finding himself in the valley west of our ponds, travelled across the pathless hills by compass. He came into camp Saturday afternoon, as we were preparing lunch, with a pack on his back in which were four pounds of sirloin steak and a bottle of whiskey.
>
> He had not been in camp ten minutes before he was insisting on being a member of a party which was going on a tramp of five miles and back in order to bring in some thirty quarts of oats for the horses expected on the morrow....
>
> "A man of culture," said Baird of him, in his camp talk later, "and a Harvard graduate." Mr. Sanborn was also par excellence the camper and out-of-door man, and made me realize more fully than I had ever done before the fraternity of feeling which exists among men who go often into the open.[29]

On January 30, 1912, New York City Mayor Gaynor fired the shot that broke down the rock wall separating the east and west tunnels, and those present walked through a tunnel of solid rock 1,100 feet below the surface of the river. On September 9, 1913, the Ashokan dam gates were closed and the reservoir began filling up. By the end of

Cross-section of the Hudson River crossing of the Catskill aqueduct looking upstream, showing the location of the tunnel and the diamond-drill borings made to explore the rock to determine its location.
New York City Board of Water Supply, 1928 report

1917, 250 million gallons per day (mgd) flowed through the tunnel from Ashokan to New York, passing through the Hudson River tunnel on its way. In 1924, the new Schoharie reservoir opened, raising the level of flow to 500 mgd.

In 1917, the jubilant mayor appointed a committee of 500 citizens to arrange for a celebration of the completion of phase one of the aqueduct system. The Catskill Aqueduct Celebration Committee had a commemorative medal struck with the inscription: "An achievement of civic spirit, scientific genius and faithful labor." Indeed, 17,000 people had been employed to build the water supply system, many of them recent immigrants from Italy, Austria, Germany, and Eastern Europe, as well as Southern blacks. They had worked in camps that were separated by race and nationality.[30]

A series of events were planned, including an allegorical pageant with dancers draped in flowing costumes to represent clouds, rain gods, and fire spirits delivering a symbolic gift of water from the mountains to the city. The celebration was cancelled because of World War I, but the New York Public Library produced an exhibition and a catalogue that described the pageant in detail as it was planned to occur.[31]

The construction of the aqueduct was a monumental achievement, and the problems conquered in crossing the Highlands gorge led to improvements in the speed and economy of sinking circular shafts; the use of concrete tunnel lining instead of timber; the use of hammer drills; the employment of steel forms on movable carriages; and the use of deep, pressurized tunnels instead of steel pipes for water supply systems crossing valleys.

Two other tunnel crossings were built at this time, both leading to Manhattan. The first, started in 1902 and completed in 1908 by the Hudson & Manhattan Railroad Company (H&M), provided a route for electric commuter trains to traverse the river between Hoboken and New York City, a 10-minute trip through metal tubes 15 feet in diameter dug into the silt of the river bottom. A south tube of the line also connected Manhattan and Jersey City. These eventually became the Port Authority Trans-Hudson (PATH) train still used by commuters today. This project was started as early as 1874 by a man named DeWitt Clinton Haskin, but had been plagued with technical difficulties, flooding, lawsuits, and bankruptcy of his company. In 1890, English investors took over but lacked sufficient funding to complete the project. In 1902, work resumed under the H&M, a new company formed by William McAdoo, who secured nearly unlimited financing from J. P. Morgan, Cornelius Vanderbilt, and others. In 1978, the American Society of Civil Engineers designated the Hudson Tunnels a National Civil Engineering Landmark. The second tunnel was the work of the Pennsylvania Railroad, built in a gambit to challenge the primacy of the New York Central. It also used tubes driven through the silt of the river bottom, and it opened in 1910, the same year that the city drove tunnel shafts for the aqueduct. The new railroad tunnel provided connecting service from Philadelphia to Pennsylvania Station in New York, and from there to the Long Island Railroad, a total of 175 miles of electrified track.[32]

In contrast to the three tunnels, two other engineering projects—the Storm King Highway and the Bear Mountain Bridge—were quite visible, and despite the enthusiasm for technological achievements at the time, both aroused a public outcry over their impact on the beauty of the Highlands. The Storm King Highway came first. By comparison with the aqueduct tunnel, construction of the Storm King road was

a minor undertaking—but it was a major highway project. The four-mile route, first surveyed in 1903, did not begin construction until 1919 and took more than three years to build. In terms of cost per mile, it was, at that time, the most expensive in New York State history.

The most significant problem was the difficulty of working on Storm King's towering slope. For most of its distance, the Storm King road is a narrow ledge benched out of sheer cliffs, clinging as much as 400 feet above the river. Surveying the route required a great deal of ingenuity—to plot the points, workmen fired rockets loaded with jars of paint at some of the most inaccessible areas. In other places, surveyors were lowered on ropes. Years later, when construction began, it was found that much of the Storm King Highway could be built only by manual labor. Although sophisticated machinery was available, cranes and other heavy equipment could not be brought onto the steep mountain face. Smaller machines had to be hauled up, piecemeal, on mule back and assembled on location. To blast the rock, it was often necessary to suspend the workmen in baskets held by ropes while they drilled 10 feet into the rock face to lay dynamite.

The cost of purchasing the land proved equally vexing. The Storm King Stone Company, incorporated in 1906, three years after the road was first proposed, operated a quarry on lands along the route. It appears that quarrying was only one of the motives for buying the land. In their offering to the stockholders, company executives pointed out that if the state condemned the land for highway purposes, the revenue would far exceed the original investment. They knew that a quarry on the site would only increase the government's urgency to purchase the land from them, and they intended to hold out for top dollar.

Concern over the costs of condemnation aroused considerable public discussion, as did the question of scarring the face of Storm King Mountain. The Palisades Interstate Park Commission (PIPC) countered that the highway would allow thousands of motorists to view the Highlands from Storm King's heights, a greater benefit. As the park commissioners were the most powerful protectors of scenery in government, their views eventually prevailed.

However, the project stalled again when successive West Point superintendents worried about the potential for interference with training exercises. Eventually, a deal was finally struck that called for the road to be closed for 2 hours a day for artillery practice. Two leading families of Cornwall, the Tafts and the Stillmans, threw their support behind the project, donating rights-of-way over the lands they owned, but the advent of war delayed construction until 1919. Three years later, in 1922, the road opened to traffic. Shortly thereafter, Ernest Stillman gave the PIPC 800 acres of riverfront land bordering 5 miles of the highway, creating a new Storm King section of the park.

Today, the Storm King Highway is one of the most scenic roads in the Hudson Valley, but it scars the beauty of the northern gateway to the Highlands. A major feat of engineering in its time, it enjoyed a brief history as a through road until the opening of the "Storm King bypass" (Route 9W) in 1940. It is now used primarily as a local route between West Point and Cornwall and as a scenic route for those who seek to enjoy the Highlands from an elevation of 400 feet.

The Bear Mountain Bridge was a response to a different problem—the need to connect the east and west shores of the Hudson. With the coming of the automobile, a highway system developed rapidly on both sides of the Hudson, but the only bridge

for cars crossing the river was north of Albany. To the south, there was only one Hudson River span, a railroad bridge at Poughkeepsie, opened in 1888.

For New Yorkers traveling to the park, this meant a long wait at ferry landings. A February 10, 1922 article in *The New York Times* observed that ferry service was woefully inadequate, resulting in long lines of cars waiting far into the night. "Even the hotels in the river towns cannot take care of the stranded ones when there is a glut of traffic. People have been known to sleep out in their cars all night." As the pressure for river crossings intensified, the technology for building suspension bridges was advancing to the point that a short span across the river could be attempted. The Highlands, where the Hudson was narrowest, offered the most likely location, and the need to provide access to Bear Mountain Park would be justification. In February 1922, a bill was introduced in the state legislature that authorized the creation of a private corporation, financed by stockholders, to construct the bridge and operate it for a 35-year period, after which the structure would become the property of the state. The cost was estimated at $10 million, although when completed it actually cost about half that much.

To recover its investment, the legislature allowed the company to collect tolls for people, vehicles, and animals. It cost 20 cents to transport horses and cattle, while calves, hogs, sheep, and lambs could cross for only 10 cents. People on foot and passengers in cars were charged 15 cents, children 10 cents. Cars were assessed 80 cents,

The Storm King Highway, Cornwall, New York.
Copyright © 1990 by Robert Beckhard

BRIDGE OVER HUDSON RIVER AT POUGHKEEPSIE.

motorcycles with sidecars 35 cents. The rates for horse-drawn wagons ranged from 60 to 75 cents depending on length.

The bridge was to be constructed where the river narrows between Anthony's Nose and Bear Mountain, the exact location where colonial forces had stretched the first of two chains across, below the redoubts assailed by British forces in 1777. Because of its proximity to Revolutionary War historic sites, some suggested that the span be called the George Washington Bridge. (The original six-lane suspension bridge by that name, spanning the Hudson between Upper Manhattan and Fort Lee, New Jersey, opened in 1931 and was expanded to two levels in 1962.)

Built in 1924, the Bear Mountain Bridge set new records for speed of construction, made possible by rapid advances in engineering. The first suspension bridges in this country date from as early as 1796 and used wood and iron, with wrought-iron chains as suspension cables, but it was not until 1844 that John A. Roebling introduced the method of using wire suspension cables (across the Allegheny River at Pittsburgh).[33] In following years, the Roebling company introduced the French method of spinning cables in place, used in 1854 for a bridge over the Niagara Falls rapids. The string that formed the first connection between the two banks was flown across the gorge by kite. The Brooklyn Bridge, built by the Roebling company in 1883, pioneered the use of steel, with galvanized coating, for bridge cable wire, utilizing 14,568 miles of wire cable to support a main span of 1595.5 feet and a total span of 3,455.5 feet, including side spans. These advances inspired a group of entrepreneurs to consider making the Bear Mountain Bridge a suspension bridge that would provide access to Bear Mountain State Park. The principal backer was E. Roland Harriman—son of Edward H. Harriman, whose philanthropy had created the park, and brother of Averell, who was then serving on the PIPC (and would later be governor). His Bear Mountain Hudson River Bridge Corporation raised more than $5 million in capital to pay for construction, to be repaid from tolls.

While the purpose of the bridge was to open the park to motorists, it had every prospect of being a successful business venture. The number of cars at the park had jumped from 2,000 in 1916, when the park opened, to over a million by 1921. The po-

The Poughkeepsie Railroad Bridge, which opened in 1888, was the only bridge crossing the Hudson River below Albany until 1924, when the Bear Mountain automobile bridge opened. The railroad bridge connected the coal, oil, and slate regions of Pennsylvania with New England and went out of operation after a fire in the 1970s.

Postcard, author's collection

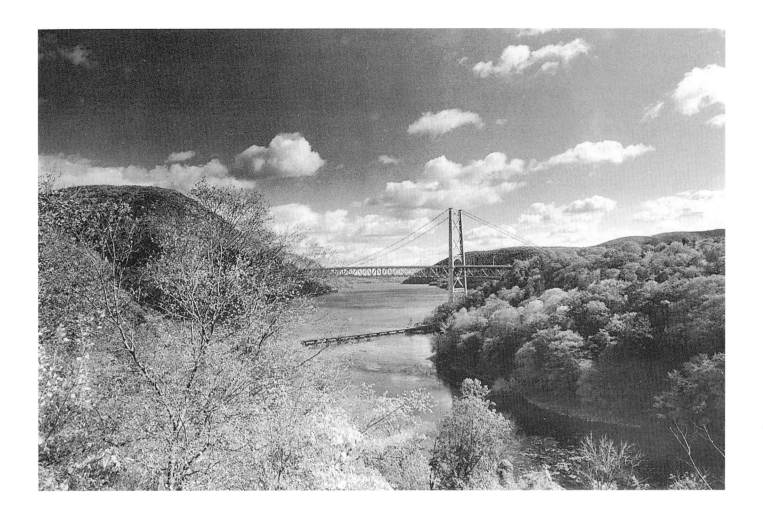

tential revenue was enormous. It was estimated that the average family of 4 visiting the park would have to pay $1.15 in tolls to cross the bridge, which newspapers reported was constructed to handle 5,000 automobiles per hour.

Like the Storm King Highway project, however, the proposed Bear Mountain Bridge was not without opponents. A July 1923 issue of *The Outlook* contained a photograph of the proposed design and an article by Lawrence Abbott, who criticized it as an unsightly structure that would mar the scenery of the Highlands. "With all due respect, it looks, in its wonderful setting of mountains and river, like a piece of tin frumpery." He also suggested a conflict of interest with investors who served on the PIPC. *The New York Times* responded to Abbott's article with an editorial that blasted the bridge company for its plans to construct "a bridge wholly out of accord with the scenery around it and indicative only of a desire on the part of the builders to make it as cheaply as they can," and continued:

> Ugly bridges, indeed, have been built in modern and ancient times, but they are so few that apparently it is easier to make them beautiful than ugly, and that to attain ugliness . . . no small amount of ingenuity and determination must be misapplied.
>
> There is no excuse at all, consequently, for what is about to happen near one of the most admirable manifestations of natural beauty in the vicinity of this city, and in this part of the country, for that matter—the erection of a bridge across the Hudson that will be an offense to the eye for as long as it stands.[34]

The Bear Mountain Bridge, between Fort Montgomery and Anthony's Nose.
Copyright © 1990 by Robert Beckhard

In the same paper, the following day, J. B. White (President of the Palisades Interstate Park Commission) defended the design of the bridge, noting that the commission had "engaged the best architectural advice we could get" and had required changes before approving it. He contended that the picture Mr. Abbott had showed was out of date and did not represent the plan finally adopted. He called the reports of conflict of interest "contemptible," suggesting that PIPC Commissioner Averell Harriman "should get a Congressional Medal for putting money into this bridge." E. Roland Harriman, president of the company, chimed in that the merits of the design would be evident once the bridge was built.

Construction proceeded, and as Roland Harriman predicted, the completed bridge was indeed exquisite. By today's standards, the size, scale, and location seem a perfect reflection of its intended use. A narrow, two-lane bridge, held aloft by a graceful sweep of cabled steel and complemented by its Victorian toll house—a cottage built of stone with a steep slate roof, diamond-paned windows, and a tower—it is, indeed, a grand entry to a grand park.

In 1925, John A. Roebling's Sons Company described how the Bear Mountain Bridge pioneered new engineering principles: "The construction of cables for the Bear Mountain Bridge may be said to have been the turning point in history of parallel wire cable fabrication, as several new theories, put to a rigid test during the construction of these cables, proved very successful, and opened the field to cables of practically any diameter and number of wires." The principal advance, according to Roebling, was the use of flat wire bands, which eliminated a slow and tedious compacting procedure in the construction of cable wires.[35]

On September 10, 1924, the first car crossed the bridge, driven by M. Belknap, the engineer in charge of construction. The official opening occurred two months later, on November 23. For the opening ceremony, 400 automobiles assembled. Accompanied by the West Point military band, they paraded across the bridge to a bronze tablet that was unveiled by Mary Harriman while the military band played "The Star-Spangled Banner." On its first day, 5,000 motorcars crossed the new bridge. The enormous difficulties of spanning the Hudson had been conquered. Only 8 years later, in 1931, the George Washington Bridge was built, with a main span of about 3,500 feet, more than twice as long as the Bear Mountain Bridge's 1,632 feet.

Although it achieved its public purpose, the Bear Mountain Bridge was a financial disaster. It operated at a loss for 13 of 16 years, until the state bought it in 1940 for about $2.3 million. However, its impact would be felt far into the future. On the fiftieth anniversary of the bridge, Frank Manthey, bridge manager for 47 years, recalled, "It was the first highway bridge over the Hudson below Albany, and it meant that for the first time in the 150 years of the Republic, you could cross the river without waiting for a ferry—which didn't even run when the Hudson was frozen over. What we learned here, others came to see—and it helped them to build the Holland Tunnel, the Lincoln Tunnel, the George Washington Bridge and every other crossing up and down the river ever since."[36]

Surviving the Depression, Connecting with Nature

FDR's River of Dignity, Robert Moses's Riverside Drive, and John D. Rockefeller Jr.'s Parkway

14

*I*N 1929, THE stock market crashed. Banks began failing, and the clouds of the Great Depression gathered. Fortunes were lost. The roaring twenties sputtered to a close, and the nation turned inward. Soon, half of all engineers were unemployed, and the fancy estates on the Hudson began to shut their doors.

Over the next decade, an interesting shift happened that would profoundly affect the river. As the American Scenic and Historic Preservation Society wrote in its 1940 Annual Report:

Prior to the collapse of the post-war inflation in 1930, the prevailing public attitude was that while conservation was eminently wise and desirable, it was not a life and death matter. With the Depression, however, and the eagerness for national self-criticism it engendered, the condition of our natural resources was evaluated anew and another point of view accepted: that conservation could no longer be

Franklin D. Roosevelt in 1932.
Courtesy of the Franklin D. Roosevelt Library, Hyde Park, NY

regarded as something that could wait until more pressing matters were disposed of, but was itself one of the most pressing and immediate necessities.[1]

This was a time when presidents, governors, and legislators would develop new programs for the protection of the valley's history and scenery, using fresh approaches never tried before. The advent of war forced them to abandon some of these efforts; however, the 1930s created a shared a vision of how things should be, and private citizens picked up where public agencies left off. People once again worked to realize their fantasies on the river and its shores. The ideas of visionary leaders would reinvent the Hudson once again, though the same vision was not always shared. Once again, the river would instruct. Once again, people would see contact with the river as a way to improve the spirit, to achieve a civilizing effect on human behavior, and to instill a sense of dignity.

The trigger for this rethinking of priorities was the decision of the Hudson River Stone Company, in 1931, to buy 1,000 acres on Mount Taurus (Bull Hill), extending from the river shore to the summit. After the transaction was made, quarrying began at a speed never previously witnessed.

As long as the quarries were able to operate in the Palisades, there had never been much pressure on the Highlands. The exception was a mine at Breakneck Mountain where, in 1846, Captain Deering Ayers had destroyed some remarkable scenery. With a single blast, he blew Turks Face (a famous promontory on Breakneck Mountain, one of the many points of interest for travelers) to pieces, and 10,000 tons of scenery crumbled into an undistinguished heap of rocks. The only consolation to the public was that the captain was himself blown to bits a few years later while checking out an explosive that had failed to go off, an event noted with some satisfaction in guidebooks. Quarrying at Breakneck ceased soon after.

However, Mount Taurus, located just south of Breakneck, remained unprotected, and its purchase jolted the public consciousness. With the demand for trap rock increasing and sites for mining on the Palisades decreasing, the Hudson River Stone Company now threatened to reduce majestic mountain scenery to rubble in a very short period of time.

The response by government and citizens was swift. Within months, Governor Franklin D. Roosevelt appointed a committee of the State Council of Parks, headed by Robert Moses, to study the possibility of securing donations for state purchase of Mount Taurus as parkland. Ironically, the previous owner of the property, Southard and Stern of Cold Spring, had offered to sell the land to the state for a park just a few years earlier, but the state had not responded.

The appointment of the Roosevelt/Moses committee seemed to assure that this time the government would act, but 1931 was two years after the stock market crash. The state was without funds for conservation, and the committee was unable to raise enough money to acquire the land from the Hudson River Stone Company. In 1932, Governor Roosevelt, who would soon be elected president, advised conservationists that the state and the stone company had not been able to agree on a purchase price.[2]

For the next five years, the blasting of dynamite continued to reverberate through the Highlands until a gash on the face of Mount Taurus dominated the view from West Point, the Storm King Highway, and the river below. On the waterfront, huge

piles of trap rock, former mountain scenery, awaited shipment to markets in New York and Albany.

In 1936, with a growing sense of frustration and outrage, twenty-nine residents of the Hudson Valley decided to do something about it. At a meeting in New York City, they formed the Hudson River Conservation Society, electing William Church Osborn as president. "Organized purely by indignation at one piece of vandalism," they determined "to preserve the beautiful and historic Hudson Valley" to the best of their ability.[3] The certificate of incorporation set forth the following purposes:

- to preserve in its natural state the Hudson River and its valley and to preserve the historic landmarks thereof;
- to make a continuing survey of the Hudson River and its valley as to conditions affecting health and recreation;
- to create public opinion and sentiment on all matters affecting the Hudson River and its valley, and to take public action thereon either directly or through community organizations.

The HRCS roster of directors in 1936 shows that concern for the preservation of the Hudson was being passed on from the nineteenth-century titans of industry to the next generation. It lists such names as Chauncey Stillman, Mr. and Mrs. William Church Osborn, the Honorable Hamilton Fish, Mr. and Mrs. Samuel Sloan, Mrs. Charles Tracy, and Mr. and Mrs. George Perkins. In addition, HRCS members soon numbered in the hundreds, including other prominent families: the Aldriches and Delafields from Red Hook, the Hasbroucks from Kingston, the Livingstons of Cheviot, the Pells of Fort Ticonderoga, the Danas of Englewood, the Whitbecks of Hudson, Mrs. William Willis Reese from New Hamburg, Mrs. Cleveland Dodge from Riverdale, and Alfred Olcott of New York (owner of the Hudson River Day Line). Many of these families remain active in Hudson River preservation today. The society membership also included a number of Van Winkles, Van Cortlandts, Schuylers, and Verplancks, linking it to the river's earliest settlers. Members lived as far away as Fort Ticonderoga on Lake Champlain and as close as Englewood Cliffs, New Jersey; there were even a few from Philadelphia.

Being men and women of influence, HRCS members took their cause to the highest levels of government immediately. In November 1936, board members William Church Osborn and General John Ross Delafield approached Governor Herbert H. Lehman in Albany. As a result of the meeting, Lehman proposed to establish a state commission to study ways of protecting the Hudson—aimed at not only ending the quarrying on Mount Taurus but also addressing the need to protect the historic resources and scenery of the entire river valley. The Governor's Annual Message to the Legislature in January 1937 announced his proposals with the following statement:

The Legislature should give thought to a comprehensive plan for the preservation of the natural beauty of the Hudson River and for its improvement and development. The Hudson River and the Hudson River Valley are among the great scenic, historic and commercial assets not only of the state of New York but of the country as a whole. While parts of the River have been permanently protected against destruction or

injury, the State has no control over the scenic and historic treasures of the greater part of the River.

Within the last few years we have witnessed the operation of a commercial quarry that is marring the beauty of an important part of the historic highlands. The commission which I propose should be charged with the duty of investigating the advisability of acquiring this quarry, protecting the scenic beauties of the River and the Valley generally and the possibilities of the further commercial development of the municipalities bordering on the River.[4]

Following the governor's lead, and with the support of an active constituency group, Hudson Valley senators and assemblymen formed a caucus and began to consider a regional approach to the problems confronting the river. They wrote and passed two laws that year. One, known as the Mailler Law, authorized the state to accept gifts of scenic properties in the Hudson River Valley. The other, introduced by Senator Erastus Corning 2nd, created a temporary Hudson River Valley Survey Commission.

The Corning Law of 1937 directed the survey commission to recommend action to protect scenic and historic sites from destruction or defacement, including possible state acquisition of important sites. The law also required a study of preservation opportunities for Mount Taurus and authorized the commission to "take an option on any privately owned site the acquisition of which it intends to recommend to the governor."[5]

The HRCS invited Assemblyman Mailler and Senator Corning to speak about the legislation at the first annual meeting, held at the Hotel Thayer at West Point on June 26, 1937. In his speech, Senator Corning advocated a number of new ideas for conservation of the valley and suggested four major initiatives: state purchase of Mount Taurus; development of a comprehensive plan for the whole river; private action to conserve land through deed restrictions; and state zoning for the river to permit quarrying only "beyond the skyline of the hills." He stressed that "if the program of

1938 photograph of the quarry at Mount Taurus, Cold Spring, New York, now part of Hudson Highlands State Park.
Collection of the Hudson River Conservation Society, courtesy of Scenic Hudson

the State for the river is not a comprehensive one the purchase of Mount Taurus would not be of any great lasting benefit, because there are other places of great beauty in the Highlands that would be just as desirable from the standpoint of the quarryman. For real success there must be a plan to take in the whole river." It was the first time that comprehensive planning for the river corridor had been advocated. It was also the first time that riverfront zoning by the state was discussed.

Meanwhile, however, the depression was deepening, and even some of the wealthy people along the Hudson were struggling to make ends meet. State coffers were running low, but the desire to protect river scenery ran high. Corning discussed the idea of citizen action, noting that "private interests can do a lot in this work by putting restrictions in the deeds to any property disposed of by them." This too was a relatively new idea—that private landowners could control the future use of their land through deeds or easements. "Many large estates are now in the position that their owners are either unwilling or unable to keep them up. Before that time, the owner in such a situation had little he could do except sell the property for what it would bring and hope that the new owner would have the same patriotic and sympathetic idea of keeping our river beautiful that he did," Corning added.

The Mailler Law, Corning noted, would make it possible for property owners to give their lands to the state "with the knowledge that they will always be kept in as beautiful and natural a state as possible." A pragmatic politician, he saw the opportunities that preservation would create for economic development, especially in the real estate, recreation, and tourist industries.

Any real success in the plan to make the Hudson more beautiful will naturally bring back to its shores many of those who have left and others too who are looking for places of beauty in which to spend their vacations. With them also will come the over-night campers and picknickers. . . . Education is gradually teaching the people the value of conservation for themselves and for their children.[6]

When Assemblyman Mailler addressed the annual meeting, he spoke specifically about the need to stop the quarrying. He pointed out that the state was spending hundreds of thousands of dollars to beautify the west shore of the river in the Highlands and the Palisades but was allowing commercial interests to spoil the view on the opposite shore. "Thousands of tourists from all over the world are annually attracted to the Storm King Highway from which, for several miles, the main view is that of Mount Taurus." His bill would allow public-spirited landholders to donate a strip of riverfront property to the state, which would permanently prevent its development without impairing the beauty of their estates.[7]

Governor Lehman appointed Senator Corning chairman of the new, temporary Hudson River Valley Survey Commission, and appointed William Church Osborn of Garrison and Dr. LeRoy Kimball, the president of the American Scenic and Historic Preservation Society, as members. As the commission began its two-year study in 1938, the HRCS continued building its membership. By the end of the society's first year, 1937, there were 1,130 members and $40,000 in the treasury. When one considers that the HRCS was organized before the days of bulk mailings and e-mail, this was a sizeable and well-financed group. To recruit members, it held garden parties up and down the river and set up local branches in each county and several riverfront towns. By 1940, the membership had swelled to an impressive 1,860 donors. By then, it was clear that state purchase of Mount Taurus would not solve the problem. The stone companies would simply move to another site. In fact, reports by the American Scenic and Historic Preservation Society complained that the quarrymen deliberately purchased mountain properties on speculation that the state would buy them out. They decided that private action was needed in addition to the state's efforts.

The HRCS began to identify and map potential quarry sites and to negotiate deed restrictions with the property owners. In its first year, the group protected 1,200 acres in the Highlands from potential quarrying—two 600-acre parcels. One, owned by the Cornish family, formed the northern border of the lands of the Hudson River Stone Company on Mount Taurus. The Osborns owned the other, in Garrison. Two years after the formation of the HRCS, the number of acres protected through deed restrictions on private property had climbed to 2,350. In most cases the owners donated their mining and mineral rights to these lands or imposed the deed restrictions without compensation. However, not all landowners were willing to make such gifts, so in some cases, the society raised money to purchase "danger spots" on the river, which it then donated to New York State under the Mailler Law. This included 250 acres of potential quarry sites on Breakneck and about 200 acres on Anthony's Nose, purchased with the assistance of the New York–New Jersey Trail Conference to assure that the land facing Bear Mountain Park and the Perkins Memorial Drive could never be mined.

To protect the scenery and to provide recreation for the public, the conservation society also advocated the creation of a state park on the east shore of the Hudson comprising the Beacon Range, part of the famous northern gate to the Highlands. Thirty years later, the prospect of a power plant on Breakneck would motivate people to protect the land and bring this vision to pass.

However, in 1938, with the mineral rights of thousands of undeveloped acres secured, the problem of quarrying at Mount Taurus still remained, and the members of the HRCS began to explore every means at their disposal to shut the operation down. Legal research revealed that permits from the state land board and the federal

War Department were required before depositing fill in underwater lands of the Hudson. In seven years of operation of the quarry, the Hudson River Stone Company had filled some 20 acres of underwater land with silt, rubble, and stone without a permit. The river fill had made it possible for the company to expand its operation to adjacent Little Stony Point.

The conservation society hired an attorney, Judge Ellis Staley, who sued for an injunction on the operation of the quarry based on the illegal fill of the river. As a result of his work, in 1939, the federal government required that by 1940 the company remove from the river all material down to the bottom. The state government also fined the company and ordered it to refrain from dumping.

Meanwhile, in 1938, the Hudson River Valley Survey Commission, created by the Corning Law and appointed by Governor Lehman, conducted public hearings throughout the valley. However, in several areas of its inquiry, the commission seemed to draw a blank. Because of strained state finances in the depression era, Senator Corning's river zoning proposals were not enacted. The idea would return decades later, but for now, it withered on the vine. In 1938, the commission concluded that historic buildings could not be preserved because the state lacked sufficient funds to care for them. Similarly, there was no way to stop the quarrying on Mount Taurus. The company rejected the commission's offer for its land as too low. The commission's *Preliminary Report* concluded that conservation would come about only by the action of public-spirited citizens and recommended educational efforts aimed at developing a conservation ethic among the people in the region.

A year later, in 1939, the Hudson River Valley Survey Commission published its final report, which made no mention of quarries or Mount Taurus but focused on promoting the public enjoyment of the river for recreation. By this time, a shift in public priorities was also taking place, and the primary concern of the legislature and a growing concern of the HRCS was pollution. The report contained a map showing sources of industrial waste such as milk products, bleaching and dyeing, powder laundries, and paper wastes. It also recommended that Congress adopt legislation transferring authority to order the cleanup of river pollution from the state to the federal government.

While the study commission ultimately had little impact on river conservation, in 1944, during World War II, the mining operation shut down forever. The property remained in the possession of the Hudson River Stone Company until 1963, when it was purchased by the local electric utility.

As these events played out, Franklin D. Roosevelt (FDR)—first as governor and then as president—developed policies and programs that would be strongly felt up and down the Hudson. Like his famous fifth cousin, Theodore Roosevelt, who had created conservation programs as governor and then as president at the turn of the century, FDR drew on the experiences of his youth to influence the future of the state and the nation.

Like Theodore, FDR had spent much of his boyhood exploring the outdoors. He had grown up roaming his family's Hudson River estate, Springwood, in Hyde Park, where he cut firewood with his father, sailed ice boats, shot birds for his collection (a common practice among bird lovers of the day), and climbed trees with his friends, pretending the sturdy trunks of hemlocks were the masts of great sailing ships.[8] As a child and teenager, he also vacationed in the Adirondacks and became an avid outdoorsman.

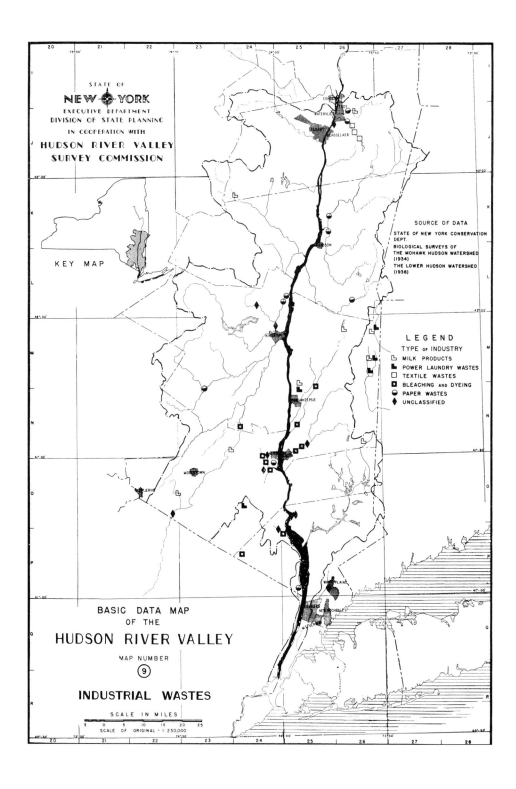

1939 map prepared by the Hudson River Valley Survey Commission showing sources of industrial wastes polluting the Hudson, including "milk products, power laundry wastes, textile wastes, bleaching and dyeing, paper wastes and unclassified" wastes.
New York State Division of State Planning

Encounters with his cousin Theodore at his Oyster Bay estate on Long Island inspired FDR to public service. Theodore had also visited young Franklin's class at Groton prep school, and regaled them with stories of his exploits as police commissioner in New York City.

FDR's political awakening to conservation appears to have occurred when he unexpectedly won election to the State Senate and was appointed chairman of the Conservation Committee in 1911. He wrote: "It was a post that was supposed to be a sinecure, one of no importance, because in those days there was no such thing as the

Conservation Department . . . there was practically no interest in what you and I know today as conservation in its broadest sense. But . . . I was very keen . . . on getting the people of the State interested in preventing soil erosion in the Adirondacks."[9] It was a time, he noted, when "Some parts of upstate New York were being eroded, a lot of topsoil was running away, we were getting more floods than we had ever had in the old days."[10]

In 1912, Roosevelt invited Gifford Pinchot, formerly the nation's Chief Forester under President Theodore Roosevelt, to speak at Albany to an audience of senators and assemblymen. Pinchot showed 2 pictures that made a dramatic impression on Franklin and all legislators present. The first was a photograph of a 400-year-old Chinese painting of a prosperous town that was home to some 3,000 people. It showed a beautiful valley with a stream running through it surrounded by fields and crops. Above the valley were mountains cloaked in spruce and pine forests all the way to the top. On one of the mountains was a small logging chute. Pinchot related that for the next hundred years the people in that valley cut down all the trees on the top of the mountain. He then showed a second, recent photo taken from the exact same spot where the painting had been made. As FDR later described it:

> There was no grass, no trees—just rocks. In other words, the entire soil had been washed off those mountains and there they were, bare for all time. Down in the valley, the old, walled town was in ruins. . . . There you saw the wreck of a great civilization of four hundred years ago, and nothing left except some ruins and rocks. Well, that picture in those days, twenty-five years ago, sold conservation and forestry to the Legislature of the State of New York.[11]

Eleanor Roosevelt described the effect of this speech on her husband: "Mr. Pinchot was waging a rather lonely fight then and few people paid much attention to his warnings. However, my husband was tremendously impressed and he began at once to replant trees on his own land in Dutchess County, New York."[12] FDR, who had experimented with farming on the family property at Hyde Park only to find that the soil was played out, planted 5,000 to 10,000 seedling trees each year at Springwood, and began thinning a 500-acre wood lot. He invited state forestry agents to make a forest management plan and consulted professors of forestry. He soon discovered that land of little value for farming could produce a good crop of trees if properly managed. This understanding would become the basis for future state policies and helped him win the presidency years later.

As a state legislator, FDR also promoted legislation to protect wildlife and prevent the sale of feathers of protected birds. He was supported in these efforts by the state Conservation Department, one of many similar agencies created by state governments after Theodore Roosevelt's 1908 White House conference on natural history. He also tried to eliminate pollution of the river by state facilities, for example, making sure that the new Hudson River State Hospital in Poughkeepsie built a treatment plant, and noted in a 1935 letter that "When I was in Albany I spent many hours trying to persuade municipalities to put in sewage disposal plants . . . I hope some day Poughkeepsie will see the light!"[13]

FDR left the state legislature after just two years to accept a position as Assistant Secretary of the Navy in 1913. However, he continued to practice forestry at Springwood and further develop his interest in conservation. Eventually, he would plant

almost a half million trees at Hyde Park. He also became an advocate for the Appalachian Trail and supported scouting organizations. A year after he was crippled by polio, in 1921, he became a founding member of the Adirondack Mountain Club, a group organized to promote the conservation of the fish, game, and wildlife of the Adirondacks and to build and maintain hiking trails for mountain climbers. In 1925, he was appointed to the state's park commission for the Taconic Region, becoming its chairperson, and he used this office to urge state land purchases along the Hudson River. He attempted to create a parkway in the Taconic Region but was thwarted by the state park chairman, Robert Moses, who was then building parkways on Long Island.[14] Though his legs completely failed him, FDR went bird-watching in the Everglades on his way to Hot Springs, Georgia, where he sought treatment for his polio, and in 1929 advocated creating a bird refuge over much of south Florida. All the while, he gathered strength and experience that allowed him to attempt elected office again.

In 1928, FDR campaigned for governor and won by a narrow margin of 25,000 votes. His stump speeches reached out to farmers who, like himself, had tried to produce a dollar from worn-out farms. Some 4 to 5 million acres of farmland had then been abandoned in New York, an area larger than the states of Connecticut, Vermont, and Rhode Island combined. Through his wife, Eleanor, FDR had become aware of plight of poor farm families, the human side of poverty. As she put it, "where land is wastefully used and becomes unprofitable, the people go to waste too. Good land and good people go hand in hand."[15] He broadcast a series of radio addresses that educated voters and helped put their personal plight into a larger context. One of his key messages was that reforesting played-out soil would be more profitable than farming it: "many of the farms abandoned within the period of the depression since 1920 should not be restored to agriculture but should be especially used for the growing of a future timber supply."[16] He told audiences how his own tree farm on the Hudson was now producing a tidy annual income that earned him thousands of dollars each year.

As governor, Roosevelt also concluded that forestry might be a way to put the unemployed back to work, following the example of his good friend Henry Morgenthau, who had hired out-of-work men to cut firewood on his 100-acre property in Dutchess County. Morgenthau had assembled statistics on how many people could be employed per hundred acres, and had figured out how to organize work assignments. When Roosevelt took office in Albany and announced his plans to hire the unemployed to carry out public works projects (work relief), he appointed Morgenthau as Conservation Commissioner. Morgenthau was the only commissioner who had a plan for assigning labor to worthwhile projects, and he was given three fourths of the state's appropriation for work relief. Roosevelt also appointed Harry Hopkins to head up the employment agency, called the Temporary Emergency Recovery Administration (TERA). Hopkins had been a social worker for the New York Association for Improving the Condition of the Poor, and he shared Roosevelt's humanitarian ideals. Together Hopkins and Morgenthau worked on reforestation projects that employed 10,000 men. As Morgenthau described it,

> We took the gas house gang, the bad boys who were loafing on the streets and getting into trouble, and we put them on the 4 A.M. train that ran up to the Bear Mountain area where they worked all day. Then because there was no housing for them we took them back at night. F.D.R. was much interested in this conservation of human resources, as in all conservation work.[17]

FDR was Governor of New York when Pinchot held the same position in Pennsylvania. Pinchot is widely known as the "hero of American forestry," but FDR got his program adopted and Pinchot did not. Hopkins and Morgenthau later became part of his Washington team, and the projects they took on in New York had trained them for the work of reconstruction and reform they would carry out nationwide.[18]

In 1932, as Roosevelt campaigned for president, he again shared his experiences on his own worn-out farm. Speaking to his fellow governors, he said:

> We are faced with a situation of hundreds of farmers attempting to farm under conditions where it is impossible to maintain an American standard of living. They are slowly breaking their hearts, their health and their pocketbooks against a stone wall of impossibilities and yet they produce enough farm products to add to the national surplus. . . . If this is true in the State of New York, it is, I am convinced, equally true of practically every other State east of the Mississippi and of at least some States west of the Mississippi.[19]

That message helped propel him to the presidency.

On March 2, 1933—less than three weeks after his inauguration as president—FDR set in motion, on a national scale, the ideas he had tried in New York. From 1933 through 1942, at a time when 1 in 4 Americans was unemployed, 3 million young men worked on reforestation for the Civilian Conservation Corps (CCC). They also started a massive public works program that included projects to improve and maintain parks. Each person signed on for a 6-month interval, with the option to renew. Employees received housing, food, clothing, and $30 a month; $25 was sent home to the family and $5 they kept.[20]

The CCC was particularly active in New York State, building roads, trails, bridges, and cabin complexes at twenty-five state parks. On the Hudson, an army of the unemployed worked on the construction of recreation facilities and trails at the Palisades

Civil Works Administration workers.
Courtesy of Palisades Interstate Park Commission

Interstate Park. The Civil Works Administratio, a separate entity, prepared plans and cost estimates for a parkway along the top of the Palisades. At Bear Mountain State Park, relief workers undertook the biggest construction program for the park since its creation. During a five-year period of public employment programs, a system of pump houses, reservoirs, sewer systems, vacation lodges, comfort stations, residences for park personnel, storage buildings, and the Bear Mountain administration building were built. One of the most significant projects was the construction of a scenic drive to the top of Bear Mountain, named the Perkins Memorial Drive in honor of George W. Perkins, the dynamic first president of the Palisades Interstate Park Commission (PIPC). Ninety-five percent of the work was done by hand labor. Additional work was conducted by relief workers in the New Jersey sections of the park and at the new Norrie State Park in Staatsburg. They built miles of water pipes, buried electric and telephone lines, and removed ugly utility poles. In 1945, when gas rationing was lifted, unprecedented crowds thronged to the refurbished Palisades Interstate Park.

Although new construction methods were available by the mid-thirties, this period of public works construction emphasized naturalistic design principles. The rustic architecture used in 1915 for the Bear Mountain Inn was now echoed in all the structures constructed by the Works Progress Administration, another New Deal agency, within the park from Fort Lee, New Jersey to Bear Mountain Park, using local stone, boulders, and timber. This became the prototype for the rustic style throughout the East.

On Manhattan Island, Robert Moses cleverly exploited the availability of relief workers. Moses was serving dual roles as chairman of the state's parks council and as parks commissioner for New York City, plus chairing several public authorities. Fiorello LaGuardia—the first Italian American mayor of the city, a man who had campaigned on reform—had appointed him. LaGuardia wanted someone with a proven track record, and Moses delivered for him.

Robert Moses was one of the most powerful civil servants in state history, if not national history. He knew how to work the system, and in a stunning decade during the Great Depression, he completed 1,800 parks renovation projects; planted flowers in 1,000 weedy plots; built 3 major bridges, 50 miles of arterial highway, and 255

Bear Mountain Inn, built in 1915, a prototype for WPA buildings.
Courtesy of Palisades Interstate Park Commission, Bear Mountain

playgrounds; and filled 5,000 acres of water to make new land.[21] Much of the trap rock leaving the Highlands in the 1930s was mixed with concrete to build projects he designed. One of these was the Triborough Bridge, which he completed despite the active efforts of President Roosevelt to have him fired. Roosevelt had never forgiven Moses for blocking the Taconic Parkway project of the park commission.

Now, Roosevelt found himself providing relief workers for Robert Moses's parks projects—68,000 laborers in 1934, including 600 engineers and architects. The work force began to undertake one of the most ambitious projects yet, a parkway on the Hudson in New York City. Parkways got their name as scenic roads connecting city dwellers to parks. They were a creation of the age when motoring was a form of recreation, but by the 1930s more and more people were driving just to get around. In fact, the number of car registrations in New York City had tripled from 1916 to 1923 and was still growing.[22] Moses wanted to build a 6-lane highway connecting the West Side of Manhattan with the northern suburbs of Westchester County. This would cost about $109 million—at a time when money was scarce, to say the least. Yet Moses pieced together the funds from a variety of sources, including $20 million from FDR's New Deal agencies.

Federal money could be used for to hire laborers for park-related projects, including park access roads, so Moses declared the 6-lane highway an access road and built it through city parks. In the process, he destroyed much of Inwood Hill Park, the city's last remaining wild forest, and filled 132 acres of the Hudson. Five hundred dump trucks per day and 6,000 WPA laborers filled in the muddy shoreline on the West Side of Manhattan to build a park and a parkway. Twenty years earlier, this stretch of river had been a wasteland of garbage dumps, tar-paper shacks, and railroad tracks. By 1937, Moses had put the tracks underground, and in their place was a triumphal entry road into the city, framed by a park of terraced trees, with tennis courts, playgrounds, ball fields, statuary, footpaths, and a magnificent marina. It offered sweeping views across the river of the unspoiled New Jersey Palisades.

When he was done, Moses had transformed six and a half miles of the Hudson River in this stretch of Manhattan. However, his project had also eliminated access to the river for all but the motorist. The roadway hugged the river's edge, while the park was set back from it. Indeed, many benches in Riverside Park had no view of the river at all—and those that did included a view of speeding cars. William Exton Jr., a reformer active with the Citizens Union, had tried to get Moses to place the road back from the water's edge. "A motorist spends a few seconds on a spot and maybe he can't even look at it," he said. "But the pedestrian spends a long time at a spot. He can sit down and look at it. So it's the pedestrian we should be thinking of."[23] Moses didn't take kindly to such suggestions and carried out the project as he wished. In the end, when the Henry Hudson Parkway and Riverside Park were completed, public opinion was highly favorable. "The traveler comes and goes in a setting of beauty which [it] is not too much to call intoxicating," wrote Simeon Strunsky for the *Times*.[24]

At the southern tip of Manhattan, where the Hudson River officially ends and New York harbor begins, Robert Moses was hard at work on another project, a tunnel connecting Brooklyn to Manhattan. To build it, he attempted to tear down Castle Clinton and suffered a rare defeat. This was the site of the earliest Dutch fort on Manhattan, the place where Peter Stuyvesant surrendered the Hudson to the British without a fight. It was later an opera house and then an immigrant processing center. In 1939 it housed the New York Aquarium, the city's most popular attraction.

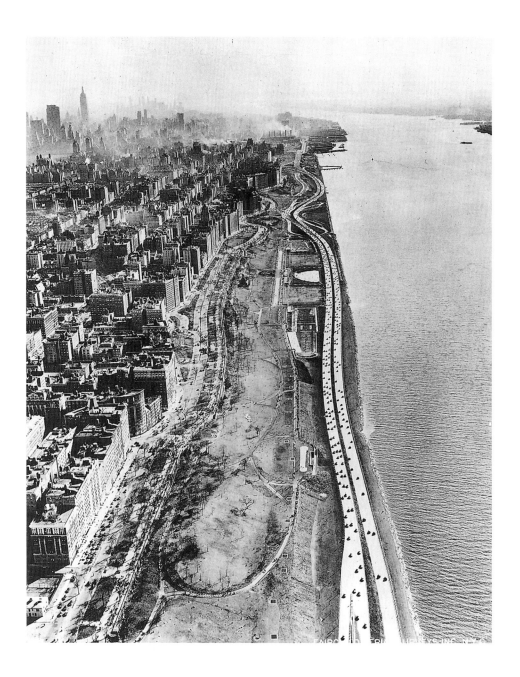

Aerial view of Riverside Drive (Henry Hudson Parkway) by Fairchild Aerial Survey.
Library of Congress

When Moses decided to build, he moved the aquarium to Coney Island; however, the American Scenic and Historic Preservation Society was able to block his plan to tear the building down, and the site is now preserved by the National Park Service as an example of the Hudson's layered history.

By contrast, FDR was keen on preserving historic sites and personally rescued several of them from destruction. The Saratoga Battle Site on the Hudson at Stillwater was one of them. In 1938, he won approval from Congress to designate the battlefield as a National Historic Park. He personally intervened with the War Department to prevent the original cannons (surrendered by Burgoyne) from being melted down for scrap metal during World War II, and in 1940, he selected the spot for a proposed visitor center on the property. The battle site was formally included in the federal park system in 1948, under legislation signed by President Truman, though the visitor center FDR envisioned was not built until 1962.

FDR was very deeply rooted in his Dutch heritage. Like his cousin Theodore, he was descended from Klaes Martenszen van Rosenvelt, who arrived from the Netherlands in 1649 and prospered as a farmer in New Netherland. In 1939, FDR remarked, "As I grew older, I came to know something of the history of these river towns of Dutchess County, and to develop a great liking for the stone architecture which was indigenous to the Hudson Valley."[25] FDR served as chairman of the Holland Society, and he commissioned Helen Reynolds to write a book on Dutch houses in the Hudson Valley so they could be documented before they disappeared.

The idea of building new structures in this style began to appeal to him, and with federal funds he commissioned new fieldstone post offices in the Dutch colonial style for the Hudson Valley. Six of them were built between 1936 and 1940, in Rhinebeck, Beacon, Hyde Park, Wappingers Falls, Poughkeepsie, and Ellenville. He selected noted artists to paint murals in each post office, depicting the history of that community from 1609 to the present. He was inspired to adopt this style for Top Cottage, his wheelchair-accessible Hyde Park retreat; for the presidential library at Springwood; and for Eleanor Roosevelt's retreat, Val-Kill. Hyde Park's Violet Avenue School is also built in this style, as is the office of the *Poughkeepsie Journal* newspaper, a companion building to the post office.

The Roosevelt era also caused many of the historic Hudson River estates to change hands and be adapted for new uses. The inheritance and income taxes FDR enacted effectively ended the era of the ancestral Hudson River estates maintained on inherited wealth. Now they were burdens to be unloaded.[26] One such property was the 212-acre Vanderbilt estate known as Hyde Park, for which the Town of Hyde Park is named. Frederick Vanderbilt, who had no children, died in 1938, leaving the house to his niece and his cash to charity. He had been one of the richest men in America, whose fortune in 1938, in the waning years of the depression, amounted to $80 million. Taxes took half of the money Vanderbilt had accumulated. When his heir, Margaret Van Alen, tried to sell the property, she found no buyers. FDR, whose own Hudson River estate lay just down the road, arranged for the federal government to purchase the mansion as an example of the excesses of the gilded age, an era that had been swept away by the depression. The estate opened to the public in 1940

Castle Clinton at the Battery, where the Hudson ends, scheduled to be torn down by Robert Moses but saved by the American Scenic Historic Preservation Society and restored to its original design. It is now managed by the National Park Service. *Undated postcard, author's collection*

as a Historic Monument within the National Park system. The site superintendent reported directly to the president.

As president, FDR also encouraged his former government colleagues in New York State to establish new parks on the Hudson. In 1933, when the heirs to riverfront property in Staatsburgh approached him with an offer to donate the property to the state, he posted a letter to Vanderbilt Webb, Commissioner of the Taconic Region of State Parks, urging that the state accept the offer and keep the land out of the hands of the county. Webb immediately secured the support of the park commission and negotiated the deal. The park, which was named Margaret Lewis Norrie State Park, is one of the few areas not cut off from the river by the railroad, an asset noted by Roosevelt in recommending it to Webb: "Here is a very wonderful property, especially because a large portion of this property lies on the river side of the New York Central tracks."[27]

Many other large estates found new uses in the 1930s and 1940s, though not through FDR's involvement. Several were donated to churches, schools, and charities. In 1949, Dr. Ernest Stillman bequeathed some 3,600 acres behind Storm King Mountain in Cornwall to Harvard University to be used as a research forest. The Black Rock Forest lands had been assembled by his father, James Stillman, founder of what is today Citibank, for a colony of summer homes that were never built. Carl Carmer, in his wonderful 1939 book, *The Hudson*, noted: "The lands on the Hudson in the last fifty years have been absorbed to an amazing degree by institutions. Some reaches of the stream seem to be completely occupied by them. Out of eighty country seats . . . thirty three are no longer operated as estates and . . . of this number nineteen are occupied by medical, educational, or religious institutions."[28] Those numbers would go up soon after his book was published.

Land conservation efforts continued as well. In 1942 the Hudson River Conservation Society and the Rockland County Conservation Association raised $12,000 to purchase High Tor on South Mountain, a premier quarry site in the Palisades region. Donations poured in from up and down the Hudson Valley. Contributors included the Columbia County Historical Society, the Fort Orange Garden Club, the Hastings Garden Club, the American Scenic and Historic Preservation Society (ASHPS), the Rufus King chapter of the Daughters of the America Revolution, and others. At about the same time, Mr. Archer M. Huntington donated the property known as Little Tor, a 470-acre estate near High Tor. In 1944, the Allison Land Company and Trustees of William O. Allison donated 42 acres in Englewood and Fort

Olin Dows's 1941 New Deal mural for the Hyde Park post office, depicting William Meier and Abe Atkins landing a sturgeon circa 1870. The African American experience is documented in several of these New Deal murals.
Courtesy of the Franklin D. Roosevelt Library, Hyde Park, NY

Lee.[29] In all, about 3 miles of mountain land overlooking the Hudson were preserved through the efforts of individuals and private conservation groups, extending to the Stony Point Battlefield acquired by ASHPS.

Though FDR had an immense impact on reforestation, park development, and historic preservation, there was another side to his policies—the buildup of industrial pollution from the expanding war effort. Even the pristine waters of the wild Adirondacks were affected. In 1944, on the upper Hudson, the long-dormant iron mine at Tahawus reopened. The titanium that had made its iron impure for an earlier generation was now valuable for munitions manufacture. Paul Schaefer, a passionate advocate for the Hudson River and the Adirondacks, raised the alarm in an article for the Adirondack Mountain Club, "The Tragedy of the Hudson," urging that ways be found to continue industrial production but prevent pollution.

The Hudson River has always symbolized the beauty and the romance of the Adirondacks. Rising on the precipitous heights of Mount Marcy, its sparkling waters drop more than a thousand feet from Lake Tear-of-the-Clouds to the valley of Lakes Avalanche and Colden and the Flowed Lands....

Famed for its native and rainbow trout and its black bass, the river has always been the delight of fishermen, campers, and hikers who drank of its pure waters and dove in its deep, cool pools. Its wooded shores, particularly in the Sanford Lake valley, probably sheltered more deer than any similar area in the north woods.

It seems incredible that all these things which have enriched the lives of so many of our people are now threatened with permanent destruction as a result of mining operations in Tahawus valley.

The other day, I stood on the bridge where the Roosevelt-Marcy highway crosses the Hudson. The river, no longer crystal-clear, was black and the rocks and the banks were covered with a thick, claylike coating.... I listened to the rumble of machinery on the open-pit mine at Sanford Lake, no longer a gem of the north glistening in the sunlight but a black, murky sewer into which poured a never-ending stream of refuse from the mine. Already the lake is filled with semisolid material from shore to island. If continued the lake will become a pit of mud—a wellspring of refuse which could conceivably pollute the Hudson for years after the mining operation stopped or after the mine owners were required to dispose of their refuse by other means ... it is difficult to conceive of animals drinking or living near such water. Other methods of disposing of the refuse of the mines surely can be devised....

If existing laws are inadequate to stop this destruction, new legislation should be at once devised and offered the legislature. We have talked with prominent people in many parts of the state, and there is no question but that the public will strongly endorse such specific legislation.[30]

However, pollution at Tahawus and many other wartime industrial sites increased unabated.

As FDR was influencing the course of the Hudson through federal policies, a number of the Hudson's wealthy citizens were having an impact as well. In 1909, John D. Rockefeller had contributed to the protection of Bear Mountain. Now, his son John D. Rockefeller Jr. (JDR Jr.) donated millions to solidify the gains of the PIPC. By 1933, the face of the Palisades had been protected in most places, but it remained to be seen what would happen on top of them. The new George Washington

Bridge had just been built across the Hudson, connecting Manhattan Island with Fort Lee, New Jersey, and a rash of new development on the west shore of the river was expected. A number of people suggested building a parkway on the top of the cliffs, but that would be an expensive undertaking, especially during the depression. Quietly, behind the scenes, John D. Rockefeller Jr. began buying up all the land in a 12-mile stretch along the top of the Palisades from the George Washington Bridge to the New York–New Jersey state line—about 700 acres, valued at $9.6 million. He offered to donate this to the PIPC if New Jersey would commit to building the road:

> My primary purpose in acquiring this property was to preserve the land lying along the top of the Palisades from any use inconsistent with your ownership and protection of the Palisades themselves. It has also been my hope that a strip of this land of adequate width might ultimately be developed as a parkway, along the general lines recommended by the Regional Plan Association, Inc.[31]

The foremost landscape architects and engineers were engaged to prepare plans. It is hard to imagine in these days of high-speed commuter traffic that the parkway was intended to be a nature park for motorists, "a scenic route restricted to pleasure vehicles, with all crossings eliminated by attractively designed, stone faced bridges." For its time, the Palisades Parkway was a model of efficiency and beauty, designed by the same people who built the Skyline Drive in Shenandoah National Park in Virginia.

PIPC also created the Greenbrook Nature Preserve, in Englewood Cliffs, as part of the parkway project, and a new hiking trail on top of the Palisades from the George Washington Bridge to the state line. All buildings along the way were demolished, including the Riviera nightclub. Only Allison Park and St. Michael's Novitiate in Englewood Cliffs remained. In 1959, after it opened, eight million passenger cars used the Palisades Parkway.

Ben Marden's Riviera—removed by the PIPC.
Courtesy of the Palisades Interstate Park Commission

John D. Rockefeller Jr. continued to support acquisition of large properties along the Palisades for the PIPC, and in 1951 he gave $300,000 through a family charity to buy the Fort Lee Redoubt, a Revolutionary War site, where a high-rise apartment complex was planned. This preserved the natural cliffs of the Palisades north of the George Washington Bridge, while the entire New Jersey shore to the south has been developed. JDR Jr. also bought Fort Tryon Park, near the northern tip of Manhattan, and gave it to New York City. It was one of his favorite spots for viewing the Hudson and the Palisades. In 1940, he purchased Philipsburg Manor in Tarrytown; he opened it to the public as a historic site in 1943. By 1951, he had supported the preservation of other historic Hudson River properties, including Van Cortlandt Manor and Washington Irving's Sunnyside. He created Sleepy Hollow Restorations (a nonprofit now known as Historic Hudson Valley) to manage these properties. He also underwrote the preservation of Colonial Williamsburg in Virginia.

In his lifetime, JDR Jr. donated $107 billion for conservation and historic preservation projects; he has been described as "one of the most generous philanthropists in the history of conservation."[32] He provided critical support for the creation and development of national parks at Yellowstone, the Great Smoky Mountains, and Yosemite. The roots of this philanthropy can be traced to his youth, when he soaked up the parklike views of Kykuit and went horseback riding below the Palisades. His involvement in the lively historic and scenic preservation movement of the Hudson Valley in the early 1900s set the stage for similar work on a grander scale.

JDR Jr. also inspired in his five sons a deep appreciation of the natural environment, and they followed in his footsteps as conservationists, in turn inspiring their children to do the same. The board of directors of the PIPC came to have an almost "hereditary position" for members of the Rockefeller family. In 1942, JDR Jr.'s son, Laurance S. Rockefeller, made his first gift to PIPC for the purchase of Tallman Mountain State Park on the Palisades near the New York–New Jersey state line, and in 1951, he donated funds to buy 640 acres in the Highlands at Dunderberg. Laurance's son, Laurance Jr., would later serve on the commission as well.

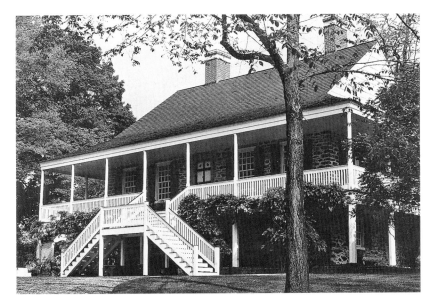

Van Cortlandt Manor in Croton-on-Hudson, an eighteenth-century manor owned by New York's prominent Van Cortlandt family. Preserved by John D. Rockefeller Jr., it is now managed as a historic site by Historic Hudson Valley.
Courtesy of Historic Hudson Valley, Tarrytown, NY

Boscobel, being moved from Montrose to Cold Spring.

Courtesy of Boscobel Restoration

When John D. Rockefeller Sr. had set up a foundation to spend his wealth for the benefit of mankind, he sought big ideas, such as the complete eradication of a disease (yellow fever). This emphasis on ambitious goals was passed on to his son and his grandchildren, who applied similar thinking to the preservation of the Hudson River shoreline in the Palisades and the Highlands, some of the most beautiful scenery in America, which they sought to protect comprehensively.

The Hudson Valley has a history of conservation that spans family generations, based on values instilled in childhood that come to define the family's sense of who they are. For example, in 1910, Averell Harriman, son of the railroad baron and future Governor of New York, had been called home from college by his mother to preside over the family gift of 10,000 acres of parkland to the state. He later donated 6,390 acres to Harriman State Park, and today, new generations of Harrimans remain committed to preservation of the Palisades Interstate Park. The descendants of William Henry Osborn have also been active, not only on the Hudson but also nationally. Professor Henry Fairfield Osborn was for many years president of the American Museum of Natural History and was a moving force behind the pioneering Save-the-Redwoods League in California. His son Fairfield wrote *Our Plundered Planet*, one of the first books on the subject of worldwide conservation. Many of the Osborn children's descendants became active in supporting Hudson River conservation. This multigenerational commitment to the river also includes families like the Perkins, Sidamon-Eristoffs, Borgs, Luddingtons, Pattersons, Lehmans, Morgenthaus, and Reeses.

New philanthropists have entered the picture as well. For a generation of wealthy people based in New York and northern New Jersey, protection of the Hudson and charitable giving on its behalf was a worthy, if not required, cause. In 1955, Lila Acheson Wallace, cofounder of *Reader's Digest,* joined the ranks of Hudson River conservationists through her friendship with Laurance Rockefeller, stepping in to save Boscobel, the 1806 Federal-style mansion of Mr. and Mrs. States Morris Dyckman on a bluff overlooking the Hudson in Montrose, New York. The mansion had been sold to a wrecker for $35 to make room for a Veterans Administration hospital.

The elegant home was considered by many to be an architectural museum piece, inspired by Robert Adam and other respected architects, and a group was hastily organized to secure its preservation. To do this, a new location would have to be found, so the group dismantled the house and stored it in barns in Garrison. Eventually, a 36-acre site in Cold Spring, 15 miles north of the original location, was chosen for the reconstruction. Lila Wallace gave a half million dollars to reconstruct and furnish the house and landscape the grounds, and later contributed $14 million to its preservation and maintenance, including a sizeable endowment. The new site is 200 feet above the Hudson River, opposite West Point, and offers a sweeping view of the Hudson to the south as well as views of Constitution Marsh, Storm King, Breakneck, and Bear Mountain. Boscobel preserves more than a historic house—it preserves an image and an idea of the Highlands by protecting a major piece of its scenery for public enjoyment.

Overall, the period from the depression to the end of the 1950s had seen a remarkable level of conservation and preservation activity, yet during this time the war effort led to a new era of industrial development on the Hudson. Pollution continued, as it did on most industrial waterways of the United States. The prosperity that followed in the 1950s and 1960s came at a cost that the river still bears, since many pollutants (now banned) persist in the environment. Municipal and factory waste together made a noxious brew that today is hard to imagine but then was commonplace. In 1961, under Governor Rockefeller, the New York State Department of Health conducted a water quality survey of the area around the state capital at Albany. Its report, written by Willard Bruce, observed that:

> At the north section of the city [of Rensselaer] there are two large discharges, one of which appears to be discharging blue colored waste which reportedly was from a plant in the northern section of the city which is involved in a dying operation of fabrics. . . . Although the city [of Albany] has a primary sewage treatment plant, a

Boscobel, as restored in Cold Spring, New York.
Courtesy of Boscobel Restoration

large portion of the city sewage is discharged raw to Patroon Creek and the Hudson River. . . . During the time of tide out, a definite pattern of flow can be seen carrying the sewage out towards the center of the river. . . . Three discharges serve the northern section of the village [of Coxsackie] and discharge into open ditches which run through a marshland into the bay at the northern section of the villages. Obnoxious odors and sewage solids are very evident in the bay and extensive sludge deposits results in profused gassing. The discharges into this bay create a very unpleasant condition. It was interesting to note that during the summer school recess many children were observed swimming in the bay section. . . . Many industries in the Capital District Area are not served by local municipal sewers and have their own discharges into the Hudson River or nearby streams that discharge directly to the Hudson River. . . .

At Waterford, the Cluett Peabody Bleachery which is located on the island has a constant warm waste discharging to the North Branch of the Mohawk River. This waste includes fabric wash waters together with bleaching compounds and at some times dyes are included. At Green Island the John Manning Paper Company has a discharge into the Hudson River which creates a condition that is noticeable half-way across the River and hundreds of feet downstream. The discharge itself has the appearance of tobacco juice and consists of beater washings, pigment, fiber, solvents and oils. . . .

In Cohoes a slaughter house discharges very offensive wastes to this canal stream, . . . [and the] Mohawk Paper Mills in Cohoes discharged paper mill wastes . . . an appreciable quantity of pigment and typical pulp fibers are discharged to the stream. . . . During certain periods of the year or when the flow is appreciable, vast quantities of this pulp waste rise to the surface and in huge cakes they are carried by the stream down into the Hudson River. . . .

At Rensselaer the General Analine and Film Corporation has two discharges directly to the Hudson River. During the course of the survey, a blue-black dye-like discoloration was noticed in the stream covering the complete width and extending about 1/3 of a mile downstream from the dock at the General Analine Plant.

Bruce concluded his report with a hopeful observation:

The Hudson River is grossly polluted by the communities and industries of the Capital District Area. . . . The one unique and perhaps interesting phase of the study was that everybody encountered was in favor of cleaning up the waters of the Hudson River by abating the pollutional load from the Capital District Area, but the common general question, especially from the municipal officials was "where are we going to get the money?"[33]

That question would soon be answered, but it was a power plant proposed on one of the Hudson's most scenic spots that brought the issue back into focus. When conditions did not seem right for conservation—a time of economic depression and war—major steps were taken to preserve the river's natural and historic heritage, spurred on by the valley's elite, people steeped in personal experience of the outdoors. The decades from 1930 to 1960 saw major new conservation efforts, both public and private. In 1963, initiatives at Mount Taurus and across the river at Storm

King would take environmental protection to a new level, with national and global effects. The movement to protect the Hudson would extend to the grassroots, although the wealth, press connections, philanthropy, and dynamism associated with the New York metropolitan area created a fertile, supportive environment for citizen action to flourish.

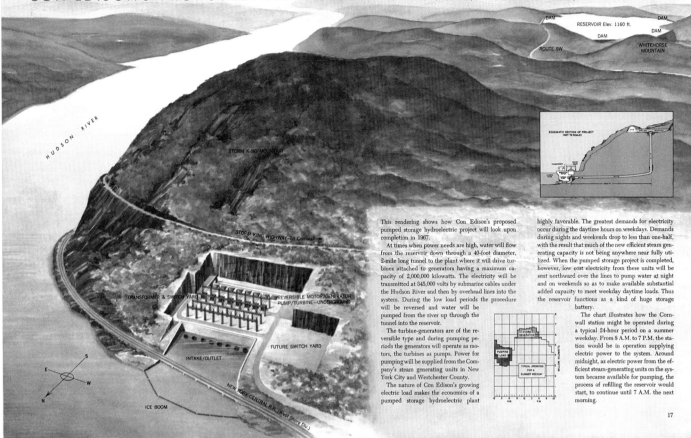

This rendering shows how Con Edison's proposed pumped storage hydroelectric project will look upon completion in 1967.

At times when power needs are high, water will flow from the reservoir down through a 40-foot diameter, 2-mile long tunnel to the plant where it will drive turbines attached to generators having a maximum capacity of 2,000,000 kilowatts. The electricity will be transmitted at 345,000 volts by submarine cables under the Hudson River and then by overhead lines into the system. During the low load periods the procedure will be reversed and water will be pumped from the river up through the tunnel into the reservoir.

The turbine-generators are of the reversible type and during pumping periods the generators will operate as motors, the turbines as pumps. Power for pumping will be supplied from the Company's steam generating units in New York City and Westchester County.

The nature of Con Edison's growing electric load makes the economics of a pumped storage hydroelectric plant

highly favorable. The greatest demands for electricity occur during the daytime hours on weekdays. Demands during nights and weekends drop to less than one-half, with the result that much of the new efficient steam generating capacity is not being anywhere near fully utilized. When the pumped storage project is completed, however, low cost electricity from these units will be sent northward over the lines to pump water at night and on weekends so as to make available substantial added capacity to meet weekday daytime loads. Thus the reservoir functions as a kind of huge storage battery.

The chart illustrates how the Cornwall station might be operated during a typical 24-hour period on a summer weekday. From 8 A.M. to 7 P.M. the station would be in operation supplying electric power to the system. Around midnight, as electric power from the efficient steam-generating units on the system became available for pumping, the process of refilling the reservoir would start, to continue until 7 A.M. the next morning.

17

The 1960s

Scenic Hudson, Riverkeeper, Clearwater, and The Nature Conservancy Campaign to Save a Mountain and Revive a "Dead" River

15

O N SEPTEMBER 23, 1962, the Nature Conservancy set up a committee, chaired by hiker Leo Rothschild, to look into the acquisition of sites in the Hudson Highlands. As Walter Boardman, executive director of the conservancy, later recalled, only the east bank of the Highlands was targeted because Storm King was considered "safe." While the east bank was still vulnerable to quarrying, no one would dream of touching such a well-known landmark.[1]

Meanwhile, at Consolidated Edison, Chairman Harland Forbes prepared for a press conference to unveil one of the company's most ambitious projects. Four days after the conservancy's first committee meeting, a front-page headline in *The New York Times* announced HUGE POWER PLANT PLANNED ON HUDSON. The *Times* article reported that the location would be "near Cornwall, New York."[2] Forbes was quoted as saying that "no difficulties are anticipated." The location was Storm King Mountain.

Artist's rendering from Consolidated Edison 1962 Annual Report.

Courtesy of Con Edison, New York

Forbes could not have been farther from the mark. Within months, a legal battle began that would last seventeen years and that is credited with launching modern environmental activism. The case would set far-reaching precedents for conservation in America and around the world: it would address the protection of natural resources and scenic beauty as a public purpose equal in importance to energy development; it would establish the right of citizen groups to sue a government agency to protect such resources; and it would lead to the passage of the National Environmental Policy Act, which established the requirement for environmental review of federally approved projects. Powerful advocacy groups would emerge, and the models they created would be copied on waterways across the United States. A movement that had once been the domain of river aristocrats and wealthy business leaders moved to the grassroots. A new generation of political leaders was elected on a platform of environmental protection, making the Hudson a poster child for river cleanup. Songwriters roused the public with pointed lyrics and messages of hope, creating a body of music that echoed in the halls of Congress and helping to inspire the passage of the Clean Water Act. Banjoes strummed, crowds demonstrated. It was the 1960s.

The Storm King issue pitted industry against conservation in a dramatic clash over an area that was well suited for both. The fight to protect the mountain drew together thousands of ordinary people from nearly every state and several foreign countries, against a utility convinced that its plan for a power plant was good not only for the public but also for the scenery. The court battles resulted in major losses for both sides, leaving the fate of the mountain hanging in the balance for nearly two decades.

The conflict began in 1961, when a neighboring utility, Central Hudson, approached Con Ed with a plan for a "pumped storage" hydroelectric power plant. Pumped storage was a new technology in the United States, conceived as a way to provide power during hours of peak demand. Excess electricity, available during off-peak hours, was used to pump river water up a hill or mountain to a storage reservoir. Then, during peak hours, when electrical power was most needed, the water would be released from the reservoir to power a turbine on its way back down to the river.

By the 1960s, changing patterns of electrical consumption were forcing all Northeast utilities to plan for peak-hour needs, occurring on hot summer days, when air conditioners were running at full blast, and during the long nights of winter, when lighting needs were greatest. Central Hudson officials told Con Ed that they planned to build on Breakneck Ridge, on the east side of the river in the Highlands. They suggested that the Storm King site, which would require more capital and produce more power, might be of interest to the larger, New York–based utility, and they offered to buy some of the power generated by the Storm King plant if Con Edison decided to proceed.

By the fall of 1962, Con Ed had studied the Storm King site, bought some of the necessary land, and drawn plans to develop it. Con Ed submitted a license application to the Federal Power Commission for a 2-million-kilowatt plant costing $115 million, and announced its project to the press. Meanwhile, Central Hudson was drawing up its plans and negotiating an option on 660 acres on Breakneck Mountain.

From the utilities' standpoint, Breakneck and Storm King were ideally situated for pumped storage power plants. In one of its promotional brochures, Con Ed stated:

> At Cornwall, 50 miles from habitation, nature has provided the physical require-ments of a pumped storage hydro-electric station: a large source of water and a reser-voir basin high above but near enough to store water for generating power. Selected after years of intensive study and consideration of possible alternatives, the Cornwall site is one of the best in the world for such a hydrostation.[3]

Such a plant at Storm King would serve as a "gigantic storage battery for the Con Ed-ison system," company representatives said.

Con Ed did not know that it had chosen a site that many Americans regarded as sacred ground. The battle to save it soon assumed the intensity and proportions of a holy crusade. The northern gate, the Hudson River gorge, the Wey-gat—by any of these names, the passage through Breakneck and Storm King had come to symbol-ize the essence of the Highlands and the Hudson Valley region. This place of con-trast—confined river with broad valley, shadow with light, and river, mountain, and sky—had captured the imagination of the artists of the Hudson River School. The scene of the northern gate, where the river meets the mountains, was painted and sketched more than any other in the Highlands. This was the view that nineteenth-century tourists saw from the plains at West Point; it greeted them from sloops and steamers as they journeyed south across the broad expanse of Newburgh Bay; and it is the image of the river that people today are most likely to remember. With Ban-nerman's Castle at its base, the northern gate is a threshold to a world of singular beauty.

So it is not surprising that the threat of a power plant on each of the two senti-nels of the northern gate drew a great national outpouring of emotion, effort, and funds over a period of almost two decades. Not merely a power plant but a principle was at stake. Storm King had acquired symbolic value. It embodied America's lay-ered connection with nature, as a Revolutionary War battleground, an inspiration for literature, and a spiritual force recorded by painters. If Storm King wasn't worth protecting, then nothing was. Ultimately, although compromise was offered, none was possible.

Con Ed's news release, which referred to a site in the "Cornwall area," did not im-mediately trigger a public outcry, because the exact location was not generally known. However, a briefing soon after by Con Edison's Vice President for Engineer-ing, Motton Waring, roused the grave concern of the Palisades Interstate Park Com-mission (PIPC). The power plant, they learned, was to be built between Crow's Nest and Storm King on PIPC parkland. The reservoir would be built nearby on lands owned by the town of Cornwall and in Black Rock Forest, owned by Harvard Uni-versity. The engineering plans called for transmission lines to be strung across the Storm King gorge from tall towers.

The PIPC commissioners were among the leading conservationists in the Hud-son Valley. Among them were Laurance S. Rockefeller—whose brother, Nelson, was then Governor of New York—and Frederick Osborn, a descendant of William Henry Osborn, who had built Castle Rock in Garrison. The commissioners

Nelson and Laurance S. Rockefeller at a park
dedication in 1962.

*Courtesy of the Palisades Interstate Park Commission
Archives*

expressed concerns about the wisdom of constructing a power plant on parkland,
and they cautioned against destroying the scenic vista of the gorge. Osborn also
discussed the project with his brother William, who was president of the Hudson
River Conservation Society (HRCS). The society soon joined the PIPC in its objec-
tion. General Westmoreland, Commandant at West Point, also voiced concern that
the transmission lines might interfere with military helicopters en route to the
academy.[4]

Eager to eliminate any political obstacles, Con Ed's Vice President Waring re-
sponded by agreeing to move the power plant off parkland onto the north face of
Storm King and to put the transmission lines underground where they crossed the
Hudson. The lines would be above ground on the east side of the Hudson across Put-
nam County to New York City. The added cost to Con Ed would be about $6 million,
but it would grease the skids for construction of the plant. After these concessions,
the PIPC and the HRCS dropped their objections, as did Westmoreland and West
Point.

However, the PIPC and the conservation society were soon to discover that they
were out of step with the thinking of many other conservationists in the Hudson
Valley. In April 1963, Con Ed published its annual report, showing the revised plan
with the new Storm King location. If anyone doubted the impact of a power plant on
the mountain scenery, the report graphically dispelled any such thoughts. It in-
cluded an artist's rendering of the proposed plant, showing Storm King Mountain
with a cavernous, square hole carved out of its northern face. This opening was filled
with transformers and switchyards, from its base at the river shore to the height of
the Storm King Highway. The image was powerful. The moment the report was pub-
lished, the battle cry sounded.

Leo Rothschild was the first to express alarm. In addition to heading the Nature
Conservancy committee, Rothschild served as Conservation Chairman of the New

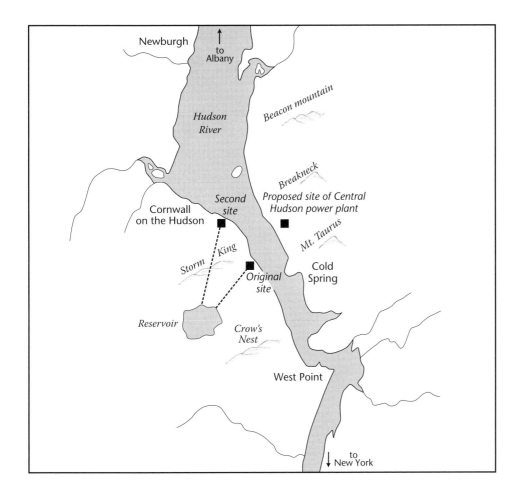

York–New Jersey Trail Conference, a group that maintained a system of hiking trails on Storm King near the proposed reservoir location. Soon after Con Ed published its annual report, he sent a telegram to Governor Nelson Rockefeller, citing the governor's interest in scenic and historic landmarks and calling on him to do everything in his power to preserve the northern gate of the Hudson Highlands. Rothschild copied his telegram to *The New York Times*. Central Hudson's announcement shortly after, that it planned a similar power plant at Breakneck, only added to his concern.

Others soon joined Rothschild in his efforts, including Carl Carmer, author of *The Hudson* and the current New York State Historian, and Walter Boardman from the Nature Conservancy. They spent several months trying to persuade officials at all levels to relocate the project. They spoke to Waring at Con Ed; they wrote to Stewart Udall, Secretary of the Interior; they sent a delegation to meet with Governor Rockefeller; and they wrote to his brother Laurance.

Their pleas fell on deaf ears. Waring remained committed to construction at Storm King. Governor Nelson Rockefeller suggested that if citizens were so concerned, they should buy the mountain. Laurance Rockefeller stood by his decision as a PIPC commissioner to endorse the project. Although he was one of the country's most outspoken leaders in preserving natural beauty, he was also a proponent of multiple uses of natural resources. He felt that with mitigation of the scenic effects, the plant was an appropriate use of the area.[5]

Sites of proposed power plants.

Only *The New York Times* offered support and published an editorial titled "Defacing the Hudson."

> If any utility proposed to construct a plant in the middle of Central Park, the absurdity of such a defacement of precious natural (or nearly natural) surroundings would be immediately apparent. It is almost as bad to plunk down a couple of power installations right in the heart of one of the most stunning natural regions in the Eastern United States: Storm King Mountain (north of Bear Mountain and West Point) and Breakneck Ridge on the opposite (eastern) side of the Hudson.
>
> All of us who have driven down from New England and northern New York have looked with awe at these breath-taking mountains. All of us who have hiked and played in Palisades Interstate Park know what a beautiful backyard exists 50 miles north of New York. Is it too close to home to appreciate? "This is very good land to fall with and a pleasant land to see," said one of Henry Hudson's officers, going up the river under these high blue hills. That great traveler Baedeker found the Hudson's scenery "grander and more inspiring" than the Rhine's.
>
> The proposed power plants of Consolidated Edison at Storm King and of Central Hudson Gas and Electric at Breakneck Ridge would desecrate great areas that are part of the natural and historic heritage of our country, are still largely unspoiled and should remain that way.[6]

The editorial was encouraging, but it held no sway with the utilities. Having failed on the diplomatic front, opponents of the power plant resolved to pursue their cause in court. On November 8, 1963, a handful of people met at the Irvington home of Carl Carmer and formed the Scenic Hudson Preservation Conference, a coalition of groups, to oppose the power plant.

A number of residents of the Hudson Highlands joined Scenic Hudson to speak out against the project, among them Ben Frazier, Alexander Saunders, Chauncey Stillman (grandson of James Stillman), and the Duggan family. The Duggans' relatives had donated to the Village of Cornwall the land for its reservoir and watershed, the same land that would now be purchased by Con Ed for a project the Duggans opposed. Similarly, the Stillmans had previously donated land on Storm King to the PIPC and had given the nearby 3,600-acre Black Rock Forest to Harvard University with an endowment for its operation as an experimental forest. Ironically, in the 1880s, James Stillman had been one of the creators of Con Edison's precursor, the Consolidated Gas Company.

At one of its first meetings, the Scenic Hudson board decided that the Federal Power Commission (FPC) licensing hearings presented the only opportunity for a legal challenge. The hearings were scheduled for early 1964, and Scenic Hudson could try to persuade the FPC to deny the license. The same approach could be tried for the plant on Breakneck, once Central Hudson filed for its license. It was a meager hope at best. The FPC conducted primarily technical and economic reviews, and generally ignored social values.

Scenic Hudson board members engaged Dale Doty, an attorney with experience in FPC proceedings. The Storm King case intrigued Doty because of the scenic and conservation policy issues it raised, and the opportunity it presented to broaden the view of public purposes to be protected by the FPC in licensing a power plant.[7]

The FPC hearings were to be held in May 1964, and Doty spent the next few months preparing the legal arguments against a power plant on the basis of scenic and historic considerations. He sought to demonstrate that construction on Storm King was not the only way to meet Con Ed's peak power needs. Using technical and economic arguments, Doty hoped to prove that the utility could use other, equally viable methods that would spare the mountain.

The hearings opened with presentations from both sides. Doty called several witnesses to support his case, among them a former FPC engineer who argued that gas turbines could serve as an alternative to pumped storage. However, Doty's primary witnesses addressed the scenic and historic importance of Storm King and the Highlands. Ben Frazier eloquently described the Highlands' role in American history, beginning with the great chain across the river in the American Revolution, continuing with the fortification of West Point and the Civil War ironworks at Cold Spring, and concluding with a description of Storm King's grandeur. Doty, in his summary, reviewed for the hearing examiners how the beauty of these mountains had influenced the Hudson River School of painting and the romantic revival in landscape design, architecture, and literature. Leo Rothschild told of Storm King's recreational importance for hikers, and Carl Carmer, the author/historian, argued that the Highlands were significant as a national natural heritage and should be kept free of industry. His testimony framed the issue as it would be debated for nearly two decades:

> The Hudson answers a spiritual need more necessary to the nation's health than all the commercial products it can provide, than all the money it can earn. . . . We believe that ugliness begets ugliness and that nature's beauty, once destroyed, may never be restored by artifice of man. . . . We would offer the peace and healing our river gives, as it has always given, to those who seek its waters for respite from the tension of their lives.[8]

Con Ed's response was offered by attorney Randall LeBoeuf, who outlined the need for the project and the cost-effectiveness of pumped storage compared to nuclear and fossil fuel plants. He also said the plant would make Con Ed's entire generating and delivery system more reliable. At the time, the utility was faced with monthly breakdowns of its steam turbine generators. Pumped storage plants were simple, rugged, and nearly trouble-proof. In addition, the "Cornwall Project" would allow Con Ed to retire some of its older power plants and provide increased capacity for electric home heating, which the company was beginning to promote. Even better, LeBoeuf said, the Storm King site was "uniquely advantageous." It was close to Con Ed's customers. The river flow would not be affected, because of tides. With the reservoir at 1,160 feet above the powerhouse, it offered a "developable head" of enormous value.

Regarding scenery, LeBoeuf offered the opinion that the beauty of the area would be improved: "the power plant will be handsome in design, adorning the waterfront below Storm King Mountain and replacing the clutter of structures that now mar the landscape of the west bank of the river at the project site."[9]

On July 31, 1964, the hearing examiner, Edward B. Marsh, submitted his recommendation to the FPC commissioners that the plant should be approved. The final

decision rested with the full commission, which scheduled its review of the proceedings and final hearings for November 1964.

In the meantime, however, support for the preservation of Storm King was spreading across the country. The issue brought into sharp focus a growing national concern over the loss of natural heritage that was felt in many places. As the FPC prepared for the November hearings, the story of Storm King appeared with increasing frequency in the news media. In July 1964, *Life* magazine published an editorial, "Must God's Junkyard Grow?" that expressed those fears. "When does a local conservation issue become national?" it asked.

> Up the river near West Point, Consolidated Edison proposes building the nation's third largest hydroelectric station in a hole gouged out of the flank of Storm King Mountain. This is the gateway to the Hudson Highlands, one of the grandest passages of river scenery in the world . . . National or local? Apparently local . . . like the battle to save the Indiana Dunes on Lake Michigan from commercial exploitation. Or like the battle to keep California's Kings and Tehipite canyons from being dammed and drowned. But like these and other campaigns . . . they also deserve to be called national issues. In a real sense, the whole country suffers every time Americans make a bad choice. . . . The destruction of such resources is irrevocable; no one can pass that way again.[10]

Such press coverage convinced Scenic Hudson that there was strong support for its position. Its leaders decided to make their arguments heard in the court of public opinion. With the hearing officer in favor of granting the license, this seemed the only way to sway the full commission. They masterminded a highly effective strategy to take the Storm King issue out of the narrow confines of the FPC hearing, where it was undergoing mainly technical review, and expose it to public debate on scenic and historic terms.[11]

Next, Scenic Hudson got the attention of Republican State Senator R. Watson Pomeroy, Chairman of the New York State Legislative Committee on Natural Resources. Pomeroy held independent hearings on the project, allowing witnesses to be heard who had not testified before the FPC. Among them were Alexander Lurkis and Robert H. Boyle. Lurkis, a paid consultant, testified about gas turbines as an alternative source of peak power, giving further credence to the testimony presented by Scenic Hudson witnesses in May. Boyle—an editor and writer for *Sports Illustrated* and an avid Hudson River sport fisherman and naturalist—testified that Con Ed's nuclear plant at Indian Point, fifteen miles downriver, was already destroying fish in the river and that the Storm King plant would add to the carnage. This was a new kind of argument. Boyle pointed out that the Hudson Highlands was a major spawning ground for Atlantic coast striped bass, and suggested that the stripers' eggs, larvae, and fingerlings would be sucked into the power plant with the intake water and destroyed. Another witness, John R. Clark, of the U.S. Marine Gamefish laboratory at Sandy Hook, New Jersey, spoke of the importance of Hudson-spawned striped bass to coastal waters.

The legislative hearings put additional pressure on the FPC, which delayed a final decision for several more months. However, on March 9, 1965 the commission completed its review and issued its decision: the license to Con Edison was granted.

Scenic Hudson's only option was to appeal, and at this critical moment, the Taconic Foundation, a family organization established by Audrey and Stephen Currier in 1958 to address social issues and public policy, offered significant help by agreeing to finance the appeal if the group would use the services of attorney Lloyd Garrison, a board member of the foundation.[12] Doty, who had artfully laid the groundwork for such an appeal in his development of the hearing record, turned the case over. Garrison drew on the assistance of several other attorneys in his law firm, assembling a team that included two of the partners and several new staff members, recent graduates of Harvard and Yale law schools. Among them was Albert Butzel, who was to work on the case for its seventeen-year duration.

On behalf of Scenic Hudson, Garrison planned to argue that, given the recognized scenic beauty of Storm King and the Highlands, the FPC should have bent over backward to seek out feasible alternatives. Instead they had ignored options like gas turbines, which Lurkis had suggested. Garrison and his staff made essentially the same point with respect to striped bass—when the FPC was presented with new evidence indicating the potential of a real threat to a fish species, they were duty-bound to inquire into it.

As Scenic Hudson began preparing its appeal, public pressure for protection of Storm King was mounting, and with it concern for the protection of the entire Hudson River. The Bear Mountain hearings held by Senator Pomeroy drew dramatic attention to the fact that, despite decades of abuse, the Hudson estuary still cradled millions of young shad and striped bass, future migrants to the Atlantic coast fishery. The hearings brought to light the massive fish kills then occurring at Con Ed's Indian Point nuclear reactor and illuminated the conflicts over the future uses of the Hudson for power, water supply, commercial fishing, historic preservation, and recreation. Most of all, the case showed how fragile was the protection accorded to the Hudson's natural resources.

In the 1960s, as now, the Hudson Valley's population was swelling at a rapid rate, threatening to intensify conflicts and leading to the possibility of irreversible destruction of scenic beauty, wildlife, and water supplies. With articles about the Hudson and Storm King appearing frequently in the state and national press—*Newsweek, Life, The New York Times*—the issue of protecting the Hudson quickly began echoing in the New York State capitol and in the halls of Congress. The battle had moved out of the FPC hearing room into the political arena.

Running in 1964 on a platform of river protection, Democrat Richard Ottinger had captured the congressional seat of a traditionally Republican Westchester and Putnam County district, an area that would be traversed by the power lines from the Storm King plant. Once in office, in 1965, he proposed legislation for a Hudson River Scenic Riverway. The bill was picked up in the Senate by both of New York's

Hugh Crisp, lithograph of a striped bass.
Courtesy of the New York State Museum

Senators, Republican Jacob Javits and Democrat Robert F. Kennedy, as well as Harrison Williams, Democrat of New Jersey. The riverway bill, prompted by the Storm King case, would give the U.S. Department of the Interior $20 million to acquire land and conservation easements in a mile-wide corridor on each side of the river for a distance of 50 miles, from Yonkers north to Newburgh, including the Highlands and encompassing territory in the states of New York and New Jersey. The bill also stated that the Federal Power Act "shall not operate to affect adversely" the riverway.[13]

It was a direct jab at New York State for failing to properly protect the Hudson River, and Governor Rockefeller voiced his opposition. Undeterred, Congress pressed its case. Senator Robert F. Kennedy, speaking before Congress on March 4, 1965, expressed the view of many of his colleagues:

> Consideration of this bill is essential because of pending encroachments on the Hudson and a heightened national awareness of the need to preserve those areas constituting our national heritage. Preservation of part of the area surrounding the lordly Hudson is of particular concern to our citizens because of the central role it has played in the history of our country, because of its unique beauty and majesty, and because of the important part it plays in the lives of such a large number of our citizens. . . . Many foreign visitors coming to the United States ride up the Hudson to get their first impressions of the American countryside. Of even more importance are the countless number[s] of future Americans who will judge us by our actions in preserving areas such as the Hudson River Valley. They rely on us to insure that "America the Beautiful" is a fact as well as a phrase.[14]

Ottinger, lead sponsor of the riverway bill, also spoke on the record and took indirect shots at the governor:

> Mr. Speaker, I regret to say that one of the Nation's greatest rivers has not yet benefited from this recent awakening of official concern. . . . It is generally recognized that no river in America is in greater need of help than our beloved Hudson: it stands of the brink of destruction. Yet it also stands on the threshold of a great new future. Decisions will be made in the next few months which will determine whether it will become a model of river development or an industrial canal.[15]

Not to be outdone, three months after Ottinger submitted his 1965 bill, Rockefeller issued an Executive Order appointing his own Hudson River Valley Commission (HRVC) and introduced a companion bill to the state legislature. The bill directed the commission to conduct a study of the river corridor from the Verrazano Narrows in New York City to the boundary of the Adirondack Park and report back to the legislature within a year with proposals for a program to protect its scenic, historic, and cultural resources. A star-studded cast was assembled to form the commission, and a few months later, it held hearings in preparation for delivering the report to the legislature. Rockefeller also announced a proposal for a billion-dollar Pure Waters Bond Act aimed at cleaning up sewage pollution in all the waterways of the state and spotlighting the Hudson as a primary area for this.

The Hudson had not received such high-powered attention since the turn of the century. From March to December, 1965 was punctuated by hearing after hearing

about the Hudson and Storm King. In November, voters approved the Pure Waters bond issue by a four-to-one majority, a dramatic showing of public support.

Meanwhile, the U.S. Court of Appeals for the Second Circuit was reviewing the FPC license to Con Ed. On October 8, 1965, the court heard oral arguments on the Storm King case. The FPC defended its grant of the license and also challenged the right of Scenic Hudson to sue. The FPC claimed that the organization did not have legal "standing" because it could claim no personal economic injury from the FPC action. "The pattern of administrative law would be seriously undermined if any interested person or group were permitted to undertake the role of representative of the public interest in the courts," the commission wrote in its brief. Scenic Hudson replied that the FPC had refused to consider other alternatives that could meet the region's power needs while also protecting the mountain. Its lawyers also argued that the effects on the striped bass fishery had not been adequately evaluated, and that the FPC had failed to consider fishery and scenic effects in the context of additional power plants planned by Central Hudson at Breakneck.

On November 9, 1965, shortly after the hearings were over, New York City suffered the worst power blackout in history. Con Ed's system experienced a massive failure. The utility was quick to point out that the pumped storage project was designed to avert such disasters. Scenic Hudson countered that the blackout was a result of Con Ed's mismanagement.

It was rumored that the court of appeals worked on its decision by candlelight in the dark hours of the blackout. On December 29, 1965, the court announced its decision: a victory for Scenic Hudson. The court sent the case back to the Federal Power Commission, requiring it to consider scenic and historic resources and alternatives. It was the first time a court had ever reversed an FPC license for a power plant. Lawyer Al Butzel recalls being so shocked that when a reporter from *The New York Times* called for comments, he had nothing to say.

The appeals court's decision was a landmark in legal history. The following statement was at its core: "The Commission's renewed proceedings must include as a basic concern the preservation of natural beauty and of national historical shrines, keeping in mind that, in our affluent society, the cost of a project is only one of several factors to be considered." The court also directed the FPC to study the issues raised by citizen groups, noting, "In this case, as in many others, the Commission has claimed to be the representative of the public interest. This role does not permit it to act as an umpire blandly calling balls and strikes for adversaries appearing before it; the right of the public must receive active and affirmative protection at the hands of the Commission."

With regard to the FPC assertion that Scenic Hudson had no right to sue, the court responded, "In order to insure that the Federal Power Commission will adequately protect the public interest in the aesthetic, conservation, and recreational aspects of power development, those who by their activities and conduct have exhibited a special interest in such areas, must be held to be included in the class of 'aggrieved' parties."[16]

Con Ed appealed the decision to the Supreme Court, which refused to hear the case, letting the court of appeals decision stand. This established a major precedent by giving resource protection equal weight with economic values and by guaranteeing citizen groups the right to argue for the protection of environmental interests in court. The case gave birth to a whole new class of environmental groups organized

to represent citizen interests in legal proceedings, among them the Natural Resources Defense Council and Environmental Defense, and set the precedent for most citizen suits today. Over the next four years, the concept stated by the court of appeals would be refined by the federal courts, gradually clarifying the public interest in natural resources, and ultimately by Congress, which adopted the National Environmental Policy Act (NEPA) in 1969, requiring an environmental impact review of all major projects proposed by or requiring approval from the federal government. Many states, including New York, followed suit with their own "little NEPAs" requiring environmental review of state projects. Thus, the principle established in the Storm King case soon became the law of the land.

The court of appeals, however, did not guarantee the protection of Storm King Mountain; it merely directed the FPC to reconsider. Nevertheless, for Con Ed, the picture did not look bright—and would soon grow darker. The December 1965 court decision was followed, in February 1966, by the report of the state's Hudson River Valley Commission, containing the following recommendation:

> The Commission strongly believes scenic and conservation values must be given as much weight as the more measurable economic values and that we should not necessarily destroy one value to create another.
>
> The immediate case in point is the plan of Con Edison to build a pumped storage plant at Storm King Mountain. The Commission believes that scenic values are paramount here and that the plant should not be built if a feasible alternative can be found.[17]

This was no small statement, coming from a group of such influential leaders. Commission members included former Governor Averell Harriman; Henry Heald, President of the Ford Foundation; Marian Sulzberger Heiskell of *The New York Times*; Frank Wells McCabe, President of the Albany-based National Commercial Bank and Trust Co.; Alan Simpson, President of Vassar College; author and news commentator Lowell Thomas; William H. Whyte of the American Conservation Association; and Thomas Watson, head of IBM. The governor's brother Laurance served as chairman. Still, Governor Rockefeller did not waver.

The FPC scheduled a new round of hearings for November 1966. At the court's direction, the commission probed exhaustively into the issues raised by Con Ed's opponents: scenic concerns, alternate energy sources, and fishery impacts. Scenic Hudson still had to prove that the Highlands and Storm King were scenic and historic, and that these values should determine the use of the land. The testimony before the FPC makes for fascinating reading. Among those who testified was Vincent Scully, professor of art history at Yale University, who compared Storm King to sacred shrines of Greece. A. Rudolf Wunderlich, a dealer in Hudson River School paintings for the Kennedy Galleries, testified to the importance of the Hudson River School in American art history and argued that the scenes the artists had painted should forever be preserved. Author/historian Carl Carmer recounted the story of the role played by the Highlands in the American Revolution. Never was there such an outpouring of praise for the river. In many cases it was pure poetry. For those who were there to hear it, Scully's imagery was among the most powerful. Here is an excerpt from his testimony under questioning from attorneys:

Q. Do you feel that the pumped storage project, as now proposed by Consolidated Edison, would damage the scenic features at Storm King Mountain?

A. I do.... I leave aside the question of woodlands drowned in the enlarged reservoir, as well as that of power lines marching across the folded hills on the eastern side of the river. Those features would probably do damage enough.

But Storm King is the central issue, and it is a mountain which should be left alone. It rises like a brown bear out of the river, a dome of living granite, swelling with animal power. It is not picturesque in the softer sense of the word, but awesome, a primitive embodiment of the energies of the earth. It makes the character of wild nature physically visible in monumental form. As such it strongly reminds me of some of the natural formations which mark sacred sites in Greece and signal the presence of the Gods; it preserves and embodies the most savage and untrammeled characteristics of the wild at the very threshold of New York. It can still make the city dweller emotionally aware of what he most needs to know: that nature still exists, with its own laws, rhythms, and powers, separate from human desires.[18]

The testimony of Brooks Atkinson, drama critic for *The New York Times* and a Pulitzer prize-winning journalist, encapsulated the history of the Highlands over three centuries, emphasizing the depth of America's cultural roots in the region:

Every generation stands on the lofty pyramid of past experience and accomplishment. The grandeur of the Hudson River Gorge contains many things that give depth and significance to our life today—first the ancient geological formation that made a splendid river out of a wide arm of sea; then the modest, inquiring voyage of Henry Hudson in the autumn when the scent of wild grapes gave the air a spicy perfume and the Indians brought him gifts of corn; then the era of the American Revolution when some blundering, ill equipped American farmers managed to keep the down river British from joining the Albany British; next, the romantic era when sloops sailed through the gorge; finally, the happy period when Hudson River steamboats thundered through the gorge and carried thousands of city dwellers up and down river. Thus, the gorge represents some fine American traditions as well as the physical grandeur of the rock-walled passage.[19]

By this time, there was also mounting concern that the Storm King plant would suck in millions of striped bass eggs and larvae. As Robert Boyle had testified in 1964, large numbers of striped bass were known to spawn at the base of Storm King. Nothing was being done to protect the Hudson's legendary fisheries. To the combined assaults of habitat destruction from filling of spawning areas, wetlands, and shallows and fish kills from low oxygen in polluted areas was added the mind-boggling daily slaughter of fish by the ton occurring at the new Indian Point nuclear plant, built in 1963, where millions of fish were piled up in trash heaps. The Storm King plant would add insult to injury. Concern over these issues led Boyle to form the Hudson River Fishermen's Association (HRFA) as a voice for sport and commercial fishermen. HRFA joined in the Storm King lawsuit and brought an ecologist to the hearings to testify.

As word of potential fishery impacts spread, powerful new allies joined the cause. Communities on Long Island and Connecticut, whose economies relied heavily on bass fishing, registered their opposition to the power plant, as did boat

owners' associations and sportsmen's clubs. The state legislature of Connecticut adopted a resolution opposing the New York power plant. Nassau County, on Long Island, intervened on the side of Scenic Hudson, as did more than forty other towns, counties, individuals, and conservation groups. Boyle began to write articles about the fish kills at Indian Point for *Sports Illustrated*, but it would be years before this began to pay off.

In an effort to avoid further controversy before the hearings started, Con Ed proposed design changes, offering to construct the entire powerhouse underground. This would raise the project cost to $169 million and was a substantial concession. However, the mountainside would still be cut away at its base, leaving a hole the size of 2 football fields with a stone wall 35 feet high behind it and concrete abutments at each level.

However, concerns about fishery impacts remained unresolved, and by this time it was clear that, for many people, any power plant at Storm King would be an industrial intrusion in an area that had become a symbol of wild, unsullied nature. This new view of the Highlands tolerated no compromise. As conservationist Richard Pough stated in his testimony to the FPC:

> I have no doubt that the replanting, the painting and the other landscaping can cover some of the scars of the project site, allowing several years for the growth of the shrubs, vines and trees to be planted. But the ultimate effect of the project cannot be avoided. The integrity of the Mountain will have been destroyed. It must be remembered that Storm King is not merely landscape. Storm King is a particularly moving embodiment of the land itself. It is the fabric of natural forces—not merely picturesque. The intrusion of industry, however disguised, would necessarily commit the Mountain to a hostile use.[20]

Richard Harrison's testimony also supported this view: "No matter how many bushes they plant on the dams, the hand of man will always be evident, and this is fatal to the idea of wilderness."[21]

Storm King struck a primal chord in American hearts. Many people felt that the time had arrived when the Highlands should be inviolate. Furthermore, they feared that allowing a power plant at Storm King would open the door to more industrialization of the scenic landscape.

Con Ed's proposal to put its powerhouse underground also created new opposition to the project from New York City. The plan would require blasting in Cornwall near the aqueduct tunnel, an area known to be unstable; the Storm King water tunnel had been plagued in 1913 by "popping rock" and shifting granite. Since the aqueduct provided 40 percent of New York City's water supply, Mayor John Lindsay was justifiably concerned. In 1968, the city decided to oppose the project, and one of Lindsay's representatives testified at the hearings not only on the danger to New York's water supply but also on the importance of protecting the scenery.

While the FPC conducted its four years of hearings, members of Congress kept the Hudson on their political agenda. Ottinger's riverway bill passed both houses of Congress, and President Johnson signed it. The bill required ratification by the states of New York and New Jersey within three years. However, Governor Rockefeller, reluctant to give any new authority to the federal government or to New Jersey, jealously guarded his jurisdiction over the Hudson, and New York never ratified it.

When Con Edison starts dynamiting Storm King Mountain, keep your fingers crossed. 40% of your water supply may go down the drain.

As early as this November, according to a recent Con Edison announcement, the utility could close an electric contact and trigger an explosive charge planted in Storm King Mountain on the Hudson River near Cornwall. It will be the first of thousands of charges necessary to dislodge 580,000 tons of rock. When the debris is cleared away, three underground chambers will be left, the largest of which could accommodate a 15-story building and will be the site of a huge powerhouse for Con Edison's proposed Storm King Pumped Storage Generating Plant.

But there's a hitch.

Just 140 feet away from a corner of the powerhouse chamber is a tunnel—part of the Catskill Aqueduct—that carries 40% of New York City's water supply (and up to 100% of the water supply of a number of Westchester communities).

The first attempt to construct this tunnel, in 1913, failed because surrounding rock formation could not support even a 20-foot boring. A new, smaller tunnel was dug. Again, unstable rock was encountered but the tunnel has held. So far.

We Need All the Luck We Can Get

But what happens to an old tunnel—which New York City engineers have called "fragile"—when a dynamite blast is set off just a stone's throw away. If we're all lucky, nothing.

What happens to that tunnel over a period of months when thousands of explosive charges, representing tons of dynamite, are triggered just a stone's throw away. If our luck holds, nothing.

And what happens to the surrounding formation when it's undercut by the removal of more than half-a-million tons of rock? If we all keep our fingers crossed, maybe nothing.

And if we're unlucky?

The aqueduct breaks.

And New York City—its people, its industry, its schools, its hospitals—would have to get along with 40% less water. Things would be even tougher for hundreds of thousands of Westchester residents, for whom the Catskill Aqueduct is the sole source of water.

There are some people who think we shouldn't have to trust to luck to keep our water supply secure. The Scenic Hudson Preservation Conference, for example. Scenic Hudson has been fighting the Storm King project ever since Con Edison first announced plans for it ten years ago. The struggle has been waged on many fronts—environmental, scenic, economic—but perhaps no issue is likely to be as critical to the immediate well-being of millions of people as the risk of losing a major portion of their water supply.

City Calls Possibilities "Catastrophic"

The City of New York, balancing the need for more power against the need to safeguard its water supply, opposes the project. As the Corporation Counsel for the City of New York argued in a brief before the Appellate Division of the New York Supreme Court:

"The City's engineers fear that such a massive excavation so close to the Aqueduct tunnel will set off stress changes in the rock, thereby causing the Aqueduct to break. Such a break could be catastrophic."

Con Edison has characterized the risk as "remote." The Federal Power Commission, in granting Con Ed license to proceed with the project, apparently agrees. But in the appellate review, which refused to reverse the FPC ruling, a dissenting judge wondered whether any risk of this magnitude was worth contemplating. He wrote:

"There is a world of difference between no danger and 'remote' danger. If a danger is 'remote' the degree of 'remoteness' assumes importance in proportion to the magnitude of the danger. Here the danger is obviously great, and there is no finding as to the degree of remoteness."

Originally, when Con Edison proposed to locate the plant above ground, a consulting geologic engineer testifying on behalf of the utility saw no danger to the aqueduct. But when the courts rejected an above ground installation, and Con Edison proposed the present underground site, this same geologic engineer was moved to the opposite conclusion, and testified on behalf of New York City as follows:

"The risk of failure of the aqueduct cannot be regarded as imminent but *it represents a definite hazard* ...The risk might be taken . . . if only money were involved; however, a failure of this water supply might jeopardize the lives and welfare of millions of persons in the City and the upstate communities served by the Catskill Aqueduct."

In other words, when they start dynamiting Storm King Mountain, keep your fingers crossed.

What Can You Do?

Fortunately, Con Edison isn't home free yet. The City is still battling in court to block the project and protect its vital water supply. Your support is needed.

Uncross your fingers long enough to write:

Governor Rockefeller	Mayor Lindsay
The Executive Chamber	Office of the Mayor
Capitol	City Hall
Albany, New York 12224	New York, N.Y. 10007
Martin Lang	Charles F. Luce, Chairman
Commissioner of Water Resources	Con Edison
2454 Municipal Bldg.	4 Irving Place
New York, N.Y. 10007	New York, N.Y. 10010

Write your Congressman, too.

Tell them the risk is too great for Con Edison to dynamite Storm King.

Write Scenic Hudson Preservation Conference. We'll tell you about committees you can join, petitions you can start, money you can contribute.

Water is one of the few things New Yorkers and Westchesterites haven't had to worry about lately. Con Edison may take care of that, too.

Scenic Hudson Preservation Conference

545 Madison Avenue, New York, N.Y. 10022

This space paid for by friends of Scenic Hudson Preservation Conference.

Scenic Hudson full-page ad, dated October 10, 1973, warning about the potential effects of the Storm King project on the New York City aqueduct, Storm King tunnel.

Courtesy of Scenic Hudson, Poughkeepsie, NY

Instead, Rockefeller strengthened his own Hudson River Valley Commission, making it a permanent commission with power to review projects visible from the river within a mile-wide corridor on each shore. The HRVC had no power to stop a project, but it could delay it through public hearings. It also had a large staff of landscape architects and other professionals to advise developers on alternate site designs that would decrease the impact of a project on the Hudson's shoreline scenery. It influenced many projects, from housing units to shopping malls and power plants. One of its more significant contributions was the alteration of the design for an oil-fired generating plant, called Roseton, to be built by Central Hudson at Danskamer Point in Newburgh, just north of the Highlands.

Central Hudson's president had put his plans for a pumped storage power plant at Breakneck Mountain on hold. He had been appointed to the advisory committee to the HRVC and had become interested in regional planning. He was very concerned that the design of the new Roseton plant should fit into the landscape as much as possible. He approached Scenic Hudson for advice and ultimately adopted a design suggested by HRVC. The facility, as finally approved, was constructed so that it would not rise above the ridge behind it. From the north, looking south, it is invisible except for a smokestack. From the south, its oil tanks are screened by an earthen berm, which also limits the view of the plant itself. In the growth years of the 1960s, HRVC reviewed and redesigned countless other projects.

As this was happening, Scenic Hudson kept Storm King in the news. On a cold November morning in 1967, the group chartered the tour boat *Miss Circle Line*. The organization's annual fund-raiser that year was on the river itself, with a trip from Manhattan up to Storm King. Senator Robert Kennedy and Congressman Richard Ottinger were among the many luminaries who spoke. Television reporter Marya Mannes was one of 23 reporters and photographers among the 300 guests. She wrote:

> After speeches we went on deck to look at Storm King. The cold mist still shrouded the top of this magnificent guardian rock. But we were unmistakably in the presence of greatness.
> Here was the untempered soul and body of earth itself, part of the organic whole of nature from which man has immemoriably drawn his strength. . . .
> Conservation is not a matter of loving nature. It is a matter of saving man.[22]

Scenic Hudson also hired a public relations firm, Selvage and Lee, to put a spotlight on the case, and soon the Storm King issue appeared in the national press on a regular basis, making news in faraway places.[23] The Sunday edition of the *San Francisco Examiner and Chronicle* carried this headline on March 2, 1969: SHOWDOWN NEAR IN FIGHT TO HARNESS GRANITE HULK OF STORM KING. The *News-Herald* of Conneaut, Ohio carried a story on March 5, 1969 titled "Conservationist vs. Engineer: Big Storm Brews Over New York's Scenic Storm King Mountain." In Massachusetts, Harvard University—the owner and potential seller of Black Rock Forest, the site of the proposed plant's reservoir—was accused in its own student newspaper, *The Crimson*, of "environmental rape."[24]

Con Ed, faced with a media barrage, put its own public relations people to work, producing a full-color booklet titled "The Cornwall Hydroelectric Project: Power and Beauty for Tomorrow." The utility also put out a newsletter of favorable press

clippings, while its lobbyists labeled power plant opponents as "misinformed bird watchers, nature fakers, land grabbers and militant adversaries of progress."[25] Despite such efforts, the public and the media, for the most part, threw their backing to Scenic Hudson. Con Ed had gained the reputation, as *Fortune* magazine put it, as the "company you love to hate."

Eventually thousands of people, from nearly all American states and several foreign countries, flocked to the cause. At the height of its activity, Scenic Hudson had 22,000 contributors from 48 states and 14 foreign countries. Chairwoman Frances S. Reese took particular pleasure in the donations she received from Con Ed stockholders who gave their dividend checks to help fund the lawsuits.

As the politics surrounding Storm King drew attention to the Hudson, issues began to emerge in other places on the river as well. Trouble started brewing on the upper Hudson when state agencies, the City of New York, and the U.S. Army Corps of Engineers proposed plans in 1968 to build the Gooley Dam No. 1 in the Adirondacks, to bring drinking water to New York City. The project would create impoundments in the mountains to collect fresh water. This would be released downstream when needed and then siphoned off at Hyde Park and sent by tunnel to existing reservoirs built at the turn of the century. It would also flood 35 miles of wild river and up to 15,000 acres of the Hudson Valley in the central Adirondacks, threatening the integrity of the famed Hudson River gorge at Blue Ledges. Most of the village of Newcomb would be underwater.

This roused the ire of Arthur Crocker, head of the Association for the Protection of the Adirondacks, and Paul Schaefer, a passionate advocate for wilderness preservation. "We need to take a stand on the Upper Hudson, a stand that knows no compromise, a stand that will accept no halfway effort, nor be satisfied with any engineering study less than one needed to permanently preserve the Hudson from destruction," wrote Schaefer. The association called a meeting in Newcomb that drew 600 people and galvanized opposition to the project. Schaefer won the cooperation of virtually all conservation and sportsmen's groups in the state to fight for the Hudson to remain natural and free-flowing in the Adirondack Park. "We need the support of all who value the wild-forest character of the Adirondacks," he wrote.[26] Their work was extremely effective. In 1969, the state assembly voted 121–0 to bar all dams on the Upper Hudson and its tributaries above Luzerne. The law passed both houses and killed the Gooley Dam project. In 1971, Governor Rockefeller created the Adirondack Park Agency to establish land use policies for the entire Adirondack Park, including both state and private lands.

Meanwhile, back in the Hudson Highlands, the Georgia Pacific Company announced in 1967 that it had purchased Little Stony Point, just below Breakneck Ridge, from the Hudson River Stone Company, with the intention of constructing a wallboard manufacturing plant. The company needed a site with access to the Hudson to receive gypsum by ship from South America. This proposal raised a great hue and cry from citizen groups and Congressman Ottinger. The HRVC (with help from William H. Osborn) involved Governor Rockefeller in persuading the company to relocate. The governor interceded, finding a location for Georgia Pacific's gypsum plant in nearby Verplanck, and made plans to conserve the Little Stony Point property.

Soon after, Laurance S. Rockefeller, chairman of the commission, approached Central Hudson with a proposal to buy its lands at Breakneck Ridge for park purposes.

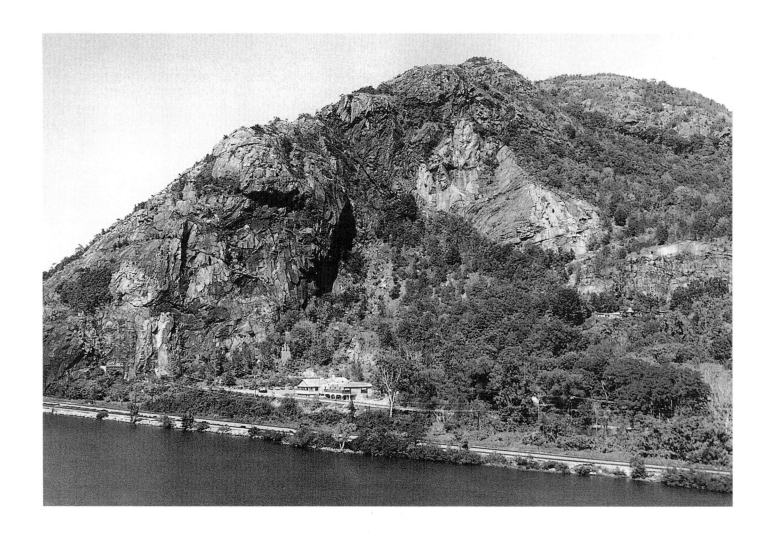

Breakneck Mountain.
Copyright © 1990 by Robert Beckhard

Rockefeller offered to purchase the land on behalf of New York State through the Jackson Hole Preserve, a family foundation devoted to conservation. Central Hudson agreed to sell the 670-acre Breakneck parcel to the state for the same amount of money it had paid for it, $827,789, stating that: "the use of the property for park and conservation purposes would be in the best interest of the company and the public which it serves."[27] Ultimately, Rockefeller assembled a plan for a 2,500-acre park including Breakneck, Mount Taurus, Bannerman's Island, and Little Stony Point. The cost was $3 million, half to be paid by Rockefeller family foundations. With great fanfare, Governor Nelson Rockefeller held a ceremony on May 23, 1970 dedicating the land as the new Hudson Highlands State Park. Little Stony Point, formerly a quarry, is now a popular park that affords some of the best views of the Storm King gorge.

This was not the end of the problems on the Hudson, however. Though Rockefeller had secured passage of a bond act to clean up the state's rivers, it took time for sewage treatment plants to be built. The Hudson's waters were still a "torrent of filth." A few summers after the 1965 Pure Waters Bond Act passed, state biologists found zero oxygen in the Hudson around Albany and no living fish.

Folksinger Pete Seeger, in Beacon, New York, was one of those who decided this should change. In 1961, before Storm King burst into the region's consciousness, he had composed a wishful song that posed a question no one else was asking:

Sailing up my dirty stream
Still I love it and I'll keep the dream
That some day, though maybe not this year
My Hudson River will once again run clear.
She starts high in the mountains of the north
Crystal clear and icy trickles forth
With just a few floating wrappers of chewing gum
Dropped by some hikers to warn of things to come.

At Glens Falls, five thousand honest hands
Work at the Consolidated Paper Plant
Five million gallons of waste a day,
Why should we do it any other way?
Down the valley one million toilet chains

Pete Seeger.

Find my Hudson so convenient place to drain
And each little city says, "Who, me?
Do you think that sewage plants come free?"[28]

In 1969, Seeger proposed to a friend that they get a few hundred families together to build a replica of a Hudson River sloop. At first, it was to be just a boat for sailing, a loving tribute to the sleek and beautiful ships that crowded the Hudson during the age of sail. As Seeger later recounted: "It really seemed a frivolous idea. The world was full of agony; the Vietnam War was heating up. Money was needed for all sorts of life and death matters, and here we were raising money to build a sailboat."[29] However, the idea soon crystallized around building the boat to save the river, to have it be owned by its members, to be "everybody's boat." It would be called the *Clearwater*.

To help raise money, the Saunders family of Cold Spring and the Osborn family of Garrison offered their lawns for a series of song festivals where Seeger, Arlo Guthrie, and others performed. The first concert drew 150 people and raised $167. Four months later, 700 people showed up—and by the end of the year, $5,000 was in the bank. By 1969, $140,000 in donations and loans were paid to the Gamage shipyard in South Bristol, Maine, which constructed the boat, and on June 27, the sloop *Clearwater* set sail down the Damiriscotta River and out to the Atlantic coast for its home port on the Hudson, piloted by a skilled captain and crewed by 11 talented musicians, including several who knew little about sailing. The boat stopped in Boston, where the crew sang to 10,000 people. A few days later, it sailed into Connecticut's Mystic Seaport. In early September, it arrived in New York harbor and tied up in Manhattan at South Street Seaport, where brass bands played, and Mayor Lindsay gave his official greetings as press helicopters zoomed overhead.[30] Soon photos of the sloop appeared in newspapers around the country, and the boat became a symbol for an emerging movement to clean up the nation's waterways. The Clearwater organization's membership grew to 2,500, and the sloop sailed up and down the Hudson, promoting a message of hope. Crowds joined in with Seeger to sing the refrain of his 1961 song:

Sailing up my dirty stream,
Still I love it, and I'll keep the dream,
That some day, though maybe not this year,
My Hudson River will once again run clear.

In 1970, the *Clearwater* crew sailed for Washington, D.C.—joining up with 20,000 people to celebrate Earth Day—and the real work of promoting river cleanup began. "We've sailed for a year now up and down the river showing people what the river used to be, how it's polluted now and what it can be," Pete Seeger told *The New York Times*. "We're going to Washington because the problems of the American rivers can't be solved by people like me who live on them. Only the Federal Government has the power to enact and enforce the laws that are needed."[31] Seeger held a press conference in the House of Representatives office building, where he "displayed a pie chart of the national budget, showing big slices for war, for highways and bridges, and a slice for the environment so small it was just a line."[32] Then he and fellow folk-

singer Don McLean began to play songs about the river. More than 70 members of Congress attended, many pledging to do something.

Two years later, the Clean Water Act of 1972 committed the federal government to restoring America's polluted waters, providing funds for building sewage treatment plants, and requiring polluters to get permits for discharging their waste. The law also halted the filling of most wetlands. It contained a citizen suit provision, modeled on the Storm King decision, and the Clearwater organization promptly filed the first successful Clean Water Act suit against a polluter: Tuck Tape, of Beacon, New York, which was dumping titanium dioxide, adhesives, solvents, latex, and sewage into the Fishkill Creek near where it drains into the Hudson. The People's Pipewatch, organized by Clearwater, encouraged citizens to report pollution wherever they saw it.

Meanwhile, the Hudson River Fishermen's Association (HRFA) formed by Boyle was developing its own track record as a pollution fighter. From its initial meeting in 1966, its membership had grown to about 300 men and women, paying $3 annual dues. These were mainly blue-collar commercial and recreational fishermen, "river rats," who loved to trap eels, fish for minnows, and save rotten chicken necks for crab bait. For fun they would catch and harness snapping turtles. Many of them were factory workers who observed the pollution of the Hudson on the job—paint

The sloop *Clearwater*.
Copyright © 1991 by Robert Beckhard

from the General Motors plant in Tarrytown, oil from the Penn Central Railroad yards, metal and solvents from the Anaconda Wire plant. In 1969, the year the *Clearwater* first set sail, Bob Boyle published *The Hudson River: A Natural and Unnatural History*, in which he painted a loving picture of the Hudson's ecosystem and railed against the state and federal bureaucracies for failing to protect it. He described two visions for the future of the river. The first seemed almost unthinkable: a clean, wholesome river, wild, biologically productive, and useful to the people who live along its shores. The second was the Hudson's current path: polluted waters, obliterated scenery, and diminishing fish populations. "As might be expected, I opt for a productive and enjoyable Hudson," he wrote. "The means to achieve this are in reach."[33] Boyle then described a program of state and federal policies and other programs to bring that about, starting with the principle that the Hudson should be considered first from an ecological point of view. Any project should be judged from the standpoint that it would do no harm to the river's living systems and aesthetic vitality.

That same year, he would find himself in a position to help make his first vision reality. HRFA had discovered that laws still on the books from 1888 and 1899 allowed citizens to report polluters and receive a bounty of half the penalty charged. In 1969, HRFA sued Penn Central and won half of the $4,000 fine. This was the first time a private group had ever collected the bounty, and it helped pay for suits against other major polluters. Soon Ciba Geigy, Standard Brands, Philmont Finishing, and American Cyanamid all paid fines in federal court, and HRFA collected more and more of the bounty fees.[34] This allowed HRFA to create a staff position of "Riverkeeper" in 1972 to go after other polluters. In 1973, Anaconda Wire paid $200,000, the largest pollution fine ever charged an American company. The case was based on the testimony of its janitor, Fred Danback, whose outrage at the flagrant dumping of waste and successful efforts to stop it, against all odds, are vividly described in the book *The Riverkeepers*.

Scenic Hudson's chairwoman, Frances Reese, and Robert H. Boyle, chairman of the Hudson River Fishermen's Association (now Riverkeeper), both wearing glasses, sign the "Peace Treaty on the Hudson" with Con Edison's Charles Luce, New York Attorney General Robert Abrams, and EPA administrator Russell Train.
Courtesy of Scenic Hudson

In 1970, Boyle stumbled on a new problem. At the Storm King hearings, a leading federal marine biologist, John R. Clark, suggested that he find a way to test Hudson River fish for DDT, a toxic pesticide that is now banned. Boyle got his bosses at *Sports Illustrated* to pay for it, and also tested for PCBs, or polychlorinated biphenyls, a carcinogen. The results came back positive for both, but PCBs dominated the samples. It was soon discovered that the General Electric Corporation had started using PCBs in capacitors starting in 1942, and it dumped the waste PCBs straight down the drain into the Hudson at its Fort Edward and Hudson Falls factories, with a permit from the state's Health and Conservation departments—about 5 tons of the chemical annually. About 430,000 pounds remained in the river sediments, scientists calculated.[35] HRFA began a campaign to rid the Hudson of its PCBs and was soon joined by Clearwater and later Scenic Hudson. However, a state settlement with GE made it difficult to pursue the company in state court, and the fight to remove the PCBs moved to the federal arena, where the Environmental Protection Agency (EPA) had jurisdiction. There it languished for decades.

Sports Illustrated first alerted the public to the PCB problem in the Hudson in its October 26, 1970 issue. A few months earlier, on August 19, 1970, the Federal Power Commission had concluded four years of review of the Storm King project. In a lengthy decision, the FPC set forth its findings that:

> The Hudson Highlands is an area of great natural beauty, having historical and artistic significance and exceptional recreational opportunities. . . . The construction of the project . . . would not adversely affect, to any significant extent, the natural beauty, the historical significance, or the recreational opportunities of the area in which such a plant would be situated.

> The project will not adversely affect the fish resources of the Hudson River provided adequate protective facilities are installed. . . .

The *Riverkeeper* patrols in front of the Indian Point nuclear power plant in Verplanck, New York.
Courtesy of Riverkeeper

Cornwall makes the best use of available resources to meet the requirements for electric energy with the minimum adverse impact on the environment.

The license was issued to Con Ed.[36]

Scenic Hudson and the Hudson River Fishermen's Association appealed the decision, but this time the court of appeals upheld the license, though Justice Oakes dissented. The Supreme Court again refused to hear the case, allowing the license to stand.

It was a major victory for Con Ed and a serious setback for Scenic Hudson and the fishermen's association. However, the legal challenges were not yet over. Three more years were spent in New York State courtrooms, challenging water quality permits granted to Con Ed by the Department of Environmental Conservation. In 1972, Scenic Hudson kept public interest alive by publishing a lush full-color book, *The Hudson River and Its Painters*, which compiled many works of Hudson River School artists. They were known mainly by art historians but had been largely forgotten by the public, and Scenic Hudson brought these spiritual images of the river back into view. Art had a long history of shaping public opinion on the Hudson. The book transformed dry testimony about old paintings into something readily accessible and easily understood. The paintings spoke in a way no expert could, sustaining popular interest in preserving the scenery through unexciting lulls in the legal process.

Then, in December 1973, the results of new fishery studies and evidence of possible impacts were presented to the U.S. Court of Appeals by the Hudson River Fishermen's Association along with Scenic Hudson. The HRFA argued that the Con Ed studies had failed to take into account that the river was tidal when calculating how many juvenile fish would be sucked into the plant's pipes as the water flowed by. In July 1974, the court of appeals ordered further hearings on the fishery issues.[37] While the utility conducted several more years of court-ordered striped bass studies, the Storm King project was put on hold.

In the course of these hearings and studies, Con Ed had acquired new leadership. Waring and Forbes had both left the company, and Charles Luce became the new chairman of the board. Luce strongly advocated the Storm King project but began to recognize the natural environment as a public concern that utilities must consider.

Luce began to speak and write on the issue that faced Con Ed and all American utilities. Speaking before the New York City Bar Association, he said:

The incompatibility . . . between protection of the environment and production of electricity is not absolute. Accommodations can be made which recognize the validity of both social objectives. . . . It is not correct to say . . . that only a "handful of people" are expressing this concern by opposing power plants. Every Gallup poll taken on the subject in the past few years shows that concern about air and water pollution ranks very high in any list of the citizenry's concerns about national problems. . . . I think it is accurate to say that the senior management of the utility industry now recognizes its responsibility to supply the electric energy needed by society in ways that will not unduly damage the natural environment.[38]

He also began to deal with the project more practically. From 1969 to 1971, to meet a power crisis in New York City, he quickly installed generating capacity in the form of gas turbines, most of them located in Brooklyn and Queens.

Even earlier, Central Hudson's chief, Leland Sillin, also began to rethink its role. In 1964, he called a conference of business, municipal, and nonprofit leaders to kick off a new regional planning effort under the auspices of a group to be called Mid-Hudson Pattern for Progress. This predated the Ottinger Riverway bill and Rockefeller's Hudson River Valley Commission and occurred years before Central Hudson sold its Breakneck property to the state. The published conference proceedings included this statement:

The Mid-Hudson's prime attraction to the would-be resident or entrepreneur is the scenic, open, and varied character of the landscape: its natural features rather than those imposed upon it by man. This regional asset cannot be guarded too jealously, when considered in the light of economic development needs for the decades ahead. . . .

We are all agreed that the remaining rural beauty, the scenic and historical delights of the Hudson Valley should be carefully preserved, but the means to accomplish this purpose are neither straightforward nor noncontroversial. But who would be better qualified to reflect upon alternative courses of action than the people themselves speaking through their voluntary regional planning association?[39]

By the late 1970s, Con Ed's Luce began to consider the possibility of a mediated settlement with Scenic Hudson. Con Ed had become embroiled not only in battles over the Storm King plant but also in lawsuits over the fish kills at its Indian Point nuclear power plant. Luce saw the possibility of a solution that could produce benefits for both sides. Through an intermediary he approached Russell Train, former chief of the EPA, for his assessment.

In December 1980, after seventeen years of bitter controversy, a settlement was announced that ended the Storm King battle forever. It provided for the pumped storage project to be abandoned and the land donated by Con Ed to the Palisades Interstate Park Commission and to the Town of Cornwall for a park. It also required that the utilities and the state power authority take measures to reduce the fishery impacts from their cooling systems at the Indian Point nuclear power plant. In return for these concessions, Con Ed and other utilities operating on the Hudson River won a reprieve from building expensive cooling towers on their riverfront power plants while technologies and operating procedures to reduce fish kills could be explored. In addition, they were required to provide a $12 million endowment for a new Hudson River Foundation to fund independent research on the river ecosystem that would provide a base of information for future decisions. The settlement was hailed as a "peace treaty on the Hudson."

The Storm King case had set a legal precedent for conservation with the so-called Scenic Hudson decision. The work of HRFA and Clearwater also created national precedents. In 1986, the HRFA reincorporated under the name Riverkeeper and began to spread its model of environmental action around the country. By 1988, "keeper" groups had been set up for Long Island Sound, the Delaware River, and San Francisco Bay—and later came the Santa Monica Baykeeper and the Chattahoochee Riverkeeper.[40] An alliance of the keeper organizations styles itself as an environmental neighborhood watch.

Similarly, flagships for pollution cleanup, modeled on the *Clearwater*, were built for other waterways, and its pioneering "classroom of the waves" became a pattern for many other outdoor programs. In 2004, the *Clearwater* sloop was listed on the

National Register of Historic Places in recognition of the role it had played in bringing about the cleanup of America's rivers.

The Nature Conservancy, which had organized the initial opposition to the power plant at Storm King, evolved from its early focus on creating nature preserves into an international organization devoted to protecting globally important ecosystems that sustain a diversity of life and people. It now has a program focused on the entire Hudson River estuary. The Scenic Hudson Preservation Conference, which started out as a coalition of groups, shifted its mission after the "peace treaty" was signed. Renamed as Scenic Hudson Inc., and no longer a coalition group, it began to focus more broadly on land preservation, waterfront development, cleanup of PCBs, and public policy. It has successfully challenged numerous projects that would mar the beauty of the river valley and provided comments that influenced the siting, design, and public amenities of many other riverfront projects, securing the right of public access and guaranteeing waterfront walkways in many developments.

The two proposed power plants were the spark that ignited the fiery environmental activism of the 1960s and 1970s on the Hudson, and today, both Storm King and Breakneck are permanently protected as sentinels of the ancient passage of the river through the gorge. For that, we undoubtedly owe a great debt to Knickerbocker writer N. P. Willis and his campaign to rename Butter Hill, suggesting "Should not STORM-KING, then, be his proper title?"[41] With this and other name changes he inspired, Willis assured the continuing place of the Hudson River in the public imagination.

The fight to save Storm King revolved around a host of issues including scenery, history, water supply, fisheries, energy production, and the obligations of government agencies to balance and protect all of these public purposes. In the press it was alternately played up as a David-and-Goliath struggle of a small band of conservationists against a mighty utility and a soulless bureaucracy, as a thinly disguised ruse of rich men and women to protect the view from their backyards, as the struggle of towns and citizens to expand their tax base against outsiders seeking to preserve valueless scenery, and as an excuse to fight "the company you love to hate." The Storm King battle was all of these things and more. It was deeply rooted in activism of the 1960s and a sense, widely shared, that America's post–World War II passion for growth needed to be tempered with an equal passion for conserving our unique heritage. Ultimately, it was the story of people rallying to maintain our nation's cultural and spiritual connection with nature.

There were many other defining battles on the Hudson in the 1970s, 1980s, and 1990s. Grassroots groups defeated several proposed nuclear power plants, and activists successfully campaigned against two highway projects—Westway on Manhattan's West Side and the Hudson River Expressway proposed for Westchester County's riverfront—that would have filled hundred of acres of prime river habitats.[42] Lawsuits forced countless polluters to clean up their acts, including many reluctant municipalities, and halted projects to fill tidal wetlands. All this was an outgrowth of events on the Hudson in the 1960s that produced a seismic shift in attitudes and behavior. Storm King and the Hudson had regained their status as a sacred landscape, and once again, events there changed the nation and the world.

Epilogue

A River of Power, and the Power of Passion

ODAY, THE HUDSON remains a world river, a military river, a sacred river, a river of empire, and a thriving ecosystem. The drumbeat still echoes from West Point, and billion-year-old Storm King Mountain forces the gathering river current into a deep, narrow channel, as it has through the eons. In places, the river flows through dense forest or open tidewater that looks much as it did to native people 6,000 years ago. The play of clouds and light and curling mist transport even the busy commuter to a place of spiritual delight. The spirit of Andrew Downing still calls out from every river city, castled estate, and rural cemetery. Foreign ships still crowd the docks of the harbor. Goods, people, and ideas still flow in and out, connecting the river to the world. The Hudson River has retained its power to inspire.

This is important. It means that creativity can still flow from it, connecting its ideas, resources, and people to the world. And yet, things might not have turned out this way. If proposed projects had been allowed to go forward, the beauty and

Kayakers greet the *Half Moon*, a replica of Henry Hudson's ship operated by the New Netherland Museum.
Courtesy of Scott Keller

vitality of the river could have been lost. Several power plants, a prison, a gypsum plant, huge quarries, and tract housing would occupy lands that have since become parks, preserves, and historic districts. Urban renewal, unchecked, would have torn down even more of the magnificent legacy of the Victorian age, and the Palisades would be a heap of rubble. Manhattan would be an even wider island, and the public would be denied access to the river along much of the shoreline in New York and New Jersey. The vitality of the port could have been destroyed by the competition between the two states that share it.

Individuals moved by an inner passion have made the difference between one future and another. There will always be a tension on the Hudson between the press of commerce and the power of nature. There will always be some who are immune to the siren song of the river and others who are drawn to it. This is the nature of the Hudson, where the usefulness of geography competes with the beauty and mystery of a unique river and valley. It is a balancing act that never ends, yet every generation has produced transformative leaders who tipped the scales in one direction or the other.

By the 1950s the Hudson was so polluted that it could no longer entrance any but the most devoted suitors. People were limited in their vision of what the river could be. They lost sight of the valley's unique blessings. The 1960s and '70s sparked a new appreciation of the river as a scenic, ecological, and historic treasure, a storybook on which the pages of American heritage are written. With time the trend has become stronger, and support for conservation is growing more sophisticated. The *Half Moon* sails again, in replica, its crew of students re-creating the voyage of Henry Hudson and reporting their findings on the Internet. The people who care about beauty, nature, and history have redoubled their efforts to protect the unique qualities of the river.

And yet, the pressure on the Hudson has never been greater. The beauty of its landscape, a source of its spiritual power, is not limited to any one mountain, waterfall, or vista—it exists in the varied, but unified landscape that connects the Adirondacks with the harbor and in the historic sites that line its shores. The Hudson faces a daily assault that threatens to transform its uniqueness into bland conformity, obliterating the very qualities we love. The river valley's ecosystem is at risk as well, with some fish, amphibian, and bird species in precipitous decline due to human activities have not been managed.

Following a tradition that began in the late nineteenth century, citizen groups are forcing a debate, taking one-dimensional decisions and putting them in the public arena for broader discussion. Today, groups like Scenic Hudson, Clearwater, Riverkeeper, and The Nature Conservancy testify in hearings to influence riverfront development; buy land and develop river access; take children sailing to educate them about the river; sue to keep the water clean and the fish abundant; and coordinate regional partnerships to create a broad constituency for the river. They organize local land trusts to conserve natural areas along much of the river valley and work with local governments to promote sound land use decisions.

The files of these organizations are filled with designs for projects never built—the river that wasn't. One such project was the 1999 proposal by the St. Lawrence Cement company to develop one of the largest cement manufacturing facilities in the nation, producing 2 million metric tons per year from a 1,222-acre mine, with a shipping and processing center on the shoreline. The plan aroused deep feelings and

illuminated the changing nature of the river and ideas about its future, as well as the continuing conflict over utility versus beauty. For miles around, one saw signs: STOP THE PLANT and BUILD THE PLANT. Supporters looked to the project for jobs. Opponents argued for a new and different kind of physical, social, and economic relationship with the river—prioritizing uses that heal the waterway's natural attributes and enhance the community's connection with it. The state's 2005 decision not to allow the project cited a shift in river uses from an industrial past and concluded that the scale of the development was not consistent with the Hudson's emerging economic future, which derives value from its scenic beauty, historic heritage, and strong sense of place.[1]

In the last twenty years, communities in the Hudson Valley have been moving away from waterfront industry, toward a more diversified economy with higher-value economic uses. Increasingly, river communities such as Hudson and Athens rely upon the area's high quality of life, enhanced by the visual appeal of the landscape, its historic fabric and texture, its pastoral setting, and attractions such as Olana as the basis for continued economic growth. This community character would have been jeopardized by the proposed plant and riverfront industrial facility.

Conservation of the river also benefits from a long tradition of giving that has been passed on as a deeply held value by many families who championed the protection of the Adirondacks, the Palisades, and the Highlands for a hundred years—the Rockefellers, the Perkinses, the Osborns, the Harrimans, the Sidamon-Eristoffs, and the Reeses, among others. The charitable arm of J. P. Morgan's bank continues this tradition as well. New donors have joined in. Lila Acheson Wallace, who did so much to preserve Boscobel at its new location in the Highlands, left a bequest to the Open Space Institute (OSI) and Scenic Hudson that enabled significant land acquisition programs. Notable Hudson River purchases by OSI include the 10,000-acre Tahawus property, protecting the headwaters of the Hudson and the "deserted village" near the former Adirondack iron and titanium mines. OSI has also acquired easements protecting views from the Saratoga Battle Site. Scenic Hudson has protected more than 13,000

Tide marsh at Iona Island. The island and marsh have been designated as a National Natural Landmark and a National Estuarine Research Reserve because of their outstanding ecological value.

Copyright © Steve Stanne/Clearwater

acres of river scenery, including the 900-acre Poet's Walk property in Rhinebeck, part of the historic east shore estate district, and gained easements protecting the vistas from painter Frederic Church's studio, Olana. It has also acquired extensive lands along Black Creek, an ecologically significant tributary of the river, which flows past nature essayist John Burroughs's Slabsides. In 1989, philanthropist William T. Golden organized a consortium of 15 scientific and educational institutions to purchase the 3,600-acre Black Rock Forest from Harvard University to be preserved in perpetuity for use in ecological research and education. Similarly, Frank and Anne Cabot have created the Glynwood Center in Cold Spring, where new methods for conserving landscapes are explored. The time is ripe for new donors to step forward, making the kind of big difference that these river heroes have enabled, as Kathryn Wasserman Davis did in 2007 with a gift of $20 million to Scenic Hudson.

The Hudson inspires more humble forms of generosity as well, a type of giving that is equally important. Highland Falls auto mechanic Allen Monks provides an example. He gives a dollar to Riverkeeper for every car he fixes. "Every week, when I do the payroll, I get a computer printout," Monks told a reporter in 2006. "If we've done 43 cars, we donate $43. It's an ongoing thing."[2] Over the years, he estimates that Allen's Import Service has donated over $30,000. He does it because it feels like the right thing to do, and he is not alone. Thousands of regular people make a difference in their own way, writing letters, writing checks, talking to their neighbors, and caring about the river through deeply knowing it. A community of Hudson aficionados comes together every week for an online sharing of river observations through the *Hudson River Almanac*, a state-sponsored electronic newsletter that keeps the art of observing nature alive.

Though conservation seemed the domain of white, Anglo-Saxon Protestant ethnic groups a century ago, its reach is expanding as the Hudson's allure attracts new generations. Many who have joined the cause of conservation of the Hudson in recent decades are descended from immigrant families of many nations: people whose ancestors arrived in this country via Castle Garden or Ellis Island; Native Americans, whose heritage on the Hudson goes back thousands of years; and the sons and daughters of slaves who came here by force.

Private conservation efforts have been matched by continuing initiatives in the political arena, where changing visions for the river crystallize into public action. On the New Jersey waterfront, Governor Brendan T. Byrne opened Liberty State Park in 1976, replacing former rail yards that had become desolate after 1967, when the Central Railroad went bankrupt. The role of the press has been crucial over and over again on the Hudson, and in New Jersey, frequent front-page reporting in the *Star-Ledger* promoted a new vision for the waterfront. Also key was the spirited activism of two citizens, Morris Pesin and Audrey Zapp.[3] Such activism also gave parts of the Jersey river shoreline back to its citizens. Over the last twenty years, the riverfront has filled with high-rises and ferry terminals, but a public walkway extends along much of its distance.

Hugh Carey was the last of the New York governors who tried to reengineer the Hudson. His Westway project—a highway to be built by filling in hundreds of acres of the river on Manhattan's West Side—ran into the buzz saw of the new Clean Water Act when the importance of the shallow-water habitats as a haven for striped bass was revealed. The Local Waterfront Revitalization Act, which he signed in 1981, resulted in numerous local government plans for recovery of the waterfront of the

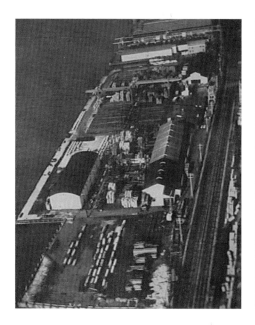

Hudson and other coastal areas. These plans are now being implemented, leading to the slow but continuing regeneration of river cities that suffered from post–World War II policies that promoted the growth of suburbs as well as the shift of manufacturing to other parts of the country.

Since the defeat of the Westway project, every New York governor has made conservation of the river a priority, showing individual passion and leadership in transforming the Hudson yet again. Governor Mario Cuomo signed legislation launching two planning efforts for the Hudson. The 1987 Hudson River Estuary Management Act called for a long-range plan for the ecosystem to be developed. The 1991 Hudson River Valley Greenway Act aimed to promote land use planning for conservation, historic preservation, and economic development and to establish trails on each side of the Hudson. These concepts had been pushed by the conservation groups Scenic Hudson, Clearwater, and Riverkeeper and were carried in the state legislature by passionate advocates on both sides of the political aisle: Democratic Assemblyman Maurice Hinchey and Republican senators Jay Rolison and Steve Saland with Assemblyman George Pataki (later also a senator and governor).

Governor Cuomo also assured the purchase of key river properties: Denning Point in Beacon; the scenic vistas around Osborn Castle in Garrison; the historic icehouse property at Nutten Hook in Stuyvesant; and Kowawese Park in New Windsor, also known historically as Plum Point, where Revolutionary War *chevaux-de-frise* stretched across the river to Pollepel Island. As with the efforts to protect the Palisades, such purchases have sometimes been leveraged by private individuals and conservation groups that offered to match state dollars in order to guarantee that these special places would be preserved forever. Cuomo's agencies also set in motion the removal of blighted postindustrial sites, known as "brownfields," and their reinvention as parks and mixed-use developments. In the Village of Catskill, an oil tank farm was removed and replaced with parkland, an interpretive center, and a greenmarket at Catskill Point. Lastly, but importantly, in 1986, the governor convinced voters to support a billion-dollar bond to purchase land and continue the cleanup of New York's polluted waters.

Irvington former industrial site (left), now a public park and kayak launch site, with most of these industrial structures removed (right). *Courtesy of New York State Archives and the Village of Irvington*

The Hudson River Park on Manhattan's West Side is located where the Westway highway would have gone. The park provides continuous open space with walking trails, bike paths, and mixed-use development from 72nd Street to Battery Park.

Courtesy of Hudson River Park Trust

By 1995, Assemblyman Hinchey had gone to Washington to serve in Congress and Pataki had gone to the statehouse in Albany, as governor. Both continued their efforts on behalf of the Hudson, citing childhood experiences on its shores that awakened a sense of connection to nature and a sense of outrage at the abuses they saw in the 1960s, '70s, and '80s. Though their political philosophies were quite different in most areas of public policy, both emphasized the positive economic value of conservation and pushed through new initiatives to protect the Hudson River, its historic sites, and its watershed.

In 1996, Congressman Hinchey passed a bill that created the Hudson River Valley National Heritage Area, providing steady funding through the National Park Service to help tell the story of the river's role in American history and culture. He had done similar work earlier, as a state legislator, to create a system of Urban Cultural Parks, later renamed Heritage Areas. Over a long career, Hinchey has tirelessly campaigned to remove PCBs from the river. He continues to serve in Congress as a bold voice for the river.

Governor Pataki devoted much of his effort, in three terms as governor, to revitalizing the Hudson from its source high in the Adirondacks to New York City. He adopted and implemented "Action Plans" for restoring the estuary to its full potential, spending about $400 million on projects that have conserved tens of thousands of acres of scenic vistas and Hudson Valley habitats, created new parks and trails, improved water quality, restored depleted fish populations, promoted conservation science, and accelerated the conversion of brownfield sites to new uses as parks, residential areas, and businesses.[4] His agencies uncovered and restored the ruins of the Fort Montgomery Battle Site, extended the greenbelt around Manhattan in the Highlands through land acquisition, and opened Schodack Island State Park, once the site of the Mohican council fire. At Beacon, he launched a research center fo-

cused on rivers and estuaries. In partnership with New York City, where the West Side Highway would have been, Pataki invested hundreds of millions in the new Hudson River Park, a project first envisioned under New York City Mayor Dinkins and advanced by mayors Giuliani and Bloomberg.

The White House continues to focus on the Hudson as well. In 1996, President Clinton issued an executive order to designate the Hudson as an American Heritage River as part of a federal program to help community organizations fulfill local visions for river conservation. First Lady Laura Bush has supported several historic preservation projects in the valley through her Preserve America Program.

As this book goes to press, newly elected Governor Elliot Spitzer has pledged "to make the Hudson River even cleaner and more accessible to the public." In his campaign speeches, he noted:

> New York's history reminds us that the most intractable environmental problems can be addressed.... Not so long ago, the Hudson was an open sewer. Few people wanted to live along its banks, let alone swim in it or drink from it. But after investing in sewage treatment plants, tightening permits on companies that discharge waste into the river, and restoring wetlands, the river is beginning to make a comeback and waterfront communities will reap the benefits.... Restoring ... the mighty Hudson expanded business opportunities, not the opposite.[5]

This view, that conservation enhances economic growth, is amply supported by the accumulated evidence of five decades of river cleanup. Real estate values increased dramatically when water quality improved. Forests have helped conserve water quality and groundwater supply, providing the equivalent of millions, if not billions, of dollars in public services.

In 2007, as the Port Authority of New York and New Jersey and the U.S. Army Corps of Engineers develop their plans for deepening channels in the harbor—necessary to maintain the world-class status of the port—they are also giving consideration to their role in the ecological revival of the estuary. A report they commissioned cites the importance of understanding the ideas and assumptions behind the concept of habitat restoration. It proposes to restore wild aspects and biological functions of the river while also recognizing the value of recreational access projects that benefit both nature and human culture.[6]

Parks, preserves, and river access sites have similarly improved real estate values and have been the anchors for the renaissance of river communities. Up and down the Hudson today, river cities, towns, and villages are ready to take off. Increasingly their historic, cultural, and natural heritage is viewed as an asset by the local leaders who determine their future direction.

Cleanup of the river has revived its inspirational power. The events of October 2007, typical of any given month lately on the river, show how the Hudson is coming alive again in people's dreams. Press reports that month contained news of two transformative proposals that challenge the skeptics or cast an old opportunity in new terms. These projects may or may not see the light of day, but they illustrate the Hudson's ability to evoke a sense of magnificence and possibility that causes people to tackle difficult challenges. The first report appeared in the *Albany Times Union* in an article about the way the river towns and cities in the Albany area, such as Cohoes, Troy, and Bethlehem, were changing their concept of what the river means.

Citing the river's legacy of noxious pollution, which as recently as 1992 prompted Rensselaer County to decide to locate its jail on the Hudson, the article noted that now "the waterfront is a canvas for big ambition." It quoted developer Victor Gush describing plans to replace an ash dump on the Hudson in Bethlehem, below Albany, with 2.4 million square feet of mixed-use development—stores, apartments, and recreational facilities. "Everyone was looking at us like we had three heads," Gush noted, but he was convinced that polluted shoreland could be replaced with something that would attract people. In Beacon, meanwhile, several news outlets reported on plans of the Clearwater organization, which announced a transformative proposal. Now, seeking to address social justice and ecological health as two sides of the same coin, Clearwater plans to focus on leadership development for people of all ages, including immigrant populations and the under-represented, to generate community revitalization focused on the river and creation of jobs that will make the Hudson Valley a leader in the green revolution. Noting that in nature, diversity is the strength of an ecosystem, Clearwater will seek to turn what has been viewed as a problem—urban proverty—into a solution. It plans to create educational opportunities that mix people of different backgrounds to produce synergies in which the diversity of the valley becomes its strength, and all people can take part in a transformative economy that connects job growth with environmental gains. An October 2007 article in *The New York Times* described another man's dream "to extend Lower Manhattan a little bit farther into the Hudson River." Environmentalists vowed to block it, citing the river's habitat value and new protective laws that point to a different kind of vision for the waterfront that builds on its ecology and recreational potential.[7]

Despite this high level of activity by many people and agencies, not everything has gone well for the Hudson. Countless decisions made at every level have torn at the fabric of the valley's landscape. Faceless sprawl has gradually replaced homes and villages designed with nature in mind. Species that depend on forests, fields, and wetlands are disappearing from the region at a rapid rate, taking with them the trills of springtime, the colors of birds in flight, and the varied beauty of the place we call home. Many valley residents whose grandparents set their clocks by the steamboat schedule or the turning of the tide scarcely know the river is *there*, let alone recognize its moods.

Among the few people who still know the river with deep intimacy are the sport and commercial fishermen. They read the signs of change in what they catch and are often the first to report trouble. However, their use of the river has been constrained by PCBs, a chemical that was banned in the 1970s. PCBs remain in the food chain, and the state has advised sport fishermen to limit their consumption of river fish. PCBs also triggered the closure of the striped bass commercial fishery in 1976, dealing a crushing blow to the net fishermen, who eagerly await the day the river will be sufficiently cleaned up.[8]

A $20 million solution for cleaning up PCBs in the river was proposed in 1978; however, the polluter, General Electric Corporation, fought this effectively in court, in Washington, and in the media, urged on for decades by its own passionate leader. After decades of waffling, the federal Environmental Protection Agency (EPA) forced GE to conduct a pilot cleanup project starting in 2009 that could lead to a larger remediation later. The cost of the project is now approaching one billion dollars.

For every dreamer or fighter who seeks to save a piece of the Hudson, there is another, equally convinced, who pursues a different vision. Ironically, a *lack* of passion

may be the most destructive force. Most of us do not intentionally destroy our precious inheritances—we are merely distracted by other things, and then wonder what happened. Conservation also seems to move in cycles. Interest in reform is followed by fatigue and then a renewed sense of urgency, when a new threat arises. Yet sustained passion and intention are the only things that can save the Hudson. It won't happen without conscious work—either as a team in which everyone cooperates or, perhaps, by the steady efforts of a few inspired people.

The new environmental issues will be global as well as local, and will demand new approaches. Climate change looms on the horizon as a new threat to the Hudson and its ecosystem, as well as its commerce. Scientists are predicting that sea level will rise anywhere from 8 inches to 3 feet in the next 100 years, which will profoundly affect river cities, transportation systems, and the harbor commerce that fuels the economy.[9] The Port Authority of New York and New Jersey Web site notes that the 2006 dollar value of all cargo moving through the port exceeded $149 billion, with 5,577 ship calls that year. Warming temperatures may also give New York a climate more like that of Virginia or Georgia, resulting in changes to its plant and animal species, not to mention the effects on human populations, drinking water, and farmland. New York City's Mayor Michael Bloomberg formed a task force on sustainability to address such climate problems.

Transformative ideas will be needed. Individuals and whole communities must step forward, with passion, not just here but around the world. Can a person make a difference? The answer is yes; this is where change begins. The Hudson has taught us that individuals, when moved to action, can inspire thousands to follow—creating new institutions, new policies, and new precedents.

The story of the Hudson also reminds us that we are part of the natural world, supported by it, inspired by it, nourished by it, frustrated by it—but not separate from it. Nature is part of our consciousness, even if we don't notice it. Our relationship to the river and to the earth is, in fact, primarily a question of how we define ourselves, who we think we are.

We now understand how much the human community depends on the fragile web of life on the planet. In the last five decades, the people of the Hudson's shores have joined their voices to demonstrate the possibilities of establishing a new relationship with the natural world, one that values and seeks to integrate its economic and spiritual importance and reverses patterns of destruction and abuse. This is one of the Hudson's unique contributions to America and the world. As a result, the river valley still maintains what most places have lost: a sense of place and identity and a beauty that continues to inspire.

It is vitally important that this should continue, for we have seen that the river is a creative force for the nation. Will the Hudson River change the world again? Almost certainly. That the nature of the Hudson; that is its disposition.

Frederic Edwin Church (American,
1826–1900). *Sunset, Hudson, New York*.
Brush and oil paint, graphite on thin
paperboard, 8⅟₁₆ x 12¼ inches.

Courtesy of the Cooper Hewitt National Design Museum,
Smithsonian Institution. Gift of Louis P. Church,
(1917-4-1313). Photographed by Matt Flynn

NOTES

PROLOGUE: RIVER OF IMAGINING, PEOPLE OF PASSION AND DREAMS

1. Van der Donck, *"A Description of the New Netherlands."*

1. WORLD'S END, WORLD TRADE, WORLD RIVER: HENRY HUDSON'S FAILED
QUEST, ADRIAEN VAN DER DONCK'S UTOPIAN VISION, AND THE LEGEND
OF THE STORM SHIP

1. Irving, *Knickerbocker's New York*, 447.
2. unn, *The Mohicans and Their Land*, 52.
3. Van der Donck, *A Description of the New Netherlands*, 156. Parts of the translation
 are considered inaccurate, though not these excerpts. A new translation has been
 prepared by Charles Gehring of the New York State Museum in cooperation with the
 New Netherlands Institute and is available on the institute Web site: www.nnp.org.
 The book was first copyrighted in 1653. This version was published in 1656.
4. Quoted in Dunn, *The Mohicans and Their Land*, 36, citing Aupaumut's mid-1700s
 "Extract from an Indian History," *Massachusetts Historical Society* 9:99–100.
5. Information on the Native American history of the Hudson is primarily from Haupt-
 man and Campisi, *Neighbors and Intruders An Ethnohistorical Exploration of the In-
 dians of Hudson's River*; Dunn, *The Mohicans and Their Land*; Hauptman and Knapp,
 Dutch Aboriginal Interaction in New Netherland and Formosa; and Stephen Kent
 Comer, "Brief History of the Mohican People," unpublished paper.
6. Hudson quoted by deLaet, "New World," in Jameson, ed., *Narratives of New Nether-
 land, 1609–1664*, 49.
7. Shorto, *Island at the Center of the World*, 291, 113, 273, 291; Albion, *The Rise of New
 York Port, 1815–1860*, 2. Shorto's groundbreaking book charts the influence of Dutch
 culture in Manhattan on American traditions and explores the transformative role of
 Adriaen Van der Donck.
8. Shorto, *Island at the Center of the World*. Statistics are for 1609–1664.
9. Ibid., 63; Albion, *The Rise of New York Port*, 2.
10. Van der Donck, *A Description of the New Netherlands*, 190.

11. Shorto, *Island at the Center of the World*, 42–43, citing Stokes, *Iconography of Manhattan Island*, 4:60.

12. Steendam, "In Praise of New Netherland," quoted in Carmer, *The Hudson*, 62. Steendam was a slave trader whose Eden was not paradise for all New Netherlanders.

13. Van der Donck, *A Description of the New Netherlands*, 146–180.

14. Ibid., 180, 208, and 179.

15. For more information on the natural history of the estuary, see Boyle, *The Hudson River*; Stanne and Panetta, *The Hudson River*; Limburg, *The Hudson River Ecosystem*; and Levinton and Waldman, eds., *The Hudson River Estuary*.

16. Danckaerts's "Journal" and Kalm's "Travels in North America" are excerpted in Van Zandt, ed., *Chronicles of the Hudson*, 30, 35, 58.

17. Father Isaac Jogues, "Novum Belgium," in Jameson, ed., *Narratives of New Netherland 1609–1664*, 259–260.

18. Goodwin, *Dutch and English on the Hudson*, 34.

19. Dunn, *The Mohicans and Their Land*; Shorto, *Island at the Center of the World*, 50–52.

20. Many Stockbridge-Munsee moved to central New York and later to a reservation in Wisconsin. Enrolled members of the Stockbridge-Munsee band still live in both Stockbridge and Wisconsin. One lives in the Hudson Valley.

21. Selyns was a minister of the Dutch Reform Church both before and after British control of the Hudson Valley. This quote is from Irving, *Tales from Irving*, 30.

22. Van der Donck, *A Description of the New Netherlands*, 147–148.

23. Ibid., 143–144.

24. Danckaerts, "Journal," in Van Zandt, ed., *Chronicles of the Hudson*, 23 and 24, describing visits to the Normanskill and the Cohoes Falls.

25. Edwards's "Personal Narrative" is quoted in O'Brien, *American Sublime*, 77–79.

26. Van der Donck, *A Description of the New Netherlands*, 143.

27. Ibid., 236.

28. Ibid., 236.

29. Ibid., 140.

30. Ibid., 236.

31. Shorto, *Island at the Center of the World*, 243–254; Goodwin, *Dutch and English on the Hudson*, 137–149.

32. Goodwin, *Dutch and English on the Hudson*, 169; Shorto, *Island at the Center of the World*, 303–305.

33. Ibid., 170.

34. Ibid., 171–179.

35. Goodrich, *Man Upon the Sea*, 351.

36. Bruce, *The Hudson*, 81.

37. Brands, *The First American*, 232, 235.

38. The U.S. National Ocean Service nautical chart shows a depth of 175 feet. The 177-foot depth is from the New York State Department of Environmental Conservation and is based on 2000–2003 measurements using advanced technologies.

39. Wilkie, *The Illustrated Hudson River Pilot*, 96, 98.

40. Carroll, "Journal," in Van Zandt, ed., *Chronicles of the Hudson*, 81.

41. Irving, *Bracebridge Hall*, 2:267–269.

1. Ford, ed., *Journals of the Continental Congress 1774–1789*, 2:59–60.
2. Calihan and Larsen, "The Hudson Highlands," 4, quoting from Hornor, "The Obstruction of the Hudson River During the Revolution," *The American Collector* 3 (1926): 436.
3. Force, ed., *American Archives*, 2:1291, 1295.
4. Ibid., 3:1294.
5. Quoted in Schecter, *The Battle for New York*, 60.
6. Fitzpatrick, *The Writings of George Washington*, 138.
7. Letter to John A. Washington, April 29, 1776, Library of Congress, http://lcweb2.loc.gov/ammem/gwhtml/gwhome.html.
8. Letter from New York, May 5, 1776, Library of Congress, http://memory.loc.gov/learn/features/timeline/amrev/north/intent.html.
9. Fitzpatrick, *The Writings of George Washington*, 138.
10. Statistics here and following for battles in the vicinity of Manhattan are from Schecter, *The Battle for New York*, 131–134, 156–157, 162–167, 266–268, 287. The Battle of Brooklyn Heights was also known as the Battle of Long Island.
11. Ibid., 106.
12. Quoted in ibid., 166.
13. Calihan and Larsen, "The Hudson Highlands," 4.
14. Ibid., 1:11–12.
15. Details of Burgoyne's northern campaign in this paragraph and following, including troop strength numbers, casualties, and dates and sequences of events, are from Murray, *The Honor of Command*, 1, 7, 39, 49, 63, 68, 75, 77, 80–85, 91.
16. Ibid., 45 (in secret message illustration).
17. Stedman, *History of the Origin, Progress and Termination of the American War,*, 361.
18. Pratt, "An Account of the British Expedition above the Highlands of the Hudson River and of the Events Connected with the Burning of Kingston in 1777," 139.
19. Ibid., 137, 144, article of 10/23. The Van Steenburgh home is the only building that remained.
20. Ibid., 153.
21. Dwight, *Travels in New England and New York*, 305, 302–303.
22. Jackson, "But It Was in New York: The Empire State and the Making of America," 11.
23. The letter is quoted in Fitzpatrick, *The Writings of George Washington*, and reproduced online by the Library of Congress (memory.loc.gov/ammem/mgwquery.html).
24. Thacher, *Military Journal of the Revolution*, 1862, quoted in Palmer, *The River and the Rock*, 170.
25. Moore and Scott, eds., *The Diary of the American Revolution 1775–1781*, 445.
26. Fitzpatrick, *The Writings of George Washington*, 20:213.
27. Chastellux, "Travels in North America, in the Years 1780–81–82," in Van Zandt, ed., *Chronicles of the Hudson*, 102.
28. John Maude, "Visit to the Falls of Niagara in 1800," in Van Zandt, ed., *Chronicles of the Hudson*, 133.
29. Washington quoted in Hosack, *Memoir of De Witt Clinton*, 278–279.
30. Ibid., 274–275, quoting a letter from Washington to the Marquis de Chastellux.
31.. Taylor, *The Divided Ground*, 6–11.

3. AMERICA'S RIVER OF EMPIRE: ROBERT FULTON'S FOLLY, ROBERT LIVINGSTON'S VENTURE CAPITAL, AND DEWITT CLINTON'S DITCH SPARK THE RISE OF NEW YORK PORT

1. Sale, *The Fire of His Genius*, 10. Sale notes that, although the name of the boat is often given as the *Clermont*, the boat was registered as the *North River Steamboat of Clermont*, and Fulton referred to it as *The North River* and never as *The Clermont*. The true maiden voyage of the boat was an earlier trial run around the harbor.

2. Sutcliffe, *Robert Fulton and the "Clermont,"* 234–327.

3. Ibid., 207, 234.

4. Sale, *The Fire of His Genius*, 121.

5. Buckman, *Old Steamboat Days on the Hudson River*, chapter 2.

6. Sale, *The Fire of His Genius*, 14, 135, 145.

7. Ibid., 148; Albion, *The Rise of New York Port, 1815–1860*, 145.

8. Sale, *The Fire of His Genius*, 112.

9. Ibid., 188–189.

10. Quoted in Burns and Sanders, *New York: An Illustrated History*, 45.

11. Van der Donck, *A Description of the New Netherlands*, 140.

12. Albion, *The Rise of New York Port*, 45.

13. Ibid., 96, 114.

14. Ibid., 120.

15. "New Netherland Ancestors of DeWitt Clinton," http://freepages.genealogy.rootsweb .com/~nnnotables/zdwc.html. Information on DeWitt Clinton and the Erie Canal that follows is from "Clinton, DeWitt" in Johnson and Malone, eds., *Dictionary of American Biography*; Hosack, *Memoir of De Witt Clinton*; and Cornog, *The Birth of Empire*.

16. Lewis, *The Hudson*, 27.

17. Clinton, "Memorial of the Citizens of New York State," 30. This petition signed by the citizens of the state, though without an author name, was written and circulated by DeWitt Clinton.

18. Quotes are of William Weston and Jesse Hawley in Hosack, *Memoir of De Witt Clinton*, 308–309.

19. Shaw, *Canals for a Nation*, 11. The Middlesex Canal connecting the Merrimac River and the Charles River in Massachusetts opened in 1804.

20. Jonas Platt quoted in Hosack, *Memoir of De Witt Clinton*, Appendix, 386.

21. Shaw, *Canals for a Nation*, 23; Hosack, *Memoir of De Witt Clinton*, 347.

22. Shaw, *Canals for a Nation*, 26; Sheriff, *The Artificial River*, 19.

23. Clinton, "Canal Policy," 36.

24. http://www.history.rochester.edu/canal/chron.htm.

25. Gilman, *The Poetry of Traveling in the United States*, 103.

26. Albion, *Rise of New York Port*, 120.

27. Quoted in Hecht, ed. *The Erie Canal Reader*, 43.

28. Colden, *Memoir at the Celebration of the Completion of the New York Canals*, http://www.history.rochester.edu/canal/bib/colden/Memoir.html.

29. Letter to Reverend Blatchford, November 5, 1824, from the RPI archives, http://www.lib.rpi.edu.

30. Buttenweiser, *Manhattan Water-Bound*, 42.

31. Schuyler information is from the New York State Museum, State Education Department. http://www.nysm.nysed.gov/albany/bios/s/sschuyler8492.html.

4. FIRST STOP ON THE AMERICAN TOUR: EUROPE DISCOVERS SYLVANUS THAYER'S WEST POINT, A CATSKILLS SUNRISE, AND A RIVER THAT DEFINES THE AMERICAN CHARACTER

1. In 1847, steamship service connected New York harbor to France and Germany as well.
2. Marryat, *A Diary in America with Remarks on Its Institutions*, 40.
3. Milbert, *Picturesque Itinerary of the Hudson River and Peripheral Parts of North America*, 41 (this work also contains a portfolio of artwork); de Montule, *Travels in America, 1816–1817* (Letter 23, 177, was published in 1821).
4. Clinton quoted in Nash, *The American Environment*, 70.
5. Dickens, *American Notes for General Circulation*, 199.
6. Huth, *Nature and the American*, 74.
7. Buckingham, *America, Historical, Statistical, and Descriptive*, in Van Zandt, ed., *Chronicles of the Hudson*, 223–228, 237–244.
8. Hunt, *Letters about the Hudson and Its Vicinity*, 68.
9. Colyer, *Sketches of the North River*, 58.
10. Willis, *American Scenery*; Lanman, *Summer in the Wilderness*, quoted in Nash, *Wilderness and the American Mind*, 74; Bryant, quoted in Huth, *Nature and the American*, 36.
11. Buckingham, in Van Zandt, ed., *Chronicles of the Hudson*, 246.
12. Leslie, "Recollections of West Point," *Graham's Magazine* (April 1842):207–209, 290–295.
13. Forman, *West Point*, 99.
14. Poe, *Best Known Works of Edgar Allan Poe*, 551–552.
15. Gray, "The Architectural Development of West Point," 4–6.
16. Excerpted in Van Zandt, ed., *Chronicles of the Hudson*, 230–232.
17. Lanman, quoted in Huth, *Nature and the American*, 78; Van Zandt, *The Catskill Mountain House*, 62.
18. Van Zandt, *The Catskill Mountain House*, 144–145, 105.
19. Gilman, *The Poetry of Traveling in the United States*, 80–82.
20. Dickens, *American Notes for General Circulation*, 86.
21. Martineau, *Retrospect of Western Travel*, 1:57.
22. Kemble Butler, *Journal*, 1835, excerpted in Van Zandt, ed., *Chronicles of the Hudson*, 200.

5. AMERICA'S FIRST ARTISTS AND WRITERS: THE SACRED RIVER OF THOMAS COLE, THE MYTHIC RIVER OF WASHINGTON IRVING AND JAMES FENIMORE COOPER

1. All quotes and discussion of Cole, Trumbull, and Durand that follow are from Noble, *The Life and Works of Thomas Cole*, xviii, 34–39, except where otherwise noted.
2. Cole, "Essay on American Scenery," *American Monthly Magazine* (1 January 1836). Available at http://www.geocities.com/steletti/pages/scenery.html.
3. Driscoll, *All That Is Glorious Around Us: Paintings from the Hudson River School*, 9.
4. Howat, *The Hudson River and Its Painters*, 27.
5. Durand, quoted in McShine, ed., *The Natural Paradise: Painting in America 1800–1950*, 62.
6. Kemble, *Journal of a Residence in America* (1835), excerpted in Van Zandt, ed., *Chronicles of the Hudson*, 199.
7. O'Brien, *American Sublime*, 124.
8. The Alice Curtis Desmond and Hamilton Fish Library in Garrison, New York has started a comprehensive reference collection of the work of the Hudson River School.

9. Noble, *The Life and Works of Thomas Cole,* 35.

10. Statistics and quote from Adler, *Early Days in the Adirondacks,* 37.

11. See also chapter 1.

12. Irving, *Knickerbocker's New York,* 13.

13. Bruce, *Along the Hudson with Washington Irving,* 44–47.

14. Funk, "Knickerbocker's New Netherland: Washington Irving's Representation of Dutch Life on the Hudson," in Harinck and Krabbendam, eds., *Amsterdam–New York,* 135–147.

15. Shorto, *Island at the Center of the World,* 3.

16. Dickens, *American Notes for General Circulation,* 71.

17. O'Brien, *American Sublime,* 294.

18. Bruce, *Along the Hudson with Washington Irving,* 9.

19. Ibid., 9, 11–12.

20. Irving, *Washington Irving's Sketch Book: The Classic Artist's Edition of 1863,* 70.

21. Ibid., 77.

22. Cooper, *The Last of the Mohicans,* 531–532.

23. Cooper, *The Pioneers, Leatherstocking Tales,* 295–296.

24. Callow, *Kindred Spirits,* 119.

25. Bryant, "Thanatopsis," in Huth, *Nature and the American,* 31.

26. Huth, *Nature and the American,* 30.

27. Smith, *Edinburgh Review* 33 (January 1820): 79.

28. Irving, *The Crayon Miscellany, The Complete Works of Washington Irving,* 22:136.

29. Cooper, quoted in Driscoll, *All That Is Glorious Around Us,* 5.

30. Cole, "Essay on American Scenery."

31. Willis, *Outdoors at Idlewild,* 188.

32. Bruce, *Along the Hudson with Washington Irving,* 128.

33. Drake, *The Culprit Fay,* 13.

34. Howat, *The Hudson River and Its Painters,* 35.

35. Cooper, *The Last of the Mohicans,* 532.

36. Pittman, "James Wallace Pinchot (1831–1908)," 5–6. He gave his son the first name Gifford in honor of the painter.

37. Cole, "Essay on American Scenery."

38. There is a portrait of Bryant at the Century Club in Manhattan.

39. Callow, *Kindred Spirits,* 19–28, 169–170.

40. Novotny, "Research Reports," 1–4.

41. Emerson, *Nature* (1836), chapter 4 (http://www.vcu.edu/engweb/transcendentalism/authors/emerson/nature.html).

42. Horrell, *Seneca Ray Stoddard,* 43–45.

43. Melville, *Moby-Dick or, The Whale,* 187.

44. Willis, *Outdoors at Idlewild,* 28.

45. "Gouverneur Kemble," in Johnson and Malone, eds., *Dictionary of American Biography.*

6. THE INDUSTRIALIZED RIVER: GOUVERNEUR KEMBLE'S WEAPON WORKS, HENRY BURDEN'S IRON FOUNDRIES, AND COLONEL STEVENS'S ENGINE FACTORY

1. Putnam County Historical Society, "Putnam County History Workshop," 1955, letter dated December 13, 1852.

2. "Gouverneur Kemble and West Point Foundry," *Americana* 30:467; "Gouverneur Kemble," in Johnson and Malone, eds., *Dictionary of American Biography,* 316–317. Verne's novel was later made into a movie, *Trip to the Moon.*

3. Blake, *The History of Putnam County*, 244; Rutsch, Cotz, Morrell, Githens, and Eisenberg, *The West Point Foundry Site*, 39.

4. As early as 1807, Troy began to develop as a site of iron manufacture, but after the Erie and Champlain canals opened, new money came in and production took off. Originally, Greater Troy included Green Island and Watervliet (West Troy).

5. Undated mid-nineteenth century quote in Phelan and Carroll, *Hudson-Mohawk Gateway*, 33.

6. Information on Henry Burden and his iron works from "Burden, Henry," in Johnson and Malone, eds., *Dictionary of American Biography*, 272; Vogel, *A Report of the Mohawk-Hudson Area Survey*, 3, 73–90; Weise, *Troy's One Hundred Years*, 268; and Phelan and Carroll, *Hudson-Mohawk Gateway*.

7. Vogel, *A Report of the Mohawk-Hudson Area Survey*, 79.

8. Ibid., 90.

9. Weise, *Troy's One Hundred Years*, 269–278.

10. Wilson, *Thirty Years of History of Cold Spring and Vicinity*, 15–16.

11. Burrows and Wallace, *Gotham*, 441, 443, 663; Albion, *The Rise of New York Port*, 148–151.

12. Albion, *The Rise of New York Port*, 148–150.

13. Proctor and Matuszeski, *Gritty Cities*, 92; Albion, *The Rise of New York Port*, 150; Stevens Institute Web site, www.stevens.edu.

14. Weise, *Troy's One Hundred Years*, 273; 57–59; Vogel, *A Report of the Mohawk-Hudson Area Survey*, 61.

15. Weise, *Troy's One Hundred Years*, 268; Vogel, *A Report of the Mohawk-Hudson Area Survey*, 79.

16. Hutton, *The Great Hudson River Brick Industry*, 10, 69.

17. McMartin, *The Great Forest of the Adirondacks*, 48, 62, 63.

18. Vogel, *A Report of the Mohawk-Hudson Area Survey*, 122.

19. William Bean, 1873, quoted in Vogel, *A Report of the Mohawk-Hudson Area Survey*, 106, 114; Proctor and Matuszeski, *Gritty Cities*, 211.

20. Weise, *Troy's One Hundred Years*, 272.

21. Proctor and Matuszeski, *Gritty Cities*, 211.

22. In 1911, family members donated the castle and the land to Stevens Institute of Technology.

23. Adler, *Early Days in the Adirondacks*, 37.

24. Lossing, *The Hudson*, 141.

25. Proudfit, quoted in Vogel, *Mohawk-Hudson Area Survey*, 85–89.

26. Buttenweiser, *Manhattan Water-Bound*, 45; Harris and Pickham, "Landscape, Land Use, and the Iconography of Space in the Hudson River Valley."

27. Van Zandt, *Chronicles of the Hudson*, 202.

28. Lossing, *The Hudson*, 246.

29. Proudfit, quoted in Vogel, *A Report of the Mohawk-Hudson Area Survey*, 85–89.

7. GOING UP THE RIVER FOR HEALTH AND FUN: NEW YORK CITY
JOURNALIST N. P. WILLIS SURVIVES TB AND DISCOVERS AN IDLE WILD

1. The history of cholera, tuberculosis, and yellow fever is described in Koeppel, *Water for Gotham*; Galusha, *Liquid Assets*; Van Zandt, *The Catskill Mountain House*; and online at www.nobelprize.org.

2. Quote of Dr. Edward Miller is in Koeppel, *Water for Gotham*, 116.

3. Ibid., 3.

4. Van Zandt, *The Catskill Mountain House*, 252.

5. Buckingham, quoted in Van Zandt, *The Catskill Mountain House*, 221

6. Willis, *Outdoors at Idlewild*, v, 399.

7. Ibid., 23–24.

8. Quotes from Holmes and Lowell are from "Nathaniel Parker Willis," in Johnson and Malone, eds., *Dictionary of American Biography*, 306.

9. Willis, *Outdoors at Idlewild*, 236, 238, 244.

10. Quote of Dr. Edward Miller is in Koeppel, *Water for Gotham*, 116.

11. Beach, *Cornwall*, 154.

12. Bruce, *The Hudson by Daylight*, 169.

13. Donaldson, *A History of the Adirondacks*, 148.

14. Bruce, *The Hudson by Daylight*, 136.

15. Willis, *Outdoors at Idlewild*, 46.

16. Roosevelt, *Theodore Roosevelt's Diaries*, 3–9

17. Van der Donck, *A Description of the New Netherlands*, 146

18. In 1882, when German scientist Robert Koch discovered the tuberculosis bacillus, Trudeau set up his own laboratory to conduct experiments. This sanatorium remained open until 1954, when drugs that could cure tuberculosis were discovered and became available.

19. Roosevelt, *Theodore Roosevelt's Diaries*, 244–247.

20. Huth, *Nature and the American*, 55.

21. Ibid., 56.

22. O'Brien, *American Sublime*, 196.

23. Paraphrased in Huth, *Nature and the American*, 111.

24. Adams, *The Hudson*, 95.

25. McGrath, "Camp Woods, Ossining, NY," 87.

26. Willis, *Outdoors at Idlewild*, 141, 48.

27. Ibid., 47.

28. The Roosevelts made their initial fortune in sugar refining, a major New York City business before refrigerated railcars eliminated the need for urban slaughterhouses—which also provided the blood and bones used in purifying sugar.

8. DESIGN WITH NATURE: THE LANDSCAPE GARDENS OF A. J. DOWNING, THE ARCHITECTURE OF A. J. DAVIS, AND THE INSPIRATION FOR CENTRAL PARK AND RIVERSIDE DRIVE

1. "American Highland Scenery: Beacon Hill," 293–294.

2. Downing, *A Treatise on the Theory and Practice of Landscape Gardening Adapted to North America With a View to the Improvement of Country Residences*, 6th ed., 30.

3. Schuyler, *Apostle of Taste*, 22.

4. Peck, ed., *Alexander Jackson Davis*, 14.

5. Downing, *A Treatise on the Theory and Practice of Landscape Gardening*, 6th ed., 30–31.

6. Davies, "Davis and Downing," in Tatum and McDougal, eds., *Prophet with Honor*, 86.

7. Downing, *A Treatise on the Theory and Practice of Landscape Gardening Adapted to North America With a View to the Improvement of Country Residences*, 7th ed., 58, 59, 328–329.

8. Downing, *The Architecture of Country Houses*, 186–187.

9. Anderson, *Carolinian on the Hudson*, 157, 180–181, 183.

10. Downing, "A Visit to Montgomery Place," *The Horticulturist, and Journal of Rural Art and Rural Taste* II, no. 4 (October 1847), reproduced in Haley, ed., *Pleasure Grounds*, 47.

11. Downing, *Treatise* (1859 edition), 328.

12. Carmer, *The Hudson*, 234–235.

13. Quoted in Huth, *Nature and the American*, 122–124.

14. Downing, *Treatise* (1859 edition), vii, 29.

15. Schuyler, *Apostle of Taste*, 72.

16. Examples can be seen on the City of Newburgh Web site and on http://www.first-stepsdesign.com/photojournalajdowning.htm.

17. Mitchell, *Out-of-Town Places*,3–7.

18. Francis Kowsky, "Downing's Architectural Legacy" in Tatum and McDougal, eds., *Prophet with Honor*, 283–284.

19. Quoted in Carmer, *The Hudson*, 249.

20. Neil Larsen, draft paper, untitled, on historic architecture of the Hudson Highlands, New York State Office of Parks, Recreation and Historic Preservation, 1981.

9. GATEWAY TO AMERICA, ESCAPE ROUTE TO CANADA: IMMIGRANTS GREET A BEACON OF LIBERTY, JOHN JERVIS CREATES A NEW RIVER ROUTE, AND A RAILROAD GOES UNDERGROUND

1. Quoted in Elizabeth Koed, "A Symbol Transformed—The Statue of Liberty," *The Social Contract* (Spring 1993), http://www.thesocialcontract.com.

2. David Moffitt, National Park Service Superintendent of the Statue of Liberty–Ellis Island National Monument in 1986, quoted in Bishop, *Gateway to America*, 62.

3. Jervis, "Report on the Project of a Railroad," 37.

4. Ibid., 3.

5. Jervis, "The Hudson River Railroad," 1.

6. Hudson River Rail Road Company, "Statement Showing the Prospects of Business and the Importance of the Proposed Rail Road," 14.

7. Jervis, "Report on the Project of a Railroad," 11.

8. The Hudson River Railroad Company later merged with the New York Central and prospered. It was one of the few railroads to survive the depression from 1893 to 1896, when 156 other rail lines failed.

9. Hungerford, *Men and Iron*, 164–165.

10. Jervis, "The Hudson River Railroad," 5–6.

11. Fitzsimons, ed., *The Reminiscences of John B. Jervis*, 178.

12. Blake, *The History of Putnam County, NY*, 166.

13. Bishop, *Gateway to America*, 76–77.

14. Holley and Smith, "The Albany and Rensselaer Iron and Steel Works, Troy, N.Y.," 590–591.

15. Bordewich, *Bound for Canaan*, 177.

16. Phelan and Carroll, *Hudson Mohawk Gateway*, 84. The 1850 Fugitive Slave Act created stiff penalties for allowing fugitive slaves to remain in free states. Many prosperous African American businesspeople fled the Hudson Valley to save their lives, going across the northern border.

10. MILLIONAIRES' ROW: THE RIVER CASTLES OF J. P. MORGAN, JOHN D. ROCKEFELLER, JAY GOULD, AND FREDERIC CHURCH, AND THE FLOATING PALACES OF MANHATTAN'S WEST SIDE

1. Collier and Horowitz, *The Rockefellers*, 24–25.
2. Bigelow, *Seventy Summers*, 47–48.
3. Huth, *Nature and the American*, 103.
4. Ibid.
5. Roosevelt, *Theodore Roosevelt's Diaries of Boyhood and Youth*, 1–10, 225–260.
6. Mearns, "Birds of the Hudson Highlands," 12:124, 13:86; 12:127–128.
7. Cook, "Memoirs," mimeograph courtesy of Anne and Constantine Sidamon-Eristoff, Highland Falls, NY, CR8–9. The Pell family noted by Cook was a prominent presence in the Hudson Valley and on Lake Champlain. Pell family archives are said to contain rich historical material about the river.
8. "John Pierpont Morgan," in Johnson and Malone, eds., *Dictionary of American Biography*, 200.
9. Cook, "Memoirs," HF1–3.
10. Winkler, *The First Billion*, 52.
11. Roberts, *Rockefeller Family Home Kykuit*, 9.
12. Ibid., 10.
13. Ibid., 13.
14. Quoted in Nash, *Wilderness and the American Mind*, 106.
15. Ibid., 106.
16. Quotes from "Gospel of Wealth," *North American Review* (1889) and Rockefeller reply, in Collier and Horowitz, *The Rockefellers,*, 49.
17. Ibid., 63, 135.
18. Ibid., 49.
19. The letters and pencil sketch by Frederic Church for William Henry Osborn are in the archives of the Olana State Historic Site, Hudson, NY. Correspondence dated 29 July 1868, 4 November 1868, 9 November 1868.
20. Susan Hale to her sister Lucretia, 29 July 1884, Sophia Smith Collection, Smith College, Northampton, MA. (Courtesy of Olana State Historic Site).
21. Ryan, *Frederic Church's Olana*, 52.
22. Ibid., 58.
23. Coincidentally, Gould was a classmate of John Burroughs in Roxbury. The two farm boys—who grew up to become icons of the nineteenth century, but with very different notions about the use of nature—attended the tiny one-room schoolhouse at the same time.
24. Smith, *The Great Estates Region of the Hudson River Valley*, 41.
25. Gray, "The Architectural Development of West Point," 14.

11. A FOREST TO PROTECT A COMMERCIAL RIVER: LAND SURVEYOR VERPLANCK COLVIN, PHOTOGRAPHER SENECA RAY STODDARD, AND THE NEW YORK BOARD OF TRADE CAMPAIGN TO SAFEGUARD THE HUDSON IN THE ADIRONDACKS

1. American Scenic and Historic Preservation Society (ASHPS), *Scenic and Historic America* 5, no. 3 (May 1940): 11.
2. *The New York Times*, 1864 editorial; Commission on Parks report 1872 in Schaefer, ed., *Adirondack Explorations*, 99.
3. Marsh, *Man and Nature by George Perkins Marsh*, 42.

4. Ibid..

5. Schaefer, ed., *Adirondack Explorations*, 15.

6. Ibid., 16.

7. Ibid., 5, 16.

8. Colvin, "Ascent of Mount Seward and its Barometrical Measurement," in Schaefer, ed. *Adirondack Explorations*, 97.

9. Schaefer, ed. *Adirondack Explorations*, 98.

10. "First Annual Report of the Commissioners of State Parks of the State of New York" (1871), reproduced in Schaefer, ed. *Adirondack Explorations*, 109, 112, 115, 116.

11. "Report on the Topographical Survey of the Adirondack Wilderness of New York," 1872, in Schaefer, ed., *Adirondack Explorations*, 152.

12. Ibid., 153.

13. Graham, *The Adirondack Park*, 98.

14. Nash, *Wilderness and the American Mind*, 119.

15. Graham, *The Adirondack Park*, 99.

16. Donaldson, *A History of the Adirondacks*, 2:172.

17. Graham, *The Adirondack Park*, 103.

18. Ibid., 100.

19. Donaldson, *A History of the Adirondacks*, 173.

20. "Proceedings of the Annual Banquet of the New York Board of Trade and Transportation, February 23, 1885," in Schaefer, ed., *Adirondack Explorations*, 30–33.

21. The legislation was signed by Governor David B. Hill.

22. Stoddard was listed in the 1878 "Seventh Annual Report" as director of photography but may also have been on surveys from 1873 to the 1880s.

23. Quoted in Horrell, *Seneca Ray Stoddard*, 60.

24. Terrie, *Contested Terrain*, 100.

25. "A Tour on Canvass," 1892, quoted in Horrell, *Seneca Ray Stoddard*, 65–66.

26. Graham, *The Adirondack Park*, 124.

27. Terrie, *Contested Terrain*, 101–102.

28. Donaldson, *A History of the Adirondacks*, 2:188.

29. Van Valkenburgh, ed., *Report of the Superintendent of the State Land Survey of the State of New York for the year 1898*, ii.

30. State of New York, "In Convention. Record. No. 113, 9/8/1894."

31. Nash, *Wilderness and the American Mind*, 137.

32. A "Catskill Park" similar to the Adirondack Park was created in 1904.

12. AN INTERSTATE PARK FOR THE PALISADES AND THE HIGHLANDS AND A NEW PROGRESSIVE VISION: ELIZABETH VERMILYE'S WOMEN'S CLUBS, EDWARD AND MARY HARRIMAN'S PARK, MRS. OLMSTED'S FRESH AIR CAMP, AND MARGARET SAGE'S CHARITY

1. O'Brien, *American Sublime*, 243, 325.

2. Howell, *The Hudson Highlands*, 1:2.

3. Howell, *Highland Notes*, n.p.

4. Palisades Interstate Park Commission (PIPC), *Sixty Years of Park Cooperation*, 17; American Scenic and Historic Preservation Society (ASHPS), *Scenic and Historic America* 2, no. 2 (June) 1930): 16.

5. Binnewies, *Palisades*, 24.

6. Ibid., 12.

7. Ibid., 12–17.

8. F. P. Albert, letter to Eben E. Olcott, 16 June 1908.

9. Howell, *Highland Notes*, entry dated May 1, 1909.

10. ASHPS, "Thirteenth Annual Report," 1908.

11. Although this bill did not pass, this vision has been substantially achieved on the west shore of the Hudson over the course of the last 100 years; on the east shore, land acquisitions continue to expand. Federal legislation passed in 2004 will continue this progress on both the east and west shores of the Highlands.

12. ASHPS, "Thirteenth Annual Report," 1908.

13. Handwritten notes from collection of the ASHPS, New York Public Library, 241.

14. ASHPS, *Scenic and Historic America* 2, no. 2 (June 1930): 27.

15. Original petition, from the personal collection of J. W. Aldrich.

16. This, despite the fact that President Theodore Roosevelt, himself an ardent conservationist, hosted a conference of governors at the White House on the subject in 1908.

17. As reported in the Fourth Annual Report to the Legislature of the Hudson–Fulton Celebration Commission.

18. Kennan, *E. H. Harriman.*

19. PIPC, *Sixty Years of Park Cooperation*, 25.

20. These quotes from Muir, and those that follow, are from Muir, *Edward Henry Harriman*, 3–6, 35–36.

21. Kennan, *E. H. Harriman*, 2:33.

22. Ibid., 2:31–32, 2:339, 2:339–340, 2:343.

23. PIPC, *Sixty Years of Park Cooperation*, 31.

13. OVER, UNDER, ACROSS, AND THROUGH: CIVIL ENGINEERS TRIUMPH OVER NATURE, EXCEPT IN NEW YORK HARBOR

1. New York State Hudson–Fulton Celebration Commission, *The Hudson Fulton Celebration 1909.*

2. Anonymous, "Vivid Panorama of the Flood"; Hayner, *Troy and Rensselaer County New York*, 1:151–152.

3. State Water Supply Commission of New York, *Second Annual Report*, 18–19.

4. State Water Supply Commission of New York, *Sixth Annual Report*, 31. The paper companies included Finch-Pruyn, Union Bag and Paper Company, Iroquois Pulp and Paper Company, West Virginia Pulp and Paper Company, and International Paper.

5. State of New York, *First Annual Report of the Conservation Commission 1911* II:7–8.

6. Hudson River Regulating District, "Sacandaga Reservoir: Its Purpose and Operation."

7. The quote is of a Mr. Genet from an 1819 commission report extensively excerpted in U.S. Department of the Army, Office of the Chief of Engineers, "Survey of Hudson River—Report of Colonel of Corps of Topographical Engineers," 4.

8. Metropolitan Sewerage Commission of New York, *Sewerage and Sewage Disposal in the Metropolitan District of New York and New Jersey*, 112.

9. Metropolitan Sewerage Commission of New York, *Main Drainage and Sewage Disposal*, 77.

10. Metropolitan Sewerage Commission of New York, *Sewerage and Sewage Disposal*, 125.

11. Ibid., 27.

12. Ibid., 83.

13. Metropolitan Sewerage Commission of New York, *Main Drainage and Sewage Disposal*, 82.

14. Metropolitan Sewerage Commission of New York, *Sewerage and Sewage Disposal*, 79–80.

15. Metropolitan Sewerage Commission of New York, *Main Drainage and Sewage Disposal*, 105.

16. Ibid., 103.

17. Metropolitan Sewerage Commission of New York, *Present Sanitary Condition of New York Harbor*, 37.

18. Hurley, "Creating Ecological Wastelands," 340–364.

19. Metropolitan Sewerage Commission of New York, *Main Drainage and Sewage Disposal*, 23.

20. Hurley, "Creating Ecological Wastelands," 340–364.

21. Ibid., 343.

22. Hetling, Stoddard, Brosnan, Hammerman, and Norris, "Effect of Water Quality Management on Wastewater Loadings During the Past Century," 33.

23. Mitchell, "The Bottom of the Harbor" from *Up in the Old Hotel and Other Stories*, 465.

24. Ibid., 585.

25. Ibid., 487–488.

26. Galusha, *Liquid Assets*, 73.

27. State Water Supply Commission of New York, *Second Annual Report*, 82–83.

28. White, *The Catskill Water Supply of New York City*. All references to White's observations are from 95, 101–103, 102, 427, 417, iii.

29. Howell, *The Hudson Highlands*, 153.

30. Galusha, *Liquid Assets*, 97, 128.

31. New York Public Library, *An Exhibition Illustrating the History of the Water Supply of the City of New York from 1639 to 1917*, 101–103.

32. Fitzherbert, "William G. McAdoo and the Hudson Tubes."

33. Whitney, *Bridges*, 195.

34. "An Infliction of Ugliness on the Hudson," editorial, *The New York Times*, July 20, 1923.

35. Roebling, quoted in Steinman, "The Place of the Engineer," 33.

36. Mulligan, "Bear Mt. Bridge—at age 50," Associated Press; undated, unidentified news clip from scrapbook at Bear Mountain State Park Archives.

14. SURVIVING THE DEPRESSION, CONNECTING WITH NATURE: FDR'S RIVER OF DIGNITY, ROBERT MOSES'S RIVERSIDE DRIVE, AND JOHN D. ROCKEFELLER JR.'S PARKWAY

1. American Scenic and Historical Preservation Society (ASHPS), *Scenic and Historic America* 5, no. 3 (May 1940): 11, 20. This bulletin is a special retrospective issue on Hudson River Conservation and provided much of the information for this chapter.

2. Hudson River Conservation Society (HRCS), *First Annual Report*, 22–23.

3. ASHPS, *Scenic and Historic America* 5, no. 3 (May 1940): 28–29.

4. "Annual Message: The Hudson River," reprinted in HRCS, *First Annual Report*, 7.

5. Ibid.

6. Ibid., 21–23. Corning's speech is reproduced in full.

7. Ibid., 24–25.

8. Sara Delano Roosevelt, *My Boy Franklin*, 7.

9. Franklin D. Roosevelt, "Extemporaneous Remarks at the Celebration of the Fiftieth Anniversary of State Conservation at Lake Placid."

10. Franklin D. Roosevelt, "Remarks at Clarksburg, West Virginia," October 29, 1944, Franklin D. Roosevelt Collection of Speeches.

11. Franklin D. Roosevelt, "Extemporaneous Remarks at the Celebration of the Fiftieth Anniversary of State Conservation at Lake Placid."

12. Patton, "Forestry and Politics,"400.

13. Nixon, ed., *Franklin D. Roosevelt and Conservation 1911–1945*, vol. I, letter 361, 380–381.

14. Ibid., 204; Caro, *The Power Broker*, 287–291.

15. Patton, "Forestry and Politics," 400, 404, 417–418.

16. October 19, 1928 speech at Jamestown, New York quoted in ibid., 400.

17. Morgenthau quoted in Blum, *From the Morgenthau Diaries*, 26–27.

18. Ibid., 27.

19. Franklin D. Roosevelt, "Address before the Conference of Governors on Land Utilization and State Planning."

20. Aldrich, "The Civilian Conservation Corps—New York's Enduring Legacy," 2.

21. Details on Moses that follow are in Caro, *The Power Broker*, 508–509, 363, 369, 372, 549–556.

22. Buttenwieser, *Manhattan Water-Bound*, 140.

23. Caro, *The Power Broker*, 543.

24. Ibid., 555.

25. Franklin D. Roosevelt, "Address at the Dedication of the New Post Office."

26. Smith, *The Great Estates Region of the Hudson River Valley*, 48, 53.

27. Franklin D. Roosevelt, letter to Van Webb, Washington, 6 September 1933.

28. Carmer, *The Hudson*, 401–402.

29. Palisades Interstate Park Commission (PIPC), *Sixty Years of Park Cooperation*, 62.

30. Schaefer, "The Tragedy of the Hudson," 135.

31. PIPC, *Sixty Years of Park Cooperation*, 51.

32. Stephen Fox, *The American Conservation Movement*, quoted in Winks, *Laurance S. Rockefeller*, 75.

33. Willard A. Bruce, "Capital District Area Special Study," 2–10.

15. THE 1960S: SCENIC HUDSON, RIVERKEEPER, CLEARWATER, AND THE NATURE CONSERVANCY CAMPAIGN TO SAVE A MOUNTAIN AND REVIVE A "DEAD" RIVER

1. Scenic Hudson Preservation Conference, "Some Important Dates in Storm King History," June 26, 1968, Marist College Library, Hudson River Collections, Poughkeepsie, NY.

2. *The New York Times*, September 27, 1962, 1.

3. Consolidated Edison Company of New York, "The Cornwall Hydroelectric Project: Power and Beauty for Tomorrow." Con Edison Archives, New York, NY.

4. Talbot, *Power Along the Hudson*, 84.

5. Ibid., 85.

6. *The New York Times*, May 22, 1963.

7. Talbot, *Power Along the Hudson*, 97.

8. Carmer, quoted in Doty, *Initial Brief to the Hearing Examiner*, 23–26.

9. LeBoeuf, Brief for Applicant, 6, 14–16; Talbot, *Power Along the Hudson*, 99–106.

10. "Must God's Junkyard Grow?" *Life* (July 31, 1964).

11. Talbot, *Power Along the Hudson*, 108–110.

12. Ibid., 115. Garrison was a partner in the law firm of Paul, Weiss, Rifkind, Wharton, and Garrison. Butzel later took the case to his own firm, Berle and Butzel.

13. H.R. 3012, 89th Cong., XX sess.

14. Senator Robert F. Kennedy; speech of March 4, 1965 published in "The Hudson: A River in Peril," *Congressional Record*, 1.

15. Congressman Richard Ottinger, speech of May 3, 1965 published in "The Hudson: A River in Peril," *Congressional Record*, 1.

16. U.S. Court of Appeals, Second Circuit; *Scenic Hudson Preservation Conference v. Federal Power Commission*, in Sandler and Schoenbrod, eds., *The Hudson River Power Plant Settlement*, 55–67.

17. Hudson River Valley Commission, *The Hudson: Summary Report*, February 1, 1966, 15.

18. Scully, in U.S. Federal Power Commission, "Testimony before the Federal Power Commission, Project No. 2338."

19. Atkinson, in U.S. Federal Power Commission, "Testimony before the Federal Power Commission, Project No. 2338."

20. Pough, in U.S. Federal Power Commission, "Testimony before the Federal Power Commission, Project No. 2338."

21. Harrison, in U.S. Federal Power Commission, "Testimony before the Federal Power Commission, Project No. 2338."

22. Scenic Hudson Preservation Conference Bulletin #25, November 1967.

23. James Cope (the chairman of Selvage and Lee) and his assistants, Lou Frankel, Ray Baker, and William "Mike" Kitzmiller, all worked on the case. Scenic Hudson hired an executive director, Rod Vandivert, who worked in the Selvage and Lee offices for a number of years. He was later joined by assistant Nancy Mathews, who was also active in the Sierra Club.

24. *The Harvard Crimson*, February 17, 1972.

25. *Newsweek* (March 5, 1969).

26. Shaefer, *Defending the Wilderness*, 137–140; also The Association for the Protection of the Adirondacks Web site: http://www.protectadk.org.

27. Central Hudson Gas and Electric Corp., letter to the Public Service Commission; quoted in the *Peekskill Evening Star*, undated news clip (c. 1970), Marist College Library, Poughkeepsie, NY.

28. "Sailing Up My Dirty Stream," http://www.peteseeger.net/dirtystre.htm.

29. Pete Seeger, "How the Clearwater Got Started," unpublished, undated (c. 1984) manuscript, provided by Hudson River Sloop Clearwater in 2004.

30. Ibid.

31. "Clearwater Carrying Pollution Drive to Washington," *The New York Times*, April 15, 1970. Quoted on Hudson River Sloop Clearwater, www.clearwater.org.

32. "National Register of Historic Places Statement of Significance," Hudson River Sloop Clearwater, 2004, www.clearwater.org.

33. Boyle, *The Hudson River*, 272.

34. Cronin and Kennedy, *The Riverkeepers*, 44.

35. Boyle, *The Hudson River*, 296–300.

36. U.S. Federal Power Commission, Opinion No. 584, Consolidated Edison Co. of New York, Project No. 2338, "Opinion and Order Issuing License Under Part I of the Federal Power Act."

37. U.S. Court of Appeals, Second Circuit, Hudson River Fishermen's Association v. Federal Power Commission, 498 F.2d.827 (2d. Cir. 1974), in Sandler and Schoenbrod, eds., *The Hudson River Power Plant Settlement*, 97.

38. Luce, "Power for Tomorrow: The Siting Dilemma."

39. Mid-Hudson Pattern for Progress, December 5, 1964. Conference Proceedings, 1965, 23–26.

40. Cronin and Kennedy, *The Riverkeepers*, 131.
41. Willis, *Outdoors at Idlewild*, 188.
42. Westway and the expressway are described in Cronin and Kennedy, *The Riverkeepers*, chapter 6.

EPILOGUE: A RIVER OF POWER, AND THE POWER OF PASSION

1. New York State Department of State, letter to David Loomes, St. Lawrence Cement Co., "Objection to Consistency Determination."
2. Middletown, NY *Times Herald Record*, June 6, 2006.
3. Bishop, *Gateway to America*, 75–95.
4. New York State Department of Environmental Conservation, "Hudson River Estuary: Report on Ten Years of Progress," 2006, 1–24.
5. Spitzer, Campaign Speech on Environmental Stewardship.
6. Hudson River Foundation, "Target Ecosystem Characteristics for the NY/NJ Harbor Estuary."
7. Chris Churchill, "Rethinking the Riverfront: New Ideas Take Root on How to Use Areas Along the Hudson and Mohawk Waterways," *Albany Times Union*, October 28, 2007; Patrick McGeehan, "Man's Vision to Carve Prime Real Estate From Hudson River Proves a Tough Sell," *The New York Times*, October 16, 2007.
8. Commercial fishing oral history archives are available at the Hudson River Foundation in New York City, and more are now being compiled by the Beacon Institute, Beacon, New York.
9. Union of Concerned Scientists, 2006.

BIBLIOGRAPHY

"A Central Park for the World." Editorial, *The New York Times*. August 9, 1864.

Adams, Arthur G. *The Hudson River in Literature: An Anthology.* Albany: State University of New York Press, 1980.

———. *The Hudson: A Guidebook to the River.* Albany: State University of New York Press, 1981.

Adler, Jeanne Winston. *Early Days in the Adirondacks: The Photographs of Seneca Ray Stoddard.* New York: Abrams, 1997.

Albert, F. P. Letter to Francis Lynde Stetson, chairman, Law Committee, Hudson-Fulton Celebration, 16 December 1907. Collection of the Hudson River Conservation Society. Marist College Library, Poughkeepsie, NY.

———. Letter to Eben E. Olcott, 16 June 1908. Collection of the Hudson River Conservation Society.

Albion, Robert Greenhalgh. *The Rise of New York Port, 1815–1860.* New York: Scribner's, 1970.

Aldrich, J. Winthrop. "The Civilian Conservation Corps—New York's Enduring Legacy." *New York State Preservationist* (Albany, New York State Office of Parks, Recreation, and Historic Preservation [NYSOPRHP]) Fall/Winter 1999.

"American Highland Scenery: Beacon Hill." *New York Mirror* 12, no. 37 (March 14, 1835).

American Scenic and Historic Preservation Society. "Thirteenth Annual Report." 1908. Marist College Library, Poughkeepsie, NY.

———. *Scenic and Historic America* 2, no. 2 (June 1930).

———. "Mount Taurus Quarry to Be Stopped." *Scenic and Historic America* 3, no. 2 (June 1931).

———. *Scenic and Historic America* 5, no. 3 (May 1940). Special bulletin on Hudson River Conservation. Joint publication with the Hudson River Conservation Society.

Americana, vol. 30. New York: The American Historical Society, 1936.

"An Infliction of Ugliness on the Hudson." Editorial, *The New York Times*. July 20, 1923.

Anderson, Jean Bradley. *Carolinian on the Hudson: The Life of Robert Donaldson.* Raleigh: University of North Carolina Press, 1996.

Anonymous. "Vivid Panorama of the Flood." Pamphlet. 1913. Rensselaer County Historical Society, Troy, New York.

Beach, Lewis. *Cornwall.* New York: E. M. Ruttenber and Son, 1873.

Berkey, Charles P. "Geology of the New York City (Catskill) Aqueduct." *Education Department Bulletin No. 489; New York State Museum Bulletin 146.* Albany: University of the State of New York, 1911.

Bigelow, Poultney. *Seventy Summers.* London: Edward Arnold, 1925.

Binnewies, Robert O. *Palisades: 100,000 Acres in 100 Years.* New York: Fordham University Press and Palisades Interstate Park Commission, 2001.

Bishop, Gordon. *Gateway to America.* Columbia, SC: Summerhouse Press, 1998.

Blake, William J. *The History of Putnam County, NY.* New York: Baker and Scribner, 1849.

Blum, John Morton. *From the Morgenthau Diaries: Years of Crisis, 1928–1938.* Boston: Houghton Mifflin, 1959.

Board of Water Supply of the City of New York. *Catskill Water Supply: A General Description.* New York, 1928.

Bordewich, Fergus M. *Bound for Canaan: The Underground Railroad and the War for the Soul of America.* New York: Amistad/HarperCollins, 2005.

Boyle, Robert H. *The Hudson River: A Natural and Unnatural History.* Expanded ed. New York: Norton, 1979.

Brands, H. W. *The First American: The Life and Times of Benjamin Franklin.* New York: Anchor Books, 2000.

Bruce, Wallace. *The Hudson by Daylight by Thursty McQuill.* New York: Gaylord Watson, 1873.

———. *The Hudson.* New York: Bryant Literary Union, 1894.

———. *Along the Hudson with Washington Irving.* Poughkeepsie, NY: Press of the A.V. Haight Company, 1913.

Bruce, Willard A. "Capital District Area Special Study." *NYS Health Department* (July/August/September 1961).

Bryant, William Cullen. *Picturesque America: or, the Land We Live In. A Delineation by Pen and Pencil of the Mountains, Rivers, Lakes, Forests, Water-falls, Shores, Cañons, Valleys, Cities, and Other Picturesque Features.* 2 vols. New York: D. Appleton and Company, 1872.

———. *Thanatopsis.* 1817; reprint, Boston: The Bibliophile Society, 1927.

Buckman, David Lear. *Old Steamboat Days on the Hudson River.* New York: Grafton Press, 1907.

Burns, Ric and James Sanders. *New York: An Illustrated History.* New York: Knopf, 1999.

Burrows, Edwin G. and Mike Wallace. *Gotham: A History of New York City to 1898.* New York: Oxford University Press, 1999.

Buttenwieser, Ann. *Manhattan Water-Bound: Manhattan's Waterfront from the Seventeenth Century to the Present.* 2nd ed. Syracuse, NY: Syracuse University Press, 1999.

Calihan, Robert J. and Judith LaBelle Larsen. "The Hudson Highlands." Poughkeepsie, NY: Scenic Hudson Preservation Conference, 1981.

Callow, James T. *Kindred Spirits: Knickerbocker Writers and American Artists 1807–1855.* Chapel Hill: University of North Carolina Press, 1967.

Canfield, Cass. *The Incredible Pierpont Morgan: Financier and Art Collector.* New York: Harper and Row, 1974.

Canning, Jeff and Wally Buxton. *History of the Tarrytowns.* Harrison, NY: Harbor Hill Books, 1975.

Carmer, Carl. "Hollowed-Out Ground." *American Heritage* 18, no. 4 (June 1967).

———. *The Hudson.* Rivers of America Series. 1939; reprint, New York: Holt, Rinehart and Winston, 1974.

Caro, Robert A. *The Power Broker: Robert Moses and the Fall of New York.* New York: Vintage, 1975.

Church, Frederic. Letter to William Henry Osborn, 29 July 1868; 4 November 1868; 9 November 1868. Archives of the Olana State Historic Site, Hudson, NY.

Clapp, Margaret. *Forgotten First Citizen: John Bigelow.* Boston: Little, Brown, 1947.

Clinton, DeWitt. [Tacitus, pseud.] "Memorial of the Citizens of New York State" (1816). In "The Canal Policy of the State of New York: Delineated in a Letter to Robert Troup, Esquire." Albany: E. and E. Hosford, 1821.

———. [Atticus, pseud.]. "Remarks on the Proposed Canal, from Lake Erie to the Hudson River." New York: Samuel Wood & Sons, 1816.

———. [Tacitus, pseud.] "The Canal Policy of the State of New York: Delineated in a Letter to Robert Troup, Esquire." Albany: E. and E. Hosford, 1821.

———. [Hibernicus, pseud.]. *Letters on the Natural History and Internal Resources of the State of New York.* New York: E. Bliss & E. White, 1822.

———. "Description of a New Species of Fish." *Annals of the Lyceum of Natural History of New-York,* 1: 49–50. New York: J. Seymour, 1824–1876.

Clinton, Sir Henry. *The American Rebellion.* Ed. William B. Willcox. New Haven: Yale University Press, 1954.

Cole, Thomas. "Essay on American Scenery." *American Monthly Magazine* (1 January 1836):1–12. http://www.geocities.com/steletti/pages/scenery.html.

Collier, Peter and David Horowitz. *The Rockefellers: An American Dynasty.* 1976; reprint, New York: Summit, 1989.

Colyer, William H. *Sketches of the North River.* New York: Author, 1838.

Cook, Grace. "Memoirs." Mimeograph courtesy of Anne and Consantine Sidamon-Eristoff, Highland Falls, NY.

Cooper, James Fenimore. *The Last of the Mohicans. Leatherstocking Tales,* Vol. I. New York: Literary Classics of the United States, 1985.

———. *The Pioneers. Leatherstocking Tales,* Vol. I. New York: Literary Classics of the United States, 1985.

Cornog, Evan. *The Birth of Empire: DeWitt Clinton and the American Experience, 1769–1828.* New York: Oxford University Press, 1998.

Countryman, Edward. "Split Wide and Split Deep—The Revolutionary War Hudson Valley." *Hudson River Valley Regional Review* 20, no. 1 (Summer 2003): 1–5.

Cronin, John and Robert F. Kennedy, Jr. *The Riverkeepers.* New York: Scribner, 1997.

Cummings, Thomas S. *Historic Annals of the National Academy of Design.* Philadelphia: George W. Childs, 1865.

D'Auermont, Frances Wright. *Society and Manners in America in a Series of Letters from that Country to a Friend in England by an Englishwoman.* New York: E. Bliss and White, 1821.

Diamant, Lincoln. *Chaining the Hudson: The Fight for the River in the American Revolution.* New York: Carol Publishing Group, 1994.

Dickens, Charles. *American Notes for General Circulation.* 1842; reprint, London: Penguin, 1972.

Donaldson, Alfred L. *A History of the Adirondacks.* 2 vols. 1921; reprint, Fleischmanns, NY: Purple Mountain Press, 1996.

Doty, Dale. *Initial Brief to the Hearing Examiner of the Scenic Hudson Preservation Conference.* United States of America before the Federal Power Commission in the matter of Consolidated Edison Company of New York, Inc. Project No. 2338. June 15, 1964. Marist College Library, Poughkeepsie, NY.

Downing, A. J. *Cottage Residences.* New York: Wiley and Putnam, 1844.

———. *Rural Essays.* Ed. George William Curtis. New York: Leavitt and Allen, 1857.

———. *A Treatise on the Theory and Practice of Landscape Gardening Adapted to North America With a View to the Improvement of Country Residences.* 6th ed. with supplement by Henry Winthrop Sargent. New York: A. O. Moore & Co. Agricultural Book Publishers, 1859.

———. *A Treatise on the Theory and Practice of Landscape Gardening Adapted to North America With a View to the Improvement of Country Residences*. 7th ed. with supplement by Henry Winthrop Sargent. New York: Orange Judd Agricultural Book Publisher, 1865.

———. *Architecture of Country Houses*. Reprint, New York: Dover, 1969.

Drake, Joseph Rodman. *The Culprit Fay*. New York: Rudd and Carlton, 1859.

Driscoll, John. *All That Is Glorious Around Us: Paintings from the Hudson River School*. Ithaca, NY: Cornell University Press, 1997.

Dunn, Shirley. *The Mohicans and Their Land 1609–1730*. Fleischmanns, NY: Purple Mountain Press, 1994.

Dwight, Timothy. *Travels in New England and New York*. Vol. 3. Ed. Barbara Miller Solomon. 1822; reprint, Cambridge: Belknap Press of Harvard University Press, 1969.

Federal Power Commission. Opinion No. 452, Project No. 2338. "Opinion and Order Issuing License and Reopening and Remanding Proceeding for Additional Evidence on the Location of the Primary Lines and Design of Fish Protective Facilities." March 9, 1965. Marist College Library, Poughkeepsie, NY.

Fitzherbert, Anthony. "William G. McAdoo and the Hudson Tubes." Pamphlet. Electric Railroaders Association, June 1964. Reproduced on www.nycsubway.org.

Fitzpatrick, John C., ed. *The Writings of George Washington From Original Manuscript Sources 1745–1799*. vols. 4–5. Washington, DC: U.S. Government Printing Office, 1932.

Fitzsimons, Neal, ed. *The Reminiscences of John B. Jervis: Engineer of the Old Croton*. Syracuse, NY: Syracuse University Press, 1971.

Force, Peter, ed. *American Archives*. 4th and 5th series. 1837–1853; reprint, New York: Johnson Reprint Corp., 1972.

Ford, Worthington Chauncey, ed. *Journals of the Continental Congress 1774–1789*. Washington, DC: U.S. Government Printing Office, 1905.

Forman, Sidney. *West Point: A History of the United States Military Academy*. New York: Columbia University Press, 1950.

———. *The American Revolution in the Hudson Highlands*. Highlands, NY: Author, 1982.

———. "From Our Past." *News of the Highlands*. Town of Highlands, NY, December 1982.

Funk, Elisabeth Paling. "Knickerbocker's New Netherland: Washington Irving's Representation of Dutch Life on the Hudson." In George Harinck and Hans Krabbendam, eds., *Amsterdam—New York: Transatlantic Relations and Urban Identities Since 1653*, 135–147. Amsterdam: VU Uitgeverij, 2005.

Galusha, Diane. *Liquid Assets: A History of New York City's Water System*. Fleischmanns, NY: Purple Mountain Press, 1999.

Giles, Dorothy. "Marshmoor and Under-cliff." *Putnam County History Workshop*. Mimeograph, 1955. Cold Spring, NY: Putnam County Historical Society, 1955.

———. *A Brief Story of the American Revolution in the Hudson Highlands*. Cold Spring, NY: Putnam County Historical Society, 1976.

Gilman, Caroline. *The Poetry of Traveling in the United States*. 1838; reprint, Upper Saddle River, NJ: Literature House, 1970.

Goodrich, Frank Boott. *Man Upon the Sea: or, A history of maritime adventure, exploration, and discovery, from the earliest ages to the present time*. Philadelphia: J. B. Lippincott, 1858.

Goodwin, Maud Wilder. *Dutch and English on the Hudson*. New Haven: Yale University Press, 1919.

Graham, Frank. *The Adirondack Park: A Political History*. New York: Knopf, 1978.

Gray, Col. David W. "The Architectural Development of West Point." West Point, NY: Department of Military Topography and Graphics, U.S. Military Academy, 1951.

Hale, Susan. Letter to her sister Lucretia, 20 July 1884. Sophia Smith Collection, Smith College, Northampton, MA.

Haley, Jaquetta, ed. *Pleasure Grounds: Andrew Jackson Downing and Montgomery Place with Illustrations by Alexander Jackson Davis.* Tarrytown, NY: Sleepy Hollow Press, 1988.

Harris, Wendy and Arnold Pickham. "Landscape, Land Use, and the Iconography of Space in the Hudson River Valley: The Nineteenth and Early Twentieth Century." Paper presented at the New York Academy of Sciences, December 9, 1996. cragscons/acsci.html.

Hastings, Hugh, ed. *Public Papers of George Clinton.* Vol. 1. Albany: Published by the State of New York as the third annual report of the State Historian, 1899.

Hauptman, Laurence M. and Jack Campisi. *Neighbors and Intruders An Ethnohistorical Exploration of the Indians of Hudson's River.* National Museum of Man Series. Ottawa, Ontario: Canadian Ethnology Service Paper No. 39, 1978.

Hauptman, Laurence M. and Ronald G. Knapp. *Dutch–Aboriginal Interaction in New Netherland and Formosa: An Historical Geography of Empire.* Reprint, Philadelphia: American Philosophical Society, 1977.

Hayner, Rutherford. *Troy and Rensselaer County New York: A History.* Vol. 1. New York: Lewis Historical Publishing, 1925.

Hecht, Roger, ed. *The Erie Canal Reader—1790–1950.* Syracuse, NY: Syracuse University Press, 2003.

Hetling, Leo, Andrew Stoddard, Thomas M. Brosnan, Diane A. Hammerman, and Theresa M. Norris. "Effect of Water Quality Management on Wastewater Loadings During the Past Century." *Water Environment Research* 75, no. 1 (January/February 2003).

Holley, Alexander Lyman and Lenox Smith. "The Albany and Rensselaer Iron and Steel Works, Troy, N.Y." *Engineering* (December 24, 1880):590–591.

Hopkins, Vivian. "The Empire State—DeWitt Clinton's Laboratory." *New York Historical Society Quarterly* 59, no. 1 (1975).

Horrell, Jeffrey L. *Seneca Ray Stoddard: Transforming the Adirondack Wilderness in Text and Image.* Syracuse, NY: Syracuse University Press, 1999.

Hosack, David. *Memoir of De Witt Clinton with an Appendix Containing Numerous Documents Illustrative of the Principal Events of His Life.* New York: J. Seymour, 1829.

Howat, John K. *The Hudson River and Its Painters.* New York: Penguin, 1978.

Howell, William Thompson. *Highland Notes.* Uncopyrighted diary/scrapbook, 2 vols., c. 1910. New York Public Library.

The Hudson Highlands. 2 vols. 1933–34; reprint, New York: Walking News, 1982.

Hudson River Conservation Society. *Certificate of Incorporation.* West Point, NY, 1936.

———. *First Annual Report.* West Point, NY, 1937. Marist College Library.

———. *Second Annual Report.* West Point, NY, 1938. Marist College Library.

Hudson River Fishermen's Association vs. Federal Power Commission, 498 F. 2d 463 (2d Cir 1971). Marist College Library, Poughkeepsie, NY.

Hudson River Foundation. "Target Ecosystem Characteristics for the NY/NJ Harbor Estuary: Technical Guidance for Developing a Comprehensive Restoration Plan for the Hudson-Raritan Estuary Environmental Restoration Study." Consultant report to the Port Authority of New York and New Jersey, 2007.

Hudson River Rail Road Company. "Statement Showing the Prospects of Business and the Importance of the Proposed Rail Road." New York: E. B. Clayton and Sons, 1846.

Hudson River Regulating District. "Sacandaga Reservoir: Its Purpose and Operation." Pamphlet. N.p.: Hudson River Regulating District, 1950.

Hungerford, Edward. *Men and Iron: The History of New York Central.* New York: Thomas Y. Crowell, 1938.

Hunt, Freeman. *Letters about the Hudson and Its Vicinity, Written in 1835 and 1836.* New York: Freeman Hunt and Co., 1836.

Hurley, Andrew. "Creating Ecological Wastelands: Oil Pollution in New York City, 1870–1900." *Journal of Urban History* 20, no. 3 (May 1994): 340–364.

Huth, Hans. *Nature and the American: Three Centuries of Changing Attitudes.* Los Angeles: University of California Press, 1957.

Hutton, George. *The Great Hudson River Brick Industry.* Fleischmanns, NY: Purple Mountain Press, 2003.

Irving, Washington. *Knickerbocker's New York: A History of New York from the Beginning of the World to the End of the Dutch Dynasty by Diedrich Knickerbocker.* 1809; reprint, New York: G. P. Putnam's Sons, 1888.

———. *Bracebridge Hall or the Humorists.* Surrey edition, vol. 2. New York: G. P. Putnam's Sons, 1896.

———. *Tales from Irving.* New York: Brant Literary Union, 1902.

———. *The Crayon Miscellany. The Complete Works of Washington Irving,* vol. 22. Ed. Dahlia Kirby Terrell. Boston: Twayne, 1979.

———. *Washington Irving's Sketch Book: The Classic Artist's Edition of 1863.* New York: Crown Publishers/Avenel Books, 1985.

Jackson, Kenneth. "But It Was In New York: The Empire State and the Making of America." Speech, New York State Museum, March 20, 2006.

Jackson, Kenneth T. and David S. Dunbar, eds. *Empire City: New York Through the Centuries.* New York: Columbia University Press, 2002.

Jameson, Franklin, ed. *Narratives of New Netherland 1609–1664.* New York: Charles Scribner's Sons, 1909.

Jensen, Oliver. *The American Heritage History of Railroads in America.* New York: American Heritage, 1975.

Jervis, John B. "Report on the Project of a Railroad on the East Bank of the Hudson River, from New York to Albany." New York, January 20, 1846. Copy in author's collection.

———. "The Hudson River Railroad: A Sketch of its History, and Prospective Influence on the Railway Movement." *Hunt's Merchant's Magazine* (March 1850).

Johnson, Allen and Dumas Malone, eds. *Dictionary of American Biography.* New York: Scribner, 1928–1964.

Joyce, Henry. *Tour of Kykuit: The House and Gardens of the Rockefeller Family.* Tarrytown, NY: Historic Hudson Valley Press, 1994.

Kennan, George. *E. H. Harriman: A Biography.* 2 vols. 1922; reprint, Freeport, NY: Books for Libraries Press, 1969.

Ketchum, Richard M. *Saratoga: Turning Point of America's Revolutionary War.* New York: Holt, 1997.

Klawonn, Marion J. *Cradle of the Corps: A History of the New York District U.S. Army Corps of Engineers 1775–1975.* New York: U.S. Army Corps of Engineers, New York District, 1977.

Koeppel, Gerard. *Water for Gotham: A History.* Princeton: Princeton University Press, 2000.

Kowsky, Francis R. *Country Park and City: The Architecture and Life of Calvert Vaux.* New York: Oxford University Press, 1998.

Larsen, Neil. Draft paper, untitled, on historic architecture of the Hudson Highlands. New York State Office of Parks, Recreation and Historic Preservation, 1981.

LeBoeuf, Randall. Brief for Applicant, Consolidated Edison Company of New York, June 13, 1964. Marist College Library, Poughkeepsie, NY.

Leslie, Eliza. "Recollections of West Point." *Graham's Magazine* (April 1842).

Levinton, Jeffey S. and John Walman, eds. *The Hudson River Estuary.* New York: Cambridge University Press, 2006.

Lewis, Tom. *The Hudson: A History.* New Haven: Yale University Press, 2005.

Limburg, K. E., M. A. Moran, and W. T. McDowell. *The Hudson River Ecosystem.* New York: Springer Verlag, 1986.

Lossing, Benson. *A Primary History of the United States*. New York: Sheldon and Co., 1858.

———. *Life of Washington: A Biography, Personal, Military, and Political*. New York: Virtue and Co., 1860.

———. *The Pictorial Field-Book of the Revolution*. 2 vols. New York: Harper Brothers, 1860.

———. *The Hudson from the Wilderness to the Sea*. New York: Virtue and Yorston, 1866.

Mabie, Hamilton Wright. *The Writers of Knickerbocker New York*. New York: Grolier Club, 1912.

Marryat, Frederick. *A Diary in America with Remarks on Its Institutions*. New York: Knopf, 1962.

Marsh, George Perkins. *Man and Nature by George Perkins Marsh*. Ed. David Lowenthal. 1864; reprint, Cambridge, MA: The Belknap Press of Harvard University Press, 1965.

Martineau, Harriet. *Retrospect of Western Travel*. London: Saunders and Otley, 1838.

———. *Retrospect of Western Travel*. Introduction by Daniel Feller. London: M. E. Sharpe, 2000.

McGrath, Bill. "Camp Woods, Ossining, NY—Methodist Camp Ground to Secular Suburb, 1831–2001." *The Westchester Historian* 79, no. 3 (Summer 2003).

McMartin, Barbara. *The Great Forest of the Adirondacks*. Utica, NY: North Country Books, 1994.

McShine, Kynaston, ed. *The Natural Paradise: Painting in America 1800–1950*. New York: Museum of Modern Art, 1976.

Mearns, Dr. Edgar A. "Birds of the Hudson Highlands." *Bulletin of the Essex Institute*, vols. 10–13. Salem, MA: Salem Press, 1878–1881.

———. "A Study of the Vertebrate Fauna of the Hudson Highlands, with Observations on the Mollusca, Crustacea, Lepidoptera and the Flora of the Region." *Bulletin of the American Museum of Natural History*, vol. 10, 1898.

Melville, Herman. *Moby-Dick or, The Whale*. Berkeley: University of California Press, 1979.

Mercer, Lloyd J. *E. H. Harriman: Master Railroader*. Boston: Twayne, 1985.

Merwick, Donna. *Possessing Albany 1630–1710: The Dutch and English Experiences*. New York: Cambridge University Press, 1990.

Metropolitan Sewerage Commission of New York. *Sewerage and Sewage Disposal in the Metropolitan District of New York and New Jersey*. April 30, 1910. Hudson River Foundation Archives, New York, NY.

———. *Present Sanitary Condition of New York Harbor and the Degree of Cleanness Which is Necessary and Sufficient for the Water*. August 1, 1912.

———. *Main Drainage and Sewage Disposal Works Proposed for New York City: Reports of Experts and Data Relating to the Harbor*. April 30, 1914.

Middleton, William D. "Penn Station Lives!" *Invention and Technology* (Fall 1997).www.AmericanHeritage.com.

Mid-Hudson Pattern for Progress. December 5, 1964, Conference Proceedings, 1965. Mid-Hudson Pattern Archives, Newburgh, NY.

Milbert, J. *Picturesque Itinerary of the Hudson River and Peripheral Parts of North America*. Trans. Constance Sherman. Upper Saddle River, NJ: Gregg Press, 1969.

Mitchell, Donald G. *Out-of-Town Places*. New York: Charles Scribner's Sons, 1907.

Montule, Edouard de. *Travels in America, 1816–1817*. Trans. Edward Seeber. Bloomington: Indiana University Press, Social Science Series #9, 1950.

Moore, Frank and John Anthony Scott, ed. *The Diary of the American Revolution* 1775–1781. New York: Washington Square Press, 1967.

Morris, Edmund. *The Rise of Theodore Roosevelt*. New York: Ballantine, 1979.

Moses, Robert, Letter to Governor Herbert Lehman, 8 February 1940. Bear Mountain State Park Archives, Bear Mountain, NY.

Muir, John. *Edward Henry Harriman.* Garden City, NY: Doubleday, Page, 1912.

Mulligan, John. "Bear Mt. Bridge—at age 50." Associated Press; undated, unidentified news clip, Bear Mountain State Park Archives.

Murray, Stuart. *The Honor of Command: General Burgoyne's Saratoga Campaign—June– October 1777.* Bennington, VT: Images from the Past, Inc. Tordis Ilg Isselhardt, Publisher, 1998.

"Must God's Junkyard Grow?" *Life* (July 31, 1964).

Mylod, John. *Biography of a River, the People and Legends of the Hudson Valley.* New York: Hawthorne, 1969.

Nash, Roderick. *The American Environment.* Reading, MA: Addison-Wesley, 1976.

———. *Wilderness and the American Mind.* 3rd ed. New Haven: Yale University Press, 1982.

National Park Service, U.S. Department of the Interior. "Hudson River Valley Special Resource Study Report." Boston: New England System Support Office, 1996.

New-York Historical Society. *Collections of the New-York Historical Society*, Second Series, vol. I. New York: H. Ludwig, 1841.

New York Public Library. *An Exhibition Illustrating the History of the Water Supply of the City of New York from 1639 to 1917.* Pamphlet. New York Public Library, 1917.

New York State, Hudson River Valley Commission. *The Hudson: Summary Report.* Albany, February 1, 1966.

New York State, Hudson River Valley Survey Commission. *Preliminary Report of the Hudson Valley Survey Commission to the Legislature.* Legislative Document No. 98. Albany, March 18, 1938.

———. *Report of the Hudson Valley Survey Commission to the Legislature.* Legislative Document No. 71. Albany, March 1, 1939.

New York State Commission of State Parks. "First Annual Report of the Commissioners of State Parks of the State of New York" (1871). In Paul Schaefer, *Adirondack Explorations: Nature Writings of Verplanck Colvin.* Syracuse, NY: Syracuse University Press, 1997.

New York State Department of Environmental Conservation. "Hudson River Estuary: Report on Ten Years of Progress." Pamphlet. Albany: NYSDEC, 2006.

New York State Department of State. Letter to David Loomes, St. Lawrence Cement Co., "Objection to Consistency Determination," 19 April 2005. NYSDOS Division of Coastal Resources Archives, Albany, NY.

New York State Hudson-Fulton Celebration Commission. *The Hudson Fulton Celebration 1909.* Fourth Annual Report to the Legislature of the State of New York. 2 vols. Prepared by Edw. Hagaman Hall, Albany, NY, 1910.

New York State Legislature. "An Act to incorporate the Bear Mountain Hudson River Bridge Company, and to authorize the construction of a bridge across the Hudson river near the village of Peekskill, together with approaches thereto and to define the rights of the state respecting such bridge." Senate Bill No. 626. Albany, NY, February 8, 1922.

———. "Preliminary Report of the Joint Legislative Committee on Natural Resources of the Hudson River and the Consolidated Edison Company Storm King Mountain Project." Robert Watson Pomeroy, Chair. Albany, February 16, 1965. New York State Archives.

Nixon, Edgar B., ed. *Franklin D. Roosevelt and Conservation 1911–1945.* Hyde Park, NY: General Services Administration, National Archives and Records Service, Franklin D. Roosevelt Library, 1957.

Noble, Louis L. *The Life and Works of Thomas Cole.* Ed. Elliot S. Vesell. Cambridge, MA: Belknap Press of Harvard University Press, 1964.

Novotny, Ann. "Research Reports." Prepared for Selvage and Lee, New York, on behalf of Scenic Hudson Preservation Conference, July 30, 1964.

O'Brien, Austin. *The Preservationist* 8, no. 2 (Fall/Winter 2004).

O'Brien, Raymond J. *American Sublime: Landscape and Scenery of the Lower Hudson Valley*. New York: Columbia University Press, 1981.

Palisades Interstate Park Commission. *Sixty Years of Park Cooperation: New York–New Jersey—A History 1900–1960*. Pamphlet. N.p.: Palisades Interstate Park Commission, 1960.

Palmer, Lt. Col. Dave Richard. *The River and the Rock: The History of Fortress West Point, 1775–1783*. New York: Greenwood, 1969.

Partridge, Dr. Edward. "The New Storm King Highway." December 15, 1921. Unidentified newsclip. Franklin D. Roosevelt Library, Hyde Park, NY.

Patton, Thomas. "Forestry and Politics: Franklin D. Roosevelt as Governor of New York." *New York History* (October 1994):397–418.

Peck, Amelia, ed. *Alexander Jackson Davis: American Architect 1803–1892*. New York: Rizzoli, 1992.

Phelan, Thomas and P. Thomas Carroll. *Hudson Mohawk Gateway: An Illustrated History*. Sun Valley, CA: American Historical Press, 2001.

Phillips, Sandra S. *Charmed Places: Hudson River Artists and Their Houses, Studios, and Vistas*. New York: Bard College and Vassar College, 1988.

Pittman, Nancy P. "James Wallace Pinchot (1831–1908): One Man's Evolution Toward Conservation in the Nineteenth Century." *Yale F&ES Centennial News* 86, no. 1 (Fall 1999) (Yale School of Forestry and Environmental Studies).

Poe, Edgar Allan. *Best Known Works of Edgar Allan Poe*. Garden City, NY: Blue Ribbon, 1941.

Pratt, George W. "An Account of the British Expedition above the Highlands of the Hudson River and of the Events Connected with the Burning of Kingston in 1777." Pamphlet. *Collections of the Ulster County Historical Society*, vol. 1, 1860 (reprinted 1977).

Pritchard, Evan T. *Native New Yorkers: The Legacy of the Algonquin People of New York*. San Francisco: Council Oak, 2002.

——. "Estuaries and Algonquins." Unpublished manuscript, 2005.

Proctor, Mary and Bill Matuszeski. *Gritty Cities*. Philadelphia: Temple University Press, 1978.

Putnam County Historical Society. "Putnam County History Workshops." Mimeographs. Cold Spring, NY: Putnam County Historical Society, 1955, 1957.

Roberts, Ann Rockefeller. *The Rockefeller Family Home, Kykuit*. New York: Abbeville Press, 1998.

Roosevelt, Franklin D. Franklin D. Roosevelt Collection of Speeches, Franklin D. Roosevelt Library, Hyde Park, NY.

——. "Address before the Conference of Governors on Land Utilization and State Planning." French Lick, IN, June 2, 1931. Franklin D. Roosevelt Collection of Speeches, Franklin D. Roosevelt Library, Hyde Park, NY.

——. "Address at the Dedication of the New Post Office." Rhinebeck, NY, May 1, 1939. Franklin D. Roosevelt Collection of Speeches, Franklin D. Roosevelt Library, Hyde Park, NY.

——. "Extemporaneous Remarks at Celebration of Fiftieth Anniversary of State Conservation at Lake Placid." September 14, 1935. Franklin D. Roosevelt Collection of Speeches, Franklin D. Roosevelt Library, Hyde Park, NY.

Roosevelt, Sara Delano. *My Boy Franklin*. New York: Ray Long & Richard R. Smith, 1933.

Roosevelt, Theodore. *Theodore Roosevelt's Diaries of Boyhood and Youth*. New York: Charles Scribner's Sons, 1928.

Rutsch, Edward, JoAnn Cotz, Brian Morrell, Herbert Githens, and Leonard Eisenberg. *The West Point Foundry Site: Cold Spring*. Newton, NJ: Cultural Resource Management Service, n.d.

Ryan, James Anthony. *Frederic Church's Olana: Architecture and Landscape as Art*. Hensonville, NY: Black Dome Press, 2001.

Sale, Kirkpatrick. *The Fire of His Genius: Robert Fulton and the American Dream*. New York: Simon & Schuster Touchstone, 2001.

Sandler, Ross and David Schoenbrod, eds. *The Hudson River Power Plant Settlement: Conference Materials*. New York: New York University School of Law, 1981.

"Saratoga, Philadelphia, and the Collapse of Britain's Grand Strategy." *Hudson River Valley Regional Review* 20, no. 1 (Summer 2003): 53–65.

Satterlee, Herbert L. *J. Pierpont Morgan: An Intimate Portrait*. New York: Macmillan, 1939.

Schaaf, Gregory. "The Birth of Frontier Democracy from an Eagle's Eye View: The Great Law of Peace to the Constitution of the United States of America." In *The Haudenosaunee, a special supplement to the Indian Time Newspaper for educators and students*. Hogansburg, NY: Indian Time, 2004.

Schaefer, Paul. "The Tragedy of the Hudson." In *Defending the Wilderness: The Adirondack Writings of Paul Schaefer*. Syracuse, NY: Syracuse University Press, 1989.

——, ed. *Adirondack Explorations: Nature Writings of Verplanck Colvin*. Syracuse, NY: Syracuse University Press, 1997.

Schecter, Barnet. *The Battle for New York: The City at the Heart of the American Revolution*. New York: Penguin, 2002.

Schuyler, David. "'Gems of Home Beauty on a Small Scale': Aspects of the Victorian Garden in America, 1840–1870." *Catalogue of the Old Lancaster Antiques Show*, November 1983.

——. *Apostle of Taste: Andrew Jackson Downing 1815–1852*. Baltimore: Johns Hopkins University Press, 1996.

Shaw, Ronald E. *Erie Water West: A History of the Erie Canal 1792–1854*. Lexington: The University Press of Kentucky, 1966.

——. *Canals for a Nation: The Canal Era in the United States 1790–1860*. Lexington: The University Press of Kentucky, 1990.

Sheriff, Carol. *The Artificial River: The Erie Canal and the Paradox of Progress, 1817–1862*. New York: Hill and Wang, 1996.

Shorto, Russell. *Island at the Center of the World: The Epic Story of Dutch Manhattan and the Forgotten Colony That Shaped America*. New York: Doubleday, 2004.

Smith, McKelden. *The Great Estates Region of the Hudson River Valley*. Tarrytown, NY: Historic Hudson Valley Press, 1998.

Smith, Sydney. *Edinburgh Review* 33 (January 1820).

Snell, Charles W. *Franklin D. Roosevelt and Forestry at Hyde Park, New York*. Washington, DC: U.S. Department of the Interior, National Park Service, 1911, 1932.

Spitzer, Elliot. Campaign Speech on Environmental Stewardship, Albany, NY, March 29, 2006 (as prepared for delivery and posted at www.Spitzer-Paterson2006.org).

Stanne, Stephen P., Roger G. Panetta, and Brian E. Forist. *The Hudson: An Illustrated Guide to the Living River*. New Brunswick: Rutgers University Press, 1996.

State of New York. "In Convention. Record. No. 113, 9/8/1894." Records of the Constitutional Convention, New York State Archives, Albany, NY.

——. *First Annual Report of the Conservation Commission 1911 vol. II Division of Inland Waters, transmitted to the Legislature January 10, 1912*. Albany: The Argus Company, 1912.

State of New York, Conservation Commission. *Water Power Resources of the State of New York*. Albany: J. B. Lyon, 1919.

State Water Supply Commission of New York. *First Annual Report.* Albany: Brandow, 1906.

———. *Second Annual Report.* Albany: J. B. Lyon, 1907.

———. *Fourth Annual Report.* Albany: J. B. Lyon, 1909.

———. *Sixth Annual Report.* Albany: J. B. Lyon, 1911.

Stedman, Charles. *History of the Origin, Progress and Termination of the American War.* 2 vols. Dublin, Ireland: Printed for Mssrs. P. Wogan, P. Byrne, J. Moore, and W. Jones, 1794.

Steinman, Dr. D. B. "The Place of the Engineer in Civilization." *State College Record.* Chapel Hill: University of North Carolina, School of Engineering, 1939.

Sutcliffe, Alice Crary. *Robert Fulton and the "Clermont."* New York: Century Co., 1909.

Sutherland. Cara A. *The Statue of Liberty.* New York: Museum of the City of New York, Barnes & Noble Publishing, 2003.

Talbot, Allan. *Power Along the Hudson: The Storm King Case and the Birth of Environmentalism.* New York: Dutton, 1972.

Tatum, George B. and Elisabeth B. McDougal, eds. *Prophet with Honor: The Career of Andrew Jackson Downing 1815–1852.* Washington, DC: Dumbarton Oaks Trustees for Harvard University, 1989.

Taylor, Alan. *The Divided Ground: Indians, Settlers and the Northern Borderland of the American Revolution.* New York: Vintage, 2006.

Terrie, Philip G. *Contested Terrain: A New History of Nature and People in the Adirondacks.* Syracuse, NY: Syracuse University Press, 1997.

Thomas, Bernice L. *The Stamp of FDR: New Deal Post Offices in the Mid-Hudson Valley.* Fleischmanns, NY: Purple Mountain Press, 2002.

Thompson, H. D. "Hudson Gorge in the Highlands." *Bulletin of the Geological Society of America* no. 47 (December 1936): 1831–1848.

Union of Concerned Scientists. *Climate Change in the U.S. Northeast: A Report of the Northeast Climate Impacts Assessment.* October 2006. www.climatechoices.org.

U.S. Congress. "The Hudson: A River in Peril." *Congressional Record.* 89th Cong., 1st sess. Washington, DC: U.S. Government Printing Office No.778–886–98643, 1965.

U.S. Court of Appeals, Second Circuit. *Scenic Hudson Preservation Conference v. Federal Power Commission,* 354 F.2d. 608 (2d. Cir. 1965). In Sandler and Schoenbrod, eds., *The Hudson River Power Plant Settlement: Conference Materials.* New York: NYU School of Law, 1981.

U.S. Department of the Army, Office of the Chief of Engineers. "Survey of Hudson River—Report of Colonel of Corps of Topographical Engineers, relative to the examination and survey of the Hudson River, &c." January 18, 1844. 28th Cong., 1st sess. House of Representatives War Dept. Doc. No. 53.

U.S. Department of the Interior. "History of the Saratoga National Historical Park." http://www.nps.gov/sara/s-parkhst.htm.

U.S. Federal Power Commission. Testimony before the Federal Power Commission in the Matter of the Application for Construction of Hydroelectric Plant at Cornwall, New York by Consolidated Edison Co. of New York, Project No. 2338. Marist College Library, Hudson River Collection, Poughkeepsie, NY.

U.S. House of Representatives. H.R. 3012, 89th Cong. January 18, 1965.

Van der Donck, Adriaen. *A Description of the New Netherlands. Collections of the New-York Historical Society,* Second Series, vol. 1. New York: H. Ludwig, 1841.

Van Valkenburgh, Norman J., ed. *Report of the Superintendent of the State Land Survey of the State of New York for the year 1898.* Schenectady, NY: The Adirondack Research Center of the Association for the Protection of the Adirondacks, 1989.

———. *The Forest Preserve of New York State in the Adirondack and Catskill Mountains: A Short History.* Pamphlet. Fleischmanns, NY: Purple Mountain Press in Cooperation

with the Adirondack Research Library of the Association for the Protection of the Adirondacks, 1996.

Van Zandt, Roland, ed. *Chronicles of the Hudson: Three Centuries of Travellers' Accounts.* New Brunswick, NJ: Rutgers University Press, 1971.

———. *The Catskill Mountain House.* 1966; reprint, Hensonville, NY: Black Dome Press, 2001.

Vogel, Robert M., ed. *A Report of the Mohawk-Hudson Area Survey.* Smithsonian Studies in History and Technology No. 26. Washington, DC: Smithsonian Institution Press, 1973.

Walker, Barbara K. and Warren S. Walker. *The Erie Canal: Gateway to Empire.* Boston: D. C. Heath, 1963.

Webb, Nina H. *Footsteps Through the Adirondacks: The Verplanck Colvin Story.* Utica, NY: North Country Books, 1996.

Weise, Arthur James. *Troy's One Hundred Years 1789–1899.* Troy, NY: William H. Young, 1891.

Wermuth, Thomas S. "'The Women in this place have risen a mob': Women Rioters and the American Revolution in the Hudson River Valley." *Hudson River Valley Regional Review* 20, no. 1 (Summer 2003): 65–73.

Wermuth, Thomas S. and James M. Johnson. "The American Revolution in the Hudson River Valley—An Overview." *Hudson River Valley Regional Review* 20, no. 1 (Summer 2003): 5–15.

Wharton, Edith. *The House of Mirth.* 1905; reprint, New York: Berkley.

White, Lazarus. *The Catskill Water Supply of New York City: History, Location, Sub-Surface Investigations and Construction.* New York: Wiley, 1913.

White, Peter. "It Can be Clear, Blue and Wonderful Again." *The New York Times Magazine,* July 17, 1966, 5:179.

Whitney, Charles S. *Bridges: A Study in Their Art, Science, and Evolution.* New York: Random House, 1988.

Wilkie, Richard. *The Illustrated Hudson River Pilot.* Albany, NY: Three City Press, 1974.

Willis, Nathaniel P. *Outdoors at Idlewild or The Shaping of a Home on the Banks of the Hudson.* New York: Charles Scribner, 1855.

———. *American Scenery.* 2 vols. 1840; reprint, Barre, MA: Imprint Society, 1971.

Wilson, M. *Thirty Years of History of Cold Spring and Vicinity, With Incidents By One Who Has Been A Resident Since 1819.* Cold Spring, NY: Shram Printing House, 1886.

Winkler, John K. *Morgan the Magnificent: The Life of J. Pierpont Morgan (1837–1913).* Garden City, NY: Garden City Publishing, 1930.

———. *The First Billion: The Stillmans and the National City Bank.* New York: Vanguard Press, 1934.

Winks, Robin W. *Laurance S. Rockefeller: Catalyst for Conservation.* Washington, DC: Island Press, 1997.

Wolfe, Thomas. *Of Time and the River.* Garden City, NY: Sun Dial Press, 1944.E. C. Coates, *View from Weehawken.*

INDEX

Page numbers in *italics* indicate illustrations.

The views expressed herein are those of the author only and do not represent the opinion or
 interest of the author's employer or of any sponsors or donors, who assume no liability for the
 contents or the use of information herein.

Columbia University Press would like to express its appreciation for assistance given by
 Furthermore: a program of the J. M. Kaplan Fund.

The support of the following foundations is gratefully acknowledged:

Gannett Foundation
The Bessemer Trust

© Words and Music by Pete Seeger "Sailing Up My Dirty Stream," Copyright 1961, renewed 1964,
 Fall River Music Inc.
© Photographs by Robert Beckhard
© Photographs by Charles H. Porter

Columbia University Press
Publishers Since 1893
New York Chichester, West Sussex
Copyright © 2008 Columbia University Press
All rights reserved

Library of Congress Cataloging-in-Publication Data
Dunwell, Frances F.
The Hudson : America's river / Frances F. Dunwell.
 p. cm.
Updated and expanded ed. of: The Hudson River Highlands. 1991.
Includes bibliographical references and index.
ISBN 978-0-231-13640-2 (cloth : alk. paper) — ISBN 978-0-231-13641-9
 (pbk.) — ISBN 978-0-231-50996-1 (electronic)
1. Hudson Highlands (N.Y.)—History. 2. Hudson River (N.Y. and N.J.)—History. 3. Hudson
 Highlands (N.Y.)—Environmental conditions. 4. Hudson River (N.Y. and N.J.)—Environmental
 conditions. 5. Hudson Highlands (N.Y.)—History—Sources. 6. Hudson River (N.Y. and
 N.J.)—History—Sources. 7. Human ecology—New York (State)—Hudson Highlands.
 8. Hudson River (N.Y. and N.J.)—Public opinion. 9. Public opinion—United States.
 I. Dunwell, Frances F. Hudson River Highlands. II. Title.
F127.H8D86 2008
974.7'3—dc22
 2007017963

Columbia University Press books are printed on permanent and durable acid-free paper.
This book was printed on paper with recycled content.
Printed in the United States of America
c 10 9 8 7 6 5 4 3 2 1
p 10 9 8 7 6 5 4 3 2 1

Designed by Lisa Hamm

References to Internet Web sites (URLs) were accurate at the time of writing. Neither the author
nor Columbia University Press is responsible for URLs that may have expired or changed since
the manuscript was prepared.